# THE
# SISTINE CHAPEL
# WALLS
# AND THE
# ROMAN LITURGY

# THE SISTINE CHAPEL WALLS AND THE ROMAN LITURGY

CAROL F. LEWINE

The Pennsylvania State University Press
University Park, Pennsylvania

Library of Congress Cataloging-in-Publication Data

Lewine, Carol F.
    The Sistine Chapel walls and the Roman liturgy / Carol F. Lewine.

        p.        cm.
    Includes bibliographical references and index.
    ISBN 0-271-00792-3
    1. Mural painting and decoration, Italian—Vatican City—Themes,
motives.    2. Catholic Church—Liturgy—Texts—Illustrations.
3. Catholic Church and art.    4. Sistine Chapel (Vatican Palace,
Vatican City)    I. Title.
ND2757.V35L48    1993
755'.2'0945634—dc20                                        91–12980
                                                              CIP

Published by The Pennsylvania State University Press, Suite C, Barbara Building,
University Park, PA 16802-1003

It is the policy of The Pennsylvania State University Press to use acid-free paper for the first printing of
all clothbound books. Publications on uncoated stock satisfy the minimum requirements of American
National Standard for Information Sciences—Permanence of Paper for Printed Library Materials, ANSI
Z39.48–1984.

*This book is lovingly dedicated to the memory of Milton J. Lewine*

# CONTENTS

List of Illustrations     viii

Preface     xi

Abbreviations     xix

I   Introduction     1

II   The First Frescoes on the Long Walls: The *Baptism of Christ* and the *Circumcision of Moses' Son*     21

III   The Second Frescoes on the Long Walls: The *Temptations of Christ* and *Moses in Egypt and Midian*     33

IV   The Third and Fourth Frescoes on the Long Walls: The *Calling of the First Apostles* and the *Crossing of the Red Sea*, the *Sermon on the Mount* and the *Lawgiving on Mount Sinai*     49

V   The Fifth Frescoes on the Long Walls: The *Gift of the Keys* and the *Punishment of Korah*     65

VI   The Sixth Frescoes on the Long Walls: The *Last Supper* and the *Last Testament of Moses*     83

VII   The Lost Frescoes on the Altar Wall: The *Nativity* and the *Finding of Moses*; and the Repainted Frescoes on the Entrance Wall: The *Resurrection and Ascension of Christ* and the *Fight for the Body of Moses*     95

VIII   Experiencing the Narrative Cycles     103

Appendix: Liturgical Themes     115

Bibliography     121

Index     129

Illustrations     135

# LIST OF ILLUSTRATIONS

## PLATES

   I.  Perugino: *The Baptism of Christ* (Vatican)
  II.  Botticelli: *The Temptations of Christ* (Vatican)
 III.  Ghirlandaio: *The Calling of the First Apostles* (Gabinetto Fotografico Nazionale)
  IV.  Rosselli: *The Sermon on the Mount* (Vatican)
   V.  Perugino: *The Gift of the Keys* (Vatican)
  VI.  Rosselli: *The Last Supper* (Vatican)
 VII.  Hendrik van den Broeck: *The Resurrection and Ascension of Christ* (Vatican)
VIII.  Perugino and Pinturicchio: *The Circumcision of Moses' Son* (Vatican)
  IX.  Botticelli: *Moses in Egypt and Midian* (Vatican)
   X.  Rosselli: *The Crossing of the Red Sea* (Vatican)
  XI.  Rosselli: *The Lawgiving on Mount Sinai* (Vatican)
 XII.  Botticelli: *The Punishment of Korah* (Gabinetto Fotografico Nazionale)
XIII.  Signorelli: *The Last Testament of Moses* (Gabinetto Fotografico Nazionale)
 XIV.  Matteo da Lecce: *The Fight for the Body of Moses* (Vatican)

## FIGURES

  1.  Sistine Chapel to the west (Alinari/Art Resource)
  2.  Plan of Chapel (Derek A. R. Moore)
  3.  Elevation, side wall of Chapel (Derek A. R. Moore)
  4.  Perugino, *The Baptism of Christ* (detail), Seated Catechumen (Alinari/Art Resource)
  5.  Perugino, *The Baptism of Christ* (detail), Christ Preaching (Alinari/Art Resource)

6. Perugino, *The Baptism of Christ* (detail), Man in Oriental Hat (Alinari/Art Resource)

7. The *Spinario*, Museo Nuovo, Palazzo dei Conservatori, Rome (Alinari)

8. Perugino and Pinturicchio, *The Circumcision of Moses' Son* (detail), Zipporah and Her Sons (Alinari)

9. Perugino and Pinturicchio, *The Circumcision of Moses' Son* (detail), The Circumcision (Alinari/Art Resource)

10. Botticelli, *The Temptations and Jewish Sacrifice* (detail), Christ and Angels (Alinari/Art Resource)

11. Botticelli, *The Temptations and Jewish Sacrifice* (detail), Boy with Grapes (Alinari/Art Resource)

12. Botticelli, *Moses in Egypt and Midian* (detail), Center of Fresco (Gabinetto Fotografico Nazionale)

13. Botticelli, *Moses in Egypt and Midian* (detail), Moses Removes His Sandals (Alinari)

14. Botticelli, *Moses in Egypt and Midian* (detail), Moses and the Burning Bush (Alinari)

15. Botticelli, *Moses in Egypt and Midian* (detail), Traveling Israelites (Alinari)

16. Melozzo da Forlì, *Sixtus IV and His Retinue at the Opening of the Vatican Library* (Alinari)

17. Sistine Chapel, Papal Throne Beneath Botticelli's *Moses in Egypt and Midian* (Vatican)

18. Ghirlandaio, *The Calling of the First Apostles* (detail), Christ, Peter, and Andrew (Gabinetto Fotografico Nazionale)

19. Rosselli, *The Crossing of the Red Sea* (detail), Song of Miriam (Vatican)

20. Rosselli, *The Crossing of the Red Sea* (detail), Horseman (Alinari/Art Resource)

21. Rosselli, *The Crossing of the Red Sea* (detail), Enigmatic Scene in Upper Right Corner (Vatican)

22. Perugino, *The Gift of the Keys* (detail), The Stoning of Christ (Vatican)

23. Perugino, *The Gift of the Keys* (detail), The Payment of the Tribute Money (Alinari/Art Resource)

24. Perugino, *The Gift of the Keys* (detail), Left Triumphal Arch (Vatican)

25. Perugino, *The Gift of the Keys* (detail), Right Triumphal Arch (Vatican)

26. Perugino, *The Gift of the Keys* (detail), Christ Hands the Keys to Peter (Gabinetto Fotografico Nazionale)

27. Botticelli, *The Revolt of Korah* (detail), The Punishment of Korah and His Followers (Vatican)

28. Botticelli, *The Revolt of Korah* (detail), The Earthquake (Vatican)

29. Botticelli, *The Revolt of Korah* (detail), The Beached Ships (Alinari)

30. Botticelli, *The Revolt of Korah* (detail), Joshua (?) (Alinari)

31. Signorelli, *The Last Testament of Moses* (detail), Moses Hands His Staff to Joshua; Nude Youth (Vatican)

32. Signorelli, *The Last Testament of Moses* (detail), Moses Reads from the Book of the Law (Vatican)

33. Signorelli, *The Last Testament of Moses* (detail), Moses Shown the Promised Land (Alinari/Art Resource)

34. Signorelli, *Madonna and Child*, Munich, Bayerischen Staatsgemäldesammlungen (Bayerischen Staatsgemäldesammlungen)

35. Van den Broeck, *The Resurrection and Ascension of Christ* (detail), The Risen Christ (Vatican)

36. Matteo da Lecce, *The Fight for the Body of Moses* (detail), Moses' Catafalque (Vatican)

# PREFACE

In this study, I propose to reconstruct a forgotten liturgical scheme that, in my view, informs the monumental history cycles painted on the Sistine Chapel walls between 1481 and 1483. I shall argue that an ancient liturgical tradition, stretching back to the time of the early church, provides a structure for this famed artistic ensemble of the later quattrocento.

In the early 1480s, two sets of narrative frescoes, illustrating episodes in the lives of Christ and Moses, were commissioned for the Sistine Chapel by Pope Sixtus IV, della Rovere (1471–84), from a group of Tuscan and Umbrian masters. The compositions created for Sixtus's chapel by such noted painters as Botticelli, Ghirlandaio, Perugino, and Signorelli display the concern with lifelike anatomy, scientific perspective, and the monuments of classical antiquity that we expect to find in Italian Renaissance art. But in many ways, the content of these narrative frescoes would have seemed familiar to the early church fathers, whose writings attracted renewed attention during Sixtus IV's lifetime. As has become increasingly clear, the revival of antiquity, so central to the intellectual life of the Italian Renaissance, was often a revival of Christian antiquity. Most modern scholars would probably agree that the history cycles on the Sistine Chapel walls reflect the Early Christian revival movement in Italian art and thought during the fifteenth century.

Within the extensive body of literature devoted to the Sistine Chapel of the fifteenth century, it was Leopold D. Ettlinger's indispensable book, *The Sistine Chapel Before Michelangelo: Religious Imagery and Papal Primacy* (1965), that first brought discussion of this artistic ensemble into the modern era. Ettlinger concluded that Ernst Steinmann's fundamental work on Pope Sixtus's chapel, *Die Sixtinische Kapelle: Der Bau und Schmuck der Kapelle unter Sixtus IV* (1901), took a view of the Christ and Moses frescoes that was somewhat too "old-fashioned." While Steinmann correctly perceived that the juxtaposed history cycles on the chapel walls form an unusual scheme of Christian typology, he claimed as well that the narrative frescoes were designed largely to commemorate some personal achievements of Sixtus IV. Steinmann's insistence on

the importance of worldly imagery in the Christ and Moses frescoes on the Sistine Chapel walls evidently reflects his view of the Italian Renaissance as a more or less secular movement. But as Egmont Lee shrewdly observes in *Sixtus IV and Men of Letters* (1978), "It seems inconceivable that . . . the iconography of the chapel should have been dictated by contemporary events and not by a coherent theological program." And in fact, Ettlinger has shown that the history cycles created for the premier Roman chapel of the popes were designed largely to promote papal primacy.

A discussion of the narrative cycles in Pope Sixtus's chapel necessarily figured in John Shearman's study of Raphael's designs for the Leonine tapestries destined to hang in the papal chapel beneath the narrative frescoes. In this erudite book, *Raphael's Cartoons in the Collection of Her Majesty the Queen and the Tapestries for the Sistine Chapel* (1972), Shearman stressed the importance of the papal *Primatus* in the decorative scheme devised for Pope Sixtus's chapel. Shearman restated this position in a later overview of the history and meaning of the papal chapel that forms part of *The Sistine Chapel: The Art, the History, and the Restoration* (1986).

Rona Goffen explored another aspect of the painted decoration created for Pope Sixtus's chapel in an illuminating article, "Friar Sixtus IV and the Sistine Chapel," *Renaissance Quarterly* (1986). There, she argued convincingly that both the narrative frescoes on the chapel walls and Perugino's lost altarpiece for the chapel evoke (or evoked) some crucial Franciscan subjects. Goffen's work takes proper account of the fact that Sixtus IV—the person ultimately responsible for the appearance of the papal chapel—was a devoted Franciscan, who had served as minister general of his order.

My own study is not undertaken in a spirit of correction. I have no wish to suggest that conclusions reached by Steinmann, Ettlinger, Shearman, or Goffen are misguided. The fifteenth-century history frescoes of the Sistine Chapel certainly recall some of Sixtus IV's worldly achievements. An assertion of the popes' supreme authority within their church is probably the primary goal of these narrative cycles in the major papal chapel of Rome. And Franciscan themes unquestionably figure in the decoration of Friar Sixtus's chapel. My purpose here is to add something else to the discussion. I have attempted to retrieve a forgotten liturgical scheme that, although largely overlooked in the literature on Pope Sixtus's chapel, appears to have played a vital role in the genesis of the painted decoration created for this sacred space, which plainly was intended as a setting for liturgical ceremonies.

So far as I am aware, no document has survived that links themes and texts of the Roman liturgy with the narrative cycles of Pope Sixtus's chapel; and perhaps there never was any document of this sort. Nevertheless, a long tradition of liturgically based imagery antedates the Sistine Chapel of the quattrocento. Some of this material was surely familiar to the learned della Rovere pope and to his associates. I shall argue that works of this kind offered models for the painted decoration in Pope Sixtus's chapel.

From an early date, narrative miniatures of liturgical content were used to illustrate lectionaries—liturgical volumes that bring together the extracts from Scripture assigned to be read at public worship on specified days of the ecclesiastical year. Related material already appears in the *Rossano Gospel Book* of the sixth century, where minia-

tures illustrating Gospel lections of Lent form a preface to the sacred text. Many Middle Byzantine churches were decorated on the interior with large-scale images of scriptural episodes worked out in mosaic, which served as glittering reminders of the "Great Feasts" of the liturgical year. Portable Byzantine icons displaying similar imagery had reached Italy by the quattrocento; for example, scenes evoking the Twelve Feasts of the Church Calendar embellish a precious Byzantine mosaic icon presented in 1394 to the Church of S. Giovanni in Florence by a pious Venetian lady. All of the works just cited offer evidence that a strong tradition of liturgical imagery in the visual arts preceded the decoration of the Sistine Chapel during the fifteenth century.

Parallel imagery was unquestionably familiar to Sixtus IV and his circle from popularized religious handbooks. Perhaps the best known and most widely read of these, Jacobus de Voragine's *Legenda Aurea,* was first compiled in the late thirteenth century and reissued often thereafter. In this popular compendium, regularly consulted during the Renaissance, the lives of individual saints appear in a sequence echoing the liturgical structure of the Church Calendar. A liturgical model was again employed in Ulrich von Lilienfeld's *Concordantia Caritatis* of the mid-fourteenth century. In this handbook, as Ettlinger points out, excerpts from the Gospels, with their accompanying illustrations, are arranged in the order in which the passages are read at church services during the course of the ecclesiastical year. Sixtus IV and his papal court undoubtedly knew both the Greek and Latin fathers and the medieval commentators so often cited by modern scholars as they try to disentangle complex religious iconography in Italian Renaissance art. But popular religious manuals were also known at the papal court. Sixtus himself cites Voragine's *Golden Legend* in the *De sanguine Christi,* a treatise dedicated by the future della Rovere pope to the pontiff who preceded him, Paul II, Barbo (1464–71).

There can be no question that Sixtus IV and the clerics around him were well acquainted with still another type of liturgical work. I refer to the basic manuals of Roman Catholicism, which serve as a kind of libretto for the ceremonial life of the church: the *Missal,* the *Breviary,* and the earlier service books on which they are based. In such liturgical manuals, year after year, Renaissance churchmen would encounter precisely the same texts and rituals on precisely the same liturgical days of the ecclesiastical calendar. I shall argue that the narrative frescoes on the Sistine Chapel walls reflect this standard liturgical material, familiar from ecclesiastical service books, from popularized Christian manuals like the *Golden Legend,* and from liturgically oriented works in the visual arts. Although some uniquely pontifical celebrations certainly took place in Sixtus IV's new chapel, it is important to recognize that those who worshiped there were expected to recite the same assigned texts from Scripture on the same liturgical days of the Christian year as everyone else throughout the Roman Church.

I propose to demonstrate more specifically that the history cycles on the Sistine Chapel walls reflect themes and texts of the Roman liturgy in the weeks between Advent and Pentecost Sunday. This idea is not new. It has appeared in the literature on the Sistine Chapel from Steinmann onward. But so far as I am aware, no serious attempt has yet been made to work out this liturgical scheme in detail. And to my

knowledge, it has not yet been suggested that the liturgy of Lent provides a major focus within this program. I shall argue that the frescoes on the long walls of the Sistine Chapel often reflect scriptural readings, ecclesiastical ceremonies, and liturgical themes associated with the six weeks of Lent, and with the official pre-Lenten period that opens on Septuagesima Sunday. In addition, I shall argue that the frescoes originally visible on the short walls of the papal chapel also echoed Lenten motifs, while at the same time recalling themes of the liturgy connected with the preceding Christmas season and with the following weeks of Pentecost.

Because this liturgical material may not be familiar to modern readers, it may be useful to give a brief account of the Lenten season. In the *Roman Missal,* the feast of the Epiphany (6 January) is followed by six Sundays. The seventh Sunday after Epiphany, *Dominica in Septuagesima,* opens the *Tempus Septuagesimae,* the official pre-Lenten period. Septuagesima Sunday is followed by two additional pre-Lenten Sundays, *Dominica in Sexagesima* and *Dominica in Quinquagesima.* All three pre-Lenten Sundays are assigned stational Masses, once actually celebrated in the designated stational churches of Rome. Lent proper, the *Tempus Quadragesimae,* now begins on Ash Wednesday, the Wednesday after Quinquagesima Sunday. From this Wednesday onward, a stational Mass is assigned in the *Roman Missal* to every weekday and Sunday until the end of the Easter Octave, on the Sunday following Easter Sunday. The Sunday following Ash Wednesday, the first official Sunday of Lent, is entitled *Dominica Prima in Quadragesima* in the *Roman Missal;* and in the primitive church, Lent began on this day. The following three Lenten Sundays are entitled: *Dominica Secunda in Quadragesima, Dominica Tertia in Quadragesima,* and *Dominica Quarta in Quadragesima.* There follow the fifth Sunday in Lent, called Passion Sunday, which opens the *Tempus Passionis;* and Palm Sunday, the sixth Sunday in Lent, which opens Holy Week. The next Sunday, Easter Sunday, *Dominica Resurrectionis,* opens the Octave of Easter.

By and large, Sundays are the major liturgical days within the Lenten season. But certain weekdays are prominent as well. Wednesday, Friday, and Saturday of the first full week in Lent constitute the Lenten Embertide, to which I shall return later. And the weekdays of Holy Week, particularly Holy Thursday, Good Friday, and Holy Saturday, are accorded particular importance. During the Renaissance, as in the early church, Christ's Resurrection was commemorated in elaborate liturgical solemnities at the Vigil Mass on Holy Saturday. Before the modern era, the Easter Sunday service was relatively simple because everything of significance had already taken place on the preceding Saturday night.

Following a pattern initiated in Christian antiquity, specified passages from Scripture were assigned in the Renaissance to each daily Mass during the Lenten season. Similarly, a specified set of texts was assigned during Lent in the daily Office, the public prayer service of priests, other religious, and some clerics. Readings assigned to particular days or weeks of Lent often stress well-defined motifs; the liturgical themes and texts highlighted on particular days and weeks of Lent appear to be echoed in the narrative cycles on the long walls of Pope Sixtus's chapel.

Many of the history frescoes painted on the Sistine Chapel walls during the

quattrocento mirror the Lenten liturgy of the early church, emphasizing such age-old Lenten motifs as penitence and baptism. An equally ancient but somewhat less familiar Lenten theme, the Babylonian captivity of the Jews, is also evoked in the decoration of Pope Sixtus's chapel. The painted allusions to Jewish exile in Babylon may refer as well to the moment when work on the Sistine Chapel was begun. Although I can offer no documentary evidence on this point, I suspect that Sixtus IV's creation of a new papal chapel in the Vatican Palace was timed, at least in part, to commemorate the one-hundredth anniversary of the end of the papal "Babylonian Captivity." Many modern historians date the end of the Avignonese exile to the year 1377, exactly one century before Sixtus IV initiated the enterprise that was to become the artistic masterpiece of his pontificate.

Contemporary history and scriptural narrative were regularly linked in Renaissance Rome. As described in Charles L. Stinger's invaluable survey, *The Renaissance in Rome* (1985), Sixtus IV's contemporaries believed that events recorded in the Old Testament foreshadowed events set down in the New Testament; moreover, both sacred volumes were consulted in order to "unfold" the inner meaning of current historical developments. There can be no question that the Babylonian Captivity of the Jews was viewed in this light throughout the Renaissance. From Petrarch onward, parallels were drawn between the ancient Jewish exile in Babylon and the papal "captivity" in Avignon. Based upon this familiar juxtaposition, the return of the Jews from Babylon to Jerusalem was likened to the homecoming of the popes from Avignon to Rome. In this equation, Rome became the *sancta Latina Ierusalem*, a uniquely hallowed capital, like the Holy City of the Jews. This point of view is expressed on the walls of Pope Sixtus's chapel, where certain biblical episodes that actually took place in the Holy Land are nevertheless depicted beside such Roman landmarks as the Arch of Constantine.

Today, the Sistine Chapel is best known for its ceiling, painted by Michelangelo between 1508 and 1512. The celebrated project was commissioned by Sixtus IV's nephew, Pope Julius II, della Rovere (1503–13), who greatly revered his papal uncle. As a result, we are entitled to expect the frescoes on the chapel ceiling—especially the nine central Genesis scenes—to exhibit connections with any liturgical scheme discerned in the history frescoes below. In fact, the content of the Genesis frescoes at the center of the Sistine ceiling in no way contradicts my assumption that the history frescoes on the chapel walls mirror the Lenten liturgy. Every one of Michelangelo's Genesis scenes illustrates a text assigned in the *Missal* or *Breviary* during the pre-Lenten weeks of Septuagesima and Sexagesima, when the Roman liturgy already resonates with Lenten themes.

Some readers of this book may be surprised to find that I detect few references to the Virgin Mary in Pope Sixtus's chapel, even though the sacred chamber is dedicated to her. In fact, no overtly Marian subjects figure on the Sistine ceiling either. Eve, often viewed as Mary's Old Testament precursor, appears in only three of Michelangelo's nine Genesis scenes. Those seeking Marian allusions on the chapel walls might consider Zipporah, Moses' wife—like Mary, a traditional type of the church—who figures prominently in the first two Mosaic frescoes on the long south wall (Pls. VIII, IX). But

I submit that the Sistine Chapel was intended as much to serve as a place for the celebration of papal liturgies as it was to serve as a Marian chapel. In an age accustomed to symbolic gestures, it was surely meaningful that Sixtus IV's first recorded visit to his new chapel did not take place on 15 August, the feast of the Virgin's Assumption, when the first Mass was, in fact, said in the chapel. Instead, the pope first officially entered his new chapel at Vespers on 9 August, the anniversary of his election to the papacy. Moreover, as pointed out in John Monfasani's authoritative article, "A Description of the Sistine Chapel under Pope Sixtus IV," *Artibus et Historiae* (1983), a contemporary account of Sixtus's visit to the papal chapel on the feast of the Assumption, 1483, by the chronicler Jacopo Gherardi, gives no indication that the pope blessed or dedicated or consecrated his new chapel on that day.

In addition, I am not particularly surprised to find that the narrative wall frescoes in this chapel dedicated to the Virgin apparently make no reference to the feasts of her Assumption or her Immaculate Conception, although both celebrations were dear to Sixtus IV. Liturgically speaking, both Marian holy days belong to the Proper of Saints, whereas the liturgical references that I detect in the history cycles on the chapel walls appear to mirror the Proper of Time. Perugino's lost altarpiece for the chapel, which was integrated with the history frescoes, did depict the adoration of the Virgin *Assunta* by Sixtus IV and various holy personages. But this lost work represented an imaginary theophanic event, not described in Holy Writ, whereas the history frescoes on the walls of Pope Sixtus's chapel all illustrate traditional biblical sources.

Like many Renaissance popes, Sixtus IV aspired to revive traditional forms of worship within his church. This devout goal may help to explain why the history cycles on the Sistine Chapel walls should contain allusions to the early Roman liturgy. Painted references to liturgical celebrations first established in the hallowed early church could serve to encourage a return to the ideals of Christian antiquity among those contemporaries of Sixtus IV who worshiped in his papal chapel. Lent could provide a natural focus for a liturgical scheme with this purpose because, from an early date, the Lenten season was largely dedicated to instructing the faithful in Christian doctrine and ritual, as made clear in Joseph A. Jungmann's magisterial *Mass of the Roman Rite* (first published in 1948). References to the early Lenten liturgy on the Sistine Chapel walls could serve to remind worshipers in Renaissance Rome of the purer liturgical practices observed in the early church.

Contemporary humanists shared Sixtus's desire to reform and restore his church in imitation of the admired early church. Belief that early Christianity offers an ideal against which to measure the contemporary church is reflected in sermons delivered by the sacred orators studied in John W. O'Malley's ground-breaking book, *Praise and Blame in Renaissance Rome* (1979). As O'Malley's highly influential study makes clear, Renaissance preachers in papal Rome repeatedly hold up the church of the apostolic era, or the church of the patristic age, as sacred models to be imitated by the contemporary church. Allusions to the early Roman liturgy on the Sistine Chapel walls could echo the nostalgia for the early church expressed by sacred orators at the papal court.

Imitation of antique models is also recommended to Renaissance prelates in Paolo

Cortesi's *De Cardinalatu*, first published in 1510 but already cited by 1506. One chapter of Cortesi's treatise, which offers advice on the decoration suitable for a cardinal's palace, was edited impeccably by Kathleen Weil-Garris and the late, much-missed John D'Amico: "The Renaissance Cardinal's Ideal Palace: A Chapter from Cortesi's *De Cardinalatu*," in *Studies in Italian Art and Architecture* (1980). In expressing his whole-hearted approval of iconographic complexity in the visual arts, Cortesi praises the "ingenious" history paintings of Sixtus IV's votive chapel in the Vatican Palace. If the *De Cardinalatu* is an accurate guide, the elaborate liturgical scheme that I discern on the Sistine Chapel walls would mirror a documented taste for erudite paintings of Christian subjects in Cortesi's Roman circle of curial humanists.

The Sistine Chapel of the quattrocento was evidently designed to recall the multiple routes leading to salvation. Mary, portrayed as the *Assunta* in Perugino's lost altarpiece for the papal chapel, represents one path particularly dear to the della Rovere pope, who, like all Franciscans, was deeply devoted to the Virgin. Another route is represented by the papacy, the supreme authority over the church that alone dispenses salvation. Consequently, the institution of the papacy was assigned a major role in the decorative scheme devised for Pope Sixtus's chapel: imposing full-length "portraits" of early popes ring the walls above the history cycles, and symbolic allusions to papal primacy appear repeatedly in the Christ and Moses frescoes.

Lent could serve as a third way to salvation, because the season was originally devoted in large measure to instructing the faithful in the Christian doctrine and church ritual upon which salvation depends. I submit that references to the early Lenten liturgy were encoded in the history frescoes of Pope Sixtus's chapel to remind those persons privileged to attend religious solemnities in that sacred space of the hallowed ancient forms of Christian worship during this vital season of the ecclesiastical year. And if Cortesi's *De Cardinalatu* is to be believed, Sixtus IV and his papal court may well have judged that the very complexity of the liturgical scheme that I discern on the walls of the papal chapel endowed it with exceptional spiritual value.

Beyond acknowledging a fundamental debt to my scholarly predecessors, I wish to thank a number of people and institutions. It seems appropriate to begin by expressing my thanks to the Art Library of my home institution, Queens College of the City University of New York; to Suzanna Simor, chief art librarian, and to her cooperative staff. I owe a considerable debt of gratitude to the Avery Library of Columbia University and to the library of the Union Theological Seminary, both neighbors of mine on Morningside Heights in New York City, and both generous in their hospitality to me.

Obviously, much of the research for this study was best carried out in Rome. In that city, I should first like to thank the librarians of the American Academy in Rome, who have found me a niche in that most agreeable working place: the late Inez Longobardi, Rogers Scudder, and Lucilla Marino. For hospitality during many summers, I am much indebted to many directors of the academy: Henry A. Millon, John H. D'Arms, Sophie C. Consagra, James Melchert, and Joseph Connors.

Like most art historians working in Rome on Roman topics, I have made repeated

use of the vast and unique resources of the Bibliotheca Hertziana. I happily acknowl-
edge my substantial debt to the librarians and staff of that distinguished institution. I
am grateful to a former director, the late Wolfgang Lotz, and to the present directors,
Christoph L. Frommel and Mathias Winner, for their help.

I am repeatedly struck by the generous welcome extended by the Biblioteca Apostolica
Vaticana to scholars of every nation, and I offer my appreciation to the directors and staff
of that world-renowned library for the privilege of working there. The accessibility of the
Vatican library is due in some measure to Sixtus IV, who created the papal chapel studied
in this book. As described by Jeanne Bignami-Odier and José Ruysschaert in *La Biblio-
thèque Vaticane de Sixte IV à Pie XI* (*Studi e Testi, Biblioteca Apostolica Vaticana*, 272)
(1973), Sixtus's bull of 1475 set aside parts of the apostolic palace for a library to be made
available to learned persons engaged in the study of letters. The pontifical library was
destined from the outset to be, in effect, a public library for accredited individuals, a
policy that has benefited scholars and scholarship for the past five centuries.

For facilitating my acquisition of photographs of the Sistine Chapel frescoes, I am
grateful to Fabrizio Mancinelli, curator of Byzantine, medieval, and modern art at the
Monumenti, Musei e Gallerie Pontificie, Vatican City, and to Lucina Vattuoni, also of
that institution. Karin Einaudi of the Fototeca Unione, housed at the American
Academy in Rome, gave me good advice on photographic matters.

My warmest thanks to Derek A. R. Moore of New York City, who, at short notice,
kindly took time out from his own busy career as architect and architectural historian
to provide the two excellent line drawings that accompany my text.

I am extremely grateful to Bernice F. Davidson of The Frick Collection, New York
City, and to Carla Lord of Kean College of New Jersey, Union, New Jersey. Both of
them patiently read through an early, rough version of this study, and both shared many
illuminating comments with me.

I owe a huge debt to Kathleen Weil-Garris Brandt of the Institute of Fine Arts and
the College of Arts and Science, New York University, who generously consented to
review a later version of this study. Her numerous searching questions prompted me to
rethink my arguments and restructure my text, with the greatest benefit to both.

Another helpful reader, Linda Bettman, of Rome, kindly suggested many useful
emendations, for which I thank her heartily.

For various kinds of assistance, both scholarly and otherwise, I offer my deep apprecia-
tion to Richard Brilliant, Evelyn M. Cohen, Richard Krautheimer, Margaret Kuntz,
Marilyn Aronberg Lavin, Edward M. Lewine, Janice Mann, Sarah Blake McHam, John
W. O' Malley, S.J., Leonard J. Slatkes, the late Walter L. Strauss, and Warren Wallace.

My greatest debt is to my late husband, Milton J. Lewine, who until his death in
1979 taught with great distinction in the Department of Art History and Archaeology
at Columbia University. It was he who first opened my eyes to the splendors of Rome,
so it seems especially fitting that this book, devoted to a celebrated monument of the
city he loved so much and knew so well, should be dedicated to his memory.

# ABBREVIATIONS

BR          *Breviarium Romanum. Verna*, Regensburg, 1950.
DACL        *Dictionnaire d'archéologie chrétienne et de liturgie.* Edited by F. Cabrol and J. Leclercq,
            Paris, 1907ff.
MR          *Missale Romanum*, New York, 1963.
PL          *Patrologiae cursus completus, Series Latina.* Edited by J.-P. Migne, 217 vols., Paris, 1844ff.
SC          *Sources chrétiennes*
STUDI E TESTI   *Studi e Testi. Biblioteca Apostolica Vaticana*
TEMI E TESTI   *Temi e Testi. Biblioteca Apostolica Vaticana*

# I

## INTRODUCTION

Pope Sixtus IV, della Rovere (1471–84), made his first recorded visit to the Sistine Chapel of the Vatican palace at Vespers on 9 August 1483, the anniversary of his election to the papacy. A few days later, on 15 August 1483, the feast of the Virgin *Assunta,* to whom the papal chapel is dedicated, Sixtus attended the first Mass ever celebrated in the sacred chamber.[1] Somewhat earlier in the 1480s,[2] the della Rovere pope had called a team of Tuscan and Umbrian masters to Rome to decorate his new chapel,[3] which was intended to replace the older *Cappella magna* of the pontifical palace;[4] and by the summer of 1483, these visiting artists had concluded their task (Fig. 1).[5] Most notably, they had created two monumental narrative cycles, of eight frescoes each, illustrating events in the lives of Christ and Moses.[6] These history cycles—now no longer complete—were the undisputed glory of Pope Sixtus's chapel in the few

1. Jacopo Gherardi, a contemporary chronicler, records that Sixtus IV attended Vespers in the Sistina on 9 August 1483, the anniversary of his elevation to the papacy, and that Mass was celebrated in the chapel for the first time on 15 August of that year (*Il Diario romano di Jacopo Gherardi da Volterra,* ed. Enrico Carusi, *Rerum Italicarum Scriptores,* XXIII, 3, Città di Castello, 1904, 121ff., cited by Monfasani, 9 n. 3). Gherardi does not say that the pope blessed, or dedicated, or consecrated the chapel on the feast day of the Assumption (Monfasani, 9 n. 5).

2. Surviving documents show that by October 1481 the new chapel had reached the stage at which the decoration could be started (Shearman, 1986, 27).

3. Ettlinger, 17ff.

4. O'Malley, 1979, 9; Shearman, 1986, 25ff., sets forth succinctly what is known of the earlier *Cappella magna.*

5. Steinmann, 185ff.; Salvini-Camesasca, 145.

6. Each long wall of the papal chapel is divided by uninterrupted cornices into three horizontal zones. Each long wall is divided vertically into six equal bays by three tiers of decorated pilasters. Pilasters and cornice are painted in the two lower zones; the upper zone contains real pilaster strips and a real cornice. Within each vertical bay, the bottom level contains painted tapestries; the middle level contains history frescoes; and each compartment of the top level contains a central window flanked, left and right, by full-length "portraits," in niches, of two early popes.

The entrance wall is divided into three horizontal zones: fictive tapestry occupies the lower zone; the central zone, divided into two fields by a fictive pier, contains two history frescoes; the top zone contains two windowlike elements, each flanked on either side by the image of an early pope.

Ettlinger suggests that "portraits" of Popes Linus and Cletus once decorated the altar wall (Ettlinger, 22). Wilde, however, argues that the upper part of the altar wall once displayed a central image of Christ, flanked by Peter and Paul, with images of Linus and Cletus in niches at the two corners of the wall (Wilde, 70 and n. 4). An altarpiece and two history frescoes by Perugino once appeared lower down on the altar wall. According to Ettlinger, the lost altarpiece rose to the height of the cornice in the tier above the history frescoes (Ettlinger, 23ff.); Shearman, however, supports Wilde's position that the lost altarpiece fit beneath the lower cornice (Wilde, 69f.; Shearman, 1972, 28).

Before Michelangelo, the ceiling of the papal chapel may have been painted blue and decorated with gold stars (Ettlinger, 15f.).

decades before Michelangelo began work on the painted ceiling for which the Sistine Chapel is best known today.

Sixtus IV was a celebrated professor of theology before becoming pope,[7] so it is hardly surprising that the decoration devised for his papal chapel presents viewers with a highly erudite program.[8] Quite a lot has been written about the complex narratives painted on the Sistine Chapel walls,[9] but comparatively little has been said about the role played in their formation by the Roman liturgy (here understood to consist of the prescribed services of the church and the texts that order these services).[10] Yet it is self-evident that Sixtus IV intended his new chapel to serve as an impressive setting for liturgical ceremonies;[11] indeed, it is vital to bear in mind that the biblical narrative on the chapel walls was not meant to be viewed in silence. When liturgical solemnities took place in Pope Sixtus's chapel, prescribed texts of the Roman liturgy were read or sung aloud; consequently, persons regularly attending services in the papal chapel would inevitably hear allusions to biblical subjects that they could simultaneously see before them on the Sistine Chapel walls.[12] In fact, I shall argue here that the biblical episodes painted on the chapel walls echo liturgical texts and ceremonies of the weeks between Advent and Pentecost, that period of the ecclesiastical year when both the entire Christian mystery and the entire life of Christ are unfolded in the Roman liturgy.[13] More specifically, I propose to show that the painted decoration of Pope Sixtus's chapel places particular emphasis on the liturgical themes of Lent.

My suggestion that the narrative cycles of Pope Sixtus's chapel echo themes of the Roman liturgy is by no means new. The observation appeared in print at least as early as 1901, in Ernst Steinmann's monumental study of the papal chapel.[14] Steinmann, however, made no real use of this insight. He made little attempt to answer his own questions about puzzling elements of the Sistine Chapel wall frescoes by examining their connections with the Roman liturgy. Yet I have found this a fruitful line of research; it permits me to offer, for example, a new interpretation of the enigmatic Jewish sacrifice at the foreground of Botticelli's *Temptations* fresco (Pl. II),[15] and a plausible explanation for the unexpected future tense of the inscriptions over Ghirlandaio's *Calling of the First Apostles* (Pl. III) and Rosselli's *Crossing of the Red Sea* (Pl. X).[16]

7. On Sixtus IV as a learned theologian: Lee, 21, 81 and passim; Steinmann, 238; Ettlinger, 9f. Goffen, 237 n. 71, cites the pope's fondness for complicated theological arguments.

8. Although "program" is a word now out of favor with some art historians (see, for example, Malcolm Bull, "The Iconography of the Sistine Chapel Ceiling," *Burlington Magazine*, cxxx, 1988, 598), it nonetheless seems to me to be a useful term, not necessarily denoting an actual document.

9. For Steinmann's secular interpretation of the cycles, see Ettlinger, 3. For Ettlinger's conception of the cycles as promulgating papal primacy, see Shearman, 1972, 47f. For Goffen's Franciscan interpretation, see her article "Friar Sixtus IV," passim, and Lavin, 1990,

199f. For other interpretations, see Ettlinger, 5f. n. 2.

10. *Concise ODCC*, 306.

11. O'Malley, 1979, 9; Steinmann, 545ff.

12. Not all liturgical celebrations were held in the Sistine Chapel during Sixtus IV's pontificate; such great feasts as Christmas and Easter, Pentecost and All Souls were habitually celebrated at St. Peter's basilica (O'Malley, 1979, 9f.; Shearman, 1986, 24).

13. Both Lightbown, 1, 60, and Salvini-Camesasca, 151, make this point; but neither attempts to connect the history frescoes with specific elements of the Roman liturgy.

14. Steinmann, 583.

15. See Chapter III, 41ff.

16. See Chapter IV, 53.

Moreover, the assumption that biblical episodes portrayed in Pope Sixtus's chapel echo motifs of the Lenten liturgy can help to account for the unusual group of biblical subjects that decorate the Sistine Chapel walls. Apart from the Healing of the Leper, represented in Rosselli's *Sermon on the Mount* (Pl. IV), the Christological narrative in the papal chapel passes over Christ's miracles, focusing instead on his ministry. By contrast, as Leopold D. Ettlinger points out, illustrations in the late medieval *Biblia Pauperum* omit all the events of Christ's ministry that took place between the Temptations and the Raising of Lazarus. And Ulrich von Lilienfeld's *Concordantia Caritatis*, a still more comprehensive Christian manual of the mid-fourteenth century, fails to illustrate the Calling of Peter and Andrew, the Sermon on the Mount, or Christ's Charge to Peter; whereas these are primary subjects in three of the eight original Christological frescoes designed for Pope Sixtus's chapel. As Ettlinger rightly concludes, these three episodes were preferred to Christ's miracles in the decoration of the papal chapel because the events in question throw light on the founding of the Roman church.[17] But as I propose to show, these same incidents refer to Lenten themes. Indeed, the virtual absence of miracles from the Christological narrative in Pope Sixtus's chapel mimics the shape of the Lenten liturgy. From Septuagesima to Quinquagesima, Christ's miracles are prominent in Gospel lessons of the Masses; but once Lent proper has begun, Gospel readings tend to focus on more personal events in Christ's life.[18] This liturgical pattern may help to explain why such personal episodes as Christ's baptism and temptations by the devil are primary subjects in two of the eight Christological frescoes originally designed for Pope Sixtus's chapel (Pls. I, II).

An equally unusual group of biblical scenes is represented in the Moses cycle of Pope Sixtus's chapel. The Mosaic narrative omits several popular subjects, such as the Miracles in the Desert and the Ten Plagues,[19] yet it illustrates such little-known episodes as the Circumcision of Moses' Son and the Punishment of Korah. "All this cannot be without significance," as Ettlinger accurately says;[20] and I propose to demonstrate that the unusual group of Mosaic subjects depicted in Pope Sixtus's chapel recalls texts and themes of the Roman liturgy between Advent and Pentecost.

The original cycle of eight Christological frescoes once started off on the short west wall, the altar wall of the chapel, with Pietro Perugino's *Nativity*, obliterated in the sixteenth century by Michelangelo's *Last Judgment* (Fig. 2).[21] The Christological cycle still ends today with an image of Christ's Resurrection and Ascension, located on the short east wall (Pl. VII), the entrance wall of the chapel. But the original *Resurrection* fresco, by Domenico Ghirlandaio, does not survive; it was repainted by Hendrik van den Broeck in the 1570s,[22] after the east wall had sustained damage during the pontificate of Hadrian VI, Dedel (1522–23).[23] Assuming that the narrative frescoes of the Christological cycle also refer to the Roman liturgy, the lost *Nativity* fresco that once opened the cycle may well have recalled some liturgical texts and themes associated

17. Ettlinger, 102.
18. Hardison, 101.
19. Ettlinger, 7.
20. Ettlinger, 7.

21. Vasari (Milanesi), III, 579.
22. Stastny, 777f.
23. Stastny, 778.

with Advent and Christmas, and perhaps with the other festivals clustered near the commemoration of Christ's birth.[24] Similarly, the work that now concludes the Christological cycle, the restored *Resurrection* fresco, with its subsidiary representation of the Ascension,[25] echoes liturgical texts and themes of Easter Sunday and Ascension Thursday. Still assuming a liturgical scheme, one might expect the six history frescoes on the intervening north wall of the chapel to mirror the liturgy of the intervening Lenten season. It is my contention that this is the case, and I shall offer support for this conviction in the coming chapters.

Corresponding allusions to the Roman liturgy evidently figure in the Moses cycle of Pope Sixtus's chapel. The set of eight Mosaic frescoes originally began with Perugino's *Finding of Moses*. This once appeared on the short west wall, the altar wall of the chapel, beside the *Nativity* fresco of the Christological cycle, before both works were replaced by Michelangelo's *Last Judgment*. The final fresco of the original Moses cycle, located on the short east wall of the chapel beside the *Resurrection and Ascension* fresco of the Christological cycle, was Luca Signorelli's *Fight for the Body of Moses*.[26] But Signorelli's composition was repainted by Matteo da Lecce in the 1570s after the east wall of the chapel had collapsed (Pl. XIV).[27] Operating on the assumption that the narrative Moses cycle also reflects liturgical themes, one might anticipate that the six Mosaic frescoes on the intervening south wall of the chapel (like the six Christological frescoes opposite) would echo the liturgy of Lent. In the coming chapters, I shall make clear why I believe this to be the case. Within the overall scheme, the primary focus was evidently on the Christological frescoes; they seem to have set the pattern to which the Moses cycle was tailored.[28]

Not surprisingly, the decoration of Sixtus IV's papal chapel echoes some major concerns of his pontificate. As Ettlinger demonstrates, many biblical subjects represented in Sixtus's chapel evoke the doctrine of papal primacy, thus reflecting the pope's staunch resistance to contemporary conciliarism.[29] Similarly, as Rona Goffen points out, scriptural episodes portrayed in Pope Sixtus's chapel are often those with particular resonance for Franciscans, thus recalling the Franciscan pope's lifelong devotion to the Friars Minor.[30] So far as I am able to determine, allusions to pontifical themes and Franciscan subjects in the decoration of Pope Sixtus's chapel need not be read in any particular order. But the opposite is plainly the case with respect to the chronological, typological, and liturgical sequences worked out on the chapel walls; in all three of these schemes, considerations of order are crucial.

It is evident that the Christ and Moses cycles of Pope Sixtus's chapel illustrate events

---

24. Righetti, II, 68, notes that some important feasts cluster around Christmas: St. Stephen (26 December), St. John the Evangelist (27 December), the Circumcision (1 January), the Epiphany (6 January). Because all the surviving history frescoes in the Sistine Chapel depict more than one event, an episode such as the Adoration of the Kings may well have been portrayed in the Nativity fresco, as suggested by Schubring, 10.

25. According to Stastny, 779, the restored fresco reproduces the earlier scheme.

26. Steinmann, 234; Stastny, 778f.

27. Stastny, 778f.

28. Steinmann, 235, observes that the Christological cycle is in better order than the Mosaic cycle.

29. Stinger, 160, 366 n. 11.

30. Goffen, 236ff.; Lavin, 1990, 199ff.

in the lives of each revered religious leader, arranged in approximate chronological order. In principle, the sequence of these biblical narratives was intended to reflect the chronology established in Exodus, Numbers, and Deuteronomy on the one hand, and in the Gospels—chiefly Matthew's Gospel—on the other.

It is equally evident that the juxtaposed narrative cycles of Pope Sixtus's chapel form a typological scheme. Episodes from the life of Christ, and related events from Moses' life that were believed to foreshadow these Christological episodes, are portrayed in two sets of frescoes situated opposite one another on the two long walls of the chapel, or side by side on the two short walls.[31] Some deviations from biblical chronology inevitably resulted from the desire to juxtapose corresponding events in the lives of the two great religious leaders.[32]

But it has been far less evident to modern viewers that the biblical cycles of Pope Sixtus's chapel also constitute a liturgical program. As I propose to show in the following chapters, individual history frescoes are arranged on the walls of the papal chapel in such a way that the order of the biblical narrative in each cycle echoes the sequence of liturgical celebrations scheduled to take place each year in the Roman church between Advent and Pentecost Sunday.

As I reconstruct this forgotten liturgical program, the six Mosaic frescoes and the six Christological compositions on each long wall of the chapel may be divided, in concept, into three units. Each unit consists of four compositions: two Christological frescoes and the two Mosaic frescoes opposite them (Fig. 2).

The first unit of four compositions is composed of the first two frescoes on the north wall: Perugino's *Baptism of Christ* (Pl. I) and Botticelli's *Temptations* (Pl. II), together with the works directly across from them on the south wall: Perugino's *Circumcision of Moses' Son* (Pl. VIII) and Botticelli's *Moses in Egypt and Midian* (Pl. IX). In these four frescoes I discern echoes of themes and lessons associated with the Roman liturgy during the pre-Lenten period that opens on Septuagesima Sunday, and during the first two weeks of Lent.

The second unit is made up of the third and fourth frescoes on each long wall: Ghirlandaio's *Calling of the First Apostles* (Pl. III) and Rosselli's *Sermon on the Mount* (Pl. IV) on the north wall, together with the works directly opposite them on the south wall: Rosselli's *Crossing of the Red Sea* (Pl. X) and his *Lawgiving on Mount Sinai* (Pl. XI). All four compositions echo motifs of the Roman liturgy during the middle weeks of Lent.

The third unit consists of the fifth and sixth frescoes on each long wall: Perugino's *Gift of the Keys* (Pl. V) and Rosselli's *Last Supper* (Pl. VI) on the north wall, together with the works directly across from them on the south wall: Botticelli's *Punishment of Korah* (Pl. XII) and Signorelli's *Last Testament of Moses* (Pl. XIII). These four compositions reflect the liturgy of Passion Week and Holy Week, the final weeks of Lent.

31. Ettlinger, 3, repeats Steinmann's comment that the intricate scheme of Christian typology created by the juxtaposed frescoes does not correspond to any traditional typological scheme.

32. See Chapters II and III, 26, 33.

At least one of the history frescoes once visible on the altar wall of the chapel, Perugino's lost *Nativity*, clearly referred to Christmastide. And both repainted frescoes on the entrance wall, *The Resurrection and Ascension of Christ* (Pl. VII) and *The Fight for the Body of Moses* (Pl. XIV), the final works in each cycle, mirror themes of the Roman liturgy between Easter and Pentecost Sunday.

Gilded superscriptions, or *tituli*, imitating a device of Early Christian art, accompany almost all of the narrative frescoes still visible on the Sistine Chapel walls.[33] There can be no question that the juxtaposition of matching Christological and Mosaic inscriptions on opposite sides of the papal chapel helps spectators to understand that they are expected to give a typological reading to the juxtaposed history frescoes located beneath the *tituli*.[34] Yet it may be the primary function of these Latin superscriptions to clarify the liturgical scheme that is also worked out on the Sistine Chapel walls. In fact, several of the surviving *tituli* exhibit little connection with events portrayed in the compositions below, but evidently refer instead to motifs of the Lenten liturgy.

As I shall discuss in greater detail at the appropriate places, references to Christ's baptism and temptations in the legends above the first two Christological frescoes on the long north wall of the papal chapel echo major liturgical themes of Septuagesima, and of the first Lenten Sunday.[35] Allusions to the acceptance and promulgation of the evangelical law, in legends over the middle frescoes on the north wall, refer to the third and fourth weeks of Lent, when the Roman liturgy commemorates the first communication of the Apostles' Creed and Lord's Prayer to baptismal candidates in Christian antiquity.[36] A *titulus* over the fifth fresco on the long north wall reflects the liturgy of Passion Week, which recalls Christ's unhappy reaction (*conturbatio*) to physical attacks that he endured near the end of his earthly life. And a legend over the sixth fresco on the north wall echoes the Holy Saturday liturgy, which commemorates the repetition (*replicatio*) of the *Credo* and *Pater noster* on Easter Eve by catechumens of the early church.[37] The *resurrectio* and *ascensio* cited in the *titulus* over the final fresco in the Christological cycle refer to major liturgical themes of Easter and Ascension Thursday.[38]

The liturgical scheme that I have just outlined places no greater stress upon any one fresco than upon another, a point implied in the very articulation of Pope Sixtus's chapel. Each long wall of the room is divided horizontally by two cornices that run, without interruption, above and below the history frescoes. Above the narrative cycles, each long wall is divided into six matching compartments; each compartment is pierced by an arched window centered over the history fresco below (Fig. 3); and each window is flanked by full-length images of early popes standing in painted niches. The segment of wall below each narrative fresco is covered by a painted damask curtain bearing a repeat pattern of oak trees and acorns from the della Rovere *stemma* of Sixtus

---

33. Presumably each of the history frescoes was once accompanied by a superscription; on the *tituli* see Redig de Campos, 1970, 299ff.; Shearman, 1972, 48 and n. 17.

34. See, for example, Goffen, 236f.; Lavin, 1990,

196.

35. See Chapters II and III, 22, 33ff.
36. See Chapter IV, 50f.
37. See Chapters V and VI, 72f., 85.
38. See Chapter VII, 97f.

IV's family, surmounted by a papal tiara and crossed keys. Because the architecture and painted decoration of the Sistine Chapel were planned and executed more or less concurrently,[39] the organization of each long wall into six matching bays suggests that the six history frescoes lining each long wall were envisaged from the start as two uniform sets.[40]

If this is indeed the case, the six matching bays on each long wall of Pope Sixtus's chapel may mirror the more or less equal importance of the six Lenten weeks. If any weeks within Lent could be considered dominant, they might be the first week, which opens the crucial season, and the final week, Holy Week, when Christ's Passion is commemorated in the liturgy. Similarly, the first and last narrative frescoes on the long walls of the chapel might, by virtue of their position, be regarded as the most privileged. Thus it seems entirely in keeping with the architectural setting that the first history fresco on the north wall of the Sistine Chapel, which represents Christ's baptism, should refer to the institution of Christian baptism, a sacrament stressed in the Roman liturgy from the very start of Lent. And it seems equally appropriate that the final history fresco on this same wall, which depicts the Last Supper, should recall the institution of the Eucharist, commemorated in the Roman liturgy on Holy Thursday, at the end of Lent. Moreover, it seems particularly fitting that the narrative frescoes prestigiously located at either end of the long north wall should refer to the major Christian sacraments, those instituted by Jesus himself.

This arrangement is not without precedent. A biblical scene evoking one of the major sacraments was purposefully placed near the main altar at S. Maria Maggiore, the venerable Roman basilica decorated in the fifth century by order of Sixtus III (432–40), Pope Sixtus IV's immediate predecessor of the same name. In the nave of the ancient church, a set of mosaic panels portraying episodes from Abraham's life now starts at the altar end of the north wall with the *Meeting of Abraham and Melchizedek*, Genesis 14:18. But this scene is clearly out of place with respect to biblical chronology, for it is followed by illustrations of Genesis 18:1–10, *Abraham and the Three Angels*, and of Genesis 13:11–12, the *Separation of Lot and Abraham*. The last-named episode is plainly the earliest and, as such, ought logically to appear first. But because Melchizedek was regarded in traditional exegesis as a forerunner of all Christian priests, and because the bread and wine that he brought to Abraham were believed to foreshadow the Eucharistic elements, the *Meeting of Abraham and Melchizedek* was deliberately placed near the altar on which the Eucharistic sacrifice takes place.[41] At S. Maria Maggiore, liturgical considerations evidently took precedence over biblical chronology in order to ensure that a leading image

39. Ettlinger, 14; Shearman, 1986, 38.

40. Wilde, 68f., proposes a different reading of the long walls, accepted by Shearman, 1972, 48. Concluding that each long wall was divided, in concept, into two groups of three frescoes each, Wilde stresses the importance of the central fresco in each group, the second and fifth frescoes on each long wall. The importance of these four works seems to him to be implied by the circumstance that they were allocated to

the two most important painters, Botticelli and Perugino, and by the fact that the fictive tapestries beneath these frescoes are pale gold and white, while the other painted hangings are warm red and gold. The latter observation may not be relevant, however, for the hangings appear to be entirely repainted, as recent investigation has revealed (Lightbown, 1, 62).

41. Brenk, 1975, 56, 113f.

in the Abraham cycle would evoke the Eucharistic sacrament. A similar attitude may be reflected in Pope Sixtus's chapel, where Perugino's *Baptism of Christ* (though not misplaced with respect to biblical chronology) may nevertheless be positioned beside the altar for symbolic, as well as chronological reasons.[42]

The liturgical scheme that I discern on the Sistine Chapel walls was worked out in various ways. In certain instances, frescoes that I associate here with particular days or weeks of the church year directly illustrate biblical passages assigned in the Roman liturgy to those very days or weeks.

Botticelli's *Temptations* fresco (Pl. II), the second on the long north wall, falls into this category. Botticelli's composition, which I associate with the Roman liturgy of the first two weeks in Lent, illustrates the Gospel pericope invariably read on the first Lenten Sunday, Matthew 4:1–11. The passage in question describes Jesus' temptations by the devil, which are depicted at the background of Botticelli's fresco. Rosselli's *Sermon on the Mount* (Pl. III), the third fresco on the north wall, offers another example of direct correlation between image and liturgy. I connect this work with the Roman liturgy of the middle Lenten weeks; and, indeed, the primary scene in Rosselli's composition, which represents Jesus' most memorable sermon, illustrates a Gospel text read on Monday in the third full week of Lent.

Similar relationships exist between texts of the Lenten liturgy and scriptural events portrayed in the Moses cycle. Rosselli's *Lawgiving on Mount Sinai* (Pl. XI), the fourth fresco on the long south wall, is associated here with the liturgy of the middle Lenten weeks. It is therefore appropriate that Rosselli's composition should depict the Worship of the Golden Calf, described in Exodus 32:7–14, for these verses are often assigned to be read on Tuesday of the fourth Lenten week. Likewise, Signorelli's *Last Testament of Moses* (Pl. XIII), the sixth fresco on the south wall of the Sistine Chapel, a composition linked here with the liturgy of the last two Lenten weeks, illustrates episodes cited in Deuteronomy 31:22–30, a lection of the baptismal Mass on Holy Saturday, in the sixth and final week of Lent.

But some history frescoes on the long walls of Pope Sixtus's chapel do not illustrate specific liturgical readings. Narrative frescoes that fall into this second category apparently allude instead to key themes (rather than texts) of the Lenten liturgy.

Perugino's *Baptism of Christ* (Pl. I), the first fresco on the long north wall of the Sistine Chapel, is an example of this second type. Although I associate Perugino's composition with the Roman liturgy of the first two Lenten weeks, no liturgical text describing Christ's baptism is assigned during this part of Lent. Nevertheless, Christian baptism is a key motif of the Roman liturgy from the opening of Lent, when baptismal candidates of the early church began preparing for their initiation into the Christian community on the approaching Easter Eve. Perugino's *Baptism* fresco thus recalls the liturgical stress on baptism around the start of Lent, and for that matter, throughout

---

42. Lavin, 1990, 198, cites other telling links between S. Maria Maggiore and the Sistine Chapel.

the Lenten season. A similar thematic link with the Lenten liturgy is exhibited by Ghirlandaio's *Calling of the First Apostles* (Pl. III). This, the third fresco on the north wall of the papal chapel, is associated here with the liturgy of the middle Lenten weeks. No biblical passage that tells of Christ calling his first four apostles from the water is assigned in the Roman liturgy during this portion of Lent. Nevertheless, the primary subject of Ghirlandaio's fresco recalls the initial communication of the Apostles' Creed to early baptismal candidates; this event, once scheduled during the middle weeks of Lent, is still remembered in the liturgy that the Roman church assigns to those weeks.

Similar relationships between liturgical themes and biblical episodes figure in the Moses cycle of Pope Sixtus's chapel. I associate Perugino's *Circumcision of Moses' Son* (Pl. VIII), the first fresco on the long south wall of the chapel, with the liturgy of the first two weeks in Lent. Exodus 4:22–25, which describes the Jewish ritual operation, is not assigned in the Roman liturgy during this part of the ecclesiastical year. Nevertheless, the circumcision of Moses' younger son, the most consequential episode in Perugino's fresco, echoes a prime liturgical theme of the second Lenten week: the special favor shown to younger brothers and younger sons. A parallel relationship between themes (rather than texts) of the Lenten liturgy and subjects depicted in the Moses cycle may be discerned in Botticelli's *Punishment of Korah* (Pl. XII). According to my reconstruction, this work, the fifth fresco on the south wall of the Sistine Chapel, reflects the liturgy of the last two weeks in Lent. Although Numbers 16:1–40, which records Korah's punishment, is not assigned in the Roman liturgy during this period, the fifth Lenten Sunday was reserved from an early date for priestly ordinations. Thus Botticelli's *Korah* fresco, with its striking images of worthy and unworthy clerics, recalls an important liturgical subject of the fifth Lenten week.

To take a liturgical approach to the decoration of Pope Sixtus's chapel is to acknowledge the deep concern with liturgical matters in Renaissance Rome. In his funeral oration for Pope Nicholas V, Parentucelli (1447–55), Cardinal Jean Jouffroy asserts that earth most truly conforms to heaven in the beauty and splendor of liturgical solemnities.[43] Similarly, Giannozzo Manetti, Nicholas's official biographer, praises the Parentucelli pope for "the remarkable care with which he observed ecclesiastical ceremonies."[44] Reports of reform commissions appointed by other Renaissance popes, from Pius II, Piccolomini (1458–64), to Alexander VI, Borgia (1491–1503), repeatedly assert that Church ritual lies at the heart of Rome's sacredness.[45] The rising status of officials put in charge of liturgical rites matches the increasing importance of the liturgy in Renaissance Rome.[46]

Pontifical ritual was doubtless a topic of great interest to the papal circle in the later quattrocento: during the pontificate of Sixtus IV's successor, Pope Innocent VIII, Cibo (1484–92), the influential masters of papal ceremony, Agostino Patrizi de' Piccolomini and Johannes Burckhard of Strassburg, completed new editions of the Pontifical (issued

43. Stinger, 46; O'Malley, 1979, 202f.

44. O'Malley, 1979, 7; Stinger, 46f. and n. 115, citing Manetti's *Vita Nicolai V summi pontificis*.

45. Stinger, 47 n. 116; O'Malley, 1979, 7 and nn. 1, 2.

46. Nabuco, 26*–28*, 33*–34*, cited in Stinger, 47, 48 n. 121.

in 1485) and Ceremonial (issued in 1488).[47] Sixtus IV's efforts to encourage proper celebration of divine worship and correct chanting of the liturgy are well documented.[48] And his creation of the Sistine Chapel as a sumptuous setting for the yearly round of liturgical rites recorded in the Church Calendar plainly demonstrates his concern for the ceremonial life of his church.

Like other Renaissance churchmen, Sixtus IV sought to restore and revitalize the church of his day by reviving liturgical practices of the revered early church.[49] Some decades before Sixtus's pontificate, Nicholas V singles out the devout performance of traditional ritual as an essential ingredient in his campaign to reform the Roman see.[50] And some decades after Sixtus's pontificate, Egidio da Viterbo expresses parallel admiration for ecclesiastical traditions established in Christian antiquity; from his vantage point in the early sixteenth century, the learned general of the Augustinian order looks back reverently to the "pristine practices of earlier times."[51] Similarly, sacred orators of the Renaissance view the early church as an ideal against which to measure the church of their own time.[52] In sermons delivered before the popes, these preachers repeatedly hold up the church of the apostolic era, or the church of the patristic age, as exemplars for Renaissance Rome.[53] Matching attitudes are evidently expressed on the Sistine Chapel walls. I conclude that allusions to the early Roman liturgy were incorporated into the decoration of Pope Sixtus's chapel in order to remind the privileged persons who worshiped there of the exemplary liturgical observances in the hallowed early church. The liturgy of Lent could provide a natural focus for a scheme with this didactic aim because the Roman liturgy associated with this season emphasizes a prime purpose of Lent: instructing the faithful in Christian orthodoxy.[54]

In seeking to assess the impact of liturgical themes on the decoration of Pope Sixtus's chapel, it is clearly crucial to establish what the pontiff may have known about liturgical matters. There can be no question that Sixtus was acquainted with those traces of the early liturgy preserved in patristic literature, for his own treatises, like the *De sanguine Christi*, published at Rome near the start of his pontificate,[55] are filled with citations from patristic sources.[56] In any case, knowledge of the Latin fathers most concerned with liturgical matters—among them, Ambrose, Augustine, Jerome, Leo the Great, and Tertullian—was already widespread by the quattrocento.[57] During that century, many of the Greek fathers were made more accessible in Latin translations; a Latin version of Origen, for example, appeared during Sixtus's pontificate.[58]

Liturgical works of the Middle Ages were demonstrably familiar to Sixtus IV. The

47. Nabuco, 22*–31*; O'Malley, 1979, 12; Stinger, 47.

48. Pastor, 392; O'Malley, 1979, 10; Steinmann, 556f.

49. Stinger, 7, 47.

50. Stinger, 47f.

51. Stinger, 140 and n. 188.

52. O'Malley, 1979, 201.

53. O'Malley, 1979, 203f., 206.

54. Jungmann, 1959, 256f.

55. Ettlinger, 9; Lee, 19f.

56. Francesco della Rovere (Pope Sixtus IV), *De sanguine Christi*, BAV, Incun. III. 12: for references to Ambrose, 126, 173 and passim; for references to Augustine, 38, 43 and passim; for references to Leo the Great, 137, 139 and passim.

57. Rice, 84–95.

58. Stinger, 229–32; Ettlinger, 95; Lee, 116 and n. 140.

future pope's *De sanguine Christi* cites such medieval exegetes as the Venerable Bede (c. 673–735) and Thomas Aquinas (c. 1225–74).[59] Editions of such medieval liturgists as Amalarius of Metz (c. 780–850), Rabanus Maurus (776–856), and the author of the *Glossa Ordinaria,* a biblical commentary of the mid-twelfth century, as well as liturgical manuals by Rupert of Deutz (c. 1075–1129/30),[60] Durandus of Mende (1230–96), and Nicolaus of Lyra (c. 1270–1340), were accessible during the Renaissance, and there can be little doubt that Sixtus was acquainted with works by some or all of these authors.[61]

Several service books that must resemble liturgical manuals known to Pope Sixtus IV are available today in later editions. Much useful information about the early Roman liturgy is contained in the so-called *Ordo Romanus antiquus,* already published in the mid-sixteenth century by Melchior Hittorp.[62] Two medieval *Ordinals* edited in the current century by S.J.P. Van Dijk are helpful for the present purpose. One, compiled by a Franciscan, Haymo of Faversham, may mirror Friar Sixtus's liturgical thinking;[63] and the other preserves papal ritual from the time of Innocent III, dei Conti dei Segni (1198–1216) to Boniface VIII, Caetani (1294–1303).[64] A late thirteenth-century *Missal* of the papal court,[65] and the early printed *Missal of 1474,* Milan, Ambrosiana, S.Q.N. III.14, first published in 1474, during Sixtus IV's pontificate, are both available in modern editions;[66] each of these handbooks must preserve some liturgical usage known to Sixtus IV. Joaquim Nabuco's study of the last edition of the papal *Liber caeremoniarum* to appear before the changes introduced during the reign of Pope Innocent VIII[67] offers additional guidance to papal liturgy of the Renaissance; no doubt much of this material was also familiar to the first della Rovere pope. An overwhelming number of liturgical handbooks—whether compiled during Christian antiquity or in the Renaissance—assign exactly the same scriptural lections to precisely the same days of the church year. Consequently, the modern *Roman Missal* and *Breviary* repay study in the present connection because these manuals often repeat a pattern of liturgical readings already fixed in far earlier times.

Many modern secular visitors to the Vatican palace might express surprise if told that themes of the Lenten liturgy provide a focus for the painted narrative on the Sistine Chapel walls. Yet an emphasis on Lenten subjects would reflect the importance accorded to Lent from Christian antiquity to the present. To Pope Leo the Great (440–61), for example, Lent is "the greatest and most holy Fast . . .";[68] and one distin-

---

59. Francesco della Rovere (Pope Sixtus IV), *De sanguine Christi,* BAV, Incun. III. 12: for references to Bede, 142; for references to Thomas Aquinas, 56, 84 and passim.

60. On the continuing importance of Rupert of Deutz into the sixteenth century, *Concise ODCC,* 448, s.v. "Rupert of Deutz."

61. Both Durandus and Nicolaus of Lyra are cited in Sixtus IV's *De sanguine Christi,* BAV, Incun. III. 12: for references, see 78, 145, 150f. An edition of Nicolaus's

*Expositiones in Pentateuchum,* printed in Rome in 1471, was dedicated to Sixtus IV (Stinger, 210 and n. 155).

62. *Ordo Romanus I.*

63. Van Dijk, 1963.

64. Van Dijk, 1975.

65. Andrieu, passim.

66. Lippe, I, II.

67. Nabuco, 9*, 10*.

68. Leo, *Sermons I,* 14.

guished twentieth-century liturgist defines the Lenten season as "the luminous center of gravity of the ecclesiastical year."[69]

From the first, Lent was given over to instruction; by the year 325, the Church Council of Nicaea defines the Lenten season as a period of preparation for baptism.[70] In the early church, individuals preparing for reception into the Christian community were known as catechumens. After several years of study, catechumens whose state of preparation was judged to be sufficiently advanced were privileged to receive instruction during Lent for their baptism on the approaching Holy Saturday.[71] The crucial steps once taken during Lent by catechumens preparing for baptism are still mirrored in the Lenten liturgy; as Jungmann observes, both the Gospel readings and the Epistles assigned in the *Roman Missal* from Septuagesima to Easter reflect concern for the instruction of early baptismal candidates.[72] This central purpose of Lent may already be reflected in the sixth-century Gospel Book of the Cathedral Library at Rossano, Calabria; in that ancient purple codex, a set of folios that preface the Gospel text are decorated with miniatures illustrating some Gospel lections of Lent.[73] A similar impulse may be expressed on the Sistine Chapel walls, where Lenten texts and rituals were evidently given visual form.

From Christian antiquity onward, many passages from the Old Testament were assigned during Lent. In the early church, all the Epistles of Lenten Masses were drawn from the Jewish Bible;[74] and in the daily Office, the entire Pentateuch was read between Septuagesima Sunday and Passion Sunday.[75] Old Testament passages assigned to the Office on Lenten weekdays were selected for various reasons. Some of these lections illuminate the discipline of Lent: the forty days of penance and prayer; the call to repentance; baptism and its effects; the law of God. Other readings from the Jewish Bible assigned to the Office on Lenten weekdays shed light on episodes recorded in the Gospel lesson of the day, or on the stational church of the day, or on the stational saint.[76] An example may illuminate this process. From the time of the early church, Genesis 1:1–16 is the first Old Testament passage assigned to the Office on Septuagesima Sunday, the first official pre-Lenten Sunday.[77] This selection from Genesis reflects the Lenten preparation of early catechumens, whose instruction evidently began at the very beginning with an explanation of the Creation, offered on the first Sunday of the extended Lenten season.[78]

Moses' prominence on the Sistine Chapel walls may echo the importance of Old Testament lessons in the Lenten liturgy. Citing Moses' traditional role as a *typus papae* who prefigures the priestly, legislative, and governing roles of the popes,[79] Ettlinger

69. Righetti, II, 95.

70. Bäumer, 87.

71. Jungmann, 1959, 249; R. Béraudy, "L'Initiation chrétienne," in Martimort, 541.

72. Jungmann, 1986, I, 402.

73. Herbert Kessler, in Kurt Weitzmann, ed., *The Age of Spirituality*, New York, 1979, 492f., s.v. "Rossano Gospels."

74. Callewaert, 1940 (1), 502.

75. Legg, II, 2; Righetti, II, 103f.

76. Jungmann, 1986, I, 397.

77. Legg, II, 2; Cabrol, 3; Daniélou, 1964, 26.

78. Two events described in this pericope are also illustrated on Michelangelo's Sistine Ceiling: the separation of light from darkness; and the creation of the sun and moon.

79. Ettlinger, 86, 116f.; Stinger, 205f.

explains the Jewish leader's exceptional prominence in the decoration of Pope Sixtus's chapel as a reference to the supreme authority of the papacy, a subject dear to the della Rovere pope.[80] Goffen offers a different explanation. Recalling Sixtus IV's lifelong devotion to the Franciscan order, she links Moses' extraordinary status in the decoration of the papal chapel with the writings of such Franciscan authors as Saint Bonaventure, who regularly draw analogies between key events in the lives of Saint Francis and Moses.[81] Saint Francis's own Rule encourages the friars to associate the founder of their order not only with the Jewish patriarch but also with Christ himself. Thus, Sixtus IV's Franciscan roots may help to explain why a cycle devoted solely to Moses is unexpectedly juxtaposed with a Christological cycle on the walls of the papal chapel.[82]

But I submit, in addition, that Moses' key role in the painted decoration of Pope Sixtus's chapel mirrors the repeated allusions to the Jewish patriarch in Lenten pericopes. Many Lenten readings from both Testaments describe acts and teachings of the Jewish leader, often with the aim of demonstrating that Moses' life and works prefigure those of Christ.[83] A typological comparison of this sort figures in the Epistle of Septuagesima Sunday, I Corinthians 9:24–27 and 10:1–5; these verses, assigned at the very start of the Lenten season, equate Christian baptism with the safe passage of Moses and the Israelites through the Red Sea waters (I Corinthians 10:2).[84] Similar parallels recur throughout the liturgy of Lent. This suggests not only that the Moses cycle of Pope Sixtus's chapel was designed to commemorate a major protagonist of the Lenten liturgy, but also that the typological scheme displayed on the Sistine Chapel walls was designed to echo the repeated typological juxtapositions of Christ and Moses in liturgical texts of Lent.

Much recent literature on Pope Sixtus's chapel indicates that the planning and decoration of the chamber involved a deliberate return to Early Christian sources.[85] This is not surprising. Like many of his contemporaries, Sixtus IV was keenly interested in the origins of Christianity.[86] Numerous early theological and liturgical volumes were gathered together in Sixtus's Vatican library;[87] and citations from the fathers fill the pope's own treatises, like his *De sanguine Christi*. Sixtus's lifelong devotion to the Franciscan order may help to account for these interests. The Franciscan Rule, as Goffen points out, represents a return to the ideals of the early church; consequently, Sixtus IV's Franciscan training may help to explain the imitation of Early Christian models in the decoration of the Sistine chapel.[88]

Even Sixtus's papal name demonstrates his admiration for the early church. When Cardinal Francesco della Rovere was elevated to the papacy in 1471, he became the

80. Ettlinger, 102.
81. Goffen, 234ff.; Lavin, 1990, 199f. arrived at the same conclusion by a different route.
82. Goffen, 237f.; Lavin, 1990, 198.
83. Righetti, II, 103.
84. Meyer Schapiro, *Words and Pictures: On the Literal and Symbolic in Illustrations of a Text*, The Hague, 1973, 18.

85. This material is summarized by Shearman, 1972, 7f., who cites earlier writers on the subject. See also Ettlinger, 12; Redig de Campos, 1967, 67; Goffen, 232.
86. Ettlinger, 54, on Sixtus's role in preserving Early Christian monuments in Rome.
87. Pastor, 434; Müntz–Fabre, 265–68.
88. Goffen, 232.

first pope in more than one thousand years to call himself Sixtus. The new pope evidently selected that name because the conclave that elected him had opened on 6 August, the feast day of Pope Sixtus II (257–58),[89] a sainted early martyr.[90] Popes and humanists of the Renaissance knew Sixtus II as a keen supporter of papal inerrancy, the doctrine that holds the Roman Church incapable of error.[91] The treatise *Contra impugnantes sedis apostolicae auctoritatem*, written by Piero da Monte (or Pietro del Monte), and presented to Pope Nicholas V in the mid-fifteenth century, credits Sixtus II with the sweeping claim that whatever heresies have arisen have been extinguished by the light of church doctrine.[92] Still later in the quattrocento, Sixtus II's struggle against early heresies is again praised, this time by Sixtus IV's own papal librarian, Bartolommeo de' Sacchi, known as Platina, in his *Liber de vita Christi ac omnium pontificum*.[93] Sixtus II's doctrine of papal inerrancy surely endeared him to Pope Sixtus IV, a proponent of pontifical supremacy.

Feelings of empathy with Sixtus III, the noted pontiff of the fifth century, may also have influenced Cardinal della Rovere in his choice of a papal name.[94] Parallel interests marked the careers of these men; both popes were energetic builders in the city of Rome,[95] and both were particularly devoted to the Virgin. Like Sixtus III before him, Sixtus IV restored or constructed Marian churches in his Holy City,[96] most notably S. Maria della Pace and S. Maria del Popolo.[97]

Like his papal name, the decoration of his papal chapel reflects Sixtus IV's nostalgia for the early church. The parallel Old and New Testament cycles painted on the chapel walls recall a type of decoration employed in some celebrated Early Christian basilicas.[98] Moreover, the juxtaposed history cycles of Pope Sixtus's chapel reflect typological parallels between Christ and Moses already cited in pre-Constantinian times.[99] Many humanist authors of the Renaissance restate the ancient comparison; Coluccio Salutati (1331–1406), for example, comments, "Finally, is not the entire Old Testament believed to be the figure and idea of the New?"[100] Such parallels form the core of a Lenten sermon preached before Sixtus IV and his cardinals on Good Friday, 1484. The orator on that occasion, a learned Jewish convert to Christianity, proved to his

89. His contemporaries recognize in Sixtus IV the virtues of all three previous pontiffs of that name (Stinger, 91).

90. Rodocanachi, 8.

91. Stinger, 200 n. 131.

92. Stinger, 200 and n. 131.

93. BAV, ms lat. 4145, fol. 25v, cited by Stinger, 373 n. 131.

94. As suggested by Rodocanachi, 8 n. 3.

95. Steinmann, 22f., lists Roman churches built or restored by Sixtus IV; on this subject, see also Lee, 43 n. 124, citing Günter Urban, "Die Kirchenbaukunst des Quattrocento in Rom," *Römisches Jahrbuch für Kunstgeschichte*, ix–x, 1961–62, 269–79.

96. Krautheimer, 1961, reprinted in *Studies in Early Christian, Medieval and Renaissance Art*, New York, 1969, 184. See also Lee, 43 and n. 122.

97. Steinmann, 24f. Given the importance of the number eight in the decoration of Pope Sixtus's chapel, it is worth noting that S. Maria della Pace is octagonal in plan and that S. Maria del Popolo is covered by an octagonal dome. The Ospedale di S. Spirito, another Roman commission of Sixtus IV, contains an octagonal chapel covered by an octagonal dome (Ludwig H. Heydenreich and Wolfgang Lotz, *Architecture in Italy, 1400–1600*, trans. Mary Hottinger, Harmondsworth, 1974, 55–58, 59f., 62–64).

98. Koehler, 211ff., and Salvini–Camesasca, 151, cite examples of the phenomenon in Rome and environs, at Old St. Peter's, at S. Paolo fuori le Mura, and at S. Urbano alla Caffarella.

99. Brenk, 1975, 119.

100. Trinkaus, II, 570.

august listeners that everything experienced by Jesus during the Passion had been foretold by Jewish prophets and rabbis.[101]

The return to Early Christian attitudes in the decoration of Pope Sixtus's chapel is further reflected in the circumstance that each biblical cycle originally consisted of eight frescoes. Surprisingly, this arrangement has attracted little attention, even though it is well known that the number eight was identified from Christian antiquity onward with Sunday, Easter, and Resurrection, with baptism and circumcision.[102]

Sunday, "the eighth day," is the crowning day of the Christian week; in the early church, Sunday was the only day on which the Eucharistic celebration took place.[103] Because Christ rose from his tomb on a Sunday, eight came to symbolize resurrection;[104] this accounts for Augustine's observation that Sunday prefigures eternal life.[105] From an early date, the number eight was connected with baptism, which results in symbolic rebirth; for this reason, many Early Christian baptisteries were built on octagonal plans.[106] Circumcision, too, has links with the number eight, for by Jewish law, the ritual operation must be performed on the eighth day after a male child is born. This ancient rule was applied to Jesus' own circumcision, as described in Luke 2:21.[107] Consequently, Christian exegetes, from Justin Martyr in the second century to Thomas Aquinas, a favored theologian in fifteenth-century Rome, argue that Christ's Resurrection on the eighth day is prefigured in his circumcision.[108] Saint Ambrose even ascribes eschatological meaning to the number eight; for him the potent numeral signifies perfection.[109] Many of the symbolic meanings ascribed by tradition to the number eight find visual expression in the eight original frescoes of each narrative cycle designed for Pope Sixtus's chapel.

It appears, moreover, that the eight Christological frescoes of Sixtus IV's chapel were meant to recall specific themes and texts of the Roman liturgy on certain Sundays that fall between Advent and Pentecost. Assuming this inference to be correct, the pattern was doubtless inspired by traditional identification of Sunday as the "eighth day." A clear-cut example of the phenomenon to which I refer is provided by the *Resurrection* fresco (Pl. VII), which plainly echoes a prime theme of the Easter Sunday liturgy. Moreover, as I shall show, Botticelli's *Temptations* fresco (Pl. II) illustrates a Gospel lection invariably assigned to the first Lenten Sunday.[110] Ghirlandaio's *Calling of the First Apostles* (Pl. III) and Rosselli's *Sermon on the Mount* (Pl. IV) evoke the middle Sundays of Lent, on which the Apostles' Creed and Lord's Prayer were once communicated to early catechumens.[111] Perugino's *Gift of the Keys* (Pl. V) echoes

101. Flavius Mithridates, *Sermo de Passione Domini*, ed. Chaim Wirszubski, Jerusalem, 1963, 11f.

102. Krautheimer, 1942, reprinted in *Studies in Early Christian, Medieval and Renaissance Art*, New York, 1969, 122ff.; Underwood, 80ff., 131.

103. Jungmann, 1959, 22, 73.

104. Eloise Angiola, "Nicola Pisano, Federico Visconti and the Classical Style in Pisa," *Art Bulletin*, LIX, 1977, 8.

105. Augustine, *Pâque*, 53.

106. According to Underwood, 45 n. 9, "Octagonal baptisteries are too numerous to mention."

107. Jungmann, 1959, 22.

108. Steinberg, 50, 54f.

109. Jungmann, 1959, 23, cites Ambrose's own words, "Spei nostrae octava perfectio est, octava summa virtutem est."

110. See Chapter III, 34.

111. See Chapter IV, 50, 59.

references to priestly ordination in the Passion Sunday liturgy.[112] And Rosselli's *Last Supper* (Pl. VI) probably illustrates some Gospel verses invariably read at the Palm Sunday Mass from the time of the early church.[113]

From his immersion in Christian antiquity, Sixtus IV doubtless knew the history of the stational Mass, a key liturgical invention of Christian antiquity. Stations are those officially designated churches of Rome at which early popes conducted public services on specified occasions during the ecclesiastical year.[114] The Roman stations, already named in the oldest known Lectionaries,[115] still appear in the early printed *Missal of 1474.* From the time when the Roman stational order was fixed, probably around the fifth century,[116] Lent was distinguished by its many stational Masses;[117] and by the eighth century, each day of Lent was assigned a stational Mass.[118] This makes clear both the importance of Lent in the early church[119] and the central role played by early popes throughout this season, when they would conduct Masses in person at the Roman stational churches. In this respect, Lent, in Christian antiquity, differed from most other liturgical seasons, when it was customary for each parish of Rome simply to hold its own divine service.[120]

Despite papal exile from Rome during much of the fourteenth century, pontifical interest in the Roman stations persisted. Nicholas V's reconstruction of Rome, undertaken in the century following the return of the papacy from Avignon, began with the restoration of stational churches.[121] By this action, Nicholas apparently sought to revive Rome's role as the preeminent holy city of Christendom; although this idea was widely accepted in Early Christian times, it probably needed to be restated after the long Avignonese exile.[122] The keen interest of Renaissance popes in the Roman stational churches was well known to their contemporaries. In 1468, when Pomponio Leto was seeking release from his imprisonment by Pope Paul II, the humanist author attempted to demonstrate his orthodox Christian sentiments by recalling that he had once composed a set of pious distichs on the Roman stations of Lent.[123] As Renaissance popes were well aware, the city of Rome has a unique place in church ritual: the Roman stational churches offer concrete evidence of the extent to which Roman topography is bound up with ecclesiastical ceremony.[124] Sixtus IV restored several of the ancient stational churches,[125] and the allusions to the Roman stations on the

---

112. See Chapter V, 71.

113. See Chapter VI, 84.

114. Jungmann, 1959, 256.

115. N. M. Denis–Boulet, "La messe," in Martimort, 287.

116. Jungmann, 1959, 257.

117. Callewaert, 1940 (1), 486ff.; Righetti, II, 124.

118. Jungmann, 1959, 256.

119. Jungmann, 1959, 256.

120. Righetti, II, 115ff.; Jungmann, 1959, 256. In the Renaissance, great prestige was attached to the Roman stations because of the mistaken belief that they

were an invention of Pope Gregory the Great, who names the stational churches in his admired cycle of Lenten sermons (Stinger, 48 n. 122).

121. Gaetano Manetti, *Vita Nicolai V,* col. 950 D, cited by Nabuco, 17* n. 28.

122. Stinger, 48.

123. G. Morin, "Les distiques de Pomponio Leto sur les Stations liturgiques du Carême," *Revue bénédictine,* XXXV, 1923, 20.

124. Stinger, 2 and passim.

125. Stinger, 49 and n. 125.

walls of his papal chapel mirror the regard of the della Rovere pope for this venerable Roman and papal institution.

Until the "Babylonian Captivity" at Avignon, stational Masses were regularly celebrated in the designated churches of Rome.[126] But parallel developments in pontifical liturgy during the Middle Ages resulted in the evolution of a new liturgical institution: the "papal chapels." By the eleventh century, the pope and his clerics occasionally conducted the daily Office in a private sanctuary located in the papal quarters. This marked the beginning of papal liturgies, as distinct from the liturgies of the churches.[127] When the papal court moved to Avignon, and popes could no longer conveniently conduct services in the churches of Rome, liturgical ceremonies were increasingly confined to the chapel of the papal palace. These new papal liturgies came to be called *cappelle pontificie* or *cappelle palatine*, phrases customarily translated into English as "papal chapels."[128] After the papacy returned to Rome, the area around the Vatican palace and St. Peter's basilica became the liturgical center of the city.[129] And once Sixtus IV's new chapel was completed, it became a designated setting for *cappelle pontificie*.[130]

Almost all of the "papal chapels" at which sermons were preached for Renaissance popes fall in the weeks between Advent and Pentecost, that is, within the crucial segment of the liturgical year evidently commemorated on the Sistine Chapel walls. Diaries kept by papal masters of ceremonies during the later fifteenth and early sixteenth centuries list the solemn Masses at which sermons were preached in the Sistine Chapel, *coram papa*, in the pope's presence; and there seems no reason to doubt that *cappelle pontificie* were already scheduled on these very days during Sixtus IV's pontificate. "Papal chapels" at which sermons were preached before the popes were customarily held in the Sistine Chapel on the Sundays of Advent and Lent (with the exception of Palm Sunday); on the feasts of the Circumcision (1 January) and of the Epiphany (6 January); on Ash Wednesday and Good Friday; on Ascension Thursday and Trinity Sunday; on All Saints (1 November), and the feasts of Saint Stephen (26 December) and Saint John the Evangelist (27 December).[131] A substantial number of "papal chapels" with sermons *coram papa* took place during Lent, when Ash Wednesday, Good Friday, and five of the six Lenten Sundays were distinguished in this way. Renaissance preachers at the "papal chapels" of Lent regularly touch upon themes stressed in the Roman liturgy on these days; when such orations were delivered in the Sistine Chapel, worshipers could admire narrative wall frescoes illustrating the very subjects discussed by papal orators.[132]

126. Righetti, II, 120.
127. O'Malley, 1979, 8; as will be obvious, my discussion of the "papal chapels" is based largely on his analysis.
128. O'Malley, 1979, 8f.
129. O'Malley, 1979, 9.
130. Moroni, 1, 15.
131. O'Malley, 1979, 10–15.

132. The importance of the Lenten season in the Church Calendar may be gauged by recalling that of eighty-five stational Masses listed in the Roman *Missal*, fifty-seven fall between Septuagesima Sunday and the end of the Easter Octave (Hartmann Grisar, *Das Missale im Lichte Römische Stadtgeschichte, Stationen, Perikopen, Gebraüche*, Freiburg im Breisgau, 1924, 54).

Sixtus IV's chapel in the Vatican palace was dedicated to the Virgin, whose image once graced the frescoed altarpiece by Perugino, later obliterated by Michelangelo. In the sixteenth century, the lost altarpiece of the Sistine Chapel was described by Giorgio Vasari, but his brief account is relatively uncommunicative,[133] and Perugino's altarpiece is best known today from a workshop drawing at the Albertina.[134] In the upper half of the Vienna sheet, the Virgin *Assunta* stands in heaven amid angels and cherubim. Sixtus IV kneels below her in prayer. The pope wears official costume. A ceremonial cape falls from his shoulders; a papal tiara lies on the ground beside him. In the Albertina drawing, Sixtus is surrounded by several apostles, including Peter and Paul the patron saints of Rome; members of this holy company stand or kneel as they look up reverently at Mary.

The dedication of Friar Sixtus's chapel to the Virgin *Assunta,* whose feast on 15 August held special meaning for Franciscans,[135] may also imply a dedication to the once-controversial cult of the Immaculate Conception.[136] For Franciscans in Sixtus's day, the assumption of Mary's incorruptible body into heaven was proof that her conception had been free of Original Sin;[137] and Friar Sixtus promoted devotion to Mary's Immaculate Conception, even though he did not proclaim it as church doctrine.[138] His bull, *Cum prae excelsa,* issued in February 1476, near the time when work was begun on the Sistine Chapel,[139] favors belief in Mary's Immaculacy, which Franciscans supported against Dominican opposition; and his bull of September 1483, *Grave nimis,* issued shortly after work on his papal chapel was complete, makes it a mortal sin to deny Mary's Immaculate Conception.[140] The dedication of Friar Sixtus's papal chapel to the Virgin of the Assumption may further demonstrate his devotion to Mary,[141] whom all Franciscans revered.[142] But in this case, the della Rovere pope may simply have followed tradition, because the older papal chapel displaced by the *Sistina* may also have been dedicated to the Virgin.[143]

Although Perugino's altarpiece for Pope Sixtus's chapel honored the Virgin *Assunta,* her feast day, on 15 August, does not fall within the weeks between Advent and Pentecost: that segment of the Church Calendar evidently commemorated on the Sistine Chapel walls. Because the lost altarpiece was integrated with the Christ and Moses frescoes, it might seem that Perugino's composition ought to fit into any liturgical scheme discerned in the narrative frescoes. But this expectation may be unjustified. Liturgically speaking, the feast of Mary's Assumption belongs to the Proper of Saints, which lists festivals of fixed date, except for those that fall between Christmas (and its

---

133. "Perugino . . . fece la tavola in muro, con l'Assunzione della Madonna, dove ginocchioni ritrasse papa Sisto" (Vasari [Milanesi], III, 579).

134. Steinmann, fig. 119; Ettlinger, 24 and pl. 34c; Shearman, 1972, 5, figs. 4, 9.

135. Goffen, 228.

136. Goffen, 230.

137. Goffen, 230 and n. 53. Similar liturgy and visual imagery were associated with the two cults, which were commemorated at least once in the same chapel

(Goffen, 231 and n. 54).

138. Sixtus granted special indulgences to those who attended services on the feast of the Immaculate Conception (Stinger, 149).

139. Monfasani, 9–14, assigns the start of work on the chapel to 1477.

140. Goffen, 230 and nn. 50, 52.

141. Pastor, 209.

142. Levi D'Ancona, 1968, 43.

143. Ettlinger, 14.

Vigil) and Epiphany. But the narrative frescoes on the Sistine Chapel walls instead reflect the Proper of Time, which lists Sundays, ferias, and movable feasts of the Church Calendar.[144]

Perugino's altarpiece was unlike the narrative history frescoes in still other ways. To begin with, the subject of this lost work, Pope Sixtus IV's adoration of the *Assunta*, was an imagined theophanic event, not a historical incident in the Virgin's life. Moreover, while Mary's Assumption into heaven was much discussed by such Franciscan preachers as Bernardino of Siena and was widely popularized in patristic texts and devotional literature, the episode has no biblical source.[145] In these respects, the lost altarpiece of the Sistine Chapel differed significantly from the narrative wall frescoes; all of them illustrate biblical texts that document events in the histories of Christ and Moses.

The forgotten liturgical scheme that I seek to reconstruct in this book is, of course, only one of the factors that determined which biblical subjects would be represented on the Sistine Chapel walls, and in what order the images would appear. Quite naturally, the history cycles of Sixtus IV's chapel reflect the multiple aims of the decorative program devised for the sacred chamber. Both narrative cycles on the Sistine Chapel walls provide a more or less chronological account of events in the lives of Christ and Moses, proceeding from birth to death and resurrection. The paired cycles also form a typological scheme that juxtaposes parallel events from the Old and New Testaments. Certain scriptural scenes promote the key concept of papal primacy; and many biblical episodes portrayed on the chapel walls have special meaning for Franciscans. Until now, the liturgical scheme that I propose to reconstitute has received only scant attention; but I intend to demonstrate the impact of the Roman liturgy on the painted decoration in Sixtus IV's papal chapel.

144. *Concise ODCC*, 418, s.v. "Proper."   145. Pagden, 15.

# II

# THE FIRST FRESCOES ON THE LONG WALLS

## The *Baptism of Christ* and the *Circumcision of Moses' Son*

TITULI:
INSTITUTIO NOVAE REGENERATIONIS A CHRISTO IN BAPTISMO
and
OBSERVATIO ANTIQUE REGENERATIONIS A MOISE PER CIRCONCISIONEM

The narrative cycles of Pope Sixtus's chapel are no longer complete. Two of the original history frescoes are missing. In the sixteenth century, both Perugino's *Nativity* and his *Finding of Moses,* the works that once started off the Christ and Moses cycles (Fig. 1), were obliterated from the altar wall of the chapel by Michelangelo's *Last Judgment.*[1]

Today, the Christological cycle begins at the altar end of the long north wall with Perugino's *Baptism of Christ* (Pl. I),[2] and the Mosaic cycle starts with Perugino's *Circumcision of Moses' Son* (Pl. VIII), directly across the chapel (Fig. 1). Although I connect these works with the first Lenten weeks, neither Christ's baptism nor the circumcision of Moses' son figures in liturgical readings assigned near the start of Lent. But both frescoes do evoke key Lenten themes. (In addition, Perugino's *Baptism* fresco recalls Jesus' institution of the sacrament of baptism, celebrated in the Roman church on 6 January, the feast of the Epiphany.)[3] Perugino's *Baptism of Christ* reflects the liturgical emphasis on baptism from Septuagesima onward. Similarly, Perugino's *Circumcision of Moses' Son* recalls a key motif of the Roman liturgy in the second full week of Lent: the favored status of younger brothers and younger sons.

Without doubt, baptism was the major sacrament of Christian antiquity.[4] In that era, eligible catechumens were encouraged to enroll during Lent for their baptismal initiation on the approaching Holy Saturday. Saint Augustine recalls this sequence of events in a Lenten sermon directed at catechumens: "Easter is near, come and register

---

1. I shall discuss these works in Chapter VII.
2. In executing this fresco, Perugino was given considerable assistance by Pinturicchio (Bernabei, 57).
3. This holiday falls between Advent and Pentecost

Sunday, that crucial segment of the Church Calendar apparently commemorated on the Sistine Chapel walls.
4. Jungmann, 1959, 240.

for baptism."[5] Once prospective candidates had declared their decision to accept baptism at the coming Easter Vigil, they were coached throughout the remaining weeks of Lent for entry into the Christian community.[6]

Reflecting this crucial period in the lives of early catechumens, allusions to baptism mark the Roman liturgy from the pre-Lenten period. A baptismal note is already sounded, for example, in I Corinthians 9:24–10:4, the Epistle assigned to Septuagesima Sunday in such liturgical books as the printed *Missal of 1474*;[7] the baptismal reference appears in I Corinthians 10:2, "And all were baptized unto Moses in the cloud and sea." Baptism is again evoked on Quadragesima Sunday, first of the six Lenten Sundays, this time by the Roman station of the day, S. Giovanni in Laterano. That church, the papal cathedral, is dedicated jointly to the Savior and John the Baptist, the chief participants in Jesus' baptism.[8] On the same Sunday, the Epistle recalls baptism's salvific effect; both Haymo of Faversham's Franciscan *Ordinal* and the *Missal of 1474* assign a passage to Quadragesima Sunday that contains the verse, "Behold, now is the accepted time; behold, now is the day of salvation" (II Corinthians 6:2).[9] There is another baptismal reference in the Gospel passage assigned by Durandus of Mende to Friday of the first full week in Lent; this lection, John 5:1–15, describes the healing at the Pool of Bethesda, a watery miracle with evident parallels to baptism.[10]

Perugino's *Baptism of Christ* (Pl. I) plainly echoes the recurrent baptismal references in the Roman liturgy near the start of Lent. Jesus' Baptism by John (Matthew 3:13–17), the most consequential event portrayed in Perugino's fresco,[11] is understood from an early date not only as the occasion of the institution of the sacrament of baptism,[12] but also as the prototype of all subsequent Christian baptisms.[13] Perhaps because the principal subject of the *Baptism* fresco is so vital to Christian doctrine, and so central to the Lenten liturgy, the composition was entrusted to Perugino, evidently the master painter among the artists called to work in Pope Sixtus's chapel.[14] Possibly as another mark of honor, Perugino's *Baptism of Christ* is the only fresco on the Sistine Chapel walls on which an artist's full name is inscribed; the legend OPUS PETRI PERUSINI CASTRO PLEBIS appears on the upper border of the frame surrounding the composition. In order to read these words, worshipers in the papal chapel must pause briefly before the fresco, thereby gaining additional time in which to contemplate the crucial importance of Christian baptism.

Christ's baptism in the Jordan River is portrayed at the center foreground of Perugino's *Baptism* fresco (Pl. I). In this scene, John the Baptist, standing to the right, pours water from a vessel onto Jesus' head, while the Dove of the Holy Spirit hovers above. Directly over this group, God the Father appears in the sky amid flying angels

5. Augustine, Sermon 132, 1, cited by Jungmann, 1959, 249 n. 7; Jungmann, 1959, 257; *New Catholic Encyclopedia*, III, 239, s.v. "Catechumenate."

6. *Concise ODCC*, 94, s.v. "Catechumens"; Righetti, IV, 54ff.

7. Lippe, I, 41.

8. Durandus, 1479, fol. 175v.

9. Van Dijk, II, 1963, 68; Lippe, I, 56; Callewaert,

1940 (I), 483.

10. Durandus, (1479), fol. 176v.

11. According to Bernabei, 57, most of the fresco was executed by Perugino's workshop, especially by his leading assistant, Pinturicchio.

12. Tertullian, *Traité*, 23.

13. *New Catholic Encyclopedia*, II, 56, s.v. "Baptism."

14. Ettlinger, 27, 30f.

and cherubim, who surround the decorative frame encircling his half-length figure. Immediately to Jesus' left, three additional angels kneel on the farther shore of the Jordan; one of these angels holds Jesus' robe, a detail known from earlier baptism scenes.[15] Three lightly clad youths standing behind the kneeling angels on the riverbank may be identified as catechumens awaiting baptism.[16] These partly dressed figures recall that early catechumens customarily prepared for baptism on Easter Eve by removing their garments;[17] the church fathers equate this action with the stripping away of sin.[18]

The three seminude youths standing on the farther bank of the Jordan have apparently not been baptized as yet; but a partly clad youth seated on the near shore has evidently passed through the purifying water, for he is shown drying his feet (Fig. 4). In creating this seated figure, Perugino turned to the *Spinario,* or thorn-puller (Fig. 7), an antique statue of demonstrable interest to Sixtus IV; a version of the celebrated bronze was presented by the first della Rovere pope to the Palazzo dei Conservatori on the Roman Campidoglio in December 1474.[19] Because some authors of the Middle Ages and Renaissance describe the thorn in the *Spinario's* foot as the thorn of sin,[20] Perugino, or an adviser, may have concluded that the *Spinario,* carefully removing a thorn from his foot, offered an apt visual symbol for catechumens, intently eliminating sin from their lives by the agency of baptism.[21]

Crowds of onlookers figure in several narrative frescoes of Pope Sixtus's chapel, presumably as witnesses to the history of salvation. But the throng of spectators in Perugino's *Baptism* fresco is additionally justified by the biblical verses illustrated there. According to Matthew 3:5, a multitude came to John to be baptized; and Matthew 3:7 records that many Pharisees and Sadducees witnessed Jesus' baptism by John. To illustrate these texts, groups of bystanders appear in many baptism scenes;[22] and in Italian Renaissance art, such observers often wear Eastern dress.[23] Perugino has adopted this convention. In his *Baptism of Christ,* a man in oriental costume stands in the crowd at the foreground on the far left side; and a man wearing an elaborate Byzantine-style hat stands at the right side of the composition in the middleground, among those who listen as Jesus preaches his first sermon (Fig. 6).[24] Marilyn Aronberg Lavin suggests that figures in exotic Eastern costume were introduced into baptism scenes in order to locate Christ's baptism on the Eastern shore of the Mediterranean in the remote Christian past.[25] Following this line of thought, Perugino may have introduced men with Byzantine-style hats into his *Baptism* fresco to make the point that Christian baptism

15. Lavin, 1981, 14f., 77. According to Réau, II, 2, 298f., these angels, not mentioned in the Gospels, symbolically fill the office of deacon and may appear in baptism scenes because at baptisms in the early church deacons helped to dress the candidates in their white robes.

16. Lavin, 1981, 15, 109.

17. Jungmann, 1959, 79 and n. 19.

18. Lavin, 1981, 112 n. 11; Davidson, 56 n. 63.

19. Lee, 148ff.; Stinger, 255.

20. Heckscher, col. 291.

21. For further discussion of the *Spinario,* see Chapters III and VI, 39f., 91ff.

22. Lavin, 1981, 61f.

23. Lavin, 1981, 62f.

24. Perugino may have known figures in Byzantine-style hats and robes from the bronze doors created by Filarete in 1433–35 for Saint Peter's basilica, Rome (Lavin, 1981, 62).

25. Lavin, 1981, 64.

should be accorded particular reverence because the vital sacrament was instituted during the most ancient period of Christian history.

In the middleground of Perugino's *Baptism* fresco, at the left side, Saint John approaches the Jordan River, in which he performed many baptisms (Matthew 3:1–6). Such Gospel texts as Matthew 3:11 distinguish John's baptism of Jesus from all other baptisms performed by John.[26] Except in the case of Jesus' baptism, John administered only the baptism of repentance, which served merely as preparation for the sacramental baptism instituted by Jesus.[27] Christian exegetes stress this distinction. Tertullian, for example, specifies that John could perform only the baptism of repentance;[28] and Petrus Lombardus (c. 1100–1160), an author cited by the future Pope Sixtus IV,[29] asserts that the remission of sin results from Christ's institution of the sacrament of baptism, whereas repentance is the only end of all John's other baptisms.[30]

At the far left side of Perugino's *Baptism of Christ,* near the background, the Baptist preaches from a hilltop. The scene may illustrate Matthew 3:6, which records that John's sermons called for penitence and the confession of sins as necessary preconditions for baptism.[31] Both this and the adjacent scene, which shows John approaching the Jordan to baptize the penitent, recall the liturgical stress on penitential themes near the opening of Lent.[32] As asserted by Leo the Great, the proper effect of the Easter celebration is the remission of sins.[33] To achieve this goal, formal penitents of the early church were readied during Lent for reconciliation with the Christian community, an event that took place in Holy Week.

The official period of Lenten penitence originally opened on the first Lenten Monday.[34] Appropriately, a penitential message is contained in Matthew 25:31–46, the Gospel lesson assigned to this day in a thirteenth-century *Ordinal* of the papal court and in the *Missal of 1474.*[35] The passage from Matthew's Gospel describes the separation of the sheep from the goats, a symbolic act that liturgists connect with the actual separation of penitents from the congregation of the faithful on the first Lenten Monday. During Mass on that day, formal penitents would exit ceremonially from the churches, to which they would not return until reconciled with the Christian community during the final week of Lent.[36] Penitential themes of the Roman liturgy on the first Lenten Monday find their echo in the Roman station of the day, "ad S. Petrum in Vincula."[37] This church, Saint Peter in Chains, is dedicated to the first Roman bishop, to whom Jesus gave the power of binding and loosing, that is, the ability to judge sinners and to absolve them after penance.[38] The images of John

26. This point is made in Matthew 3:11; Mark 1:8; Luke 3:16; John 1:33; Acts 19:1–5 (R. Béraudy, "L'Initiation chrétienne," in Martimort, 517f.; *New Catholic Encyclopedia,* II, 55, s.v. "Baptism."

27. *New Catholic Encyclopedia,* II, 55, s.v. "Baptism."
28. Tertullian, *Traité,* 79 n. 2, 81.
29. Ettlinger, 77.
30. Ettlinger, 77 n. 1; Righetti, IV, 15.
31. *New Catholic Encyclopedia,* II, 55, s.v. "Baptism."
32. Jungmann, 1959, 259.
33. Dom Maria Bernard de Soos, *Le Mystère li-*

*turgique d'après Saint Léon le Grand* (Liturgiewissenschaftliche Quellen und Forschungen, 34), Münster, Westphalia, 1958, 85. See also Jungmann, 1959, 254ff.

34. Jungmann, 1959, 245; the opening of the penitential period of Lent was eventually shifted back to Ash Wednesday (Jungmann, 1959, 246).

35. Van Dijk, 1975, 191; Lippe, I, 57.
36. Jungmann, 1959, 246.
37. Lippe, I, 57.
38. Jungmann, 1959, 246.

preaching repentance and of John approaching the Jordan to baptize the penitent (at the left side of Perugino's *Baptism* fresco) recall the penitential Mass held on the first Lenten Monday at S. Pietro in Vincoli.[39] This stational church had personal meaning for Sixtus IV. It was the future pope's titular church while he was still a cardinal, and it later became the titular church of his nephew, Cardinal Giuliano della Rovere, the future Pope Julius II, who served as papal grand penitentiary during his uncle's pontificate.[40]

Christ's First Sermon (Matthew 4:17) is represented near the right side of Perugino's *Baptism* fresco in the middleground (Fig. 5). This preaching scene may allude yet again to Lenten penitence, for Matthew reports that repentance was the subject of Jesus' first homily. Although Matthew's account of the occasion is confined to a single verse, and images of Christ's first sermon are rare in the visual arts,[41] Perugino portrays the event in some detail, for reasons not always fully understood.[42] But the corresponding images of Christ preaching repentance from a hilltop (at the right side of the *Baptism* fresco) and of the Baptist preaching repentance from a hilltop (at the left side of the fresco) evoke both the penitential character of Lent and the vital importance of sermons throughout this liturgical season.[43]

Preaching scenes in Perugino's *Baptism* fresco recall the Lenten classes in Christian doctrine that early catechumens were expected to attend. Leo the Great records that the *electi*—as the Romans called catechumens already enrolled for baptism on the coming Easter Eve—were readied during Lent for entry into the Christian community by means of regular preaching, "frequentibus praedicationibus."[44] Moreover, preaching scenes in Perugino's *Baptism* fresco probably reminded Sixtus IV's contemporaries of the celebrated Lenten sermons of Francesco della Rovere, a popular Franciscan preacher before he became pope.[45]

Repeated allusions to penitence and penitential preaching in Perugino's *Baptism* fresco may, in addition, mirror the growing importance of the sacrament of penance during the fifteenth century. One modern historian suggests that penance, rather than baptism or the Eucharist, was in effect the central Christian sacrament during the Renaissance,[46] when the pope's capacity to heal and purify became increasingly crucial in the penitential process.[47] Sixtus IV's bull *Salvator Noster* (1476), which extends the pope's jurisdiction to cover not only the living but also souls in purgatory, reflects contemporary ideas about the unique power of the papacy in connection with penance.[48] Scenes evoking

39. By the quattrocento, however, stational Masses were not normally celebrated at the designated Roman stational churches (Stinger, 49).

40. Steinmann, 477; Pastor, 235. Sixtus IV's interest in S. Pietro in Vincoli continued; in 1477 he presented a bronze shrine to this church (Steinmann, 34, 64).

41. Ettlinger, 55f., cites examples of this subject in medieval manuscripts.

42. Ettlinger, 76f., "Christ's sermon can hardly have been placed within the *Baptism* because Perugino needed a symmetrical composition. Such displacements . . . indicate that some definite argument is being put forward."

43. Dix, 354, on the traditional importance of preaching and instruction in Lent. Ettlinger, 77, suggests that preaching scenes appear in this fresco, "to indicate the whole scope of salvation."

44. *New Catholic Encyclopedia*, III, 239, s.v. "Catechumenate."

45. Panvinio, 454.

46. Stinger, 150.

47. Stinger, 152.

48. Stinger, 154 and n. 224.

Lenten penitence may figure in Perugino's *Baptism of Christ* to underscore the key role of fifteenth-century popes with respect to this crucial sacrament.

Perugino's *Circumcision of Moses' Son* (Pl. VIII) is located directly across the Sistine Chapel from his *Baptism of Christ*.[49] Although the *Circumcision* fresco depicts an obscure episode in Moses' life, it also evokes a prime theme of the liturgy during the second Lenten week: the special favor shown to younger brothers and younger sons.

Perugino's *Circumcision* fresco illustrates some verses from Exodus 4 that record events connected with Moses' return to Egypt after his exile in Midian. As the Bible relates, the youthful Moses was forced to flee to Midian in the first place because he had murdered an Egyptian taskmaster who was mistreating an Israelite. In fact, Moses' murder of this cruel man (Exodus 2:11–13) is illustrated in Botticelli's *Moses in Egypt and Midian* (Pl. IX), the second fresco on the south wall of the Sistine Chapel. Inasmuch as the first fresco on the south wall, the *Circumcision of Moses' Son*, illustrates verses from the fourth chapter of Exodus, while the second fresco on this wall, *Moses in Egypt and Midian*, illustrates verses from the second chapter of Exodus, it is plain that these Mosaic episodes appear on the Sistine Chapel walls in a sequence that diverges significantly from the chronology established in the Bible. This divergence from biblical chronology evidently resulted from a wish to juxtapose Jewish circumcision with Christian baptism (Fig. 2).

Like baptism, circumcision distinguishes members of a particular religious community;[50] according to Saint Paul, baptism is the fulfillment and replacement of circumcision (Colossians 2:11f.).[51] For the church fathers, circumcision is the seal of incorporation into the Old Israel, as baptism is the seal of incorporation into the New Israel.[52] As Augustine asserts, "In baptism there was unveiled that which was veiled in the shadow of the ancient circumcision."[53] On the walls of Pope Sixtus's chapel, the familiar analogy between baptism and circumcision is repeated in matching *tituli* inscribed over the juxtaposed *Baptism* and *Circumcision* frescoes: INSTITUTIO NOVAE REGENERATIONIS A CHRISTO IN BAPTISMO and OBSERVATIO ANTIQUE REGENERATIONIS A MOISE PER CIRCONCISIONEM. Nevertheless, the Circumcision of Moses' Son, a most unusual subject in the visual arts,[54] is not normally coupled with Christ's baptism. As Ettlinger accurately comments, "[A] typological reading alone would not account for this choice of imagery."[55] Instead, the chief subject in Perugino's *Circumcision of Moses' Son* echoes a key motif of the Roman liturgy during the second week of Lent.

In the upper left-hand corner of Perugino's *Circumcision* fresco, a group of shepherds dance to the music of pipes. This bucolic scene recalls the years that Moses spent in Midian tending flocks for his father-in-law, Jethro; according to Philo of Alexandria,

49. In the former fresco, Perugino was probably assisted by Pinturicchio (Ettlinger, 27f.; Bernabei, 42).

50. Daniélou, *The Bible and the Liturgy*, 1966, 63–69, as cited by Steinberg, 50 n. 45.

51. *New Catholic Encyclopedia*, II, 57, s.v. "Baptism."

52. Daniélou, 1964, 55, 64.

53. Augustine, *Pâque*, 80f.

54. Steinmann, 232, 235; Ettlinger, 59, notes that the Circumcision of Moses' Son was apparently not depicted in Western art until the fourteenth century.

55. Ettlinger, 60f.

this period of Moses' life foreshadows his later role as shepherd of Israel.[56] As Ettlinger points out, Philo's exegetical interpretation was familiar to Sixtus IV; a Latin translation of Philo's *Life of Moses* issued during Sixtus's pontificate was dedicated to the della Rovere pope.[57] But the dancing shepherds in Perugino's *Circumcision* fresco also echo a theme of the Roman liturgy on first Lenten Monday. On that day, many service books list the Gospel lesson as Matthew 25:31–46, a passage describing the separation of the sheep from the goats;[58] and the Epistle on this day is listed as Ezekiel 34:11–16, a passage that refers to the Lord as a shepherd.[59] The rustic scene at the upper left-hand corner of Perugino's *Circumcision* fresco recalls the allusions to shepherds and their flocks in liturgical texts of the first Lenten Monday.

Events leading up to the Circumcision of Moses' Son (Exodus 4:18–25) are represented next in Perugino's *Circumcision* fresco. A small scene located at the center of the composition, in the middleground, probably shows Moses parting from Jethro (Exodus 4:18).[60] A more prominent scene, at the left side of the composition in the foreground, shows Moses, accompanied by his wife, Zipporah, and their two sons, on the road back to Egypt with his household (Exodus 4:20) (Fig. 8). In this part of Perugino's fresco, Zipporah holds the hand of the smaller child, presumably her younger son; while the larger boy, presumably the older brother, walks beside his father. Moses' forward progress is abruptly halted by the authoritative gesture of an angel, unexpectedly seen from the back; this striking figure marks the center of Perugino's composition. Moses' encounter with the angel refers to Exodus 4:22, which records that the patriarch was stopped on the road back to Egypt and commanded to circumcise his son. In the Vulgate, the Lord himself gives this order but an angel conveys the command in the Septuagint version of the Bible. The Septuagint text is cited in explanations of this passage by Saint Augustine,[61] and by Petrus Comestor (c. 1100–80); and the angel who delivers the Lord's command in Perugino's composition may illustrate one of these commentaries.[62] Like the inscription on the frame of Perugino's *Baptism* fresco directly opposite, the arresting figure of the angel in Perugino's *Circumcision* fresco encourages spectators to pause before the latter work. The slight break in the narrative caused by the angel's pose gives viewers additional time in which to contemplate the crucial message conveyed by Perugino's *Circumcision of Moses' Son*.

The Jewish ritual operation, the most consequential subject in Perugino's *Circumcision of Moses' Son*, occupies the right foreground of the composition. In this part of the fresco, Moses and one of his sons look on while Zipporah circumcises the other boy (Exodus 4:25) (Fig. 9). Neither the Vulgate nor the Septuagint specifies which of Moses' sons was circumcised on this occasion,[63] but in Perugino's fresco the operation is performed on the smaller child, presumably the younger son. By twice depicting Moses'

56. Philo, *De Vita Mosis*, 55, para. 60.
57. Ettlinger, 116f.
58. Van Dijk, 1975, 191; Lippe, 1, 58.
59. Lippe, 1, 58.
60. Ettlinger, 61 and nn. 4, 5, notes that this scene has also been identified as an illustration of Exodus

3:27f. and of Exodus 18:1ff.
61. Steinmann, 232.
62. As suggested by Ettlinger, 59 and n. 4.
63. On the Circumcision of Moses' Son, see Bede, *In Pentateucham*, 298; Rabanus Maurus, *In Exodum*, 26f.

sons, Gershom and Eliezer, in the foreground of his *Circumcision* fresco, Perugino returns to the "continuous narration" of Early Christian art. The twofold appearance of Moses' sons underscores their importance while at the same time recalling that scriptural readings of the second Lenten week refer often to brothers,[64] and to fathers and sons, frequently stressing the preferential treatment of younger brothers and younger sons.

A fraternal reference appears in Matthew 17:1–9, the Gospel pericope assigned to the Sunday that opens the second Lenten week in a thirteenth-century *Ordinal* of the papal court and in the *Missal of 1474*.[65] In these verses, Matthew describes the Transfiguration, an occasion when Jesus honored the brother apostles, James and John, by taking them with him to the mountain. The motif of brothers is again evoked by the Roman station on Wednesday of the second Lenten week. As specified, for example, by the *Missal of 1474*,[66] the stational Mass on this day is at S. Cecilia, the church dedicated to an early Roman martyr, who was put to death in company with two brothers.[67] On this same Wednesday, from Christian antiquity onward, there was a reading of Matthew 20:17–28,[68] which again names James and John, the brother apostles.

Toward the end of the second Lenten week, the Roman liturgy increasingly records the preferential treatment of younger brothers and younger sons. On Friday of this week, the *Missal of 1474* lists Genesis 37:6–22 as the Epistle of the Mass.[69] While this pericope describes the humiliating occasion when Joseph's older brothers sold him into slavery, the passage begins with Joseph's account of two dreams in which his older brothers bow down before him symbolically (Genesis 37:7). These visions foretell the future importance of Joseph, a younger son and younger brother who far surpassed his older brothers in eminence.

Similarly, the particular favor shown a younger brother and younger son is recorded in Luke 15:11–32, the passage assigned to Saturday of the second full week in Lent by a thirteenth-century papal *Ordinal* and by the *Missal of 1474*.[70] Luke 15:11–32 records the Parable of the Prodigal Son, another text on the subject of sibling rivalry. Significantly, the parable opens with the words, "A certain man had two sons," and it goes on to recount the chagrin of the dutiful older son at the loving reception given the prodigal younger son on his return to the paternal home.

On the same Saturday, both Rupert of Deutz and the *Missal of 1474* assign the history of Jacob and Esau, Genesis 27:6–40, as the Epistle.[71] A still earlier verse, Genesis 25:23, defines the twin brothers as representatives of two nations, and predicts that the older will serve the younger. The accuracy of this prophecy is borne out in the passage read as the Epistle on the second Lenten Sunday, for Genesis 27:6–40 tells of the ruse by which the patriarch Isaac was tricked into offering his wily younger son, Jacob, the

64. Jungmann, 1959, 260.
65. Van Dijk, 1975, 195; Lippe, I, 69.
66. Lippe, I, 75.
67. Jungmann, 1959, 260.
68. Van Dijk, 1975, 197.

69. Lippe, I, 79.
70. Van Dijk, 1975, 197; Lippe, I, 83.
71. Rupert of Deutz, *Liber de divinis officiis*, 128f.; Lippe, I, 81.

parental blessing destined by right of birth for Esau, the older son. Like the story of Joseph and the Parable of the Prodigal Son, the history of Jacob and Esau demonstrates that younger brothers and younger sons may unexpectedly be favored over their older siblings.

The preference for younger brothers and younger sons that is expressed in the Roman liturgy during the second Lenten week is illuminated by the Parable of the Vine Dressers, Matthew 21:33–46, a passage often assigned on Friday of this week.[72] In these verses, Jesus tells of a certain householder who sends his servants to gather fruit from his vineyard. But the vine dressers who have rented out the vineyard thrash one of the householder's servants, kill another, and stone a third. When the householder finally sends his own son to the vineyard, he too is murdered by the vine dressers. The parable next prophesies that the owner of the vineyard will destroy the evil vine dressers and rent out his property to others. At this point, Jesus asks his audience, "Did you never read in the Scriptures, 'The stone which the builder has rejected has become the cornerstone' [Psalm 117:22 (KJ 118:22)]. Therefore I say unto you that the kingdom of God shall be taken from you and given to a nation bringing forth the fruits thereof" (Matthew 21:42). The implication contained in Matthew 21:42, that God's favor can be withdrawn from one group and bestowed upon another, elucidates a major liturgical theme of the second Lenten week: the unexpected preferment of younger sons over their older brothers.

Like many biblical episodes recounted in liturgical readings of the second full week in Lent, the Parable of the Vine Dressers was thought to predict the supplantation of Judaism by Christianity; for Rupert of Deutz, the parable foreshadows the passing of God's favor from Jews to Christians.[73] Likewise, Isaac's blessing of Jacob in place of Esau was taken to signify the substitution of the New Law for the Old. This interpretation of the Epistle assigned on Saturday of the second Lenten week is offered by the French Franciscan, Nicolaus de Lyra, whose Postillae litteralis, explaining the Roman liturgy, were first printed in Rome in 1471–72, during Friar Sixtus's pontificate.[74] Commenting on the history of Jacob and Esau, Nicolaus observes: "The younger people, that is, the Gentiles, will take the place of the firstborn people, that is, the Jews."[75] In this, the Franciscan exegete follows Saint Ambrose, who had already identified Jacob as the church and Esau as the synagogue many centuries earlier.[76]

A related message could be extracted from the Parable of the Prodigal Son, the Gospel lesson of Saturday in the second Lenten week. According to Nicolaus de Lyra, the prodigal younger son, who is lovingly welcomed by his father, represents the Gentiles; while the older son, who is more or less ignored by the end of the tale, stands for the Jews.[77] Rupert of Deutz's suggestion, that the church welcomes newly baptized

---

72. For example, in a thirteenth-century papal Ordinal (Van Dijk, 1975, 197).

73. Rupert of Deutz, Liber de divinis officiis, 127f.

74. Henri Labrosse, Recherches sur la vie et l'oeuvre de Nicolas de Lire, Toulouse, 1906, 4.

75. Nicolaus de Lyra, Postillae maiores, 32r.

76. V. Hahn, Das wahre Gesetz. Eine Untersuchung der Auffassung des Ambrosius von Mailand und vom Verhältnis der beiden Testament, Münster, Westphalia, 1969, 149–63, cited by Brenk, 1975, 109.

77. Nicolaus de Lyra, Postillae maiores, 151r.

Christians much as the prodigal son was welcomed by his father, may explain why the passage was read during Lent.[78] Rupert evidently equates the father's loving reception of his prodigal younger son (after the youth had experienced many hardships) with the church's loving reception of her catechumens on Easter Eve (after baptismal candidates had experienced the rigors of Lenten asceticism).

It was not difficult to interpret the Circumcision of Moses' Son as another paradigm of supplantation; Rabanus Maurus, for one, identifies Moses' older son with the Church of the Jews, and his younger brother with the Church of the Gentiles.[79] Exodus 4:25, which describes the Circumcision of Moses' Son, is not assigned in the Roman liturgy during the second week in Lent. Nevertheless, in line with the commentary of Rabanus Maurus, Perugino's image of Zipporah circumcising her younger son (Fig. 9) could recall the repeated allusions to triumphant younger brothers and younger sons that figure in the Roman liturgy throughout this week.

A peculiarity of the papal liturgy may mirror the mysterious process of supplantation. As Durandus of Mende points out, Masses celebrated by the Roman pontiff are unusual in that the Apostles' Creed is recited in two stages on these occasions. The first stage, which precedes the pope's salutation of peace, is chanted by subdeacons alone; according to Durandus, they signify the origins of the church among the Jews. During the next stage, a second portion of the *Credo* is chanted by members of the choir; according to Durandus, they stand for the Church of the Nations (Gentiles).[80] This unusual feature of pontifical Masses may be reflected symbolically in Perugino's *Circumcision* fresco. The circumcision of Moses' younger son is rarely portrayed in the visual arts; but Durandus's commentary, which links the supplantation of Judaism by Christianity with the two-stage rendition of the Apostles' Creed at pontifical Masses, could help to explain why the circumcision of Moses' younger son (an event symbolizing the process of supplantation) is depicted on a monumental scale in Pope Sixtus IV's chapel.

Zipporah appears more than once in Perugino's *Circumcision* fresco (Pl. VIII). This example of "continuous narration" reflects the high status of Moses' wife among church fathers and medieval commentators, who regard her as a figure of *Ecclesia*.[81] According to Rabanus Maurus, the knife that Zipporah used while circumcising her son represents the doctrine of the Holy Spirit, by means of which the "veteris hominem," the "Old Adam," is stripped away.[82] Consequently, the circumcision that Zipporah performed on Moses' younger son foreshadows the purification of mankind effected by the church. In traditional exegesis, the purifying operation functions by the agency of Christ himself. That point is explicit in Augustine's directive, repeated by Rabanus Maurus among others, that stone knives must be used for circumcisions because "Christ was the stone"

---

78. Rupert of Deutz, *Liber de divinis officiis*, 236, during a discussion of the liturgy of Holy Saturday.

79. Rabanus Maurus, *In Exodum*, 27.

80. Wind, 1960, 57, 76.

81. Rabanus Maurus, *In Exodum*, 27.

82. Rabanus Maurus, *In Exodum*, 27, cited in connection with this fresco by Ettlinger, 61 nn. 1–3, who points out that Bede had interpreted this episode in similar terms (Bede, *In Pentateucham*, 298) and that Nicolaus de Lyra, linking circumcision and baptism, gave special significance to Zipporah's stone knife, calling it the similitude of Christ, the living stone (Nicolaus de Lyra, *Moralia super Bibliam*, 1480, 8r).

(I Corinthians 10:4).[83] I Corinthians 10:4 is a verse from the traditional Epistle of Septuagesima Sunday, which opens the pre-Lenten period.

Christ himself was circumcised with a stone knife according to a fourteenth-century Italian edition of Pseudo-Bonaventure's *Meditations on the Life of Christ* (Paris, Bibliothèque Nationale, MS Ital. 115).[84] (Until the eighteenth century, the *Meditations* was credited to Saint Bonaventure himself; but modern scholars attribute the devotional tract to an unknown Franciscan living in Tuscany during the latter part of the thirteenth century.)[85] The one surviving Italian exemplar of the *Meditations* contains the information—lacking in Latin editions—that Mary circumcised her own son;[86] an illustration on folio 24 verso of the Italian version shows Mary performing the ritual operation.[87] The modern editors of the Italian *Meditations* manuscript could find no parallel images of the Virgin circumcising Jesus,[88] but it seems likely that the circumcision scene in the Paris codex is modeled on earlier representations of Zipporah circumcising Moses' son. Perugino's *Circumcision of Moses' Son* may refer, by implication, to the traditional connection between Zipporah and the Virgin Mary, to whom the Sistine Chapel is dedicated, while at the same time alluding to a key theme of the Roman liturgy during the second Lenten week.

Christ is symbolically identified as a stone in commentary on the Parable of the Vine Dressers (Matthew 21:33–46), a text read on Friday of the second full Lenten week. The parable alludes (in Matthew 21:42) to the allegorical cornerstone first described in Psalm 117:22. That architectural element is widely understood as a figure of Christ; to Nicolaus of Lyra, for example, "lapis iste figurabat Christum."[89] Stones also figure in Matthew 21:35, a verse of the parable that describes the stoning of the householder's servant. These allusions to stones in the Roman liturgy on Friday in the second full week of Lent find their echo in the Roman station of the day. This is at S. Vitale, the church dedicated to an Early Christian martyr, who was first thrown down a well and then pelted with stones.[90] Based upon the exegetical tradition that stone knives must be used in circumcisions, Perugino's *Circumcision of Moses' Son* could serve to recall these stony references in the Roman liturgy during the second full week of Lent.[91]

Throughout the centuries, Christian commentators view circumcision as a purifying ritual. According to the Venerable Bede, "[T]he daily practice of virtues . . . is our daily circumcision, that is, the continuous cleansing of the heart."[92] Pseudo-Bonaventure's *Meditations on the Life of Christ* makes a related point: "[W]e must undergo spiritual circumcision, that is, refuse all superfluous things."[93] And a sermon by Battista Casali,

83. Augustine, *Pâque*, 249.

84. Ragusa-Green, 43f., as cited in Steinberg, 57 and n. 62.

85. Ragusa-Green, xxi and n. 2.

86. Ragusa-Green, 44 and n. 21.

87. Ragusa-Green, 42, fig. 34.

88. Ragusa-Green, 411, in the note on 42, fig. 34.

89. Nicolaus de Lyra, *Postillae maiores*, 149v.

90. S. Vitale is one of the stational churches restored by Sixtus IV for the Jubilee Year of 1475, as attested by

an inscription on the entrance portal (Urban, "Die Kirchenbaukunst des Quattrocento in Rom," *Römisches Jahrbuch für Kunstgeschichte*, 1961–62, 214, cited in Stinger, 226f. and n. 211).

91. It should be noted, however, that Zipporah does not appear to hold a knife of any kind in Perugino's *Circumcision* fresco.

92. Bede, *In die festo circumcisionis domini*, PL XCIV, cols. 54A, 55A, as cited in Steinberg, 53 n. 50.

93. Ragusa-Green, 44.

preached for Pope Julius II at a "papal chapel" held on the feast of the Circumcision, 1 January 1508, defines the exercise of virtue as "interiorized circumcision."[94] Members of the circle around Sixtus IV were doubtless familiar with such interpretations. To that group of learned clerics and laymen, the ancient Jewish ritual operation portrayed in Perugino's *Circumcision of Moses' Son* doubtless recalled the cleansing and purification required of all Christians during Lent.

94. John W. O'Malley, "The Vatican Library and the Schools of Athens: A text of Battista Casali," *Journal of* *Medieval and Renaissance Studies,* VII, 1977, 271, 278.

# III

## THE SECOND FRESCOES ON THE LONG WALLS

### The *Temptations of Christ* and *Moses in Egypt and Midian*

TITULI:

TEMPTATIO IESU CHRISTI LATORIS EVANGELICAE LEGIS

and

TEMPTATIO MOISI LEGIS SCRIPTAE LATORIS

Botticelli's *Temptations of Christ* (Pl. II) and his *Moses in Egypt and Midian* (Pl. IX) are, respectively, the second frescoes from the altar end of the north and south walls in the Sistine Chapel. Both compositions—like Perugino's *Baptism of Christ* (Pl. I) and his *Circumcision of Moses' Son* (Pl. VIII), the preceding narrative frescoes on the long walls of the chapel—echo texts and themes of the Roman liturgy during the pre-Lenten period beginning with Septuagesima Sunday and during the first two weeks of Lent.

Jesus' Temptations by the Devil (Matthew 4:1–11) are represented in the background of Botticelli's *Temptations* fresco (Pl. II). But the preceding composition on the north wall, Perugino's *Baptism of Christ* (Pl. I), illustrates Jesus' first sermon (Matthew 4:17), an episode that *follows* the Temptations in Matthew's Gospel. The overlap in chronology suggests that the two Christological frescoes were designed as a unit; and indeed, both compositions mirror motifs of the Roman liturgy near the opening of Lent. Perugino's *Baptism* fresco, the first on the north wall, evokes the need for repentance, sermons, and baptism, liturgical themes stressed from Septuagesima Sunday on,[1] whereas the background scenes in Botticelli's *Temptations* fresco, the second on the north wall, illustrate Matthew 4:1–11, the Gospel lesson of the first Lenten Sunday.

Botticelli's *Temptations* fresco is often called the *Purification of the Leper*; but I agree with Ettlinger that this title, which refers to the scene of Jewish sacrifice at the foreground, is inaccurate.[2] The textual basis of the foreground scene in the *Temptations*

---

1. See Chapter II.    2. Ettlinger, 4, 78.

fresco has been the subject of much learned speculation.[3] I will explain later why I connect this image of Jewish sacrifice with II Maccabees 1:18–23, verses associated in the Roman liturgy with the Saturday that ends the first full week of Lent.

By contrast with the enigmatic sacrifice portrayed at the foreground of Botticelli's composition, the Temptations scenes in the background are easy to interpret. As underlined by the accompanying *titulus*, TEMPTATIO IESU CHRISTI LATORIS EVANGELICAE LEGIS, they illustrate Matthew 4:1–11, a text invariably assigned to the first Lenten Sunday, both in Christian antiquity[4] and in Renaissance service books like the printed *Missal of 1474*.[5] (The first Lenten Sunday was known as *Caput Quadragesimae*, because Lent once began on this day in the early church;[6] but by the fifteenth century, the opening of Lent had been shifted back to the preceding Wednesday, now known as Ash Wednesday.)[7] The impact of the *Caput Quadragesimae* liturgy on Botticelli's *Temptations* fresco, which has not been appreciated properly in modern times, would have been clear to Sixtus IV and his court, for these learned churchmen were accustomed to hearing sermons on the Triple Temptation at "papal chapels" held on the opening Sunday of Lent.[8] Indeed, the illustrations of Matthew 4:1–11 in Botticelli's *Temptations* fresco exemplify a phenomenon already mentioned:[9] the correspondence between subjects of the Christological frescoes in Pope Sixtus's chapel and themes of the Roman liturgy on important Sundays that fall between Advent and Pentecost.

While the devil's temptation of Jesus is often represented in the Middle Ages, the subject is rare in Renaissance art, even in New Testament cycles.[10] Botticelli's Temptations scenes must therefore serve some special purpose. From an early date, Christ's Temptations are viewed as a symbol of Lent: the fathers regularly compare the forty days of Lenten fasting with Jesus' fast of forty days and nights during the period in which he was tempted by Satan.[11] Based upon this traditional analogy, Botticelli's Temptations scenes may be intended as an emblem of the entire Lenten season.

In medieval art, representations of the Temptations often illustrate Psalm 90 (KJ 91), a prominent liturgical text of the first Lenten Sunday.[12] From Christian antiquity onward, parts of Psalm 90 serve as the Introit, Gradual, Offertory, and Post-Communion of the Mass on this day; and the psalm in its entirety is chanted as the Tract.[13] In the Roman *Breviary*, from the beginning of Lent to Passion Sunday, Psalm 90 provides texts for the nine responses of Matins, for all the proper verses of the hours,

3. For Steinmann, 236, 245ff., this scene illustrates the rite of purification described in Leviticus 14:1–7, an interpretation accepted by Shearman, 1972, 49. Ettlinger, 81, links the scene with Hebrews 9:11–14.

4. Chavasse, "Le cycle pascal," in Martimort, 708.

5. Lippe, 1, 56.

6. Callewaert, 1940 (1), 482.

7. Callewaert, "Le Carême primitif dans la liturgie Mozarabe," *Sacris Erudiri*, Steenbrugge, 1940, 507.

8. O'Malley, 1979, 250, cites a "Sermo de pugna Christi cum daemone," preached before Pope Innocent VIII on the first Sunday of Lent.

9. See Chapter I, 15f.

10. The first surviving image of the Triple Tempta-

tion, a subject unknown in Early Christian art, appears in the eighth-century *Book of Kells*, illustrating Luke's Gospel (Brenk, 1966, 197ff.).

11. The forty days spent by Moses in the cloud, Exodus 24:12–18, and the forty-day walk of Elijah, I Kings 19:3–8, were also viewed as Lenten prototypes. In the early church, all three texts were assigned to the first Lenten week, and all three are cited by the fathers in a Lenten context (Callewaert, 1940 [1], 451).

12. Such illustrations of Psalm 90 appear, inter alia, in the *Chludov Psalter*, the *Pantocrator Psalter* of Mount Athos, and the *Stuttgart Psalter* (Brenk, 1966, 198).

13. Righetti, II, 129.

and for the brief responses of Terce, Sext, and Nones. In addition, the entire psalm is repeated at the aliturgical service of Good Friday.[14] Psalm 90, the Lenten psalm *par excellence,* is closely related to Matthew 4:1–11, the pericope of the Triple Temptation, because Matthew 4:6 is, in essence, a repetition of Psalm 90:12: "In their [the angels'] hands they shall bear thee up, lest thou dash thy feet against a stone."[15] Botticelli illustrates these liturgical texts of the first Lenten Sunday in a scene that so far has not been identified correctly.

At the background of Botticelli's *Temptations* fresco (Pl. II), the Temptation by Stones appears at the left side; the Temptation by High Places is at the center; and the Temptation by the Kingdoms of the World is at the right. In these scenes, the devil wears a monk's habit, in accord with a well-known convention.[16] A scene still further to the right illustrates Matthew 4:11, which records that angels ministered to Jesus following his Temptations. In this part of Botticelli's fresco, three angels have prepared a table for Jesus; but he gestures in consternation as the devil, now revealed in his hairy nakedness, plummets from a rocky ledge following the third and final rejection by Christ.[17] Illustrations of Matthew 4:1–11 at the background of Botticelli's *Temptations* fresco recall the traditional reading of that passage on the first Lenten Sunday.

The incident recorded both in Matthew 4:6 and in Psalm 90:12 is depicted at the left side of Botticelli's fresco, in the middleground. There, sustained by three angels, Jesus stands beside a sizable rock (Fig. 10).[18] This scene must refer to the words from Matthew 4:6, "lest thou dash thy feet against a stone." Nevertheless, Steinmann identifies this as an image of Christ supported by angels while traveling to meet the devil in the wilderness.[19] For Michael Levey, the scene represents Christ's return to Galilee after the Temptations.[20] And Ettlinger remarks, "The curious group of Christ with three angels at the left remains meaningless unless we regard it as a duplication of the ministration scene."[21] But the scene in question makes perfect sense as a reference to the shared text of Matthew 4:6 and Psalm 90:12. Patristic exegesis links Psalm 90:12 with Christ's struggle against the devil's temptations: as Origen observes in commentary on this verse, "The devil thought that he could tempt Christ, but Christ was helped by angels not to hit his foot against a stone."[22] The misunderstood scene at the left side of Botticelli's *Temptations* fresco thus evokes a prime theme of the Lenten liturgy: rejection of the devil.

---

14. Righetti, II, 130.

15. During the Temptation by High Places, as described by both Matthew and Luke, the devil quotes Psalm 90 (Schiller, I, 143).

16. Schiller, I, 144.

17. This monkish devil with ass's ears and talons for feet may be a late-medieval Italian type (Ettlinger, 78); he resembles the devil in Temptations scenes from the fourteenth-century Italian manuscript of Pseudo-Bonaventure's *Meditations on the Life of Christ* (Ragusa-Green, fig. 90, 120 [fol. 68v]).

18. If the illustration of Psalm 90:12 and Matthew 4:6 follows the illustration of Matthew 4:11 in

Botticelli's composition, as it seems to, the former scene is out of order with respect to Matthew's narrative. In this case, Botticelli may have followed an earlier manuscript tradition, because this "incorrect" order appears in an illustration of the Temptations from the eleventh-century Coronation Gospel Book of Vyšehrad (Schiller, I, fig. 393).

19. Steinmann, 463.

20. Levey, 93.

21. Ettlinger, 55. Lightbown, I, 64, identifies this as a scene in which Christ expounds the Jewish blood sacrifice to three angels.

22. Origen, *Nombres,* 119.

Illustrations of Matthew 4:1–11 and of Psalm 90:12 in Botticelli's *Temptations* fresco recall some prominent texts of the Roman liturgy during the first full Lenten week. Similarly, episodes portrayed in Botticelli's *Moses in Egypt and Midian* (Pl. IX), the work directly opposite, mirror still other texts and themes of the liturgy during the opening weeks of Lent.

The Mosaic fresco depicts some youthful exploits of the Jewish leader while living in Egypt and Midian. The accompanying inscription, TEMPTATIO MOISE LEGIS SCRIPTAM LATORIS,[23] recalls the *titulus* over the juxtaposed *Temptations* fresco, TEMPTATIO IESU CHRISTI LATORIS EVANGELICAE LEGIS. These matching legends reflect a traditional view that certain events in Moses' early career were analogous to the devil's temptation of Jesus near the start of his ministry, a key subject of the Roman liturgy on the first Lenten Sunday. The analogy is implicit in Gregory of Nyssa's *Life of Moses*, where Moses' early adventures in Egypt and Midian are viewed as his first temptations.[24]

Botticelli's *Moses in Egypt and Midian* depicts at least seven distinct episodes from the patriarch's younger days, all represented within a leafy landscape setting (Pl. IX). At the right side, in the foreground, Moses is shown killing the Egyptian taskmaster (Exodus 2:12).[25] Medieval commentators regard this cruel individual as a figure of the devil. Rabanus Maurus, for example, equates Moses' murder of the wicked taskmaster with Jesus' rejection of Satan,[26] a theme illustrated in the *Temptations* fresco directly opposite. A fleeing couple located behind the murder scene in *Moses in Egypt and Midian* probably constitutes another reference to Exodus 2:12; the frightened man in this part of Botticelli's fresco may be the Israelite maltreated by the Egyptian taskmaster.[27] These illustrations of Exodus 2:12 refer, symbolically, to rejection of the devil, a prime motif of the Roman liturgy on the first Sunday of Lent.

Moses' Flight to Midian after murdering the Egyptian taskmaster (Exodus 2:15), another uncommon biblical subject recalling a Lenten theme, is represented near the central axis of Botticelli's *Temptations* fresco. An earlier illustration of Moses' Flight to Midian, in a thirteenth-century *Bible moralisée* now divided among libraries in London, Oxford, and Paris, is accompanied by the legend, "Moyses qui reliquit Pharaonem et filiam suam et familiam, figurat Iesus Christum qui delicias et divitias mundi et prosperitatem carnis dereliquit."[28] This inscription, stressing the rejection of worldly pleasures, indicates that Moses' Flight to Midian—like Jesus' temptation in the wilderness—was viewed symbolically as a paradigm of Lenten asceticism and penitence.

At the very center of Botticelli's fresco, the youthful Moses is seen pouring water

23. Here and in other *tituli* on the Sistine Chapel walls, Moses is called *legis latoris*, the lawgiver, a phrase perhaps borrowed from Philo's *Life of Moses* (Ettlinger, 117 and n. 1). Humanists of the fifteenth century view Moses as the true founder of the Jewish religion (Trinkaus, II, 731), drawing the same parallel between Christ and Moses that is illustrated on the Sistine Chapel walls.

24. Gregory of Nyssa, *Moïse*, 137ff.

25. This subject seems to be otherwise unknown in monumental art (Ettlinger, 62).

26. Rabanus Maurus, *In Exodum*, 17; Bede, *In Pentateucham*, 291; both cited by Ettlinger, 62.

27. Ettlinger, 50, describes these figures as two horrified spectators.

28. Ettlinger, 62 n. 2; Laborde, pl. 39 (Oxford, Bodley MS 270b, fol. 39v).

from a silvery vessel for Jethro's sheep (Fig. 12). The scene illustrates Exodus 2:17, a verse recited during the baptismal initiation of catechumens on Holy Saturday, according to Saint Jerome.[29] Perhaps following Jerome's lead, Ludwig von Pastor, learned biographer of the popes, suggests that the water offered by Moses to Jethro's sheep in this scene symbolizes the water of baptism.[30] The single black animal in Jethro's herd may testify to Botticelli's understanding that the episode in question had traditional connections with baptism, a key theme of the Roman liturgy at the opening of Lent. Botticelli may have included a black sheep in Jethro's flock in order to distinguish symbolically between the elect and those not yet eligible to be baptized.

Exodus 2:16–17, which tells of Moses' encounter at the well with his future wife Zipporah, who was one of Jethro's daughters, is another biblical passage illustrated near the center of Botticelli's *Moses in Egypt and Midian* (Fig. 12). Ettlinger comments, "The idyllic meeting at the well is, strangely enough, given great prominence."[31] But the central location of the scene is readily explained by its baptismal meaning. As Origen observes,[32] Old Testament patriarchs, whose spouses were first encountered at wells, resemble the church, united with Christ in the "bath of water."[33] Because Zipporah is a well-known figure of *Ecclesia*, Botticelli's "Meeting of Moses and Zipporah" could illustrate Origen's assertion that encounters with wives of the patriarchs at wells prefigure Christ's union with his church by the agency of baptism. Viewed in this light, Botticelli's "Meeting of Moses and Zipporah" evokes baptismal themes of the Roman liturgy at the opening of Lent.

Although Exodus 2:16 specifically mentions Jethro's seven daughters, only two young women stand beside the well in Botticelli's *Moses in Egypt and Midian*.[34] One of them is seen from the back; she wears a rough sheepskin cloak and carries a shepherd's staff. The other girl, seen from the front, must be Moses' future bride, Zipporah, for she is the more elegantly dressed: Zipporah wears a fine pair of sandals, while her sister goes barefoot. The costume worn in this scene by Zipporah, a traditional figure of *Ecclesia*,[35] suggests a link with the popes who govern the church, for Zipporah's gown is decorated with acorns from the della Rovere *stemma* of Sixtus IV. The primitive spindle carried by Zipporah in Botticelli's *Moses in Egypt and Midian* may link Moses' future wife with another holy personage often identified as *Ecclesia*: the Virgin Mary, to whom the Sistine Chapel is dedicated. According to the apocryphal *Protoevangelion of James*, Mary spent part of her youth spinning yarn for the veil of the temple.[36]

Still another event recorded in Exodus 2:16, Moses Driving Away the Hostile

29. Jerome, *Epistle* LXIX, 6 (*Corpus Scriptorum Ecclesiasticorum Latinorum*, 54), 690, cited in Tertullian, *Traité*, 27.

30. For Pastor, cited in Barzotti, 112, the water offered by Moses to Jethro's sheep in this fresco refers both to the water of baptism and to the *Aqua Vergine*, which Sixtus IV brought back into Rome.

31. Ettlinger, 39.

32. For the revived interest in Origen during the fifteenth century, see Wind, 1954, 142ff., cited by Ettlinger, 54 n. 3.

33. Cited by Daniélou, 1950, 123f. The parallelism between Moses, Isaac, and Jacob in this respect may have originated in Jewish sources where this comparison appears (Ginzberg, II, 290).

34. The reduced number of Jethro's daughters in this composition may depend upon Byzantine *Octateuch* illustrations (Ettlinger, 51, pl. 38a).

35. Barzotti, 113.

36. *Protoevangelion of James* IX:2, in *The Apocryphal Books of the New Testament*, Philadelphia, 1901, 29.

Shepherds, is illustrated near the center of Botticelli's *Moses in Egypt and Midian* (Fig. 12). The biblical episode was widely understood to signify the expulsion of demons, a prime liturgical theme in the first full Lenten week and, for that matter, throughout all of Lent. The connection is made explicit in an inscription that accompanies illustrations of Exodus 2:16 and 17 in the thirteenth-century *Bible moralisée* cited above. The legend in question, "Moyses qui pastores expulit et puelle hauriunt aquam figurat Iesus Christum qui diabolos expulit . . . ,"[37] links the expulsion of demons with the expulsion of the hostile shepherds recorded in Exodus 2:16 and 17. Horned demons inhabit the scenes of contemporary medieval life that alternate with the illustrations of Exodus 2:16 and 17 in this *Bible moralisée,* thus further emphasizing the devil's connection with the scriptural episodes.[38]

Demons and the devil are particularly prominent in the Lenten liturgy,[39] because baptismal candidates of the early church were regularly exorcized during Lent to purify them in preparation for their baptism on Easter Eve.[40] Alluding to this ancient practice, Tertullian urges catechumens to renounce Satan, his pomps, and his angels.[41] And Leo the Great, describing Lent as a time of particular temptation for all Christians, warns that the devil attacks then to ensure that those who keep Easter will be in mortal sin.[42] Medieval service books repeat this thought. Under the heading, "De prima dominica quadragesime," Durandus's *Rationale* asserts that Lent is the time when the devil most tempts us: "in quo dyabolus fortius contra nos insurgit."[43] Moses Slaying the Egyptian Taskmaster and Moses Driving Away the Hostile Shepherds are both episodes traditionally interpreted as exorcisms of the devil. Consequently, the illustrations of these subjects in Botticelli's *Moses in Egypt and Midian* evoke a major theme of Lent. Exorcism is further evoked by Botticelli's *Temptations* fresco, situated directly across the Sistine Chapel. In the background of this composition, Botticelli portrays some notable occasions on which Jesus repulsed the devil (Pl. II).

The special prominence of demons and the devil in the Roman liturgy at the start of Lent reflects the circumstance that an Embertide traditionally fell in the first full Lenten week.[44] Embertides were four separate penitential weeks, spaced three months apart during the course of the ecclesiastical year. Wednesdays, Fridays, and Saturdays of Ember weeks were days of fasting, and a Vigil Mass took place on the evening of Ember Saturday.[45] Many Embertide Gospel lections describe the expulsion of demons,[46] and the Embertide of Lent is no exception. On Wednesday of the Lenten Ember week, both

37. This inscription appears near the top left-hand column of roundels on fol. 40r (Laborde, pl. 40).

38. Laborde, pls. 39, 40.

39. The devil appears in the following Gospel passages assigned during Lent: first Sunday, Triple Temptation, Matthew 4:1–11; Wednesday of the first week, Demon Chased Away, Matthew 12:38–50; third Sunday, Healing of the Possessed Mute, Luke 11:14–28; Wednesday of the third week, Healing of Possessed Persons, Matthew 15:1–20; Tuesday of the fourth week and Passion Sunday, Christ Accused of being Possessed, John 7:14–31 and John 8:46–59 (Van Dijk, 1963, II,

68f., 70, 73f., 76, 78).

40. Dix, 340; Righetti, iv, 31, 43. Lenten exorcisms are already attested by Augustine, *Pâque,* 24.

41. *New Catholic Encyclopedia,* ii, 60, s.v. "Baptism."

42. Leo, *Sermons I,* 15; idem, Homily 39, *PL* liv, as cited in A *Dictionary of Catholic Theology,* 201, s.v. "Lent."

43. Durandus, 1479, fol. 175r.

44. Callewaert, 1924, 208.

45. On Ember days, see G. G. Willis, "Ember Days," *Essays in the Roman Liturgy,* London, 1964, 51–94.

46. Callewaert, 1924, 224.

a thirteenth-century *Ordinal* of the papal chapel and the printed *Missal of 1474* specify a reading from Matthew 12:38–50, which describes the expulsion of unclean spirits.[47] The Gospel lection of Thursday in this week, Matthew 15:21–28, recounts the Cure of the Daughter of the Canaanite Woman, a girl possessed by the devil. And John 5:1–15, assigned in the *Missal of 1474* to the Mass on Friday of this week, records the miraculous cure at the Pool of Bethesda,[48] often interpreted as an exorcism.[49] Symbolic references to Lenten exorcism in Botticelli's *Moses in Egypt and Midian,* which depicts several episodes from Moses' youth traditionally thought to signify expulsion of the devil, are echoed in the background of the *Temptations* fresco directly opposite, where Christ's triple rejection of Satan is portrayed.

Exodus 3:1–5, which tells of Moses' encounter with the Lord in the Burning Bush while tending Jethro's flocks, is illustrated at the upper left side of *Moses in Egypt and Midian.* Here, Moses respectfully removes his sandals because he is on holy ground (Fig. 13).[50] From an early date, Moses' dramatic encounter with the Lord at the Burning Bush, and other events recounted near the start of Exodus 3, are cited in connection with the Lenten preparation of catechumens for their baptism at Easter.[51] A Milanese *Lectionary* of the twelfth century assigns Exodus 3:1–2 to Friday in the first full Lenten week.[52] And Amalarius's *Liber officialis* offers evidence that Exodus 3:5 was recited on Ash Wednesday.[53] The relevance of this biblical passage for the Ash Wednesday liturgy is explained by Sicard of Cremona (1160–1215), who likens Christians at the opening of Lent to Moses, obeying the command in Exodus 3:5, "Solve calciamentum de pedibus tuis."[54] The analogy drawn by Sicard of Cremona points to a further connection between Botticelli's "Moses at the Burning Bush" and the Roman liturgy during the opening days of Lent.

As the youthful Moses uncovers his feet before the Burning Bush in Botticelli's *Moses in Egypt and Midian,* the bare-legged Jewish leader takes up a pose derived from the *Spinario* (Figs. 7, 13). Imitations of the famed antique statue appear regularly in representations of Moses at the Burning Bush;[55] and in the Renaissance, the *Spinario* was identified as a young shepherd, like Moses when he tended Jethro's flocks.[56] In view of baptismal meanings evidently attached to the *Spinario,*[57] Botticelli's recourse to this ancient model in his "Moses at the Burning Bush" may reflect a traditional link between the encounter described in Exodus 3:1–5 and the rite of baptism. If so,

47. Van Dijk, 1975, 193; Lippe, I, 62. This lection, which recalls Jonah and the Whale, a figure of Christ's death and resurrection, evokes the asceticism of Lent: one should repent like the Ninevites to escape enslavement by the devil (Callewaert, 1924, 226).

48. Lippe, I, 65.

49. Tertullian, *Traité,* 74.

50. Frederick Hartt, "*Lignum Vitae in Medio Paradisi,* the Stanza d'Eliodoro and the Sistine Ceiling," *Art Bulletin,* XXXII, 1950, 130, links the Burning Bush or *roveto ardente* with Sixtus IV's family name, della Rovere. Goffen, 241 and n. 93, demonstrates that the Burning Bush was an image of the Virgin: as the bush

was not consumed by fire, so Mary conceived without being consumed by the flames of concupiscence.

51. Augustine, *Pâque,* 352, PL XXVIII, 59.

52. *DACL,* V, 1, col. 291, no. 32, s.v. "Epitres."

53. Amalarius, *Liber officialis,* 155: "De . . . Septuagesima . . . officium quartae feriae, quod est caput jejunii, illi tempori quando dixit Dominus ad Moyses: Solve calciamentum de pedibus tuis, Exodus 3:5 . . ."

54. Sicard of Cremona, *Mitrale,* 361.

55. Heckscher, col. 290.

56. Bober–Rubinstein, 236.

57. See Chapters II and VI, 23, 91ff.

It is tempting to speculate that these verses may be illustrated at the foreground of Botticelli's *Temptations* fresco. II Maccabees 1:18 credits the high priest Nehemiah with rebuilding both the temple and the altar. These praiseworthy actions by the Jewish prelate may be mirrored in the temple facade and altar marking the central axis of Botticelli's composition. A fire burns atop the central altar, recalling the newly kindled blaze described in II Maccabees 1:22–23; and the Jewish ceremony takes place beneath a sunny sky, as specified in II Maccabees 1:22. At the very center of Botticelli's sacrifice scene, an acolyte hands the high priest a silvery basin. This is customarily described as a bowl of blood;[68] but I see no reason why it could not be the vessel of liquid fire brought to Nehemiah by descendants of the ancient priests (II Maccabees 1:19–21).

Perhaps reflecting the text of II Maccabees 1:21, "when the materials for the sacrifice were present," paraphernalia needed for an Old Testament sacrifice are displayed in the *Temptations* fresco: two birds, bundles of wood, and, resting in the acolyte's basin, a hyssop branch bound with red thread. As recorded in Leviticus 14:1–7, these items are required for the ritual purification of lepers; and some of these same sacrificial objects are again listed in Hebrews 9:11–19, which describes a symbolic rite of purification.[69] On the evidence of these biblical texts, it seems clear that Botticelli wished to represent a purification ritual at the foreground of his *Temptations* fresco; but the ceremony that he portrays need not necessarily involve the purification of a leper.[70]

It is largely owing to Steinmann that the *Temptations* fresco became known as the *Purification of the Leper;*[71] but even Steinmann comments that the individual whom he identifies as the leper—a man standing to the right of the altar, supported by two companions—can be located only with some effort.[72] Ettlinger, who identifies the scene at the foreground of the *Temptations* fresco as a blood sacrifice, nonetheless observes that nothing in Botticelli's composition indicates what kind of animal was sacrificed.[73] I propose instead that this Old Testament sacrifice, set before a majestic temple facade, may depict the ritual purification of the Jewish temple cited in II Maccabees 1:18.

If the foreground scene in Botticelli's *Temptations* fresco does, in fact, represent the Jewish ceremony described in II Maccabees 1:18, this subject—or indeed any Old Testament subject—would seem, at first, to be totally out of place in the Christological cycle. But the anomaly may be explained by the circumstance that Jews regard Second Maccabees as apocryphal, and only Christians accept it as a canonical text.[74] While

---

crassam. 21: Et jussit eos haurire et afferre sibi, et sacrificia, quae imposita erant, jussit sacerdos Nehemiah aspergi ipsa aqua et ligna, et quae erant superposita. 22: Utque hoc factus est, et tempus affuit, quo sol refulsit, qui prius erat in nubilo, accensus est ignis magnus, ita ut omnes mirarentur. 23: Orationem autem faciebant omnes sacerdotes dum consumaretur sacrificium, Jonatha inchoanta, ceteris autem respondentibus.

68. Ettlinger, 80; Lightbown, I, 63.

69. Sixtus IV's *De sanguine Christi* contains many citations of this passage from Hebrews 9 (Ettlinger, 81ff.).

70. As suggested by Steinmann, 236, 245, and Shearman, 1972, 49.

71. Steinmann, 245, cited by Ettlinger, 4 and n. 3.

72. Steinmann, 245.

73. Ettlinger, 80.

74. Hastings, *Dictionary*, III, 192, s.v. "Maccabees." The two Books of the Maccabees, officially declared canonical at the Council of Florence, c. 1440, were already regarded as canonical by Augustine: "[T]he books of the Maccabees . . . are held as canonical, not by the Jews, but by the Church . . ." (Augustine, *The City of God*, trans. Marcus Dods, New York, 1948, bk. 18, 36, 263).

Nehemiah's sacrifice after the return of the Jews from Babylon is a crucial event in the history of Israel, the passage describing this event is, in effect, found only in the Christian Bible. For this reason, it may have seemed appropriate to illustrate this episode from Jewish history in the Christological cycle of Pope Sixtus's chapel. Moreover, an image of Nehemiah's sacrifice could serve to recall some matching achievements ascribed to the Jewish high priest and to Sixtus IV, the Christian *pontifex maximus*.

Accounts of Nehemiah's career were readily available in the quattrocentro. Along with the relevant biblical texts, Flavius Josephus's works on Jewish history were accessible by the latter part of the century, both in a Latin translation and in the original Greek. In addition, episodes from I and II Maccabees were recapitulated in a contemporary treatise, Aurelio Brandolini's *On the Sacred History of the Hebrews*; Brandolini, a Florentine humanist close to Sixtus IV,[75] uses Josephus as a source.[76] That noted Jewish historian celebrates Nehemiah for rebuilding the temple at Jerusalem, a pious action also mentioned in II Maccabees 1:18,[77] and for reconstructing the walls of his Holy City.[78] Nehemiah receives further praise, in II Maccabees 2:13, for founding a library to house books that contain writings by David, information about kings and prophets, and letters from various rulers on the subject of votive offerings.[79]

These laudable deeds by the Jewish high priest resemble some achievements of Sixtus IV singled out for praise in a poem of three couplets composed by Platina, the pope's official biographer. Platina's poem is inscribed beneath a celebrated fresco by Melozzo da Forlì that shows Sixtus, accompanied by his nephews, formally appointing Platina prefect of the Vatican Library (Fig. 16).[80] The last three lines of the poem seem particularly relevant here:

> Et Vaticanum cingere Syxte iugum,
> Plus tamen urbs debet; nam quae squalore latebant
> Cernitur in celebri biblioteca loco.[81]

At least two of the accomplishments credited to Sixtus IV in Platina's lines match praiseworthy actions by Nehemiah. Like Nehemiah, who achieved renown by rebuilding the walls of Jerusalem and by founding a library, Sixtus, as Platina records, has constructed a wall around the Vatican City and established a celebrated library of his own.[82] Melozzo's fresco was already completed by 1477;[83] consequently the verses

75. Stinger, 90.

76. Trinkaus, II, 601.

77. Hastings, *Dictionary*, III, 190, s.v. "Maccabees"; Josephus, *Antiquities IX–XI*, 39 (bk. XI, lines 165f.).

78. Josephus, *Antiquities IX–XI*, 401 (bk. XI, lines 179–83), 403 (bk. XI, line 183).

79. Hastings, *Dictionary*, III, 510, s.v. "Nehemiah." Like Nehemiah, whose library included letters from kings, Sixtus IV kept three volumes of privileges and royal letters in a chest adjacent to his *Bibliotheca secreta*

(Lee, 120).

80. Steinmann, 18, 78; Lee, 119, 124.

81. Steinmann, 18.

82. The library ranked high among the accomplishments for which Sixtus IV wished to be remembered. The inscription on his tomb recalls the opening of the library, and a fresco at his Ospedale di S. Spirito shows Sixtus visiting the newly founded library (Lee, 117).

83. Steinmann, 21 and n. 1.

inscribed below it naturally fail to mention that Sixtus IV later replaced an older chapel in the Vatican Palace with the sacral chamber that still bears his name. But the Sistine Chapel, probably Sixtus's most consequential Roman building project, could easily recall the Jewish temple that Nehemiah piously reconstructed in his own Holy City.

The impressive edifice at the background of Botticelli's *Temptations* fresco forms part of Christ's Temptation by High Places (Matthew 4:5). This verse from the traditional Gospel lection of the first Lenten Sunday is customarily illustrated by an image of Jesus and Satan facing one another atop a building.[84] Matthew 4:5 leaves little doubt that the imposing structure at the center of Botticelli's fresco must refer to Solomon's temple.[85] But this painted building, a recognizable example of Roman quattrocento architecture, has been linked as well with Old St. Peter's, which it resembles only generically, and with the Roman Ospedale di S. Spirito, a project dear to the first della Rovere pope.[86] Recently Eunice D. Howe has demonstrated convincingly that the apparent resemblance of the Ospedale to Botticelli's painted facade is tenuous at best.[87] Howe's conclusion makes it possible to suggest that the impressive edifice on the central axis of Botticelli's composition could well refer, symbolically, to the celebrated places of worship created by Nehemiah and by Sixtus IV. Both men, high priests of their respective cults, achieved fame by replacing, or restoring, sacred structures of an earlier age.

The first chapter of II Maccabees—which contains the text that I associate with Botticelli's scene of Jewish sacrifice—records Nehemiah's desire to revive traditional forms of worship among the Jews after their return to Jerusalem from captivity in Babylon. In this endeavor, as well, the Jewish high priest resembles Sixtus IV, who devoutly encouraged a return to hallowed models of Christian antiquity in his own church during the century after the "Babylonian Captivity" at Avignon.[88] Many modern church historians regard the year 1377 as the end of the Avignonese exile.[89] If this date is correct, work was begun on Sixtus IV's new papal chapel in the Vatican Palace precisely one century after the official return of the popes to Rome from their "Babylonian Captivity."

A date of 1477 for the start of work on Pope Sixtus's chapel emerges from the earliest known account of the sacred space, contained in an essay by Sixtus's private secretary, Andreas of Trebizond, that prefaces an earlier edition of Ptolemy's *Almagest.* From Andreas's preface, John Monfasani infers that work on the Sistine Chapel began around 1477,[90] rather than around 1475, the date formerly assigned to the inception of this project.[91] Monfasani's revised dating suggests to me that Sixtus wished to mark the

---

84. Schiller, I, 144.

85. Howe, 209.

86. Ettlinger, 79ff., identifies this building as Old St. Peter's; on this point, see Howe, 212f. Wilde, 70, and Steinmann, 252, identify it as the facade of the Ospedale di S. Spirito. Shearman, 1986, 62, identifies it as the temple of Jerusalem represented by the Ospedale di S. Spirito, noting that one prominent witness to the

sacrifice in Botticelli's fresco is Sixtus IV's nephew, Cardinal Giuliano della Rovere, protector of the Ospedale.

87. Howe, 214–19.

88. See Chapter I, 10.

89. *Concise ODCC,* 44, s.v. "Babylonian Captivity."

90. Monfasani, 11–14.

91. Monfasani, 14.

one-hundredth anniversary of the ending of the modern "Babylonian Captivity"[92] by commissioning a new pontifical chapel in Rome to provide a worthy setting for the celebration of sacred liturgies.[93] By his creation of the Sistine Chapel, Sixtus IV—like Nehemiah—could hope to encourage a return to the purer and more authentic rituals of earlier times in the period following a protracted absence of the faithful from their Holy City.

There can be no question that Sixtus IV and his papal court viewed the ancient Babylonian Captivity of the Jews, and its aftermath, as an Old Testament parallel to the history of the papacy in the fourteenth century.[94] Moreover, the original Babylonian Captivity is a recurrent motif of the Lenten liturgy. Comparison of the Jewish exile in Babylon with Septuagesima, and with the entire Lenten season, can be traced back at least as far as Saint Augustine;[95] and the analogy became a commonplace among later authors.

Amalarius of Metz likens the Lenten season, starting with Septuagesima, to the Babylonian Captivity;[96] and he equates the asceticism and fasting of Lent with the ordeal of the exiled Jews.[97] Some centuries later, Rupert of Deutz again equates Septuagesima and Lent with the seventy years of Jewish exile in Babylon.[98] For Durandus as well, Septuagesima symbolizes the Jewish exile: "Septuagesima ergo tempus iudaice captivitatis repraesentat."[99] Durandus even claims that Orations of the Lenten Sundays recapitulate the period of Jewish exile in Babylon;[100] and he links the ancient Babylonian Captivity with penitence, a prime liturgical theme of Lent. According to Durandus, repentant sinners, like the Jews exiled in Babylon, will be freed from captivity and allowed to enter the heavenly Jerusalem.[101]

Such exegetical commentary helps to explain why Botticelli's *Temptations* fresco might well illustrate the ritual purification performed by Nehemiah after the Jews had returned to Jerusalem from the Babylonian exile. To begin with, the subject could recall the ancient Babylonian Captivity, a well-documented Lenten theme, thus echoing other allusions to the Lenten liturgy that I discern on the Sistine Chapel walls. Moreover, Nehemiah's sacrifice is described in verses associated in the Roman liturgy with the Mass on the Saturday that ends the first full Lenten week; consequently, an

92. The end of the Babylonian or Avignonese Captivity is regularly dated 1377 (*Concise ODCC*, 44f., s.v. "Babylonian Captivity"). On the movements of Pope Gregory XI from Avignon to Rome, see Mollat, 62f. I owe these references to Eugene F. Rice, Jr.

93. D. S. Chambers, "Papal Conclaves and Prophetic Mysteries in the Sistine Chapel," *Journal of the Warburg and Courtauld Institutes*, XLI, 1978, 322, remarks that "Sixtus's new palatine chapel . . . was under way in 1477," attributing this information to John Shearman.

94. *Concise ODCC*, 44, s.v. "Babylonian Captivity": "The expression was used metaphorically of the exile of the popes at Avignon." One polemical aim of II Maccabees is to identify the temple in Jerusalem as the only legitimate sanctuary, despite the devotion of

Egyptian Jews to their temple at Leontopolis (Hastings, *Dictionary*, III, 192, s.v. "Maccabees"). This point would have interested popes of the fifteenth century who, after the return from Avignon, wished to assert that Rome was the only legitimate holy city of Christendom.

95. Augustine, *Contra Faustum*, bk. XII, c. 36, *PL* XLII, 273, cited in Amalarius, *Liber officialis*, 30f.: De Septuagesima.

96. Amalarius, *Liber officialis*, 155.

97. Amalarius, *Liber officialis*, 33.

98. Rupert of Deutz, *Liber de divinis officiis*, 104: Liber Quartus: De Septuagesima.

99. Durandus, 1568, cap. 24, 191r: De dominica septuagesima.

100. Durandus, 1479, fol. 180v.

101. Durandus, 1479, fol. 166v.

image illustrating these verses might logically appear in Botticelli's *Temptations* fresco, in company with scenes that illustrate Matthew 4:1–11, a lesson of the Mass on the opening Sunday of the same Lenten week. In fact, an image of Nehemiah purifying the temple, at the foreground of the *Temptations* fresco, could provide a fitting parallel to the images of Christ rejecting the devil, at the background of the same composition. In addition, an image of Nehemiah's priestly sacrifice could recall the priestly ordinations conferred on the Embertide Saturday that ends the first full Lenten week. Finally, Nehemiah's sacrifice following the Jewish return from Babylon could evoke the popes' return from their "Babylonian Captivity" at Avignon, a relatively recent historical event surely still of great interest to Sixtus IV's papal court.

A small boy with a snake wrapped around one leg appears in the right foreground of Botticelli's *Temptations* fresco, holding an oversized bunch of grapes (Fig. 11).[102] For Ettlinger, both grapes and snake are Christological symbols,[103] employed here as substitutes for Christ, who is unaccountably absent from the foreground of this Christological fresco.[104] Grapes in Renaissance art can be assigned many meanings;[105] but the huge bunch of grapes in Botticelli's composition may be intended to recall two days during the liturgical year on which this fruit was blessed. It was customary to bless grapes on 6 August, feast day of Saint Xystus,[106] also known as Pope Sixtus II, whose papal name was adopted by Sixtus IV. Grapes were also blessed on Holy Thursday, as noted parenthetically in Amalarius's account of the Holy Thursday liturgy: "in this place [during the service], where it is customary to bless the grapes . . ." (In eo loco ubi solemus uvas benedicere . . . ).[107] These liturgical references to the benediction of grapes, which recall both Sixtus IV's name saint, and the Lenten liturgy, may help to account for the large bunch of grapes displayed near the foreground of Botticelli's *Temptations* fresco.

When important ceremonies were held in the Sistine Chapel during Sixtus IV's pontificate, the papal throne was placed beneath Botticelli's *Moses in Egypt and Midian* (Fig. 17).[108] As a result, the first della Rovere pope would often have sat directly across from Botticelli's *Temptations* fresco on the wall opposite. As Steinmann shrewdly observes, the latter composition would, in consequence, be an obvious place in which to pay homage to the founder of the papal chapel.[109] And as I have suggested, Botticelli's composition may depict a sacrifice performed by the high priest Nehemiah, whom the della Rovere pope resembled in many ways. While identification of the Jewish prelate in Botticelli's *Temptations* fresco as Nehemiah remains somewhat speculative, Botti-

102. This figure may be based on the Hellenistic sculpture, *Girl with the Snake*, in the Capitoline Museum, Rome (Steinmann, 468f. and fig. 216).

103. Ettlinger, 88.

104. Ettlinger, 84.

105. Levi D'Ancona, 1977, 166.

106. Jungmann, 1986, II, 260.

107. Amalarius, *De Ecclesia officio*, I, 12, PL cv, 1013A, as cited in Jungmann, 1986, II, 260.

108. Steinmann, 495.

109. Steinmann, 249.

celli's high priest is plainly a papal figure. His headgear, resembling the papal tiara,[110] seems to be trimmed with acorns from the della Rovere coat of arms;[111] and his priestly costume is of della Rovere blue and gold.[112]

If Botticelli's high priest does represent Nehemiah, and if this clerical figure was deliberately identified with the first della Rovere pope, the *Temptations* fresco in the Sistine Chapel may have helped to establish a family precedent. At a later moment, Egidio da Viterbo likened Sixtus IV's papal nephew, Julius II, della Rovere, to another Old Testament prelate named in II Maccabees: the high priest Onias of II Maccabees 3:1–40, another text from Jewish apocrypha that only Christians accept as canonical. Julius II may be represented in the guise of this ancient Jewish prelate in Raphael's *Stanza d'Eliodoro,* another celebrated papal chamber of the Vatican Palace.[113]

110. Paul II, Sixtus IV's immediate predecessor and the first pope to wear the tiara rather than the miter at liturgical functions, knew from Josephus that Jewish high priests had worn the tiara while officiating at the temple in Jerusalem. This suggests that the "tiara" of the high priest in the *Temptations* fresco was meant to evoke the parallel roles of Jerusalem and Rome as sacred cities. This point would have seemed worth making after the decades of Avignonese exile (Stinger, 215 and n. 186).

111. Cartwright, 102. Shearman, 1986, 62, observes that two oak trees stand behind the portrait of Giuliano della Rovere at the left side of the *Temptations* fresco, one pruned to the pattern adopted in the family's coat of arms.

112. Shearman, 1986, 62.

113. Loren Partridge and Randolph Starn, *A Renaissance Likeness: Art and Culture in Raphael's Julius II,* Berkeley, Los Angeles, and London, 1980, 46; Stinger, 218f. and n. 193. On the Heliodorus fresco, Shearman, "The Expulsion of Heliodorus," in *Raffaello a Roma, Il Convegno del 1983,* Rome, 1986, 75–88.

# IV

## THE THIRD AND FOURTH FRESCOES ON THE LONG WALLS

### The *Calling of the First Apostles* and the *Crossing of the Red Sea*

TITULI:
CONGREGATIO POPULI LEGEM EVANGELICAM RECEPTURI
and
CONGREGATIO POPULI A MOISE LEGEM SCRIPTAM ACCEPTURI

### The *Sermon on the Mount* and the *Lawgiving on Mount Sinai*

TITULI:
PROMULGATIO EVANGELICAE LEGIS PER CHRISTUM
and
PROMULGATIO LEGIS SCRIPTE PER MOISEM

The Christological frescoes at the middle of the long north wall in Pope Sixtus's chapel—Ghirlandaio's *Calling of the First Apostles* and Rosselli's *Sermon on the Mount* (Pls. III, IV)—together with the Mosaic frescoes directly opposite—Rosselli's *Crossing of the Red Sea* and his *Lawgiving on Mount Sinai* (Pls. X, XI)—constitute a unified group. Biblical subjects depicted in all four compositions evoke themes of the Roman liturgy during the middle weeks of Lent. For this reason, it makes sense to discuss all four works within a single chapter.

Reference to the shape of the Roman liturgy in the middle weeks of Lent can help to illuminate the meaning of the third and fourth frescoes on each long wall of the Sistine Chapel. None of the Christological frescoes on the Sistine Chapel walls alludes to the second Lenten Sunday, a relatively inconsequential day from the liturgical point of

view.[1] In the early church, this Sunday was frequently "vacant," without liturgy, because it immediately followed the Saturday Vigil Mass of the Lenten Embertide, a service that lasted until dawn on the following day.[2] Medieval service books reflect the vacant character of the second Sunday in Lent,[3] and the printed *Missal of 1474* assigns no Gospel lesson on this day.[4]

By contrast, the third and fourth Lenten Sundays had considerable liturgical significance, for on these days the Apostles' Creed and Lord's Prayer were first communicated to baptismal candidates of the early church.[5] The transmission of these basic Christian texts to early catechumens is commemorated in the Roman liturgy during the middle Lenten weeks,[6] which were once devoted to the instruction of baptismal candidates.[7]

The Apostles' Creed, sometimes called the *symbolum,* or sign of recognition, is a concise authorized statement of faith used throughout the Roman Church.[8] In origin, the Creed is an ancient catechism devised for the instruction of baptismal candidates.[9] In Christian antiquity, the *Credo* was transmitted only by means of the spoken word;[10] catechumens were required to memorize the Apostles' Creed, but were forbidden to write it down.[11] In the primitive church the first transmission of the Creed to the catechumens, the *traditio symboli,* probably took place on the third Sunday of Lent. Some days or perhaps as much as a week later, there followed the *redditio symboli,* when baptismal candidates were asked to repeat the Creed from memory.[12] Finally, catechumens were expected to recite the *symbolum* in public at their baptismal initiation on Easter Eve.[13]

The Lord's Prayer, or *Pater noster,* was always taught to catechumens as it appears in Matthew 6:9–15.[14] Baptismal candidates in the primitive church were probably first taught the *Pater* on the fourth Lenten Sunday.[15] One week later, catechumens were expected to repeat the *Pater* from memory; and they were subsequently required to recite the Lord's Prayer in public at their baptismal initiation on Holy Saturday.[16] Like the Creed, the *Pater* was to be transmitted only by word of mouth[17] and was to be kept secret from the uninitiate.[18] Hence, Saint Ambrose's warning to catechumens: "Beware lest you inadvertently reveal the mystery of the Lord's Prayer and Apostles' Creed."[19] Tremendous prestige attached to the *Pater* because Jesus himself had taught the prayer to his followers during his Sermon on the Mount. As Augustine comments in a Lenten homily directed at catechumens, "the prayer which you receive today to be

1. Jungmann, 1959, 260.

2. Jungmann, 1959, 271ff.; Callewaert, 1940 (1), 488.

3. Durandus, 1479, fol. 177r; see also Callewaert, 1940 (1), 488.

4. Lippe, 1, 70f.

5. Jungmann, 1959, 258; Cabrol, 112.

6. Béraudy, "L'Initiation chrétienne," in Martimort, 526.

7. Chavasse, "Le cycle pascal," in Martimort, 705.

8. Jungmann, 1959, 96.

9. Jungmann, 1959, 78.

10. Augustine (Sermon 212:2) cautioned the catechumens of his day, "Nec, ut verba symboli perdiscere,

nec, cum didiceritis scribere, sed memoria semper tenere atque recolere" (cited by Righetti, 1, 188).

11. Righetti, 1, 188.

12. Cabrol, 112.

13. Augustine, *Pâque,* 26 n. 2.

14. Cabrol, 88f.

15. Jungmann, 1959, 258.

16. Amalarius, *Liber officialis,* 122; Righetti, 1, 178.

17. Righetti, 1, 188.

18. Righetti, 1, 178f.

19. "Cave ne, incaute, symboli vel dominicae orationis divulges mysteris," Ambrose, *De Cain,* XI, 35, as cited by Righetti, 1, 179.

learned by heart and to be repeated eight days hence was dictated (as you heard when the Gospel was being read) by the Lord himself to his disciples."[20]

Biblical passages associated with the transmission of the *Credo* and *Pater noster* to early catechumens originally formed part of the Roman liturgy on the third and fourth Lenten Sundays. But these lections were soon shifted over to certain weekdays at the middle of Lent.[21] Some of the lessons in question were transferred to Wednesday of the fourth Lenten week and are listed on this day in such service books as the *Missal of 1474.*[22] This prestigious Wednesday service is regularly assigned not one, but two Old Testament lessons.[23] According to the *Ordo Romanus antiquus,*[24] the service on this Wednesday begins with a reading of the preface to the Creed; next the *Credo* itself is recited, and its importance explained.[25] John 9:35–38, a Gospel lesson often assigned to this Wednesday, evokes the first communication of the *Credo* to baptismal candidates, for the passage begins with the query, "Dost thou believe on the Son of God?" and it ends with the affirmation, "Lord, I believe."[26] At the important Wednesday service in the fourth full week of Lent baptismal candidates were also taught the Lord's Prayer, as Durandus of Mende records.[27]

Ghirlandaio's *Calling of the First Apostles* (Pl. III),[28] the third fresco on the long north wall, illustrates Matthew 4:18–22, verses that describe the moment when Jesus first called Peter and Andrew, and then James and John, to follow him. Ghirlandaio portrays these momentous events within a landscape dominated by a spacious lake ringed with hills. Near the background of the composition, at the left side, the brother disciples Peter and Andrew, who were the first apostles called by Christ, are seen fishing on the lake; a net in their boat refers to Matthew 4:18. Near the background of the fresco, at the right side, Ghirlandaio shows Jesus summoning a second pair of brother apostles, James and John (Matthew 4:21–22); a third man shown fishing from their boat must be Zebedee, their father, named by Matthew in this passage. The primary scene in Ghirlandaio's fresco, an illustration of Matthew 4:20, occupies the center of the composition, near the foreground (Fig. 18). Here, Peter and Andrew, portrayed as large and imposing figures, kneel reverently before Jesus on the near shore of the lake. In this part of the composition, Jesus' first two disciples have covered their simple work clothes with more elegant cloaks, in honor of the important occasion.

The Calling of the First Apostles is rarely represented in Christian art.[29] But the

20. Augustine, *Sermons*, 288: sermon IX.

21. For a detailed discussion of these changes, see Chavasse, "Le cycle pascal," in Martimort, 704ff.

22. Lippe, I, 106.

23. Callewaert, 1940 (I), 492; both Amalarius (*Liber officialis*, 54) and the *Missal of 1474* (Lippe, I, 105) assign two Old Testament lessons on this day.

24. *Ordo Romanus I*, 31ff.

25. *Ordo Romanus I*, 38f., "Haec summa est . . . fide nostrae."

26. Durandus, 1479, fol. 184r.

27. Durandus, 1568, 209r.

28. A work probably executed by Ghirlandaio with the help of his workshop (Bernabei, 45).

29. The Calling of Peter and Andrew and the Calling of James and John are illustrated in a single zone of one miniature in the ninth-century manuscript of the *Homilies of Gregory of Nazianzus*, Paris, Bibl. Nat., MS Grec., 510, fol. 87v. (Sirarpie der Nersessian, "The Illustrations of the Homilies of Gregory of Nazianzus: Paris Gr. 510; A Study of the Connections between Text and Images," *Dumbarton Oaks Papers*, XVI, 1962, fig. 1). See also Schiller, 155, for the pairing of the two callings.

event is crucial in establishing that Saint Peter, founder of the Roman Church, was the first disciple called by Jesus.[30] In consequence, it is easy to understand why the unusual subject should be illustrated on a monumental scale in the primary Roman chapel of the popes, who are Saint Peter's heirs.

In addition, Ghirlandaio's *Calling of the First Apostles* could serve to recall the opening verses of the Apostles' Creed. From an early date, each article of the *Credo* was traditionally ascribed to one of the twelve disciples.[31] While the attribution of specific articles to particular apostles seems to have varied, the first four articles of the Creed are most often credited to the very individuals portrayed in Ghirlandaio's fresco: Peter, Andrew, James, and John.[32]

Moreover, Ghirlandaio's *Calling of the First Apostles* could recall heated controversies about the correct form of the Apostles' Creed that took place around the middle of the fifteenth century. A key issue at the Church Council of Florence, Ferrara, and Rome, which ended in August 1445, concerned the advisability of making additions to the Creed. By this date, the Latin Church had already introduced at least one crucial change; while the Greek Church wished to retain the hallowed ancient *Credo* intact.[33]

Liturgically speaking, Ghirlandaio's *Calling of the First Apostles,* the third fresco on the north wall of the Sistine Chapel, could serve to recall the initial communication of the Apostles' Creed to early catechumens on the third Lenten Sunday. Ghirlandaio's fresco, at the middle of the north wall, could also evoke a call to the faithful that was issued during the middle of Lent. As medieval service books record, candidates eligible for baptism on the approaching Holy Saturday were expected to commit themselves formally to this course on Wednesday of the fourth Lenten week.[34] The *Ordo Romanus antiquus* preserves the injunction: "On the fourth feria [Wednesday] of the fourth week in Lent let those who are to be baptized [at Easter] have their names inscribed."[35] Matthew 4:18–21, the passage illustrated in Ghirlandaio's *Calling of the First Apostles,* is not assigned in the Roman liturgy during the middle Lenten weeks. But Ghirlandaio's fresco, which represents Jesus calling his first four apostles from the water, evokes both the first transmission of the Apostles' Creed to early baptismal candidates on the third Lenten Sunday, and the calling of catechumens on Wednesday of the fourth Lenten week to enroll for their baptism at Easter.

Even the *titulus* over the *Calling of the First Apostles* suggests that Ghirlandaio's fresco was intended to evoke the first communication of the *Credo* to early catechumens at the middle of Lent. The superscription, CONGREGATIO POPULI LEGEM EVANGELICAM RECEPTURI, does not refer directly to events portrayed in the composition below. Rather, the legend speaks of the future acceptance, or reception, of the evangelical law by the congregation of the people, not merely by the disciples represented in

30. Ettlinger, 90.

31. C. F. Bühler, "The Apostles and the Creed," *Speculum,* XXVIII, 1953, 335.

32. Bühler, "The Apostles and the Creed," 336.

33. Joseph Gill, *The Council of Florence,* Cambridge, 1959, 10, 13, 153. It would have seemed crucial to stress the apostolic origins of the Creed in the decora-tion of the Sistine Chapel because Lorenzo Valla (1406–57) had recently cast doubt on the authenticity of the *Credo* by demonstrating that it could not be a product of the Apostolic Age (Stinger, 251f.).

34. Amalarius, *Liber officialis,* 55.

35. *Ordo Romanus 1,* 31; the same point is made by Rupert of Deutz, *Liber de divinis officiis,* 134ff.

Ghirlandaio's composition. The future tense employed in this superscription—and in the *titulus* above the Moses fresco directly opposite—is exceptional; all other superscriptions now visible on the Sistine Chapel walls are couched in the present tense. The future verb forms employed in these two *tituli* have yet to be properly explained,[36] but I suspect that they reflect the system by which the *Credo* was communicated to baptismal candidates of the early church.

The subject of Ghirlandaio's *Calling of the First Apostles* evokes the middle of Lent, when catechumens were first taught the Apostles' Creed and enrolled for baptism; but the future tense of the accompanying *titulus* evokes the end of Lent, when catechumens were expected to repeat this basic Christian text in public during their baptismal initiation on Holy Saturday. At the middle of Lent, when catechumens first learned the *Credo* and first enrolled for baptism, their official reception of Christ's law lay in the future. The future verb form in the *titulus* over Ghirlandaio's *Calling of the First Apostles* appears to echo this situation.

The inscription CONGREGATIO POPULI LEGEM EVANGELICAM RECEPTURI should perhaps be considered in conjunction with the *titulus* over Rosselli's *Last Supper* (Pl. VI), REPLICATIO LEGIS EVANGELICAE A CHRISTO. The legend above Ghirlandaio's fresco, located at the middle of the north wall, seems to predict the acceptance of the *Credo* by early baptismal candidates on Easter Eve. And the legend above Rosselli's fresco, located at the altar end of the north wall, apparently alludes to the Mass on Easter Eve at which early baptismal candidates repeated the *Credo* in public, thus formally accepting the evangelical law.

The *titulus* over Rosselli's *Crossing of the Red Sea* (Pl. X), located on the long south wall of the Sistine Chapel, directly across from Ghirlandaio's *Calling of the First Apostles*, is also couched in the future tense. The inscription accompanying Rosselli's *Red Sea* fresco, CONGREGATIO POPULI A MOISE LEGEM SCRIPTAM ACCEPTURI, predicts that the congregation of the people will receive the written law from Moses at a future time. This *titulus* has little connection with events portrayed in the composition below, and should probably be considered in conjunction with the *titulus* accompanying the final fresco on the long south wall, Rosselli's *Last Testament of Moses* (Pl. XIII); the legend above the latter fresco, REPLICATIO LEGIS SCRIPTAM A MOISE, uses the present tense in alluding to revelation of the written law. Rosselli's *Last Testament of Moses* seems to illustrate the accompanying *titulus*, for one scene in the fresco shows the Jews listening raptly as they accept the written law that their aged leader reads from a massive volume of Holy Writ (Pl. XIII). This occasion is described in a traditional Old Testament lesson of Holy Saturday, Deuteronomy 31:22–30.[37]

Parallel wording in the *tituli* that accompany the *Calling of the First Apostles* (Pl. III) and the *Crossing of the Red Sea* (Pl. X) indicates that the juxtaposed frescoes should be interpreted in a parallel vein. But the paired *tituli* also draw a distinction between the law of Christ and the law of Moses, well known from Early Christian exegesis. Am-

36. Redig de Campos, 1970, 308.

37. See Chapter VI, 87.

brose, for example, approvingly cites John 1:17, "The law was given by Moses, but truth and grace were brought by Jesus Christ";[38] Augustine quotes II Corinthians 3:6, "The letter kills, but the spirit giveth life";[39] and Leo the Great, citing Romans 7:6, contrasts the ancient law of the letter with the new law inspired by the spirit. The latter comparison figures in one of Leo's Lenten sermons,[40] suggesting that the distinction between the letter and spirit of the law may be a Lenten theme.

Similar sentiments are voiced in Renaissance Rome. A sermon preached by Timotheis de Totis at a "papal chapel" during the later quattrocento observes that "grace is in the New Law, not written on tablets of stone, but infused in our souls."[41] At about the same time, Giovanni Pico della Mirandola asserts that God commanded Moses not only to commit the law itself to writing, but also to keep alive a mysterious unwritten explanation of the law, to be transmitted solely by word of mouth.[42] The prestige that Renaissance humanists assign to the unwritten law, and to arcane interpretations of the law, recalls the enthusiasm for recondite visual imagery expressed in Paolo Cortesi's *De Cardinalatu* (1510). As made clear by Kathleen Weil-Garris and John D'Amico, Cortesi, a curial humanist at the papal court, believes that religious paintings with veiled meanings can confer moral and spiritual benefits on those who make the effort required to decipher them.[43] The reverence for the unwritten law expressed in the juxtaposed inscriptions over the *Calling of the First Apostles* and the *Crossing of the Red Sea*—and in other paired *tituli* on the Sistine Chapel walls—may echo the high value placed on the esoteric by humanists in Renaissance Rome.

Although the *tituli* above the *Calling of the First Apostles* and the *Crossing of the Red Sea* are parallel in grammatical construction, the frescoes they accompany seem at first to form an unlikely pair.[44] In traditional exegesis, the Crossing of the Red Sea, Exodus 13:5–15:2, is most often coupled with Christ's baptism;[45] but in Pope Sixtus's chapel, the *Baptism of Christ* is paired with the *Circumcision of Moses' Son* (Pls. I, VIII), a juxtaposition evidently inspired at least in part by liturgical considerations.[46]

While correspondences between the *Crossing of the Red Sea* (Pl. III) and the *Calling of the First Apostles* (Pl. X) may not be immediately evident,[47] the watery setting of both frescoes evokes the middle weeks of Lent, when repeated allusions to baptism figure in the Roman liturgy. From the time of the early church, it was customary to read the biblical account of the passage through the Red Sea on Easter Eve, to underscore the typological link between the Old Testament miracle and the baptismal initiation of catechumens on Holy Saturday. (The familiar comparison appears, for example, in Amalarius's *Liber officialis*.)[48] But liturgical passages containing both overt and veiled

38. Ambrose, *Sacraments*, 123; Leo, *Sermons III*, 18.
39. Augustine, *Pâque*, 321 and n. 2.
40. Leo, *Sermons II*, 132.
41. O'Malley, 1979, 149 and n. 86.
42. Trinkaus, II, 756.
43. Weil-Garris–D'Amico, 93 n. 109.
44. Sauer, cited in Salvini–Camesasca, 48 n. 56, explains the parallel between the *Crossing of the Red Sea* and the *Calling of the First Apostles* in this way: on the one side,

the destruction of the enemies in the sea; on the other, the calling of the advocates of faith from the sea.
45. Ettlinger, 3.
46. See Chapter II, 26.
47. Ettlinger, 64; Goffen, 247.
48. Amalarius, *Liber officialis*, 156. Augustine also makes the point that, "as all our enemies died in the Red Sea, so all our sins die in Baptism" (Brenk, 1975, 126 n. 124, for the citation).

allusions to the salvation of the Jews after passing through the Red Sea waters are regularly assigned as well to the middle Lenten weeks, when catechumens first enrolled for baptism.

During the third and fourth weeks of Lent, medieval service books list various texts that refer directly to the Crossing of the Red Sea. On the fourth Lenten Sunday, Durandus of Mende assigns "a reading from Exodus in which the Lord, seeing the suffering of his people . . . frees them from the hand of Pharaoh." According to Durandus, this passage demonstrates that "one escapes from the enslavement of the devil by means of baptism . . . signified by the Red Sea."[49] On the same Sunday, a twelfth-century Milanese *Lectionary* specifies a reading from Exodus 14:15–31, which describes how the Red Sea parted before Moses.[50] Even Responsories assigned to this Sunday Mass in the modern Roman *Breviary* evoke the Crossing of the Red Sea: "Transtulisti illos per Mare Rubrum et transvexisti eos per aquam nimiam"; and, "In columna nubis doctor eorum fuisti."[51] (John 6:1–5, the Gospel lesson assigned to the same Lenten Sunday in a thirteenth-century *Ordinal* of the papal court, also alludes to the crossing of a body of water—in this case the Sea of Galilee.)[52] Further Old Testament verses recalling the exit of the Jews from Egypt after their safe journey through the Red Sea waters are assigned on Tuesday in the fourth Lenten week; Exodus 32:7–12, listed as the Epistle on this day in the printed *Missal of 1474*,[53] evokes the final departure of the Israelites from Egyptian soil.

Symbolic references to baptism also figure in the Roman liturgy during the third and fourth weeks of Lent. On Friday of the third full Lenten week, for example, the Epistle, Numbers 20:1–13, tells of Moses striking water from a rock; and the Gospel lesson, John 4:5–42, records Jesus' encounter with the Woman of Samaria at the well. On Saturday of this week, the Epistle, from Daniel 13, describes the Bath of Susanna, a figure of baptism from the third century onward.[54] Additional watery themes are plentiful in liturgical readings of the fourth Lenten week. Amalarius of Metz, who assigns John 9:1–38, the Miracle of the Man Born Blind, to the Sunday that opens the week, repeats Augustine's baptismal interpretation of the text: "Lavit ergo oculos in ea piscina quae interpretatus Missus; . . . baptizavit tunc illuminavit."[55] On the Saturday that ends the fourth Lenten week, the Introit of the Mass, Isaiah 55:1–2, opens with the phrase, "Come to the waters"; according to Durandus, this signifies, "Come to the waters of Baptism."[56] Watery themes of the Roman liturgy during the middle weeks in

49. Durandus, 1479, fol. 180v. Starting in the tenth century, a golden rose was presented by the reigning pope on this Sunday to Ss. Croce in Gerusalemme, the stational church of the day (Righetti, II, 133f.). For Durandus, 1479, fol. 181v, this rose symbolizes the joy of the Jews contemplating their return to Jerusalem after release from captivity in Babylon. His explanation provides another instance of a symbolic connection between the Babylonian Captivity and the liturgy and rituals of Lent.

50. *DACL*, v, 1, col. 292, s.v. "Epitres": Dom. IV in Quadragesima, Exodus 14:15–31. Rosselli's *Crossing of*

*the Red Sea* may thus provide a link between a fresco in the Mosaic cycle of the Sistine Chapel and the liturgy of a Sunday that falls between Christmas and Pentecost.

51. *BR*, 292.

52. Van Dijk, 1975, 201.

53. Lippe, I, 103f.

54. Jungmann, 1959, 258.

55. Amalarius, *Liber officialis*, 54; Augustine, *In Ioannem evangelium tractatus XLIV*, PL XXXV, 1714. *BR*, 293: Dom. IV in Quadragesima.

56. Durandus, 1479, fol. 184v.

Lent are reflected in Rosselli's *Crossing of the Red Sea,* located at the middle of the long south wall of the Sistine Chapel because Rosselli's composition depicts the best-known Old Testament prototype of Christian baptism.

The watery death that overtook Pharaoh's army is depicted at the center of Rosselli's *Crossing of the Red Sea* (Fig. 20); but the Book of Exodus does not record the violent storm shown raging above the drowning Egyptians. This part of Rosselli's composition may depend upon Petrus Comestor's account of the destruction of Pharaoh's army in the *Historia Scholastica,*[57] or possibly upon Josephus's gloss on Exodus 14:23 in his *Jewish Antiquities:*[58] "When . . . the army of the Egyptians was within it, back poured the sea, enveloping, and with sweeping windswept billows, descending upon the Egyptians; rain fell in torrents from heaven, crashing thunder accompanied the flash of lightning . . . a night of gloom and darkness overwhelmed them."[59] Perhaps Rosselli, or one of his advisers, chose to illustrate the extrascriptural storm in order to contrast the murky heavens above the Old Testament "Baptism" scene with the sunlit sky beneath which Jesus calls his first disciples from the water in the Christological fresco opposite.

While much of Rosselli's *Red Sea* fresco is occupied by the Egyptians' watery destruction,[60] an occasion of Jewish triumph is portrayed at the left side of the composition, in the foreground. This subsidiary scene, illustrating the Canticle of Moses (Exodus 15:1–21), shows the Jews rejoicing over their safe passage through the water (Fig. 19). Here, Moses, a mature, bearded man grasping his staff of leadership, and his sister Miriam, a young woman holding a stringed musical instrument, are shown leading the Israelites in a hymn of thanks to God for their deliverance. The scene directly echoes the Roman liturgy at the middle of Lent: in the modern Roman *Breviary,* a part of Moses' song, "Cantemus domino: gloriose enim honorificatus et equus et ascensorem projecit in mare . . . ," serves as a Responsory on Thursday of the fourth Lenten week.[61] Clearly, the biblical song of Thanksgiving could be interpreted in a baptismal sense: the Israelites rejoice at their salvation after passing through the water. Consequently, the scene of Jewish jubilation in Rosselli's *Red Sea* fresco recalls baptismal themes of the Roman liturgy at the middle of Lent.

Another subsidiary scene is tucked into the upper right-hand corner of Rosselli's *Red Sea* fresco (Fig. 21). There, a gray-haired individual, enthroned beneath a baldachin, is shown conferring with some men outside a city gate. For Samuel Ball Platner, this image represents Pharaoh deliberating with his council before the Jews' departure from Egypt;[62] but Platner's interpretation did not convince Steinmann. He argues instead that Pharaoh should not be identified with the enthroned ruler in this scene, a white-

---

57. Ettlinger, 64 and n. 1.

58. Josephus was well known at Sixtus's court: in 1475, Platina published an edition of the *Jewish War,* which he evidently intended to supplement with an edition of the *Jewish Antiquities* (Lee, 113).

59. Josephus, *Antiquities I–IV,* bk. II, chap. 3, 315. The translator notes, "For these added details [about the storm] cf. Psalm 77:16–20, which describes a severe thunderstorm at sea."

60. This is also the case at S. Maria Maggiore, Rome (Brenk, 1975, 84ff., fig. 51). Ettlinger, 44 n. 2, cites instances of large-scale representations of the Crossing of the Red Sea that appear within an Old Testament cycle of smaller pictures, starting from the Early Christian era.

61. *BR,* 301: Feria Quinta Infra Hebdomadum IV.

62. Steinmann, 435 n. 1.

haired, elderly man, but rather with the crowned horseman half-submerged near the foreground of the composition, whom Steinmann describes as a younger-looking man with dark hair (Fig. 20).[63] Recent cleaning has revealed that the impressive military rider near the foreground of the *Red Sea* fresco actually has gray hair. This suggests that both the regal horseman near the foreground of the fresco and the enthroned ruler at the background may represent Pharaoh, in another return to the "continuous narration" of Early Christian art. If this is the case, the enigmatic scene at the upper right-hand corner of Rosselli's fresco may portray Moses urging Pharaoh to let the Jews leave Egypt; this biblical episode is characterized as a type of Lent by Sicard of Cremona.[64]

As Evelyn M. Cohen has suggested to me, the half-submerged rider in elaborate armor near the foreground of Rosselli's *Red Sea* fresco may illustrate a Jewish legend. This asserts that Pharaoh did not actually drown in the Red Sea waters because, at the very moment of death, he recited the words from Exodus 15:11: "Who is like unto thee, O Lord, among the gods? Who is like thee in holiness, fearful in praise, doing wonders?" Bezalel Narkiss points out that this explanation is found in a Midrash by the eighth century.[65] According to the legendary tale, Pharaoh was taken down to the depths of the sea and kept there until he acknowledged God's power; moreover, Pharaoh is still alive and he stands at the gates of hell, warning other rulers to follow his example and acknowledge their belief in the one God.[66] Miniatures depicting the rescued Pharaoh appear in Hebrew manuscripts of the Haggadah, the Passover service that commemorates the deliverance of the Jews from Egypt and their safe passage through the Red Sea; images of this sort are known from Haggadoth of the second half of the fifteenth century, approximately contemporary with Rosselli's *Red Sea* fresco.[67]

The crowned horseman in the *Red Sea* fresco may be receiving spiritual illumination in accord with the Jewish legend, for both he and his horse are well lit by rays of light that emanate from heaven (Fig. 20). Moreover, the royal rider's mouth is opened wide, perhaps to identify him as Pharaoh proclaiming the verse from Exodus 15 that begins, "Who is like unto thee, O Lord." An image of Pharaoh's salvation after his immersion in the Red Sea waters would accord with the baptismal imagery that pervades Rosselli's *Red Sea* fresco, and the artist may have known some early images of the legendary episode. Narkiss identifies the subject on the wooden doors of S. Sabina and in the nave mosaics of S. Maria Maggiore,[68] two revered Early Christian monuments that Rosselli could well have inspected while working in Rome on the Sistine Chapel. These examples of late-antique date suggest that Christians were familiar with the Jewish legend from an early moment, even though none of the fathers records this interpretation.[69]

In keeping with the future tense of the *titulus* over the *Red Sea* fresco, liturgical texts and rituals associated with the very end of Lent are evoked by three elements in

---

63. Steinmann, 435 n. 1.

64. Sicard of Cremona, *Mitrale*, 361.

65. Narkiss, 10. I owe this reference to Evelyn M. Cohen.

66. Narkiss, 10.

67. Narkiss, 10.

68. Narkiss, 11.

69. Narkiss, 12.

Rosselli's composition: the reddish sea water, the pillar of fire, and the scene of Jewish thanksgiving.

The rosy water in Rosselli's *Red Sea* fresco recalls traditional comparisons of the Red Sea with the mixture of blood and water that flowed from Christ's body during the Crucifixion. Rupert of Deutz, for example, draws this analogy in his *Liber de divinis officiis*.[70] Sixtus IV, whose *De sanguine Christi* contains a lengthy discussion of the status of the blood shed by Christ on the Cross, was probably familiar with the well-known comparison.[71] Based on the traditional analogy, the reddish water in Rosselli's *Red Sea* fresco could serve to recall the Good Friday service commemorating the Crucifixion.

The biblical pillar of fire that guided the Jews out of Egypt hovers in the sky above the drowning Egyptians on the central axis of Rosselli's *Red Sea* fresco (Pl. X); following a well-known convention, this pillar has the form of a classical column.[72] Both Amalarius of Metz and Rupert of Deutz identify the biblical column of fire with the paschal candle, customarily blessed at the Mass on Holy Saturday;[73] and one later exegete likens the scriptural pillar of fire to the paschal candle, which guides catechumens in their passage through the Red Sea of baptism to the promised land.[74] In the light of such explanations, the pillar of fire in Rosselli's *Red Sea* fresco could serve to recall liturgical texts that relate to the benediction of the paschal candle on Easter Eve.

"Moses and Miriam Leading the Hebrews in Song," the scene at the lower left-hand corner of Rosselli's *Red Sea* fresco (Fig. 19), may provide a further reference to the Holy Saturday liturgy, for Exodus 15:1–21, Moses' hymn of thanks for the safe passage of the Jews through the Red Sea, is traditionally read at the baptismal Mass on this day. Rupert of Deutz, among others, records this practice.[75]

All of the proleptic elements in Rosselli's composition cited above recall forward-looking occasions commemorated in the Roman liturgy during the third and fourth Lenten weeks. These occasions include the inscription of catechumens at the middle of Lent for their baptismal initiation on Holy Saturday, at the end of Lent; and the first transmission of the *Credo* and *Pater noster* to catechumens at the middle of Lent, in preparation for their public repetition of these primary Christian texts on Easter Eve, at the end of Lent.

Christ's Sermon on the Mount, Matthew 5:1–7:29, is the most consequential subject depicted in the fourth Christological fresco on the long north wall of Pope Sixtus's chapel. Jesus is seen preaching his celebrated sermon at the left foreground of Rosselli's *Sermon on the Mount* (Pl. IV), while three additional events are portrayed on the right side of the composition: in the background, Jesus prays on a hilltop beside a church; in the middleground, he descends the mountain with some nimbed followers; and in the right foreground, he heals a leper. The images of Jesus descending the mountain with his nimbed disciples, and preaching to the crowd from a grassy knoll, may reflect a late-

---

70. Rupert of Deutz, *Liber de divinis officiis*, 199.
71. Ettlinger, 83f.
72. Ettlinger, 64 and n. 2.
73. Amalarius, *Liber officialis*, 111: De Cereo benedicendo (on Holy Saturday); Rupert of Deutz, *Liber de divinis officiis*, 212: Quid cereus significet.
74. Cancellieri, 1818, 165ff.
75. Rupert of Deutz, *Liber de divinis officiis*, 230.

medieval Italian tradition; a similar illustration of Christ's Sermon on the Mount appears in the Italian manuscript of Pseudo-Bonaventure's *Meditations on the Life of Christ*. [76]

As the Sermon on the Mount is only rarely depicted in Christian art, [77] the episode must figure on the Sistine Chapel walls for some particular purpose. To begin with, Rosselli's *Sermon on the Mount* could recall the importance of preaching throughout Lent. More specifically, the prime subject of Rosselli's fresco could evoke the initial transmission of the Lord's Prayer to baptismal candidates, because Jesus first communicated the prayer to his followers during the Sermon on the Mount. [78] The first transmission of the Lord's Prayer to the catechumens in the middle weeks of Lent is commemorated in a set of Ambrosian pericopes dating from the twelfth century, which assign part of the Lord's Prayer, Matthew 6:9–13, to Monday of the third Lenten week. [79] In addition, one distinguished modern liturgist connects the first transmission of the *Pater* to early catechumens with the Gospel lesson of Saturday in the fourth Lenten week, John 8:12–20. [80]

Even the inscription over Rosselli's *Sermon on the Mount*, PROMULGATIO EVANGELICAE LEGIS PER CHRISTUM, seems to evoke the transmission of the *Pater* to early catechumens at the middle of Lent. While the *titulus* in question may simply allude to rules of conduct promulgated throughout the Sermon on the Mount, it may refer more specifically to the evangelical law transmitted by Jesus to his followers in the form of the Lord's Prayer during his celebrated sermon.

Christ's cure of a leper is the subject of the foremost subsidiary scene in Rosselli's *Sermon on the Mount*. It is customary to identify this image with the miraculous cure recorded in Matthew 8:3, the verse immediately following Matthew's account of Jesus' celebrated sermon. [81] But it is not altogether certain why this should be the only one of Jesus' healing miracles represented on the Sistine Chapel walls. [82] The mystery may be clarified by turning once more to the Roman liturgy at the middle of Lent. References to lepers figure in scriptural lessons of Monday in the third Lenten week. The Epistle on this day, IV Kings 5:1–5, [83] records the history of Naaman, a Syrian prince who suffered from leprosy. According to the Bible, the prophet Elijah advised Naaman that his disease could be cured by bathing in the Jordan River, but the skeptical Naaman tried at first to heal himself by bathing in other waters. Eventually, however, Naaman

76. Ragusa–Green, 155, fig. 137.

77. Ettlinger, 89; Schiller, 156.

78. Durandus, 1568, 209r.

79. *DACL*, v, 1, col. 874, no. 60, s.v. "Epitres."

80. Chavasse, "Le cycle pascal," in Martimort, 705; this lection is listed on this Saturday in the printed *Missal of 1474* (Lippe, 1, 114).

81. Steinmann, 236.

82. Juxtaposition of the Healing of the Leper with the Sermon on the Mount may be traditional. These subjects appear side by side in a miniature from an eleventh-century Catalonian manuscript, the *Ripoll Bible*, Vat. lat. 5729, fol. 367r. On this, see Wilhelm Neuss, *Die katalanische Bibelillustration um die Wende des* *ersten Jahrtausends und die altspanische Buchmalerei*, Bonn, Leipzig, 1922, pl. 49. This miniature is divided into six horizontal zones. The three compartments of the topmost zone depict the Three Temptations. In the three compartments of the next zone down are: the Calling of Two Apostles; the Sermon on the Mount; the Healing of the Leper. The same six subjects appear in this order on the north wall of the Sistine Chapel, which may indicate some contact with a model resembling this miniature. The model may have been the *Ripoll Bible* itself, if the manuscript had entered the papal library by Sixtus IV's pontificate.

83. Jungmann, 1959, 258.

took the prophet's advice and cleansed himself in the Jordan. Luke 4:22–30, the Gospel lection customarily assigned to this same Monday—for example, in the printed *Missal of 1474*—refers again to Naaman's cure: "And there were many lepers in Israel in the time of Eliseus, and none of them was cleansed but Naaman the Syrian" (Luke 4:27).[84] Even the Roman station on this Monday, the church of S. Marco, evokes the theme of leprosy, for old lives of Saint Mark credit him with the power to cure lepers.[85] Leprosy is a well-known symbol of sin among patristic authors,[86] and Naaman the Syrian became an important Old Testament exemplar of the efficacy of baptism in washing sin away.[87] Rosselli's "Healing of the Leper" thus recalls the familiar analogy between the cure of lepers and the eradication of sin by baptism, cited in the Roman liturgy during the third Lenten week.

The "Healing of the Leper" in Rosselli's *Sermon on the Mount* (Pl. IV) plainly alludes, by implication, to the theme of purification, a fundamental purpose of Lent. In addition, the healing scene looks forward to a central motif of the adjacent fresco, the fifth on the north wall, Perugino's *Gift of the Keys* (Pl. V). Christ's consignment of the apostolic keys to Peter, the primary subject of Perugino's celebrated composition, was of vital importance for the Roman Church, whose priests inherit from Peter the power that came with the keys: that is, the ability to bind and loose. This is customarily interpreted as the capacity to judge sinners and to absolve them after penance. A celebrated reference to this priestly power is found in Matthew 18:15–22, assigned to Tuesday of the third Lenten week in the *Missal of 1474*:[88] "Whatsoever ye shall bind on earth shall be bound in heaven; and whatsoever ye shall loose on earth shall be loosed in heaven" (Matthew 18:18). Exegetes regularly compare the power of Christian priests to "bind and loose" with the capacity of Old Testament priests to distinguish those afflicted with leprosy from those who have been cured.[89] Thus, the Cure of the Leper may be the only one of Christ's miracles to be depicted in Pope Sixtus's chapel because the healing miracle could recall the familiar analogy between the crucial power of Roman priests to "bind and loose" sinners and the capacity of their Old Testament counterparts to distinguish between lepers and those no longer afflicted by the disease.

The legend over Rosselli's *Sermon on the Mount* (Pl. IV),[90] PROMULGATIO EVANGELICAE LEGIS PER CHRISTUM, is echoed in the superscription of the Moses fresco directly across the chapel, Rosselli's *Lawgiving on Mount Sinai* (Pl. XI).[91] The *titulus* above the latter

---

84. Lippe, I, 86.

85. Grisar, *Das Missale im Lichte Römischer Stadtgeschichte,* 32. The healing theme recurs in the liturgy on Thursday of the third week of Lent when the Gospel is Luke 4:38–44, the Cure of Peter's Mother-in-Law, and the stational church is dedicated to Cosmas and Damian, who were doctors (Durandus, 1479, fol. 179v).

86. Anciaux, 169.

87. Lundberg, 17 n. 1.

88. Lippe, I, 89; *MR,* 96: Feria tertia post dominicam III in Quadragesima.

89. Shearman, 1972, 49.

90. Probably executed with the help of Rosselli's workshop (Bernabei, 48).

91. In the Sistine Chapel, the *Sermon on the Mount* is painted directly above the *cantoria* or singers' gallery, which was called a *pulpitum;* the possible significance of this conjunction may be related to Pope Innocent III's understanding of the pulpit as a symbol of those eminences from which divine messages, such as the Sermon on the Mount, were delivered (Shearman, 1986, 35).

fresco appropriately reads, PROMULGATIO LEGIS SCRIPTE PER MOISEM, for the Lawgiving on Sinai is the primary subject in the composition below. As Steinmann points out, this key episode in Moses' life is already coupled with the Sermon on the Mount in a *titulus* of Early Christian date: "Moses ascendit in montem; Christus in monte docet."[92]

The Bible records more than one occasion on which the Lord communed with Moses on Mount Sinai for the purpose of establishing the law; but Rosselli has evidently illustrated some events reported in Exodus 24:12–34:35.[93] The most crucial episode occupies the center of Rosselli's fresco; there, Moses kneels before the Lord atop Mount Sinai while receiving the tablets that bear God's commandments (Exodus 31:18). Early exegetes see a parallel between the forty days that Moses spent on Sinai and the forty days of Lenten fasting;[94] hence, the central lawgiving scene in Rosselli's fresco may symbolize all of Lent. An image of Moses Receiving and Expounding the Law illustrates Psalm 90, the most characteristic Lenten psalm, in the *Theodore Psalter*, a Constantinopolitan manuscript dated 1066 (London, B.L. 19, 352, fol. 193v).[95] This conjunction of text and image in the Byzantine Psalter suggests that Moses' reception of the law on Sinai was viewed as a Lenten subject.

At the center of Rosselli's *Lawgiving* fresco, a young man sleeps in a cave on the mountainside. While such figures are rare in Lawgiving scenes,[96] the sleeping youth may represent Joshua,[97] whose role during the Lawgiving on Sinai is unclear. Although Exodus 24:13 reports that Joshua accompanied Moses to the mountain, the verse fails to mention Joshua's sleep.[98] But the sleeping youth in Rosselli's composition recalls Jewish exegesis of Exodus 32:15, a verse perhaps illustrated in a scene near the center of Rosselli's *Lawgiving* fresco, in the middleground, where Moses and Joshua descend the mountain together. Although Exodus 32:15 indicates that Moses came down from Sinai by himself, a Jewish explanation of the verse asserts that Joshua waited for Moses on the slope of Mount Sinai during the forty days and nights of Lawgiving, and eventually returned with Moses to the Israelite camp.[99] If the *Lawgiving* fresco does indeed illustrate this legendary interpolation, Rosselli may have shown Joshua sleeping on the mountainside to explain how the younger Jewish leader passed the forty days and nights on Sinai. I suspect that Rosselli (or an adviser) wished to illustrate the Jewish legend in order to establish Joshua's presence at the Lawgiving. This point might be crucial, for if Joshua was present when the Lord gave Moses the commandments, it would be possible to claim that God's law was intended, from the first, for Christians as well as Jews. That possibility depends upon the opinion of many Christian exegetes that Joshua is a Jewish forerunner of Jesus, with whom he shares his name.[100] Joshua's presence at the Lawgiving on Sinai could thus foreshadow the supplantation of the Old

92. Cited by Steinmann, 240.

93. For Ettlinger, 65, the fresco depicts events from Exodus 19 and 31–34; for Steinmann, 233, the subjects are from Exodus 32–34.

94. Callewaert, 1940 (1), 451.

95. *The Bird's Head Haggadah of the Bezalel National Art Museum in Jerusalem*, ed. M. Spitzer, facsimile and text, Jerusalem, 1967, 102, fig. 46.

96. Ettlinger, 47.

97. As suggested by Steinmann, 233.

98. Bernabei, 62.

99. Ginzberg, III, 128.

100. Brenk, 1975, 122.

Israel by the New, a theme evoked elsewhere in the decoration of Pope Sixtus's chapel.[101]

While Moses was with the Lord on Sinai, the Jews began to lose their faith, and they asked Aaron to create new gods for them (Exodus 32:1). In response to this request, Aaron caused a golden calf to be fashioned; and the adoration of the idol (Exodus 32:4–6) is portrayed near the center of Rosselli's *Lawgiving* fresco, in the middleground. Reacting with anger to this idolatry, which he discovered on his return from Sinai, Moses smashed the first set of God-given tablets (Exodus 32:19), as depicted at the foreground of Rosselli's fresco, near the center. The idolators' punishment is illustrated in a scene at the right side of the fresco, in the middleground; there, the sons of Levi, who had remained faithful monotheists, are shown beheading those who worshiped the golden calf (Exodus 32:27–28). A scene containing many tents, at the left side in the middleground of the *Lawgiving* fresco, may illustrate Exodus 33:7–11; that passage records that the Jews worshiped with Moses from their tents while the Lord addressed the patriarch from a pillar of cloud. Near the foreground of Rosselli's *Lawgiving* fresco, at the left side, Moses, with rays of light shining from his head, and again accompanied by Joshua, brings the Israelites a second set of tablets (Exodus 34:29–35).[102] These scenes in Rosselli's *Lawgiving* fresco evoke the preparation of early catechumens during Lent, when baptismal candidates were expected to observe God's laws, to reject pagan practices, and to worship with their priests, the Lord's appointed representatives.

Several events depicted in Rosselli's *Lawgiving on Mount Sinai* echo themes of Roman liturgy on Wednesday in the third full Lenten week, when the *Missal of 1474* assigns Exodus 20:12–24 as the Epistle.[103] This lection, which describes an occasion on which the Lord gave commandments to Moses, cannot be the text illustrated in Rosselli's *Lawgiving on Mount Sinai*, because Exodus 20 makes no mention of stone tablets; nevertheless, lawgiving is central both in Rosselli's fresco and in Exodus 20:12–24. Rosselli's *Lawgiving* fresco also reflects some themes of the Gospel pericope assigned to this Wednesday in the *Missal of 1474*;[104] that passage, Matthew 15:1–10, restates one of the Ten Commandments, "Honor thy father and thy mother" (Matthew 15:4),[105] and makes clear in what spirit God's laws should be kept.[106] The Roman station on this Wednesday is at S. Sisto,[107] a church with personal meaning for Sixtus IV. S. Sisto is dedicated to Pope Sixtus II, the Early Christian martyr whose papal name was adopted by the first della Rovere pope; and it was the titular church of Sixtus IV's nephew, Cardinal Pietro Riario, until Pietro's death in 1474.[108]

Rosselli's *Lawgiving on Mount Sinai* also evokes texts of the Roman liturgy read on Tuesday in the fourth Lenten week. Exodus 32:7–14 is the Epistle assigned to this

101. For example, in Perugino's *Circumcision of Moses' Son* (Pl. VIII).

102. Steinmann, 424ff.; Salvini–Camesasca, 51f.

103. Lippe, I, 90.

104. Lippe, I, 90.

105. According to rabbinic sources, the fifth commandment, concerning the honor due to parents, is among the most important (Ginzberg, III, 100).

106. Jungmann, 1959, 258.

107. Lippe, I, 89.

108. Pastor, 235.

Tuesday in many service books, from the ninth-century *Comes* of Alcuin to the *Missal of 1474*; these verses describe the Lord's anger at the worship of the golden calf (Exodus 32:8),[109] an occasion depicted near the center of Rosselli's *Lawgiving on Mount Sinai*.[110] In addition, Moses' role as the Jewish lawgiver is mentioned in John 7:14–31, the Gospel lesson assigned to this Tuesday in Haymo of Faversham's Franciscan *Ordinal* and in the *Missal of 1474*;[111] a query voiced in this pericope, "Did not Moses give you the Law?" (John 7:19), recalls a key theme of Rosselli's *Lawgiving* fresco.

Mediation is another motif of the Roman liturgy on the fourth Lenten Tuesday. Exodus 32:7–14, the Epistle of the day, presents Moses as a mediator of the Old Law, urging the Lord to forgive the Jews their sins (Exodus 32:11–13). Echoing this theme, Rosselli's *Lawgiving* fresco depicts more than one occasion on which Moses served as an intermediary between the Lord and the Children of Israel. In a similar vein, the Gospel lesson on this Tuesday, John 7:14–31,[112] presents Christ as a mediator of the New Law. The Gospel passage opens with the phrase, "Iam die festo mediante . . ." (John 7:14), translated into English as, "Now about the middle of the feast. . . ." Liturgists connect these words with the circumstance that they are read on the Tuesday that marks a midpoint of the Lenten season.[113] Rosselli's *Lawgiving* fresco, with its scenes of mediation, could serve to remind alert worshipers in Pope Sixtus's chapel that punning juxtapositions between the median day of the feast and the mediators of the Old and New Testaments mark the Roman liturgy on this middle Tuesday of Lent.

Both the *Lawgiving on Mount Sinai* and the *Sermon on the Mount* show a religious leader descending from a mountain to communicate heavenly laws. Thus, both frescoes evoke a basic purpose of Lent: instructing baptismal candidates in the laws of Christian orthodoxy. And Rosselli's "Beheading of the Idolators," in the *Lawgiving* fresco, demonstrates that those who disobey God's laws will be severely punished. Although Steinmann could find no connection between this scene and any subsidiary scene in the Christological fresco opposite,[114] I suspect that the "Beheading of the Idolators" was seen as a telling parallel to the "Healing of the Leper" in the juxtaposed *Sermon on the Mount* (Pl. IV). The swift execution of the idolators could illustrate the harsh justice meted out to sinners under the stern Mosaic law, whereas the miraculous cure of the leper could demonstrate the possibility of absolution from sin (leprosy) under Christ's more compassionate law.

109. Exodus 32:7–14 is assigned to Tuesday of the fourth Lenten week in the *Comes* of Alcuin, in a Milanese *Lectionary* of the twelfth century, in the *Sacramentary of Bergamo* (*DACL*, v, 1, col. 303, no. 57; col. 292, no. 50; col. 286, no. 68, s.v. "Epitres"), and in the *Missal of 1474* (Lippe, 1, 103).

110. The Lawgiving on Sinai remains a liturgical theme of the fourth Lenten week; on the fourth Tuesday of Lent, the modern *Roman Breviary* assigns, "Ascendans Moyses in montem Sinai ad Dominum, fuit ibi quadraginta dies et quadraginta noctibus"; and on Wednesday of this week, the *Breviary* assigns, "Cumque descendisset de monte Sinai, portabit duas tabulas testimonii, ignorans quod cornuta esset facies eius ex consortio sermonis Dei" (*BR*, 298f.).

111. Van Dijk, 1963, II, 76; Righetti, II, 134; Lippe I, 104.

112. Righetti, II, 134; Callewaert, "Notes sur les origines de la Mi-Carême," *Sacris Erudiri*, 591f., 599.

113. Righetti, II, 134ff.; Callewaert, "Notes sur les origines de la Mi-Carême," 592. This calculation was based on the fact that Quinquagesima Sunday, which begins the seven weeks of Lenten fasting, is, in effect, the fiftieth day, when counting back from Easter Sunday (Chavasse, "Le cycle pascal," in Martimort, 707).

114. Steinmann, 240.

Rosselli's "Adoration of the Golden Calf," a central scene in his *Lawgiving on Mount Sinai,* recalls the impious behavior of Aaron, the high priest, who wrongfully provided a golden idol for the Jews to worship. This painted reference to Aaron's grave theological lapse was probably intended as a warning to dissident priests. A still stronger cautionary reminder to rebellious clerics is delivered with still greater force in the composition adjoining Rosselli's *Lawgiving on Mount Sinai:* Botticelli's *Punishment of Korah* (Pl. XII).[115]

115. See Chapter V.

# V
# THE FIFTH FRESCOES ON THE LONG WALLS

## The *Gift of the Keys* and the *Punishment of Korah*

TITULI:
CONTURBATIO IESU CHRISTI LEGIS LATORIS
and
CONTURBATIO MOISI LEGIS SCRIPTE LATORIS

Both Perugino's *Gift of the Keys,* the fifth fresco on the north wall of the Sistine Chapel (Pl. V), and Botticelli's *Punishment of Korah,* the corresponding fresco on the opposite south wall (Pl. XII), echo liturgical themes of Passion week and Holy Week, the fifth and sixth weeks of Lent. In addition, biblical subjects portrayed in both frescoes recall texts and ceremonies connected with the papacy. More than any other compositions of the Christ and Moses cycles, these works by Perugino and Botticelli refer directly to the iconography of pontifical power.

On the central axis of Perugino's fresco, Christ hands Peter the apostolic keys. The momentous event takes place within a noble square marked with colored bands that form a perspectival grid. At the very foreground of the piazza, Christ offers his first disciple a gold key and a silver key before an audience composed of apostles in antique costume and personages wearing quattrocento dress. A subsidiary scene in the right middleground of Perugino's composition depicts the Stoning of Christ (Fig. 22); a corresponding subsidiary scene in the left middleground of the composition may represent the Payment of the Tribute Money (Fig. 23). Near the back of the spacious plaza, two Constantinian arches flank a domed octagonal structure. Beyond the impressive man-made setting, the realm of nature begins.

Perugino's *Gift of the Keys* is the only Christological fresco with an urban setting. This unusual aspect of the composition recalls the repeated references to Jerusalem in the Roman liturgy during the second half of Lent. On the fourth Lenten Sunday, as Durandus notes, the station of the Mass is at Ss. Croce in Gerusalemme;[1] the word

1. Durandus, 1568, 207v.

"Jerusalem" figures in the Introit, Tract, Offertory, and Communion of the Mass; and the Epistle refers to the two Jerusalems.[2] On Palm Sunday, the sixth Lenten Sunday, a liturgical procession commemorates Christ's triumphal entry into Jerusalem; the opening words of Psalm 147, "Lauda, Ierusalem, Dominum," are recited during this procession; the Gospel lesson of the Mass, Matthew 21:1–9, describes Christ's Entry into Jerusalem; and several antiphons of the Mass evoke the Holy City.[3] There are further allusions to Jerusalem in the liturgy of Holy Week, the final week in Lent. The phrase "Jerusalem, Jerusalem" concludes each segment of the passage from Jeremiah's Lamentations assigned by Durandus to the morning Office on Holy Thursday,[4] and additional references to the Holy City conclude lessons of the nocturnal Office on Holy Thursday, Good Friday, and Holy Saturday.[5] Perhaps inspired by the recurring liturgical invocation of Jerusalem during the latter part of Lent, events depicted in Perugino's *Gift of the Keys* (the fifth fresco on the long north wall) unfold within a cityscape.

The noble eight-sided building in Perugino's fresco (Pl. V) evokes such Lenten motifs as baptism and Resurrection, both linked by long tradition with the number eight. Moreover, this painted edifice resembles the Dome of the Rock, an ancient mosque in Jerusalem identified with Solomon's temple by medieval pilgrims.[6] The famed mosque—octagonal on the exterior, surmounted by a dome, and embellished at the cardinal points by four porches leading to the platform on which the building stands[7]—may have served Perugino as a model. By the later quattrocento, the Dome of the Rock was familiar to Europeans from travelers' reports,[8] and from views of Jerusalem in prints issued around the middle of the fifteenth century,[9] shortly before work was begun on Sixtus IV's new papal chapel.

By its resemblance to a building long thought to be Solomon's temple, the octagonal structure in Perugino's *Gift of the Keys* evokes the repeated allusions to Solomon and his temple in the Passion week liturgy.[10] Solomonic themes actually surface in the Roman liturgy on the Saturday preceding Passion Sunday. On that Saturday, the printed *Missal of 1474* specifies a reading from John 8:12–20, which tells of Jesus teaching in the temple at Jerusalem;[11] and at least one service book lists the Epistle as III Kings 3:16–23, which records the Judgment of Solomon.[12] On Passion Sunday, one verse in the Gospel lesson reads, "Jesus . . . went out of the temple" (John 8:59).[13] And John 10:22–28, a passage assigned to the Wednesday of Passion week in Haymo of Faversham's Franciscan *Ordinal* and in the *Missal of 1474*, tells of Jesus walking in the temple, in Solomon's porch (John 10:23).[14]

2. Righetti, II, 133.

3. *MR*, 133ff.: Dominica II Passionis seu in palmis.

4. Durandus, 1568, 291r; Righetti, II, 154.

5. Bäumer, I, 385, cited by Righetti, II, 154.

6. Krinsky, 5.

7. Krinsky, 4.

8. Krinsky, 7.

9. Krinsky, 14–17.

10. For Schubring, 19, the central structure represents the temple of Jerusalem. For Ettlinger, 91ff., and Barzotti, 4, it symbolizes, respectively, the perfection or the triumph of the church.

11. Lippe, I, 114.

12. The text is assigned to this Saturday in the *Sacramentary of Bergamo* (*DACL*, v, 1, col. 286, no. 67, s.v. "Epitres"); it is assigned to the Monday after Passion Sunday in a Milanese *Lectionary* of the twelfth century, and in the earlier Roman *Comes of Alcuin* (*DACL*, v, 1, col. 292, no. 49; col. 303, no. 56).

13. Lippe, I, 115f.

14. Van Dijk, 1963, II, 80; Lippe, I, 121.

A further allusion to the Jewish temple at Jerusalem is concealed in John 10:22, the first verse of the Gospel lesson on Wednesday of Passion week. The verse opens with the words "Facta sunt Encaenia," a Latin phrase rendered into English as, "And it was at Jerusalem, the feast of the dedication." As learned members of Renaissance "papal chapels" surely knew, medieval exegetes identify the *Encaenia* as a Jewish festival commemorating the dedication of the temple following its restoration by the Maccabees in the aftermath of the ancient Babylonian Captivity.[15] The octagonal edifice in Perugino's *Gift of the Keys* may allude to the restored Jewish temple commemorated at the *Encaenia,* a festival recalled in the Passion week liturgy (John 10:22).

Yet another reading of John 10:22 suggests still another interpretation of the central "temple" in Perugino's *Gift of the Keys.* As Amalarius's gloss on this verse from the Passion week liturgy explains, "Templum hoc domini corpus significat."[16] This comparison of Christ's body with the Jewish temple restates a theme sounded in John 2:13–35, a Gospel lesson of Monday in the fourth Lenten week. In John 2:19, Jesus asserts, "Destroy the temple and in three days I will raise it up." In John 2:20, the Jews argue that the original temple had taken forty-six years to build, and they ask Jesus, "Wilt thou rear it up in three days?" But, as explained in John 2:21, "He spake of the temple of the body."[17] Renaissance worshipers in Pope Sixtus's chapel with sufficient expertise in scriptural exegesis to grasp the inner meaning of such Lenten texts as John 10:22 and John 2:19–21 may well have recognized a symbolic connection between the *corpus domini* and the painted "temple" in Perugino's *Gift of the Keys.*

In further commentary on John 10:22, Amalarius explains that the forty-six years required to build the Jewish temple correspond to the forty-six Lenten days that fall between Ash Wednesday and Holy Saturday.[18] In accord with this explanation, the ecclesiastical structure in Perugino's *Gift of the Keys* may symbolize all of Lent. Indeed, Amalarius's claim that Lent corresponds to the period of time needed to construct, or reconstruct, the Jewish temple at Jerusalem can help to explain why painted allusions to the Lenten liturgy should appear in Pope Sixtus's chapel. If the Sistine Chapel was somehow equated with the Jewish temple at Jerusalem, as suggested by Eugenio Battisti,[19] then Sixtus IV and his contemporaries may have identified the new papal chapel (like Solomon's ancient temple) as an architectural emblem of the forty-six Lenten days between Ash Wednesday and Easter Eve.

Two men carrying tools of the builders' trade look on at the Consignment of the Keys from the right foreground of Perugino's fresco. These individuals have been identified as Baccio Pontelli, architect of the papal chapel (holding a compass), and Giovanni de' Dolci, who supervised its construction (holding a carpenter's square).[20] According to

---

15. See, for example, Durandus, 1568, 213r.

16. Amalarius, *De ecclesiastica officiis,* I, 112.

17. Lippe, I, 102.

18. Amalarius, *De ecclesiastica officiis,* I, 112.

19. Eugenio Battisti, "Il significato simbolico della cappella Sistina," *Commentari: Rivista di critica e storia dell'arte,* VIII, 1957, 96–112.

20. Redig de Campos, "L'architetto e il costruttore della Cappella Sistina," *Palatino: Revista romana di cultura,* 3d ser. IX, 1965, 90–93, as cited by Stinger, 207n. 147. On the identity of these individuals, see Carlo Castellaneta, *L'Opera completa di Perugino* (Classici dell'arte, 30), Milan, 1969, 92.

Shearman, the builders may appear in Perugino's *Gift of the Keys* to remind viewers of a celebrated architectural metaphor from the Gospels: Christ's promise to Peter during the Consignment of the Keys, "On this rock I will build my Church" (Matthew 16:18).[21] These well-known words (of the greatest importance for the papacy) derive from two pericopes assigned during Lent: the *Missal of 1474* specifies a reading of Matthew 18:15–22 on the third Lenten Tuesday,[22] and a medieval *Ordo Romanus* assigns Matthew 16:17–19 to the Mass of absolution celebrated on Holy Thursday.[23] Perugino's portraits of two builders responsible for Sixtus IV's new Christian "temple" in Rome could also evoke a favored motif of the Roman liturgy during the latter part of Lent: the building of Solomon's ancient Jewish temple at Jerusalem.

Solomonic themes of the Lenten liturgy may find further expression in the epigraph displayed on triumphal arches in Perugino's *Gift of the Keys,* for the Latin inscription names the Jewish king (Figs. 24, 25). Both arches in Perugino's fresco bear a single legend, inscribed in gold, that replaces the Latin texts actually carved on the attics of Perugino's famed model, the Roman Arch of Constantine.[24] The painted epigraph, IMENSU [M] SALAMO TEMPLUM TU HOC QUARTE SACRASTI SIXTE OPIBUS DISPAR RELIGIONE PRIOR, is obscure in meaning, and perhaps deliberately so. That possibility is suggested by a comment in Paolo Cortesi's treatise, *De Cardinalatu* (1510). According to Cortesi, a humanist scholar who moved in papal circles, the message of Latin culture is often extremely subtle, and is therefore best understood by the cultivated *cognoscenti*.[25] Many members of the *cappelle pontificie* who worshiped in the papal chapel during Sixtus IV's pontificate were doubtless competent to interpret the knotty Latin text displayed in Perugino's *Gift of the Keys;* indeed, Cortesi's treatise suggests that the puzzling inscription may have been aimed specifically at these erudite persons.

The Latin epigraph in Perugino's fresco, which praises the fourth Sixtus for consecrating the Sistine Chapel, compares the pope with Solomon, another famed builder of ecclesiastical architecture, asserting that Sixtus is superior to the sage Jewish king in wisdom, if not in riches.[26] The admiration for Solomon's temple conveyed by this text may be reflected in the very architecture of the Sistine Chapel, if the sacred chamber is actually modeled in some way on the Jewish temple, as suggested by Battisti. His proposal has not met with universal acceptance.[27] But there can be no question that a desire to create in the Sistine Chapel a structure worthy of comparison with Solomon's temple would be consistent with the admiration for early Christian ideals that is evident throughout the decoration of Pope Sixtus's chapel: to builders of ecclesiastical

21. Shearman, 1986, 64f.

22. Lippe, I, 89.

23. *Ordo L,* cited by Michel Andrieu, *Les Ordines Romani du haut moyen âge,* V, *Les Textes* (Suite) (Spicilegium sacrum Lovaniense, XXIX), Louvain, 1961, cap. XXV, 52, 204.

24. Filippo Magi, "Il coronamento dell'arco di Costantino," *Atti della Pontificia Accademia Romana di Archeologia, Rendiconti,* XXXIX, 1957, 83.

25. Weil-Garris–D'Amico, 62f.

26. Stinger, 207, proposes the translation: "You, Sixtus IV, unequal in riches, but superior in wisdom to Solomon, have consecrated this vast temple."

27. Wilde, 64, believes there was no direct emulation of Solomon's temple in the Sistine Chapel; Monfasani, 13, notes that contemporary commentators feel no need to compare the Sistine Chapel with the Jewish temple.

architecture in Christian antiquity—and perhaps to Pope Sixtus IV—the celebrated temple at Jerusalem was a model to be imitated or, if possible, surpassed.[28]

Comparison of Solomon's temple with pontifical building projects was probably something of a cliché by Sixtus IV's pontificate. Still earlier in the fifteenth century, Giannozzo Manetti makes the claim that architectural projects undertaken by Nicholas V surpass even Solomon's achievements as a builder; according to Manetti, the pope's superiority to Solomon in the field of architecture is a paradigm for the superiority of Nicholas's Christian church over the Jewish faith.[29] In like manner, the painted epigraph in Perugino's *Gift of the Keys* suggests that Sixtus IV's new Christian chapel may outshine even Solomon's famed temple, a structure devoted to rituals of the ancient Jewish faith, now supplanted by a superior new religion.[30]

Neither Sixtus IV nor Solomon is actually represented in Perugino's fresco; but the Latin epigraph that names them both suggests that both may be present symbolically. Sixtus IV may appear in the guise of his papal predecessor, Saint Peter, who wears robes of della Rovere gold and blue as he kneels at the center foreground of Perugino's fresco to accept the pontifical keys. And Solomon, a celebrated temple-builder, may be represented emblematically by the ideal eight-sided structure situated on the central axis of Perugino's composition. Prompted by the Latin inscription in Perugino's *Gift of the Keys*, discerning viewers might conclude that the fresco before them functions as a painted assertion that Sixtus's church—governed by a papal heir to Saint Peter, whose powers derive from Jesus himself—has supplanted Solomon's antique religion.

The central scene in Perugino's *Gift of the Keys* illustrates a biblical event of great consequence for the papacy. As early as Leo I's pontificate, Matthew 16:17–19, which records the Gift of the Keys, is cited in support of Roman and papal primacy;[31] and the modern *Roman Missal* still assigns these verses to the papal coronation Mass.[32] Because the Gift of the Keys was crucial for the founding of the Roman church, it is easy to see why the episode should figure prominently in the decoration of the major papal chapel in Rome, even though the subject is not often represented in the visual arts.[33]

In addition to its meaning for the papacy, the central scene in Perugino's *Gift of the Keys* evokes the Lenten theme of penitence. From Christian antiquity onward, official penitents were denied access to the churches during most of Lent as a form of temporary excommunication. On Holy Thursday, these public penitents were finally reconciled with the Christian community;[34] the *Gelasian Sacramentary* of the eighth century already

28. The most famous competitor is probably Justinian, said to have exclaimed at the consecration of the Hagia Sophia, "Solomon, I have vanquished thee!" (Krautheimer, 1965, 153).

29. Westfall, 125 and n. 79.

30. This trope lived on. As cited in Davidson, 82 n. 176, Vasari (Milanesi), VII, 709f., compares Solomon with Cosimo de' Medici, another Christian ruler dedicated to building and restoring churches.

31. Michele Maccarone, "San Pietro in rapporto à

Christo nelle più antiche testimonianze," in *Studi Petriani*, Rome, 1968, 97; Ettlinger, 91.

32. MR, p. (72): Missa votiva in die coronationis Papae, et in anniv.

33. Ettlinger, 91.

34. Righetti, II, 138f. The reconciliation of penitents, which may once have taken place on Easter Eve, was soon moved back to Holy Thursday (P. M. Gy, "Pénitence," in Martimort, 573).

lists a ceremony for the reconciliation of public sinners on that day.[35] References to sin and penitence pervade the Lenten liturgy, particularly during the latter part of Lent. On Thursday of Passion week, for example, the Gospel lection, Luke 7:36–50, speaks of the repentant Magdalen; the Epistle describes the exiled prophet Daniel grieving over the sins of the Jews;[36] and a penitential antiphon of the Mass recalls the ancient Jewish captivity, "By the waters of Babylon we sat and wept, when we remembered Zion" (Psalm 136:1).[37] Matching allusions to sin and repentance figure in sermons preached for Renaissance popes at "papal chapels" held on Passion Sunday; on Passion Sunday, 1516, for example, an "oratio de peccato" was preached for Leo X and his court.[38] Perugino's *Gift of the Keys* echoes the liturgical emphasis on penitence and absolution from Passion Sunday to Holy Thursday, because the priestly power to absolve sinners stems directly from Christ's consignment of the apostolic keys to Peter.[39]

This interpretation of Matthew 16:17–19 has a long history.[40] Saint Jerome identifies the passage as a textual source for the priestly power of absolution,[41] and his arguments are taken over by Gregory the Great and the Venerable Bede.[42] Leo the Great's assertion that the gates of God's mercy may be opened to sincere penitents by the apostolic keys confided to the bishop expresses a related thought.[43] Later theologians make similar points. For Thomas Aquinas, the silver key that Christ gave to Peter connotes the ability to distinguish between good and evil, that is, the capacity to judge sinners; while the golden key consigned by Jesus to his first disciple connotes the ability to bind and loose, that is, the capacity to absolve sinners after appropriate penance.[44] This point of view is incorporated into an early *Ordo Romanus* that assigns Matthew's account of the Consignment of the Keys to the Holy Thursday ceremony of absolution.[45]

Perugino's *Gift of the Keys* recalls some features of this ceremony. At the center of Perugino's composition, in the foreground, a kneeling Saint Peter accepts the keys (Fig. 26). Peter's humble posture is not unusual in depictions of this episode and may simply express his reverence for Jesus. In any case, the kneeling figure of Peter at the center of Perugino's composition—and a matching image of Peter on his knees before Christ, at the center of Ghirlandaio's *Calling of the First Apostles* (Fig. 18)—could remind alert visitors to Pope Sixtus's chapel that both frescoes portray occasions on which Jesus singled out the first Roman bishop for special honor. But Saint Peter, the revered founder of the Roman church, was also a noted sinner and penitent; thus the kneeling saint in Perugino's *Gift of the Keys* could recall the humble posture of official

35. Righetti, II, 158ff.; see also Jungmann, 1986, II, 430.

36. Callewaert, 1940 [2], 629.

37. Callewaert, 1940 [2], 631.

38. A. Filippi, *Orationes novem coram Iulio II et Leone X*, Rome, 1518, fols. 114v–116r. I owe this reference to John W. O'Malley.

39. Shearman, 1972, 49.

40. A *Dictionary of Catholic Theology*, III, 360, s.v. "Ordinations"; Anciaux, 284ff.

41. Jerome, *In Matthaeum*, III (PL XXVI, col. 118,

cited by Anciaux, 17 n. 8) compares this priestly power with the capacity of Old Testament priests to distinguish lepers from those who are cured. (On this subject, I have followed Shearman, 1972, 49 and n. 25.)

42. Anciaux, 276.

43. Leo the Great, *Sermons*, 5:5, 49:3, *Epistles*, 108:2, as cited in *New Catholic Encyclopedia*, VIII, 638f., s.v. "Leo I."

44. Cited by Steinmann, 339, and Barzotti, 13.

45. *Ordo L*, cited by Andrieu, *Les Ordines Romani*, V, *Les Textes* (Suite), cap. XXV, 52, 204.

penitents until the bishop raised them from the ground during the Holy Thursday ceremony of absolution.[46]

Some of those attending services in the Sistine Chapel during Sixtus IV's pontificate had surely been present in 1480, when the della Rovere pope absolved a group of ambassadors from Florence who were seeking to end ecclesiastical censures imposed after the Pazzi conspiracy. On this occasion, the repentent Florentines first prostrated themselves before the closed doors of St. Peter's basilica and demanded pardon. Next, Sixtus IV read the instrument of absolution, touching each dissident on the shoulder with a penitential rod. Finally, the Florentines were officially reunited with the community of the faithful, at which point the closed doors of the papal basilica were opened wide.[47] (Sixtus's ritual absolution of the Florentines evidently followed Durandus's prescription that the reconciliation of penitents should take place outside the church.)[48] Those who remembered Sixtus's public absolution of the penitent Florentine ambassadors might well connect Perugino's *Gift of the Keys* with that memorable display of papal authority.

In addition to its meaning for the papacy, and its evocation of Lenten penitence, Perugino's *Gift of the Keys* refers to priestly ordination. Nicolas Poussin twice used the Consignment of the Keys to represent the sacrament of ordination;[49] and Poussin, who was well informed about Christian archaeology, may have known that Matthew 16:17–19, which records the Gift of the Keys, was already associated with ordination in the *Apostolic Constitutions* of the early church.[50] Ordination surfaces in the Roman liturgy toward the end of Lent because, from Christian antiquity onward, the Saturday immediately preceding Passion Sunday was one of five days during the year set aside for the sacrament.[51] An allusion to ordination figures in Hebrews 9:11–15, the Epistle assigned to Passion Sunday in Durandus's *Rationale* and the *Missal of 1474*,[52] for the biblical passage in question speaks of Christ as a high priest (Hebrews 9:11). Perugino's *Gift of the Keys*, the fifth fresco on the north wall of the Sistine Chapel, could recall the ordinations commemorated in the Roman liturgy on the fifth Lenten Sunday, thus providing another instance of correlation between subjects of the Christological frescoes and themes of the liturgy on certain Sundays between Advent and Pentecost.

A group of men pelt Christ with stones in a subsidiary scene at the right side of Perugino's *Gift of the Keys*, in the middleground (Fig. 22). Because the Stoning of Christ is reported only in John's Gospel, Steinmann was surprised to find the episode

46. Jungmann, 1959, 244.

47. Stinger, 45, and n. 110, citing Gherardi, *Diario romano*, 27–29, and Carusi, "L'instrumento di assoluzione dei Fiorentini dalle censure di Sisto IV," *Archivio Muratoriano*, II, 16, 1915, 286–92.

48. Durandus, 1479, fol. 194r.

49. For the influence of the Early Christian revival movement upon Poussin, see Howard Hibbard, *Poussin: The Holy Family on the Steps*, London, 1974, 45f. See also Anthony Blunt, *Nicolas Poussin* (The A. W. Mellon Lectures in the Fine Arts, 1958), I, New York, 1967,

154f., 186, 205. Poussin seems to have looked at Perugino's *Gift of the Keys* before painting the second version of *Ordination* in his Seven Sacraments series (Blunt, *Poussin*, I, 255).

50. Blunt, *Poussin*, I, 195; P. Jounel, "Les Ordinations," in Martimort, 480.

51. The legal dates of ordination set forth by Pope Gelasius in 494 include the Saturdays of the first and fourth Lenten weeks (Righetti, IV, 262).

52. Durandus, 1568, 211r; Lippe, I, 115.

illustrated in the Christological cycle of the Sistine Chapel, which focuses mainly on events recounted by Matthew.[53] But the anomaly that puzzled Steinmann actually mirrors the shape of the Roman liturgy during the latter part of Lent. From Friday of the third week in Lent to the Saturday of Passion week, John's Gospel provides many lections of the Masses;[54] moreover, additional passages from John's Gospel are assigned on Monday, Thursday, and Friday of Holy Week.[55] Like Rosselli's *Last Supper,* the final fresco on the north wall of the Sistine Chapel, which illustrates still other verses from John's Gospel,[56] Perugino's "Stoning of Christ" recalls the many Johannine texts of the Roman liturgy during the fifth and sixth Lenten weeks.

While the Stoning of Christ is seldom portrayed in religious art,[57] the episode recalls a prime theme of the Passion week liturgy: the violence directed at Jesus toward the end of his earthly existence. The Gospel lection of Passion Sunday includes the phrase, "And they took up stones therefore to cast them at him" (John 8:59). On Tuesday of Passion week, the Gospel pericope opens with the words, "The Jews sought to kill him" (John 7:11). Stones reappear in the Gospel lection on Wednesday of Passion week, "And the Jews took up stones to stone him" (John 10:31). And the Gospel reading of Friday in Passion week records, "Then from that day forth they took counsel together for to put him to death" (John 11:53).[58] CONTURBATIO IESU CHRISTI LEGIS LATORIS, the inscription over Perugino's *Gift of the Keys,* recalls the violence recorded in Passion week lessons; *conturbatio,* the confusion or disturbance mentioned in the *titulus,* could aptly describe Jesus' reaction to these threats of bodily harm.

Perugino's "Stoning of Christ" may refer specifically to John 8:59. From Christian antiquity onward, this verse marked a dramatic moment of the Passion Sunday Mass. As the deacon pronounced the words "Tulerunt ergo lapides, ut iacerent in eum; Iesus autem abscondit se . . . ," the Crucifix and holy images on the altar wall were covered up, and, as a penitential gesture, they remained covered until the end of Lent.[59] This practice was still observed in the Sistine Chapel during the Renaissance.[60]

In some medieval manuscripts, miniatures that represent the stoning of Christ are used to illustrate the liturgy of Passion Sunday. This conjunction of text and image occurs in the *Pericope Book of Henry III* (Bremen, Stadtbibliothek, cod. b. 21, fol. 40v); in that Ottonian codex, a miniature that represents the Stoning of Christ adjoins the Passion Sunday lessons.[61] A similar pairing of miniature and liturgy appears in the fourteenth-century *Missal of Cardinal Bertrand de Deux;* on folio 97 verso of the Bolognese codex, readings of Passion Sunday accompany an image of the Stoning of Christ.[62] By analogy

53. Steinmann, 237.

54. Chavasse, "Le cycle pascal," in Martimort, 709; Righetti, II, 129; *DACL,* V, 1, col. 916, s.v. "Evangiles."

55. *MR,* 145: Feria II Hebdomadae Sanctae, John 12:1–9; 158: Feria V in Cena Domini, John 13:1–15; 167ff.: Feria VI in Passione et Morte Domini, John 18:1–40, 19:1–42.

56. See Chapter VI, 83f.

57. Réau, II, 2, 405, for examples.

58. *DACL,* V, 1, col. 917, s.v. "Evangiles."

59. Hardison, 110 and n. 52.

60. Steinmann, 571.

61. Joachim M. Plotzek, *Das Perikopenbuch Heinrichs III in Bremen und seine Stellung innerhalb der Echternacher Buchmalerei* (Diss.), Cologne, 1970, 172.

62. E. Cassee, *The Missal of Cardinal Bertrand de Deux: A Study in Fourteenth-Century Bolognese Miniature Painting,* trans. M. Hoyle (Istituto Universitario Olandese di Storia dell'Arte, Firenze, IX), Florence, 1980, 103.

with these earlier examples, it seems likely that Perugino's "Stoning of Christ" must illustrate a text of the Passion Sunday liturgy, presumably John 8:59. If so, Perugino's "Stoning of Christ" would provide another instance of correlation between subjects of the Christological frescoes in Pope Sixtus's chapel and themes of the Roman liturgy on Sundays that fall between Advent and Pentecost.[63]

A subsidiary scene at the left middleground of Perugino's *Gift of the Keys* (Fig. 23) appears to me to represent Peter's Payment of the Tribute Money (Matthew 17:24–27); but Stinger suggests that the scene may instead portray the episode known as "Render unto Caesar" (Matthew 22:15–22).[64] This suggestion is not totally convincing, because the main actor in this part of Perugino's fresco, a nimbed figure shown presenting a coin to a Roman soldier, is dressed in della Rovere blue and gold. His costume seems to identify the nimbed man as Saint Peter, who wears garments of these papal colors not only in the foreground of Perugino's *Gift of the Keys* but also throughout the Christological cycle of Pope Sixtus's chapel.[65] This color-coding makes it possible to conclude that the Payment of the Tribute Money (Matthew 17:24–27) must be the subject of the scene at the left middleground in Perugino's fresco, because Matthew 22:15–22 gives no indication that Saint Peter took part in the episode known as "Render unto Caesar."[66]

While the Payment of the Tribute Money is rarely depicted in Christian art,[67] both Steinmann and Ettlinger suggest that the subject may appear in Pope Sixtus's chapel to recall the stormy relations between medieval popes and their emperors.[68] But Perugino's "Payment of the Tribute Money" may allude as well to the Lenten theme of penitence. This interpretation can be supported by recalling Ambrose's comment that the repayment of monetary debts may signify repentence.[69]

Because Matthew 17:24–27 records the distribution of coins, Perugino's "Payment of the Tribute Money" may plausibly be linked with a papal almsgiving regularly scheduled on the Saturday before Palm Sunday. Saint Jerome already knows of pontifical almsgiving on this Saturday;[70] Alcuin of York (c. 735–804) records the distribution of alms by the pope at St. Peter's basilica on this day;[71] and Durandus's *Rationale* describes the Saturday as privileged, because "Dominus papa tunc elemosinus dat."[72] Christian exegetes link this occasion of papal charity with a liturgical text of the day, "The poor you have always with you" (John 12:8).[73] And such charitable action could satisfy one of the essential Lenten obligations, which Leo the Great defines as prayer, fasting, and almsgiving.[74] Perugino's "Payment of the Tribute Money" may, additionally, refer to a

63. Steinmann, 242 n. 1, suggests that Perugino's "Stoning of Christ" may refer to the stones actually thrown at Sixtus IV during his "possesso."

64. Ettlinger, 92; Stinger, 207.

65. For example, in the *Calling of the First Apostles* (Pl. III).

66. In referring to this scene, Ettlinger, 92, incorrectly cites "Matthew xxvii [sic] 15–22," which refers neither to "Render unto Caesar" nor to the "Tribute Money."

67. Réau, II, 2, 321.

68. Steinmann, 272; Ettlinger, 92.

69. Ambrose, *Pénitence*, 185.

70. Righetti, II, 140.

71. Cited by Righetti, II, 140.

72. Durandus, 1479, fol. 187r.

73. Callewaert, 1940 [1], 489; Lippe, I, 142.

74. Leo, *Sermons*, II, 19; *New Catholic Encyclopedia*, VII, 638, s.v. "Leo I, Pope, St." Leo's Lenten sermons urge

charitable civic reform instituted by the first della Rovere pope. One of the papal bulls issued by Sixtus IV calls for the creation of a new office at the pontifical palace to ensure distribution of alms to the poor.[75]

Although the Payment of the Tribute Money is not often represented in the visual arts, Perugino, who had lived and worked in Florence, surely knew Masaccio's famed *Tribute Money* in the Brancacci Chapel at S. Maria del Carmine. It is not altogether clear how this masterpiece of the 1420s was interpreted in the later quattrocento.[76] Millard Meiss, citing Augustine's exegesis of Matthew 17:24–27, identifies the episode illustrated in Masaccio's celebrated fresco as a symbol of the redemption made possible by the church: "Thus it conveys, in a different guise, the idea normally expressed by the Gift of the Keys."[77] But Anthony Molho, for whom the entire Brancacci Chapel "may be a propaganda statement on behalf of papal primacy in the administration of ecclesiastical affairs," understands Masaccio's *Tribute Money* to reflect the voluntary contribution by the Church to civic needs.[78] Both the motif of redemption and the motif of socially concerned civic Christianity, which modern scholars have discerned in Masaccio's fresco, seem to fit with the aims of Sixtus IV's pontificate; and both motifs may be expressed in Perugino's "Payment of the Tribute Money."

Like Perugino's *Gift of the Keys* (Pl. V), Botticelli's *Punishment of Korah* (Pl. XII),[79] directly across the Sistine Chapel, echoes themes of the Roman liturgy during the last two weeks of Lent. Botticelli's composition illustrates the text of Numbers 16:1–40, which records that Korah the Levite, with his associates Dathan and Abiram, presumptuously challenged the supremacy of Moses and Aaron among the Jews; not content with their office as servants of the tabernacle, these Jewish rebels coveted the additional honor of the priesthood. To determine whether the Lord favored Korah's revolt, a test was undertaken. At the appointed hour, Korah and his band, swinging bronze braziers filled with burning incense, joined Moses and Aaron at the tabernacle. Commanding Moses and Aaron to move away from the dissidents, "that I may consume them," the Lord directed Moses' followers to quit the tents of Korah, Dathan, and Abiram. At this point, the open earth swallowed up the rebels, and fire from heaven consumed two hundred and fifty men who had offered incense along with Korah. Later, the Lord ordered Eleazar, Aaron's son, to gather up the censers used by the sinners and to transform these vessels into an altar covering, "to be a memorial to the children of Israel that no stranger, that is not of the seed of Aaron, come near to offer incense before the Lord . . ." (Numbers 16:40).[80] A Latin text that amalgamates this biblical

---

generosity in almsgiving (*PL* LIV, De Quadragesima I, 6, col. 267; De Quadragesima III, 3, col. 274; De Quadragesima VI, 2, col. 287, cited in Callewaert, 1940 [1], 481).

75. O'Malley, 1979, 223.

76. Stinger, 194 and n. 114.

77. Millard Meiss, "Masaccio in the Early Renaissance: The Circular Plan," in *The Painter's Choice: Problems in the Interpretation of Renaissance Art*, New York, 1976, 63f., cited by Stinger, 104 and n. 114.

78. Anthony Molho, "The Brancacci Chapel: Studies in Its Iconography and History," *Journal of the Warburg and Courtauld Institutes*, XL, 1977, 69.

79. Executed by Botticelli with the help of his workshop, according to Bernabei, 48.

80. The Jewish Bible mentions Korah's revolt in Psalm 105:16–18, in Deuteronomy 11:16, in Ecclesiastes 45:18, in the Book of Wisdom, 18:45. The single New Testament reference is from Jude, verse 11 (*Enciclopedia cattolica*, IV, col. 539f., s.v. "Core").

verse with Numbers 5:4 is displayed on the central arch of triumph in Botticelli's *Korah* fresco.

While the Constantinian arches in Perugino's *Gift of the Keys* (Pl. V) are intact and festively draped with garlands, the attic of the triumphal arch in Botticelli's *Punishment of Korah,* directly across the papal chapel (Fig. 27), is in disrepair. Yet another ruined building stands at the right side of the *Korah* fresco; this crumbling classical structure has been plausibly identified as the Septizonium of Septimius Severus.[81] When contrasted with the pristine arches in Perugino's *Gift of the Keys,* the dilapidated ancient structures in Botticelli's *Korah* fresco offer visual evidence that the Old Law has been supplanted by the New. Thus the paired frescoes refer again to a theme favored in Pope Sixtus IV's chapel: the triumph of Christianity over the older Jewish faith.

At the center of his *Korah* fresco, Botticelli groups eight men around a hexagonal altar.[82] Three worthy clerics appear to the right of the altar. Aaron, in garments of della Rovere blue and gold,[83] wears a papal tiara in matching colors.[84] Moses, in the green and gold robes that distinguish him throughout the Mosaic cycle, gestures toward heaven with his golden staff of office. Eleazar, Aaron's youthful son (Fig. 27), dressed in gold and purple, is shown brandishing a thurible. With his energetic gesture, Eleazar may be scattering fire from a censer once used by one of the rebels (Numbers 16:37).[85]

Five dissidents also cluster near the central altar in Botticelli's *Korah* fresco. Their unstable poses suggest that these men may stand for Korah and the two hundred and fifty rebels struck by lightning as punishment for their revolt against Moses and Aaron. Ettlinger, however, prefers to identify these five individuals as Korah, Dathan, and Abiram, the three rebellious Levites of Numbers 16, in company with Nadab and Abihu, Aaron's two impious sons.[86] According to Ronald Lightbown, the combination of these persons from different biblical episodes in a single scene is already known in earlier illustrated Bibles and illustrated commentaries on Hebrews 5:4.[87] (Along with Numbers 16:40, Hebrews 5:4 is paraphrased in the Latin inscription on the triumphal arch in Botticelli's *Korah* fresco, and I shall have more to say about this verse.) In their interpretation, these modern scholars seem to follow Vasari, who identifies Botticelli's subject as the moment when "sacrificando i figliuoli di Aron, venne fuoco dal cielo."[88]

Nadab and Abihu are the sons of Aaron to whom Vasari refers. They were initially admitted to the priesthood (Exodus 28:1). But unlike their brothers, Eleazar and Ithamar, who were privileged to take up priestly office (Numbers 3:4),[89] Nadab and

81. Ronald Lightbown, *Sandro Botticelli, Life and Work,* New York, 1989, 106.

82. This six-sided structure may refer to the Lenten commemoration of Christ's Crucifixion, which took place on Friday, "the sixth day" (Underwood, 136).

83. Shearman, 1986, 55.

84. This papal headgear recalls the precious tiara made for Sixtus IV at a cost of more than 100,000 ducats (Pastor, 463).

85. Lightbown, I, 65.

86. Ettlinger, 66–68.

87. Lightbown, I, 65 and nn. 2, 3, cites the following texts in connection with this fresco: Numbers 14:1–10 (Stoning of Moses), Leviticus 10:1–3 (Punishment of Nadab and Abihu), and Numbers 16:1–39 (Rebellion of Korah).

88. Vasari (Milanesi), III, 317.

89. Hastings, *Dictionary,* III, 471, s.v. "Nadab."

Abihu were devoured by flames on the day of their consecration because their censers held "foreign fire."[90] According to Jewish sources, Nadab and Abihu were destroyed because the Lord had not commanded them to offer incense at that time. Like Korah and his band, who also offered incense inappropriately, Nadab and Abihu were killed because they failed to understand that incense, while pleasing to the Lord, holds deadly poison for those who have not been called to offer it.[91] If Vasari is correct in identifying Botticelli's subject as the moment when fiery bolts from heaven struck down Aaron's impious sons,[92] the central scene of the *Korah* fresco may refer to a blessing for the new fire of Easter,[93] assigned to the Holy Saturday Vigil in the *Ordo Romanus antiquus* and other early *Ordines*. This blessing recited on Easter Eve asserts that the new fire of Easter (customarily ignited on Holy Saturday) will be welcome flame, unlike the foreign fire offered by Nadab and Abihu: "ut non cum Nadab et Abihu, igne tibi offerentibus alienum, incendamur, sed cum Aaron pontifice et filius eius Eleazaro et Ithamaro, hostias tibi pacificas sancti spiritus igne assatas immolare valeamus."[94] This benediction, which refers to Nadab and Abihu as well as to Aaron and Eleazar, may provide further guidance to the identity of the eight priestly figures gathered near the flaming altar in Botticelli's *Punishment of Korah*.

Whether or not Nadab and Abihu actually appear with Korah at the center of Botticelli's fresco, the polemical point of the scene is the same: only those expressly called by God may legitimately seek ecclesiastical preferment. Botticelli gave this message concrete visual form by differentiating between the braziers of the righteous and unrighteous clerics. Aaron and Eleazar perform their censing deftly; but the thuribles of the dissidents have slipped from their hands and fly about helter-skelter, an apt image for the Lord's rejection of their sacrifices. To underline the importance of these vessels in Botticelli's fresco, the censers clustered near the center of the composition are built up in relief and painted in glittering gold.

At the left side of the *Korah* fresco, Botticelli shows the ground swallowing two men (Fig. 28); they may be Dathan and Abiram,[95] perhaps suffering the punishment described in Numbers 16:30–34.[96] The identity of two youths who hover on a cloud above the gaping earth in this scene is also uncertain. They may stand for the Israelites spared the fate of Dathan and Abiram, thanks to intervention by Moses and Aaron. But the youthful figures on the cloud may also represent the sons of Korah; a

90. Hastings, *Dictionary*, III, 471, s.v. "Nadab."

91. Ginzberg, III, 189.

92. Lightbown, I, 65, also connects this fresco with the history of Aaron's sons.

93. This benediction was once repeated on Holy Thursday, Good Friday, and Holy Saturday (Righetti, II, 186).

94. *Ordo Romanus* I, 70; Andrieu, *Les Ordines Romani*, V, 261, 265ff.; "Item ordo de sabbato sancto . . ." This citation is from *Ordo L*, dated c. 950, but still known in manuscripts of the twelfth century (Andrieu, *Ordines*, V, 416).

95. As suggested by Lightbown, I, 65.

96. Miniatures in two Greek Psalters juxtapose the Punishment of Dathan and Abiram with the Lawgiving on Mount Sinai and the Adoration of the Golden Calf, episodes depicted in the Mosaic fresco that immediately precedes Botticelli's *Punishment of Korah*. Both miniatures illustrate Psalm 105, which refers to Korah (S. Dufrenne, *L'Illustration des psautiers Grecs du Moyen Age*, I, Pantocrator 61, Paris Grec. 20, B.M. Add. 40, 731 [Bibliothèque des Cahiers Archéologiques, I], Paris, 1966, 45, pl. 40 [Paris Grec. 20, fol. 16v]; S. der Nersessian, *L'Illustration des psautiers Grecs du Moyen Age*, II, Londres, Add. 19,352 [Bibliothèque des Cahiers Archéologiques, V], Paris, 1970, fig. 230 [fol. 143v]).

Jewish legend,[97] repeated by the Franciscan exegete Nicolaus de Lyra,[98] asserts that Korah's sons were saved from the earthquake recorded in Numbers 16:10 by "flying in the air."[99]

A scene at the right side of Botticelli's *Punishment of Korah* presents further problems of identification (Pl. XII). A group of men depicted in this part of the composition carry stones; Moses stands among them, pressing one hand to his forehead. Moses' gesture conveys fear and confusion, the *conturbatio* mentioned in the inscription over Botticelli's fresco, CONTURBATIO MOISI LEGIS SCRIPTE LATORIS. In Steinmann's view, the men holding stones may refer to Leviticus 24:10–16, which records the stoning of a blasphemer.[100] Ettlinger suggests that the men holding stones refer to Numbers 14:1–10, which records a threat by the rebellious Jews to stone Moses.[101] And Ettlinger tentatively identifies the distinctive-looking individual standing beside Moses as Joshua (Fig. 30),[102] even though this figure has little in common with images of the Jewish hero found elsewhere in the Sistine Chapel (Pls. XI, XIII).

But I believe that the group of menacing Israelites at the right side of Botticelli's fresco may refer instead to an extrabiblical episode cited in some commentaries on Korah's rebellion. In describing Korah's revolt, both Origen and Rabanus Maurus[103] mention a threat by the Jews to stone Moses. This interpolated episode was probably inspired by Numbers 16:41, the verse that immediately follows the biblical account of Korah's punishment: "And all the children of Israel murmured against Moses and Aaron. . . ." Similar threats figure in other Jewish sources, which record the Lord's warning to Moses that the Jews are a contentious people: "You must be prepared to stand their abuse, even to the length of being pelted by them with stones."[104]

Liturgically speaking, the *Korah* fresco, like Perugino's *Gift of the Keys* directly opposite, evokes the priestly ordinations commemorated at the Passion Sunday Mass. There is no direct liturgical reference to Korah's punishment either on Passion Sunday or on the preceding Saturday, when ordinations were actually conferred. But the striking exemplars of proper and improper priestly conduct in Botticelli's *Korah* fresco echo a key motif of the Roman liturgy on both these days.

In fact, the juxtaposition of Perugino's *Gift of the Keys* with Botticelli's *Punishment of Korah* on the walls of Pope Sixtus's chapel recalls an assertion, by Origen among others, that the power transmitted to Peter along with the keys may be exercised only by worthy priests.[105] Based upon this belief, the rebellious Korah plainly did not merit priestly office. Perugino's *Gift of the Keys* focuses on Peter, appointed by Jesus himself as the first Roman bishop; but the central group of figures in Botticelli's *Punishment of Korah* contrasts unrighteous clerics (Korah, Dathan, Abiram, and their fellow rebels) with righteous priests (Aaron and Eleazar). This visual juxtaposition of worthy and

97. Ginzberg, VI, 104 n. 590.

98. Ettlinger, 69; Lightbown, I, 65.

99. It seems unlikely that the hovering figures are Eldad and Medad (Numbers 11:16–19), as proposed by Steinmann, 234, 241.

100. Steinmann, 234 n. 1.

101. Ettlinger, 70 n. 1.

102. Ettlinger, 70, followed by Lightbown, I, 65.

103. Origen, *Nombres*, 153; Rabanus Maurus, *In Exodum*, col. 684, citing Numbers 16:41ff., speaks of the threatened stoning of Moses.

104. Ginzberg, II, 340.

105. Anciaux, 288, 300.

unworthy clerics recalls the rhetorical antitheses employed by Renaissance orators at the papal court; in their sermons, these preachers repeatedly assign both praise and blame.[106]

Like the Gospel lections of Passion week, which record antagonism toward Jesus, a traditional Epistle of Passion week records antagonism toward Moses. Exodus 15:7–16:2, the pericope in question, recounts the events that took place at the Seventy Palms of Elim. The final verse of the passage conveys the Jews' hostility to their leaders, "Et murmuravit omnis congregatio filiorum Israel contra Moisen et contra Aaron" (Exodus 16:2). The threat of violence reported in Exodus 15:7–16:2, a lesson of the fifth Lenten week, may help to explain why the threatened stoning of Moses is illustrated in Botticelli's *Punishment of Korah*, the fifth fresco on the south wall of Pope Sixtus's chapel. No doubt because it refers to palm trees, Exodus 15:7–16:2 is often assigned to the service at which branches for the Palm Sunday procession were once consecrated: the *Ordo Romanus antiquus*,[107] a twelfth-century *Missal* of the Lateran,[108] and the printed *Missal of 1474*,[109] all specify a reading of this lesson on the Saturday that ends Passion week and immediately precedes Palm Sunday. References to palms in the Roman liturgy on Palm Sunday and on the preceding Saturday are evidently echoed in the decoration of the ancient monument at the center of the *Korah* fresco, for Botticelli has introduced palmette forms into the great frieze of his Constantinian arch.[110]

Many narrative frescoes on the walls of Pope Sixtus's chapel allude to Roman and papal primacy, as Ettlinger makes clear; and there is direct commemoration of the papacy in full-length "portraits" of early popes that ring the sacred chamber above the narrative cycles. These pontifical figures recall Roman church decoration of an earlier time, when papal "portraits," in *tondi*, embellished the walls of Old St. Peter's and S. Paolo fuori le Mura, and full-length papal images decorated the Oratory of S. Niccolò al Laterano.[111] Botticelli's *Punishment of Korah* and Perugino's *Gift of the Keys* further celebrate the papacy and its supreme authority.[112]

Latin epigraphs displayed on Constantinian arches in both frescoes may serve to emphasize the secular power of the popes. Some Renaissance humanists ascribe "political power" to the Latin language;[113] Leon Battista Alberti, for one, claims that Roman emperors derived authority from their knowledge of Latin, and he argues that remnants of imperial splendor survived until the "influence of . . . Latin letters had faded away."[114] Like the emperors of ancient Rome, Pope Sixtus IV, Rome's Christian ruler, evidently sought to express the might of the papacy in the Latin epigraphs inscribed in

106. O'Malley, 1979, 36–76 and passim.

107. *Ordo Romanus I, 42*.

108. Van Dijk, 1975, 215.

109. Lippe, I, 128; Jerome, in a passage derived from Tertullian, interprets the Seventy Palms of Elim and their sources as a figure of baptism (Tertullian, *Traité*, 27).

110. Magi, "Il Coronamento dell'arco di Costan-tino," *Rendiconti*, XXXIX, 1957, 83.

111. Camesasca–Salvini, 153.

112. Lewine, 14–18.

113. Baldwin, 10.

114. Leon Battista Alberti, *The Family in Renaissance Florence*, trans. Renée Neu Watkins, Columbia, S.C., 1969, 151, cited by Baldwin, 10 and n. 23.

golden letters on the attics of Roman triumphal arches in Perugino's *Gift of the Keys* and Botticelli's *Punishment of Korah.*

Discussions of papal authority often allude to Korah's unsuccessful rebellion, the central subject of Botticelli's fresco. For early exegetes, Korah's revolt is a paradigm for any rebellion against the established church:[115] such commentators as Origen, Gregory of Nyssa, and Gregory of Nazianzus draw analogies between the Jewish rebels and clerical intriguers of their own day.[116] Similar interpretations of Korah's rebellion are put forward by Renaissance authors seeking to uphold the popes' authority over church councils. Piero da Monte's *Contra impugnantes,* issued near the middle of the fifteenth century, pointedly compares Korah and his fellow rebels with contemporary conciliarists who dare to challenge papal supremacy.[117] In a related vein, Aeneas Silvius Piccolomini, the future Pope Pius II, expresses concern that his former proconciliar position may consign him to hell with Korah and his rebel band.[118] Rodrigo Sanchez de Arevalo cites the harsh punishment of Korah and his followers in a treatise of 1469 that asserts the pope's superiority over church councils.[119] And Henricus Institoris's *Letter* of 1482, censuring the dissident archbishop, Andreas Zamometič, reminds that rebellious prelate of Korah's grim fate when he dared to challenge Moses and Aaron.[120] Such patristic commentaries and Renaissance glosses on Korah's revolt were doubtless familiar to Sixtus IV and his court. These learned men would quickly have grasped the implied reference to papal supremacy in Botticelli's *Korah* fresco; and they surely understood as well that Botticelli's composition forms a particularly suitable pendant to Perugino's *Gift of the Keys,* the work directly opposite, because the unchallengeable authority of the Roman bishop derives from Christ's consignment of the keys to Peter, from whom all later popes inherit their authority.

Somewhat surprisingly, a group of grounded ships located behind the triumphal arch in Botticelli's *Korah* fresco may serve as additional emblems of papal authority (Fig. 29). Steinmann was perplexed by the apparent lack of connection between Korah's fate and this unexpected detail in Botticelli's composition.[121] But the shipwrecked vessels may, in fact, refer to an account of Korah's rebellion in Josephus's *Jewish Antiquities.* There it is recorded that when Moses was threatened with stoning,[122] he urged the Lord to punish Dathan and Abiram;[123] at this point, "Suddenly, the earth shook . . . as when a wave is tossed by the violence of the wind."[124] Josephus's metaphor of the wind-tossed wave may help to explain the beached ships near the central axis of the *Korah* fresco. If this puzzling scene in Botticelli's composition does, in fact, refer to Josephus's description of the earthquake that destroyed the Jewish rebels, the

115. Origen, *Nombres,* 162ff.

116. Origen, *Nombres,* 165; Gregory of Nyssa, *Moïse,* 297f. and n. 2.

117. Stinger, 203ff.

118. Ettlinger, 105f.

119. Hubert Jedin, "Sanchez de Arevalo und die Konzilsfrage unter Paul II," *Historisches Jahrbuch im Auftrag des Görresgesellschaft,* LXXIII, 1954, 94 and n. 4; 96 and n. 4; 97, 117, cited in Ettlinger, 106 and n. 3.

120. Ettlinger, 107ff.

121. Steinmann, 498.

122. Josephus, *Antiquities. I–IV,* bk. IV, line 22, 486: here the translator adds a note on the Stoning of Moses, "traditional detail, not in Scripture."

123. Josephus, *Antiquities. I–IV,* bk. IV, lines 47ff., 499.

124. Josephus, *Antiquities. I–IV,* bk. IV, lines 51ff., 501.

shipwrecked vessels vividly demonstrate the Lord's power to punish such presumptuous and unworthy claimants to religious office as Dathan and Abiram.[125] Josephus's metaphor of the wind-tossed wave makes a point about God's protection of legitimate religious leaders that may have seemed worth illustrating in the major papal chapel of Rome.

Liturgically speaking, the triumphal arches in Perugino's *Gift of the Keys* and Botticelli's *Punishment of Korah* recall the Roman custom of erecting temporary arches for the Palm Sunday procession led by the pope.[126] From a political point of view, the Constantinian arches in both frescoes evoke the ancient *Donation of Constantine*, a famed, if forged, source of pontifical authority.[127] In addition, the painted arches and censers in these compositions echo the iconography of papal ceremony.

In Renaissance Rome, a pontifical rite involving both arches and censers, the festival of *archi e turiboli*, took place on Easter Monday.[128] The occasion is described in the *Liber censum* of the Roman church, compiled in the late twelfth century,[129] but still known at the papal court in the quattrocento.[130] During this festival, the pope rode on horseback from the Vatican Palace to the Lateran complex, along a route known as the *Via sacra* or *Via papalis*. Temporary arches were erected along the road for this occasion, and coins were thrown to spectators lining the processional route.[131] On his arrival at the Lateran, the pontiff was greeted by the clerics of Rome, each swinging a thurible filled with incense.[132]

The *possesso*, another pontifical ceremony involving arches and censers, was regularly scheduled following papal elections. This celebration, already known in the ninth century,[133] again involved a formal procession from St. Peter's basilica to the Lateran.[134] An account of the *possesso* appears under the heading *De clericis Romanis occurentibus Pape* in a *Ceremonial* of the papal court compiled between the pontificates of Nicholas V and Sixtus IV.[135] According to this description, triumphal arches extolling the new pope were erected along the path traversed by the pontiff; the pope was censed by the clerics of Rome as he traveled the processional route in his official *sedia*;[136] and a member of the papal household threw coins to spectators along the way.[137] During the course of this ceremony, the newly elected Roman bishop was presented with keys to both his papal churches, St. Peter's and the Lateran;[138] these keys symbolized the papal power "of closing and opening, of binding and absolving."[139]

125. Lightbown, I, 67, suggests a connection between this image and paintings of ships in antiquity.

126. Cancellieri, 1818, 7.

127. Ettlinger, 113; Roberto Salvini, "The Sistine Chapel: Ideology and Architecture," *Art History*, III, 1980, 147, 151.

128. The Monday and Tuesday after Easter were important feast days; with Easter Sunday, they were regarded from the early Christian era as the *triduum sacrum* of the Resurrection (Jungmann, 1959, 253).

129. The *Liber censum* was compiled in 1192 by Cencio Savelli, or Cencio Cameraria, the future Pope Innocent III (Fabre, 1ff.). For the history of the text, see Huelsen, 5f.; Armellini, I, 53ff.

130. Fragments of the *Liber censum* are still cited by Innocent VIII in a letter of 1486 (Fabre, v, 6). Three examples of the work were in the papal library in the fifteenth century; one appears in an inventory prepared by Platina for Sixtus IV (Fabre, 204, 212).

131. Huelsen, 5; Armellini, I, 54f.

132. Armellini, I, 55.

133. Stinger, 53.

134. Stinger, 53ff.

135. Nabuco, 23 (Vat. Urb. Lat. 496, fol. 9r).

136. Nabuco, 23.

137. Cancellieri, 1802, xiii.

138. Cancellieri, 1802, xiv.

139. Stinger, 55.

The central scene in Perugino's *Gift of the Keys* recalls the ceremonial transmission of keys to newly elected popes of the Renaissance. And Perugino's "Payment of the Tribute Money" (Fig. 23), a subsidiary scene in the same fresco, recalls the coins distributed both at the papal *possesso* and at the festival of *archi e turiboli*.[140] Even the golden wand that Moses wields in Botticelli's *Punishment of Korah,* directly opposite, echoes a detail of the papal *possesso,* for new popes were handed an official rod at that ceremony, "as a sign of rule and correction."[141] These evocations of papal ritual in the *Punishment of Korah* and the *Gift of the Keys* impart a distinctively pontifical tone to both works.

NEMO SIBI ASSUMMAT HONOREM NISI VOCATUS A DEO TANQUAM ARON, the golden words on the central arch in Botticelli's *Punishment of Korah* (Fig. 27), recall the Latin text of Numbers 16:40, the final line in the biblical history of Korah. The verse cautions the Jews that no stranger (no one not of Aaron's race) may offer incense to the Lord, "Ne quis accedat alienigena et qui non est de semine Aron ad offerandum incensus domino." But as Steinmann pointed out long ago, the inscription on the triumphal arch also resembles Hebrews 5:4, "Nec quisquam sumit sibi honorem sed qui vocatur a Deo tanquam Aron."[142] The verse may be translated, "Let no man presume to take [this] honor upon himself unless called by God as Aaron was." As Steinmann knew, Hebrews 5:4 is assigned to the ninth lesson of the Office of *Tenebrae* on Good Friday.[143] Thus, like other elements within the *Korah* fresco, the inscription on the Constantinian arch recalls a text assigned in the Roman liturgy during the latter part of Lent.

In addition, the inscription on the central arch of triumph in Botticelli's *Punishment of Korah* recalls a recurring event commemorated in the Roman liturgy.[144] Like Numbers 16:40, Hebrews 5:4 could point to the divine source of papal authority because popes, like Aaron, are essentially chosen by God.[145] Liturgists in the quattrocento apparently read Hebrews 5:4 in this way, for the fifteenth-century *Ceremonial* of the papal court just described above assigns the passage containing this verse to the recurrent period known as the *sede vacante.*[146] This is the interval between the death of one pope and the elevation of another, the moment when Saint Peter's seat is temporarily vacant. Hebrews 5:4 is a verse assigned to the Office recited by cardinals while they are engaged in selecting a new pope.[147]

The Latin epigraph on the central arch of triumph in Botticelli's *Punishment of Korah* names Aaron, who (somewhat surprisingly) makes his unique appearance on the Sistine Chapel walls in this composition. Within the *Korah* fresco, Aaron is overshad-

---

140. Coins were tossed to the crowd at Monte Giordano and at other designated spots en route to the Lateran. Upon reaching the basilica, the pope threw coins to the crowd, while reciting the words, "Gold and silver are not mine, what I have I give to you," from Acts 3:6 (Stinger, 54).

141. Stinger, 55.

142. Steinmann, 240.

143. D. P. Guéranger, *La Passion de la semaine sainte,* Paris, 1857, cited by Steinmann, 240 n. 1; Van Dijk, 1975, 243.

144. Lewine, 17.

145. On the use of this text to support the belief that priests are divinely chosen, see Ettlinger, 68f.

146. Nabuco, 201 (Vat. Urb. Lat. 496, fol. 77r): Officium misse vacante sede apostolica.

147. Sixtus IV plainly understood the meaning of Hebrews 5:4 for the doctrine of papal supremacy; he cites the verse at the conclusion of a bull excommunicating the dissident archbishop Andreas Zamometič (Stinger, 205; Ettlinger, 107ff.).

owed by Moses, who appears there no less than three times. Nevertheless, once literate spectators read Aaron's name on the central arch of triumph in the *Korah* fresco, they are encouraged to seek out the high priest's image. And Botticelli's Aaron is clearly a pontifical figure: wearing a papal tiara of della Rovere blue and gold, the high priest is represented in strict profile, from the shoulders up, like a papal portrait stamped on a medal. Reacting to these verbal and visual clues, learned members of "papal chapels" in Sixtus IV's day could hardly fail to recognize the pontifical meaning of the Latin epigraph in Botticelli's *Punishment of Korah.*

From the outset, the Sistine Chapel was expressly designated as a place for cardinals and others to reside during papal conclaves.[148] This meant that Hebrews 5:4, one of the biblical texts amalgamated into the Latin inscription displayed in Botticelli's *Korah* fresco (Fig. 27), would be recited in Pope Sixtus's chapel as part of the Office assigned at times of pontifical elections.[149] Knowledge of this fact permits an expanded reading of the Latin epigraph in Botticelli's *Punishment of Korah.* To those taking part in papal conclaves, the golden words displayed on the arch would recall not only Korah's impious and abortive challenge to the surpreme (and quasi-papal) authority of Moses and Aaron, the Lord's chosen representatives (Numbers 16:40), but also a verse as-signed in the Roman liturgy to the interval known as the *sede vacante* (Hebrews 5:4). During this fateful period, cardinals and other designated persons are authorized to meet in the Vatican palace, and there, under God's guidance, to choose the next legitimate ruler of the Roman church. Small wonder that the evocative words NEMO SIBI ASSUMMAT HONOREM NISI VOCATUS A DEO TANQUAM ARON were boldly emblazoned on the central arch of triumph in Botticelli's *Punishment of Korah.*

148. Ettlinger, 10.
149. It is still assigned to this occasion in the modern *Missale Romanum,* MR (70): Missa pro eligendo summo Pontefice.

# VI

## THE SIXTH FRESCOES ON THE LONG WALLS

### The *Last Supper* and the *Last Testament of Moses*

TITULI:
REPLICATIO LEGIS EVANGELICAE A CHRISTO
and
REPLICATIO LEGIS SCRIPTAE A MOISE

Both Rosselli's *Last Supper* (Pl. VI), the final Christological fresco on the long north wall of the Sistine Chapel, and Signorelli's *Last Testament of Moses* (Pl. XIII), the Mosaic fresco directly across the chamber, recall texts and rituals of Holy Week, the final week in Lent. Scriptural episodes portrayed in both compositions evoke three major liturgical days of Holy Week: Palm Sunday, Holy Thursday, and Holy Saturday. These biblical scenes recall Pope Sixtus IV's interest in reorganizing the Holy Week liturgy.[1]

An octagonal chamber provides the setting for Rosselli's *Last Supper*. The ceiling of this dining room is carved elaborately; its floor gleams with colored marbles. Within the dining chamber, Jesus sits behind a five-sided table with eleven of his disciples. Judas is isolated on the near side of the table. Decorative pilasters on the back wall of the room frame three windowlike apertures, through which there appear images of the Agony in the Garden, the Betrayal, and the Crucifixion. Persons in quattrocento dress stand on both sides of the painted chamber looking on at these momentous events.

All of the episodes represented in Rosselli's *Last Supper* (Pl. VI) are recorded in accounts of Christ's Passion given by Matthew, Mark, Luke, and John; these texts are assigned, respectively, to Palm Sunday, to Tuesday and Wednesday of Holy Week, and to the Good Friday service. This pattern of Holy Week readings is specified, for example, in the printed *Missal of 1474*.[2] For the most part, the Christological cycle of Pope Sixtus's chapel illustrates pericopes from Matthew's Gospel. But as Goffen points out, parts of Rosselli's *Last Supper* allude to episodes reported only by John. A small

1. Steinmann, 576f.    2. Lippe, i, 136, 144, 151, 163.

black devil shown whispering into Judas's ear refers to John 13:2; and some vessels on the chamber floor remind the viewer that Christ washed his disciples' feet at the Last Supper (John 13:4–12).[3] These specifically Johannine references in Rosselli's composition echo the shape of the Roman liturgy during the final weeks of Lent, when many lections of the Masses are drawn from John's Gospel.[4] Nevertheless, in keeping with a pattern generally observed throughout the Christological cycle, it is most likely that Rosselli's *Last Supper* refers principally to Matthew's account of the Passion, a traditional Palm Sunday lesson.[5] As Durandus of Mende explains, this pericope is read on Palm Sunday, the first day of Holy Week, because Matthew's text gives the earliest written account of Christ's last earthly days.[6] If Rosselli's *Last Supper* does in fact illustrate the traditional Gospel lesson of Palm Sunday, this fresco, like others in the Christological cycle, evokes a text assigned in the Roman liturgy to a Sunday that falls between Advent and Pentecost.[7]

Near the center of the *Last Supper* fresco, Rosselli shows Jesus blessing the host and chalice. The absence of food or dishes on the table before Christ indicates that the scene refers less to Jesus' final meal with his disciples than to one of the crucial events that took place in the course of that meal: the institution of the sacrament of the Eucharist.[8] Liturgically speaking, Rosselli's image of Jesus blessing the host and chalice evokes the Vespertine Mass on Holy Thursday, which commemorates Jesus' institution of the Eucharist at the Last Supper.[9]

The pitchers and basin isolated on the marble pavement near the foreground of Rosselli's *Last Supper* recall another event commemorated in the Holy Thursday liturgy: the washing of the disciples' feet at the Last Supper. Such liturgical books as the *Missal of 1474* assign John's account of the ritual *pedilavium* (John 13:1–15) to the Vespertine Mass on Holy Thursday.[10] Baptismal meaning may also be attached to the vessels on the floor in Rosselli's *Last Supper,* for some exegetes, particularly in the Byzantine world, regard the washing of the apostles' feet as their baptism. (This interpretation of the *pedilavium* helped to resolve a grave theological problem: although baptism is required of all Christians, no evidence exists that Jesus' original disciples were ever baptized.)[11]

Two scenes at the background of Rosselli's *Last Supper,* "The Agony in the Garden" and "The Betrayal," evoke still other motifs of the Holy Thursday liturgy. Both the Masses and the Office of Holy Thursday contain repeated allusions to Jesus' Agony in the Garden,[12] and the Betrayal is another prime liturgical subject on that day.[13] An image of the Crucifixion, in the third framed scene at the background of Rosselli's fresco, recalls the Good Friday service commemorating Jesus' death on the cross.

---

3. Goffen, 258.

4. See Chapter V, 72.

5. Righetti, II, 151; Jungmann, 1959, 261.

6. Durandus, 1479, fol. 189r.

7. See Chapter I, 15f.

8. Steinmann, 414; Ettlinger, 83 and n. 1.

9. Righetti, II, 153.

10. Lippe, I, 157. Ambrose, *Sacraments,* 28, describes the washing of the feet of the newly baptized on Easter Eve, rather than on Holy Thursday.

11. Ernst H. Kantorowicz, "The Baptism of the Apostles," *Dumbarton Oaks Papers,* IX/X, 1955/56, 207ff.

12. Righetti, II, 153, 155.

13. Righetti, II, 153.

Rosselli's *Last Supper* is filled with references to the number eight, linked from Christian antiquity onward with baptism, Easter, and resurrection.[14] Rosselli's insistence upon this symbolic number in his *Last Supper* was not lost upon Vasari, who describes Rosselli's composition (not altogether accurately) as "l'ultima cena degli apostoli . . . nella quale [Rosselli] fece una tavola a otto facce in prospettive e sopra quella, in otto facce simili, il palco che gira in otto angoli."[15] Several devices from Sixtus IV's coat of arms embellish the eight-sided dining chamber in Rosselli's fresco. Golden acorns decorate the octagonal ceiling, which is marked at its center point by an eight-sided medallion bearing the oak tree of the della Rovere.[16] By incorporating these emblems from Sixtus IV's *stemma* into the *Last Supper* fresco, Rosselli may have wished to signify that the first della Rovere pope participates symbolically in the culminating events of Christ's earthly life that the Holy Week liturgy commemorates.

Early Christian numerology may also account for the five-sided table in Rosselli's *Last Supper* fresco. According to Goffen, this striking piece of furniture (not altogether unlike sigma-shaped tables in Last Supper scenes of Christian antiquity)[17] may allude to Christ's Five Wounds, which Franciscans venerated.[18] If Goffen's supposition is correct, Rosselli's table would constitute yet another reference to the Holy Week liturgy, specifically, to the Good Friday service commemorating the Crucifixion, the occasion when Christ received his five wounds. In addition, the striking table in Rosselli's *Last Supper* could remind worshipers in Pope Sixtus's day that the table used at the Last Supper was a sacred relic of Renaissance Rome; Giovanni Rucellai admired the treasured piece of furniture at the Lateran during his visit to Rome in the Jubilee year of 1450.[19]

REPLICATIO LEGIS EVANGELICAE A CHRISTO, the *titulus* over Rosselli's *Last Supper* fresco, does not allude directly to events portrayed in the composition below. This inscription, which mentions repetition of the evangelical law, may refer instead to the experience of early catechumens, who accepted Christ's law during their baptismal initiation on Easter Eve by publicly repeating the *Credo* and *Pater noster*.[20] In Christian antiquity, the first communion of the *electi* immediately followed their baptism on Easter Eve;[21] in this way, as Leo the Great observes, the catechumens' first reception of the Eucharist served to consummate their sacramental imitation of Christ, already begun at their baptismal initiation during the same Holy Saturday service.[22] The Eucharistic host and chalice near the center of Rosselli's fresco recall the First Communion of early catechumens.

A snarling cat and dog square off at one another near the foreground of Rosselli's *Last Supper*. These animals, isolated against the colored marble floor where they attract the viewer's attention, may also have Eucharistic meaning. As Leo Steinberg points out, dogs are sometimes introduced into Last Supper scenes to recall Christ's words,

14. See Chapter I, 15.
15. Vasari (Milanesi), III, 187f., cited by Steinmann, 392.
16. Steinmann, 414.
17. Réau, II, 2, 411.
18. Goffen, 258f. and n. 145.

19. Stinger, 36; see also Ragusa–Green, 401 n. 200.
20. See Chapter IV, 50f.
21. Dix, 356; Jungmann, 1959, 263; Righetti, IV, 79f.
22. Leo, *Sermons I*, 41.

"Do not give that which is holy to dogs" (Matthew 7:6); from an early date, this biblical injunction is understood to signify unworthy reception of the Eucharist.[23] A dog (and a cat) who represent unworthy recipients of the Eucharist might well serve as cautionary symbols in Rosselli's *Last Supper,* for the fresco evokes both the institution of Eucharist at the Last Supper (recalled in the Holy Thursday liturgy) and the catechumens' first reception of the Eucharist (which once took place on Easter Eve).

The fresco directly across the Sistine Chapel from Rosselli's *Last Supper,* Signorelli's *Last Testament of Moses* (Pl. XIII),[24] is the final Mosaic composition on the long south wall. In most frescoes of the Mosaic cycle, the narrative proceeds in order from right to left; but the foreground scenes in Signorelli's composition are ordered in the opposite direction and flow from left to right. Reacting to the unexpected directional shift, spectators are likely to pause before Signorelli's composition; and this enforced pause may help viewers to recognize that the first biblical scene in the *Last Testament of Moses* illustrates a crucial occasion in the life of Joshua, a Jewish hero of particular importance to Christians.

At the left side of Signorelli's fresco in the foreground, Moses is seen transferring his staff of leadership to Joshua, his successor (Fig. 31).[25] For many Christian exegetes Joshua is a Jewish precursor of Jesus, in part because their names are similar.[26] Consequently, Moses' transfer of his official staff to Joshua can be said to symbolize the supplantation of Judaism by Christianity.[27] Rupert of Deutz offers precisely this interpretation of the transfer in his commentary on the Holy Saturday liturgy.[28] Thus, the supplantation of Judaism by Christianity, a key liturgical theme of Easter Eve, is evoked in Signorelli's *Last Testament of Moses,* as in several other narrative frescoes on the Sistine Chapel walls.[29]

The high visibility of Moses' staff in Signorelli's *Last Testament of Moses* (and in other Mosaic frescoes of Pope Sixtus's chapel) recalls a detail of pontifical ceremony. During the quattrocento, a rod or *ferula,* symbolizing papal office, was presented ceremonially to each newly elected pope at his *possesso;* Sixtus IV's immediate successor, Pope Innocent VIII, received such a rod during his official "possession" of the Lateran in 1484.[30] Moreover, the recurring images of Moses' wand, in Signorelli's *Last Testament of Moses* and elsewhere in Pope Sixtus's chapel, could remind worshipers that the patriarch's staff was one of those sacred treasures that made Rome the premier city of Christendom; during the Renaissance, the precious Mosaic relic was housed at the Vatican.[31]

23. Leo Steinberg, "Leonardo's *Last Supper,*" *Art Quarterly,* XXXVI, 1973, 405. I owe this reference to Jack Wasserman.

24. In this fresco, Signorelli may have been assisted by Bartolomeo della Gatta (Alberto Martini, "The Early Work of Bartolomeo della Gatta," *Art Bulletin,* XLII, 1960, 141 and n. 28). According to Shearman, 1986, 46, the fresco was probably begun by Perugino, whose drawing style may be seen toward the left side.

25. Ettlinger, 49 and n. 1, observes that this scene, illustrating an extrabiblical incident, appears in a

number of Western medieval manuscripts, which he lists.

26. Brenk, 1975, 122 n. 140, cites such statements from Jerome, Tertullian, Augustine, and Ambrose.

27. Ettlinger, 73, further discusses the symbolism of Moses' rod and the meaning of its transfer to Joshua.

28. Rupert of Deutz, *Liber de divinis oficiis,* 232.

29. See Chapters II and V, 29f., 69.

30. Cancellieri, 1802, 50.

31. Réau, II, 1, 176 n. 2.

Signorelli's narrative continues near the center foreground of his *Last Testament of Moses*. There, a group of men form a semicircle around a seated, half-nude youth (Fig. 31),[32] of whom more later. The next event in chronological sequence is depicted in the right foreground of the composition. In this scene, Jewish elders and other members of the Israelite community cluster around Moses; the patriarch, enthroned on the far bank of a small stream, clasps the book of the law in his hands (Fig. 32). This part of Signorelli's fresco appears to illustrate the accompanying *titulus*, REPLICATIO LEGIS SCRIPTAE A MOISE, for the aged Moses is evidently repeating tenets of the written Mosaic law contained within the massive volume that he holds.

The biblical narrative continues in the background of Signorelli's *Last Testament of Moses*. There, Moses is first shown at the edge of a cliff, accompanied by an angel who points into the distance (Fig. 33); this scene represents Moses on Mount Nebo viewing the promised land of milk and honey, which he was not, however, permitted to enter. The following episode in chronological sequence is illustrated further to the left in the background of Signorelli's fresco; this scene, in which the patriarch looks down from the mountain,[33] may represent Moses Going to his Death.[34] The final Mosaic episode in Signorelli's composition appears still further to the left in the background; in this part of the fresco, the mourning Israelites hover over their leader's dead body.[35]

Correspondences between this Mosaic fresco by Signorelli—which depicts Moses' last acts and death—and Rosselli's Christological fresco directly opposite—which depicts Christ's last acts and death—are so obvious that it seems unnecessary to offer any further explanation for the juxtaposition of these works. But it is important to recognize, in addition, that both frescoes illustrate Holy Week lections. As I have pointed out already, Rosselli's *Last Supper* probably refers to the traditional Gospel lesson of Palm Sunday. Similarly, Signorelli's *Last Testament of Moses* illustrates a pericope invariably read at the Vigil Mass on Holy Saturday, Deuteronomy 31:22–30.[36] This Old Testament passage, already specified as a Holy Saturday reading in one of the oldest known Roman lectionaries,[37] is assigned to Easter Eve by Amalarius of Metz,[38] by Durandus of Mende,[39] and by the *Missal of 1474*.[40] Signorelli's *Last Testament of Moses* directly illustrates at least two events recorded in this pericope: the appointment of Joshua as Moses' successor (Deuteronomy 31:23), and the gathering of the elders of Israel to hear Moses (Deuteronomy 31:28). In addition, the background scenes in Signorelli's fresco, "Moses Viewing the Promised Land," "Moses Going to His Death," and "The Israelites Mourning over Moses' Body," recall events adumbrated in Deuteron-

32. As in most other history frescoes on the Sistine Chapel walls, some of these bystanders are portraits of members of the papal court (Bernabei, 52).

33. According to Ettlinger, 52, this scene may be based on illustrations in Octateuch manuscripts. Kury, 81f. and n. 23, connects the scene with Deuteronomy 34:1–4.

34. Kury, 82 n. 23.

35. Ettlinger, 49 n. 2, for the observation that this is an extrabiblical subject.

36. Chavasse, "Le cycle pascal," in Martimort, 696.

37. This is the *Comes of Alcuin*, preserved in a ninth-century manuscript, Paris, Bibl. Nat. Lat. 9425 (*DACL*, v, 1, col. 266, no. 65, s.v. "Epitres").

38. Amalarius, *De ecclesia officio*, cap. 22, 134.

39. Durandus, 1568, 236r.

40. Lippe, 1, 187.

omy 31:22–30. That Holy Saturday lesson alludes both to the promised land (Deuteronomy 31:23) and to Moses' death (Deuteronomy 31:27 and 29).

Another verse of this Holy Saturday lection, Deuteronomy 31:25, mentions the Ark of the Covenant, represented near the right foreground of Signorelli's *Last Testament of Moses,* with gold and purple irises growing festively around it.[41] Deuteronomy 31 makes no reference to the golden bowl or to the tablets of the law, shown resting on the ark in Signorelli's fresco; but Hebrews 9:4 does speak of these sacred items in conjunction with the holy ark.[42] According to Hebrews 9:4, the golden pot stored within the ark contained manna; as suggested by this text, the whitish substance within the golden bowl that stands on the ark in Signorelli's fresco may be that heaven-sent food. The typological meaning of "manna" is expounded in commentary on Deuteronomy 31 from the *Glossa Ordinaria:* "Ibi urna quae continet manna, id est caro Christi."[43] This explanation equates manna, the miraculous food that saved the Jews in the desert, with Christ's body and, by extension, with the Eucharistic host, a miraculous "food" that offers salvation to Christians. Based upon this interpretation of manna, a golden bowl of that heavenly food in Signorelli's *Last Testament of Moses* could remind worshipers of two key events recalled in the Holy Week liturgy: the institution of the Eucharist (commemorated on Holy Thursday) and the first communion of early catechumens (once scheduled on Holy Saturday). A bowl of manna in Signorelli's *Last Testament of Moses* would parallel the Eucharistic host displayed in Rosselli's *Last Supper* fresco.[44] Juxtaposition of a Last Supper scene with an image of manna may reflect a long-standing convention in religious art. The subjects are already linked on the Romanesque altar frontal of 1181 known as the *Verdun Altar;* on that masterpiece of Mosan enamelwork, an image of manna in an urn accompanies a Last Supper scene.[45]

The tablets of the Mosaic law are sometimes represented as a kind of diptych, and sometimes as a single fixed panel bisected into vertical segments. But in narrative frescoes of Pope Sixtus's chapel, Moses' Ten Commandments invariably occupy two unconnected tablets.[46] A Mosaic tablet stands at either side of the golden bowl that rests on the Ark of the Covenant in Signorelli's *Last Testament of Moses* (Pl. XIII);[47] and the Mosaic tablets are clearly separated throughout Rosselli's *Lawgiving on Mount Sinai* (Pl. XI). This circumstance may be meaningful. In commentary on the Mosaic tablets stored within the ark, the anonymous author of the *Glossa Ordinaria* observes, "Ibi duae tabulas testimonii, libri scilicet legis et evangelii."[48] Based upon this explana-

41. Levi D'Ancona, 1977, 188, has suggested that these flowers, named for the messenger goddess of Olympus, appear beside Moses as symbols of his message to the Jewish people.

42. Ettlinger, 71.

43. *Glossa Ordinaria,* col. 487.

44. Ettlinger, 71.

45. H. Buschhausen, *Der Verduner Altar,* Vienna, 1980, 44, pl. III. At S. Giorgio Maggiore, Venice, Tintoretto's famed *Last Supper* stands opposite a depiction of the Fall of Manna.

46. For various representations of the tablets of the Law, Ruth Mellinkoff, "The Round-Topped Tablets of the Law: Sacred Symbol and Emblem of Evil," *Journal of Jewish Art,* I, 1974, 28ff., figs. 1–6 (diptychs); figs. 9, 12, 13 (separated).

47. Representation of the tablets as rectangles conforms to the account in the Bible and in the Talmud (Mellinkoff, "The Round-Topped Tablets of the Law," 28; Cecil Roth, "Jewish Antecedents of Christian Art," *Journal of the Warburg and Courtauld Institutes,* XVI, 1953, 31).

48. *Glossa Ordinaria,* col. 487.

tion, the separated tablets of the law that decorate the ark in Signorelli's *Last Testament of Moses* may reflect the traditional distinction between the old written law of Moses and Christ's new evangelical law. As I have pointed out already, this distinction is stressed in juxtaposed legends accompanying the third fresco on each long wall of Pope Sixtus's chapel: CONGREGATIO POPULI LEGEM EVANGELICAM RECEPTURI and CONGREGATIO POPULI A MOISE LEGEM SCRIPTAM ACCEPTURI.[49] And the distinction is emphasized again in the *tituli* above the juxtaposed frescoes under discussion here: Rosselli's *Last Supper*, inscribed REPLICATIO LEGIS EVANGELICAE A CHRISTO, and Signorelli's *Last Testament of Moses*, inscribed REPLICATIO LEGIS SCRIPTAE A MOISE.

In the background of Signorelli's *Last Testament of Moses*, an angel shows Moses the promised land of milk and honey (Fig. 33); this scene recalls the ceremonial drink of milk and honey once offered to early catechumens on Easter Eve immediately after their baptism.[50] Both Hippolytus's *Apostolic Tradition*[51] and Tertullian's *De Baptismo*[52] record that catechumens were offered a mixture of milk and honey, as well as the Eucharistic elements, at the baptismal Mass on Holy Saturday.[53] In the early Middle Ages, John the Deacon links the symbolic beverage with the Easter Vigil.[54] A benediction for the drink of milk and honey follows the Easter Mass in Egbert of York's *Pontifical,* and similar blessings appear in *Missals* up to the fourteenth century.[55] As late as the nineteenth century, a beverage of milk and honey was still offered at the Lateran on Holy Saturday.[56]

This liturgical drink, symbolizing the entry of baptismal candidates into the promised land of milk and honey,[57] must have seemed well suited to the newly baptized, who were often likened to children.[58] Augustine, for example, calls these new Christians "infantes."[59] Although situated in the background of Signorelli's *Last Testament of Moses,* the image of Moses Shown the Promised Land occupies a prestigious spot near the central axis of Signorelli's composition; indeed, Vasari describes the entire fresco by reference to the subject: "[Signorelli] . . . dipinse il Testamento di Mosè al popolo Ebreo nell'avere veduta la terra di promessione."[60] As Vasari may have understood, this axial scene could recall the ritual drink of milk and honey once offered to catechumens on Holy Saturday.

A handsome, half-nude youth sits near the center foreground of Signorelli's *Last Testament of Moses* (Fig. 31). Judging by his place in the composition, the young man

49. See Chapter IV, 53f.

50. Salvini–Camesasca, 161.

51. Hippolytus, *Tradition*, 92; see also Jungmann, 1959, 35. The *Apostolic Tradition* was not known directly after late antiquity until the nineteenth century, but Hippolytus's work was transmitted through a medieval Pontifical consulted by the papal masters of ceremony, Giovanni Burckhard and Agostino Patrizi de' Piccolomini, while composing their Pontifical of 1485 (Jungmann, 1959, 53, 57, 64). Thus, parts of Hippolytus's text must have been known in papal circles during the reign of Sixtus IV, who died in 1484.

52. Tertullian, *Traité,* 44.

53. Jungmann, 1986, II, 260.

54. Righetti, IV, 79.

55. Jungmann, 1959, 35, 139.

56. Moroni, 300.

57. Righetti, IV, 79.

58. Righetti, IV, 13, cites pseudo-Barnabas: "Quare lac et mel? quoniam infans primam melle tunc lacte viviscit."

59. Augustine, *Pâque,* 112.

60. Vasari (Milanesi), III, 691, cited by Steinmann, 516 n. 1. See also Adelheid Heimann, "Moses Shown the Promised Land," *Journal of the Warburg and Courtauld Institutes,* XXXIV, 1971, 321–24.

must be someone of importance. But he is evidently not a character in Mosaic history; nor is he one of those Renaissance notables who mingle freely on the Sistine Chapel walls with biblical figures in antique costume. Steinmann, identifying the youth as a personification of the tribe of Levi, explains his nudity by reference to Numbers 18:20 and 23, in which the Levites' traditional poverty is described.[61] Ettlinger, rejecting Steinmann's interpretation,[62] takes up Franz Wickhoff's suggestion that the nude youth stands for the stranger among the Israelites to whom the laws of Moses also apply.[63] In fact, Ettlinger speculates further that the seated young man may represent the Church of the Gentiles, who were, by definition, strangers to the Mosaic law.[64]

The apparent impact of the Holy Week liturgy on Signorelli's *Last Testament of Moses* suggests to me that the half-naked youth, so prominent in the composition, should be identified with the early catechumens whose baptism took place on Easter Eve. It was well known in Renaissance Rome that early catechumens were baptized on Holy Saturday.[65] Both the church fathers and medieval exegetes allude to baptism at this Vigil Mass; in commentary on the service of Holy Saturday, Rupert of Deutz, for one, reflects at length upon the sacrament of baptism.[66] Baptism is further evoked by the Roman station of Holy Saturday: the cathedral of S. Giovanni in Laterano. This church, dedicated jointly to the Savior and to John the Baptist, adjoins the pontifical baptistery of Rome, where popes customarily conducted baptismal ceremonies during the Holy Saturday Vigil; this practice is attested by a late thirteenth-century *Missal* reflecting usage of the papal chapel.[67] Even the modern *Roman Missal* retains a benediction for baptismal waters as part of the Easter Eve liturgy.[68]

If my baptismal interpretation of the seminude youth in the *Last Testament of Moses* is correct, Signorelli (or an expert adviser) may have employed this half-clad figure to stand for the catechumens once baptized on Easter Eve, because he knew that early catechumens wore little or no clothing at their baptism. This is clear from an instruction in Hippolytus's *Apostolic Tradition,* "Let them (the candidates) stand in the water naked";[69] Saint Ambrose repeats this injunction in one of his sermons.[70] Moreover, the muscular body of the half-dressed youth seated near the center of Signorelli's fresco recalls the athletic imagery traditionally invoked to characterize the catechumens' intensive preparation during Lent. Athletic metaphors figure in the Roman liturgy from the start of the pre-Lenten season: the Epistle of Septuagesima Sunday, for example, likens Christians at the opening of Lent to athletes "qui in stadio currunt" (I Corinthians 9:24). And athletic imagery is often employed to characterize the Lenten season. Pope Leo the Great speaks of Lent as a "jejuniorum stadium" and a "quadraginta dierum

---

61. Steinmann, 524 n. 1.
62. Ettlinger, 72.
63. Franz Wickhoff, "Den Apollo von Belvedere als Fremdling bei der Israeliten," *Schriften,* ii, ed. M. Dvorak, Vienna, 1913, 406ff., cited by Ettlinger, 72 nn. 2, 3.
64. Ettlinger, 72.

65. Chavasse, "Le cycle pascal," in Martimort, 697.
66. Van Engen, 65.
67. Andrieu, 367.
68. *MR,* 201: Sabbato Sancto, De Vigilia Paschali. De benedictione aquae baptismalis.
69. Jungmann, 1959, 81 n. 23.
70. Righetti, iv, 63.

exercitatio";[71] Amalarius describes Lent as a time of spiritual combat.[72] Athletic symbolism was even attached to the liturgical unctions that preceded baptism in the early church. Before the baptismal candidate approached the font on Easter Eve, a priest and deacon would oil his chest and shoulders as though he were an athlete; as Ambrose told catechumens of his day, "Unctus es . . . quasi athleta Christi."[73]

The seminude youth seated near the center foreground of Signorelli's *Last Testament of Moses* resembles other athletic figures created by that artist. As Colin Eisler shows, other works by Signorelli contain male nudes of athletic build who evoke both the sacrament of baptism and the person of John the Baptist.[74] In Signorelli's Munich *tondo*, for example, a youthful nude Saint John perches on a tree stump situated on the far bank of a river (Fig. 34). By means of this composition, Signorelli conveys the baptismal message that John must pass through the water to the near shore of the stream, in order to reach the Virgin and Child who await him there.[75]

The youthful Baptist in Signorelli's Munich *tondo* supports one leg on the other as he loosens his sandal. This pose clearly derives from the *Spinario* (Fig. 7),[76] an antique bronze statue seemingly endowed with baptismal meaning by Signorelli and other Renaissance artists. I have already singled out an athletic nude of the *Spinario* type near the foreground of Perugino's *Baptism of Christ*, on the north wall of the Sistine Chapel (Fig. 4);[77] this youth, shown drying his feet, evidently represents a catechumen recently baptized in the Jordan. Inasmuch as the *Spinario* copies in Signorelli's Munich *tondo* and in Perugino's *Baptism of Christ* evoke the rite of baptism,[78] it seems likely that baptismal meaning was attached to the comparable figure near the center of Signorelli's *Last Testament of Moses* (Pl. XIII). Because early catechumens were customarily baptized on Easter Eve, a figure symbolizing newly baptized Christians might well appear in Signorelli's fresco, which exhibits other connections with the Holy Saturday liturgy.

There are several reasons for connecting the *Spinario* with the sacrament of baptism. In Italy, the antique statue was nicknamed *Marzo*, perhaps because copies of the work so often personify March in medieval Italian cycles representing Labors of the Months.[79] Early catechumens were often baptized during March because Holy Saturday, the day set aside for baptism in Christian antiquity,[80] regularly falls in that month. Moreover, the early church designated 27 March as the conventional date for commemoration of the Resurrection,[81] although the liturgical feast of Easter (and the Holy

71. Leo, Sermon 39, 5; Sermon 341, 1, cited by Callewaert, 1924, 214; see also Righetti, II, 109.

72. Amalarius, *Liber officialis*, III, 37, as cited in Jungmann, 1986, II, 429 n. 16.

73. Ambrose, *Sacrements*, 33, 62.

74. Eisler, 82ff.

75. On the baptismal meaning of comparable nudes in Michelangelo's *Doni Madonna*, Levi D'Ancona, 1968, 48.

76. Eisler, 91.

77. See Chapter II, 23.

78. Eisler, 91.

79. Bober–Rubenstein, 235. Such medieval personifications survive on a baptismal font from Lucca, now in

the Bargello, Florence; on the jambs of the portal of the Pisa Baptistery; among the archivolt reliefs on the facades of the cathedrals of Parma and Sessa Aurunca; and on a pavement in the cathedral of Otranto (Glass, 130; Webster, 52, 62, 64, 100).

80. Jungmann, 1959, 264; P. Béraudy, "L'Initiation chrétienne," in Martimort, 527, 541. The related belief that the world was created in spring, an idea perhaps connected with the new life associated with baptism, is expressed in sermons by Leo the Great (Leo, *Sermons III*, 66 and n. 1).

81. Righetti, II, 153; C. M. Rose, "March 27 as Easter and the Medieval Liturgical Calendar," *Manuscripta*, xxx, 1986, 114.

Saturday vigil) may fall anywhere between 20 March and 25 April. In view of these circumstances, it is possible to see how the *Spinario,* nicknamed *Marzo,* may have come to symbolize the sacrament of baptism.

Further baptismal meaning may be attached to the thorn that the *Spinario* removes from his foot. Thorns traditionally have negative connotations. This is plain, for example, from Hebrews 6:8, "But that which beareth thorns and briers is rejected and is nigh unto cursing."[82] Similar sentiments are voiced by Pope Gregory the Great (590–604), who equates thorns with every kind of sin;[83] and, at a later moment, by Peter Berchorius (1290–1302), for whom thorns signify original sin, "Spina pungens significat peccatorum originale quod pungit per carnis stimulum peccatores."[84] As Eugene F. Rice makes clear, a related tradition informs the legend that Saint Jerome, by extracting thorns from a lion's paw, was enabled to tame the wild beast.[85] This and similar tales are glossed in the *Gesta Romanorum* (Tale 104), where a thorn removed from a lion's foot is said to signify Original Sin, drawn from the ferocious animal (an emblem of the erring human race) by the redemptive power of baptism.[86]

The tradition connecting the removal of thorns with the washing away of sin by baptism could be easily applied to the *Spinario.* Indeed, as noted here already, some medieval authors describe the spine lodged in the statue's foot as the thorn of sin.[87] In addition, the *Spinario* was identified with *Luxuria,* the vice of carnality,[88] by the English traveler known as Magister Gregorius, in his account of a visit to Rome around the year 1200.[89] From such traditional characterizations of thorns and of the *Spinario,* it is easy to understand how the ancient statue may have come to stand for newly baptized Christians on Easter Eve, intently ridding themselves of carnal impulses by removing the thorn of sin from their flesh through the agency of baptism. Interpretations of this kind may have prompted Signorelli to include a *Spinario* copy in his *Last Testament of Moses* as a symbolic reference to the early catechumens once baptized on Holy Saturday.

In Signorelli's fresco, the *Spinario* figure perches on a tree stump (Fig. 31), rather than sitting on a rock like the antique original (Fig. 7);[90] and this relatively minor change is worthy of comment. Severed tree trunks are sometimes associated with John the Baptist.[91] Marilyn Lavin suggests that the tree stumps present in many baptism scenes reflect John's statement during the Baptism of the Multitude: "And now also the axe is laid unto the root of the trees" (Matthew 3:10). As Lavin further points out, broken trees figure in Psalm 29 (KJ 28), which is recited in its entirety during the Office on the feast of the Epiphany, 6 January, when Christ's baptism is commemorated in the Roman Church. Psalm 29:5 reads, "The voice of the Lord shall break the cedars, yea the Lord shall break the Cedars of Lebanon;"[92] these words, as Saint Jerome

82. Levi D'Ancona, 1977, 377.

83. Gregory, *Moralia, PL* LXXVI, 150, cited in Levi D'Ancona, 1977, 377.

84. For this citation, Levi D'Ancona, 1977, 377.

85. Rice, 37–40 nn. 38–42.

86. Rice, 40 and n. 44.

87. Heckscher, col. 292.

88. Slatkes, 19. I am indebted to Leonard J. Slatkes for this and many other references to the meaning of the *Spinario.*

89. Heckscher, col. 290f.

90. Bober–Rubinstein, 235.

91. Lavin, 1981, 108.

92. Lavin, 1981, 108f.

explains in a homily for Epiphany, allude symbolically to the fall of sinners at the moment of Christ's baptism.[93] The severed tree trunk used as a seat by the half-nude youth in Signorelli's *Last Testament of Moses* recalls these references to the cutting down and breaking up of trees at the time of the earliest baptisms. Consequently, the very tree stump on which this young man sits may carry baptismal meaning.

The evident impact of the Roman liturgy on Rosselli's *Last Supper* and Signorelli's *Last Testament of Moses* may help to explain the marginal place of the Crucifixion scene in Rosselli's fresco. Because the Crucifixion is usually a central episode in Christological cycles, Steinmann was perplexed to find the subject relegated to the right background of Rosselli's composition.[94] But this arrangement may be designed to recall the aliturgical character of the Good Friday service that commemorates Christ's death on the cross.[95] For the early church, Good Friday is the aliturgical day *par excellence;*[96] on that day, according to the *Ordo Romanus antiquus*, "Missa non cantatur."[97] The modern *Missale Romanum* still categorizes the Good Friday service as an *actio liturgica* rather than a *Missa.*[98] Biblical subjects given a prominent place in Rosselli's *Last Supper* fresco are those that evoke major liturgical days within Holy Week: Palm Sunday, Holy Thursday and Holy Saturday. In this context, the marginal place of the Crucifixion scene may constitute a reference to the circumstance that the service on Good Friday is technically aliturgical.[99]

In addition, the peripheral Crucifixion scene in Rosselli's *Last Supper* fresco may reflect the Incarnational bias of Renaissance theology. As John O'Malley points out, Christ's death on the cross is often a prime subject in late medieval art, but the Christological cycle of the fifteenth century in Pope Sixtus's chapel offers only a distant view of the Crucifixion. According to O'Malley, the subsidiary place of the Crucifixion in Rosselli's *Last Supper* may reflect the belief held by some Renaissance theologians that the redemptive efficacy customarily reserved for Christ's passion is shared, or perhaps even usurped, by the mystery of the Incarnation.[100]

Finally, the marginal place of the Crucifixion in Rosselli's *Last Supper* fresco may reflect the wish of Renaissance painters to shun antitriumphal themes. This attitude, best known in High Renaissance art,[101] may already inform the narrative cycles designed in the quattrocento for Pope Sixtus's chapel. In that sacred chamber, the Crucifixion, an occasion of pain, suffering, and humiliation for Jesus, occupies a subsidiary position in Rosselli's *Last Supper.* By contrast, the Resurrection, an episode affirming Christ's triumph over death, is the primary subject in the adjacent composition, the reworked *Resurrection and Ascension of Christ* (Pl. VII), the culminating fresco of the Christological cycle.

93. Lavin, 1981, 109.

94. Steinmann, 237.

95. Durandus, 1568, 227r: "De die parasceves, cap. 77, missae officium . . . haec dies caret."

96. Righetti, II, 170.

97. *Ordo Romanus I*, 65.

98. MR, 164: Feria Sexta in Passione et Morte Domini, De solemni actione liturgica postmeridiana. . . .

99. In fifteenth-century Rome, the service on Good Friday was the occasion of a "papal chapel"; on this subject, see O'Malley, 1979, 245, 247, 250, 251, 253.

100. O'Malley, in Steinberg, 140.

101. Baldwin, 7.

# VII

## THE LOST FRESCOES ON THE ALTAR WALL

The *Nativity* and the *Finding of Moses*

## THE REPAINTED FRESCOES ON THE ENTRANCE WALL

The *Resurrection and Ascension of Christ* and the
*Fight for the Body of Moses*

TITULUS:
RESURRECTIO ET ASCENSIO CHRISTI EVANGELICAE LEGIS LATORIS

Any discussion of the four history frescoes originally painted on the short walls of the Sistine Chapel inevitably presents some serious difficulties. To begin with, both Perugino's *Nativity* and his *Finding of Moses*, the compositions once visible on the altar wall (Fig. 2), have been totally obliterated. In addition, the narrative frescoes still visible on the entrance wall opposite, the *Resurrection and Ascension of Christ* (Pl. VII) and the *Fight for the Body of Moses* (Pl. XIV), have not survived in their original form. Nevertheless, as I propose to show, all four compositions apparently mirror (or mirrored) the liturgical scheme that I have already discerned in the Christ and Moses frescoes on the long side walls of Pope Sixtus's chapel. Like the history frescoes lining each long wall, the paired compositions on each short wall of the papal chapel were evidently designed to evoke themes of the Lenten liturgy. But both narrative works on the altar wall were also designed to allude more specifically to the Roman liturgy in the weeks around Christmas—the important liturgical period preceding Lent; and both

narrative works on the entrance wall were also designed to allude more specifically to the Roman liturgy in the weeks between Easter Sunday and Pentecost Sunday—the important liturgical period following Lent.

Each narrative cycle in Pope Sixtus's chapel originally started off on the altar wall with a fresco by Perugino (Fig. 2); but both compositions were replaced in the following century by Michelangelo's *Last Judgment*. Vasari describes the first fresco of the Christological cycle simply as "la Natività"; he defines the subject of the adjacent fresco, the first in the Moses cycle, as, "il nascimento di Mosè, quando dalla figliuola di Faraone è ripescato nella cestella."[1]

In the latter statement, Vasari appears to identify Moses' birth with the moment when Pharaoh's daughter rescued the future leader of Israel from the bullrushes, even though these were two quite different events. Perhaps influenced by Vasari, Ettlinger suggests that at least two separate episodes were portrayed in the lost Moses composition on the altar wall. (This idea is convincing because multiple scenes are the rule within the surviving history frescoes.) According to Ettlinger, the lost Moses fresco may have depicted both the Birth of Moses, an extrabiblical subject, and the Finding of Moses by Pharaoh's daughter (Exodus 2:5–10).[2] Even if Moses' birth was not actually illustrated in Perugino's lost fresco, Moses' salvation by the Egyptian princess was apparently represented there, and this episode could be viewed symbolically as the future patriarch's true birth. Consequently, the *Finding of Moses* would have provided an appropriate pendant to the adjacent *Nativity* fresco. Precisely this parallel appears in exegetical literature, where it is maintained that Moses' dramatic rescue from the water by Pharaoh's daughter prefigures the birth of Christ.[3]

Moreover, baptismal meaning could be attached to the Finding of Moses. The Egyptian princess who rescued Moses is understood by exegetes as a figure of the church, saving the child after his passage through the purifying water.[4] In this way, the salvation of the infant Moses after passing through the water[5]—an incident evidently illustrated in Perugino's lost Mosaic fresco—could evoke Christian baptism, a prime motif of Lent.

Liturgically speaking, the primary subject of the *Nativity* fresco on the altar wall of the Sistine Chapel could recall the period of Advent and Christmastide, when the Roman liturgy commemorates Christ's birth. And the baptismal theme of the adjacent *Finding of Moses* could recall the liturgy of the feast of the Epiphany, celebrated twelve days after Christmas, on 6 January, when Jesus' institution of the sacrament of baptism is commemorated in the Roman Church.[6]

---

1. Vasari (Milanesi), III, 579.
2. Ettlinger, 57f.
3. Davidson, 76.
4. Davidson, 76.
5. According to Josephus, *Antiquities I–IV*, bk. II, chap. 9, 6, 263, "Moses' very name recalls his immersion in the river, for the Egyptians call water 'mou' and those who are saved 'eses,' so they gave him a name made up of those two words." For the same interpretation of Moses' name, Philo, *Life of Moses*, I, 4, par. 17.
6. Lavin, 1981, 108f.

The final compositions in the Christ and Moses cycles, the *Resurrection and Ascension of Christ* (Pl. VII) and the *Fight for the Body of Moses* (Pl. XIV), appear on the short entrance wall of the Sistine Chapel. Both works portray events that followed the earthly death of each religious leader. These frescoes may not look today as they once did, because they were completely repainted in the sixteenth century. Both the original *Resurrection* fresco by Ghirlandaio and the first version of Signorelli's *Fight for the Body of Moses* were badly damaged when the wall that held them collapsed in December 1522.[7] At that point, the *Resurrection* fresco was, in Vasari's words, "guasto in maggior parte";[8] and the adjacent Moses fresco must have suffered a similar fate.[9] Later in the sixteenth century, Matteo Pérez de Alesio (known in Italy as Matteo da Lecce) repainted the *Fight for the Body of Moses,* as attested by Carel van Mander and Francisco Pacheco.[10] At about the same moment, according to an anonymous manuscript of 1600 utilized by Giovanni Baglione, Hendrik van den Broeck, whom the Italians called Arrigo Fiammingo, repainted the *Resurrection and Ascension of Christ.* Van den Broeck introduced his own monogram into the *Resurrection* scene; the letters HVDB, enclosed in a small medallion, decorate the front panel of Christ's sarcophagus (Fig. 35).[11]

It is sometimes presumed that both reworked compositions on the entrance wall of the Sistine Chapel must date from the pontificate of Gregory XIII, Buoncompagni (1572–75), because a dragon from the Buoncompagni coat of arms occupies a decorative cartouche on the front panel of the catafalque in the *Fight for the Body of Moses* (Fig. 36).[12] But Francisco Stastny has shown that the work of replacing the final compositions in the history cycles actually began toward the end of the pontificate of Saint Pius V, Ghislieri (1566–72). In May 1572, while this project of renewal was already under way, Pius V died and Gregory XIII succeeded him. At this point, Stastny suggests, Matteo da Lecce may have added the Buoncompagni dragon to the final fresco of the Moses cycle in honor of the newly elected Buoncompagni pope.[13]

The legend currently inscribed above the *Resurrection* fresco, RESURRECTIO ET ASCENSIO CHRISTI EVANGELICAE LEGIS LATORIS,[14] refers directly to events depicted in the composition below. At the center of this work, the resurrected Christ rises in triumph from his tomb, while soldiers set to guard the sepulcher fall back in astonishment (Fig. 35). Liturgically speaking, this scene recalls the Masses of Holy Saturday and Easter Sunday, when Christ's Resurrection is commemorated in the Roman liturgy. A subsidiary scene in the upper right-hand corner of the *Resurrection* fresco depicts Christ's Ascension. This occasion, mentioned in the accompanying *titulus,* is commemorated by the Roman Church on Ascension Thursday, a movable feast that follows

---

7. Stastny, 777f.
8. Vasari (Milanesi), III, 259, cited by Stastny, 778.
9. Stastny, 778.
10. Stastny, 779.
11. Stastny, 779.
12. Stastny, 780.
13. Stastny, 781.

14. Shearman, who discovered a list of the Sistine Chapel *tituli* in a pamphlet of 1513, asserts that the inscription over the *Resurrection* fresco was not preserved (Shearman, 1972, 48 and n. 17). However, Redig de Campos, 1970, 308, cites the inscription currently visible above this fresco.

forty days after Easter Sunday. Although Ascension Thursday takes place after Lent, it falls within the weeks bracketed between Christmas and Pentecost Sunday, that segment of the liturgical calendar evidently mirrored on the Sistine Chapel walls.[15]

While an explanatory *titulus* is still visible over the *Resurrection* fresco, the corresponding legend that must once have accompanied the adjacent work has disappeared.[16] Consequently, there is no textual clue to explain why the Fight for the Body of Moses, an extremely uncommon subject, makes its unique appearance in monumental art on the Sistine Chapel walls.[17] Ettlinger and Stastny agree that the repainted Moses fresco essentially reflects the original of the quattrocento.[18] If they are right, the original *Fight for the Body of Moses* conformed to the liturgical pattern that I discern on the walls of the papal chapel, because the final Moses fresco currently visible in the Sistine Chapel echoes liturgical themes of Lent and Pentecost (Pl. XIV).

In the Bible, the Fight for the Body of Moses is mentioned only in the New Testament. The episode is cited, in passing, in the Epistle of Jude, verse 9: "Yet Michael the archangel, when contending with the devil about the body of Moses, durst not bring against him a railing accusation, but said: The Lord rebuke thee." Sixtus IV was unquestionably familiar with this obscure incident in Moses' history, for, as Ettlinger points out, the future della Rovere pope cites Jude 9 in his theological treatise, *De potentia Dei*. Moreover, the introduction to a Latin translation of Philo's works, dedicated by the translator, Lilio Tifernate, to Pope Sixtus IV, complains that Philo's *Life of Moses* fails to describe the Fight for Moses' Body.[19] Tifernate's complaint may show that the learned Renaissance humanist knew of discussions at which Sixtus and his advisers determined which episodes from Moses' life were to be portrayed on the Sistine Chapel walls.[20]

From his familiarity with patristic literature, Sixtus IV may well have been aware that both Origen and Clement of Alexandria repeatedly cite a treatise entitled *The Assumption of Moses*.[21] This theological work, now lost, described both the dispute over Moses' body between Satan and the archangel Michael, and the aftermath of that dispute: the Jewish leader's bodily assumption into heaven.[22] Jewish legends also record both events. These sources report that Satan raised fierce objections when Michael requested the Lord's permission to bury Moses. But, as Jewish legends further relate, the Lord refused to deliver Moses' body to the devil, and even undertook to organize the patriarch's funeral. To accomplish this task, three angels were sent from heaven: Gabriel, who arranged Moses' funeral couch; Michael, who spread a purple garment over it; and Zagzagel, who furnished it with a woolen pillow. Once the angels had finished their work, the Lord commanded Moses to close his eyes and to fold his hands upon his breast.[23]

15. See Chapter I, 2.
16. Shearman, 1972, 48 n. 17.
17. Ettlinger, 74.
18. Ettlinger, 74 n. 1; Stastny, 780.
19. Ettlinger, 74f.
20. Stinger, 214.

21. *A New Catholic Commentary on Holy Scripture*, ed. Rev. Reginald C. Fuller et al., Walton-on-Thames, 1957, 1264, s.v. "Jude"; Wind, 1954, 420.
22. Hastings, *Dictionary*, III, 450, s.v. "Moses, Assumption of."
23. Ginzberg, III, 472.

In Matteo da Lecce's *Fight for the Body of Moses,* the patriarch's catafalque is covered by a cloth (Fig. 36). While the painted coverlet is blue, it may nevertheless represent the purple garment described in Jewish legend.[24] In the Moses fresco, as in the Jewish text, the patriarch's head rests on a pillow, his hands are crossed on his breast, and his eyes are closed. Moses' burial by celestial beings, also reported in Jewish sources,[25] is illustrated at the upper left-hand corner of Matteo da Lecce's fresco. There, a group of flying figures lift Moses' bier up to heaven.

For Sixtus IV, the primary episode portrayed in the *Fight for the Body of Moses* may have served to demonstrate the binding force of papal authority. According to Ett-

pe's polemical treatise, *De potentia Dei,* in
er Moses' body is said to prove that even
e learned Sixtus may well have known a
or Moses' Body. This was offered centuries
Michael's dispute with Satan symbolizes
from captivity in Babylon.[27] Bede's gloss
sts a plausible rationale for the surprising
dy in Pope Sixtus's chapel. An image of
Moses cycle of the papal chapel to evoke a
Jews from their Babylonian Captivity.[28]
apel walls, the *Fight for the Body of Moses*
gy.[29]

is tempting to speculate further that the
ewed during Sixtus IV's pontificate as a
ivity" of the popes during the trecento.
led to Moses' liberation from the devil's
try into the heavenly Jerusalem, these
eration of the popes from "captivity" in
thly Jerusalem. Looked at in this way, the
a momentous occasion in papal history. I
f my belief that Sixtus's new papal chapel
ate the one-hundredth anniversary of the

have seemed a subject worth portraying
re incident could allude, by implication,
Like the biblical account of Nehemiah's
eground of Botticelli's *Temptations* fresco
s known to Jews solely from apocryphal

24. This garment may refer to the purple mantle worn by popes from the mid-eleventh century, as a sign of the imperium uniquely inherent in the bishopric of Rome (R. L. Benson, *The Bishop-Elect,* Princeton, 1968, 152 and nn. 7,8).

25. Ginzberg, VI, 162 n. 952, notes that Philo's *Life of Moses,* 2 (3), also contains this information.

26. Ettlinger, 75; Stastny, 778 and n. 22.
27. Bede, *In Epistulum Judae, PL* XCIII, 126, cited by Ettlinger, 74 n. 4.
28. See Chapter III, 45.
29. See Chapters III, V, 45, 67.
30. See Chapter III, 44ff.

literature. Although neither event is recorded in canonical Jewish scripture, the Christian Bible accords canonical status to the passages that describe these episodes. As a result, illustrations of both little-known events from Jewish history in Pope Sixtus's chapel could make the gratifying point that only Christians had correctly understood and properly valued these meaningful occasions in the history of Israel. From this it might follow that—while Christianity is indeed rooted in the Jewish religion—the younger faith has surpassed the older in wisdom. That message may be encoded in the golden epigraph on the triumphal arches in Perugino's *Gift of the Keys* (Figs. 24, 25): IMENSU[M] SALAMO TEMPLUM TU HOC QUARTE SACRASTI SIXTE OPIBUS DISPAR RELIGIONE PRIOR.[31] The enigmatic inscription, suggesting that Sixtus is wiser than Solomon, appears to imply that the pope's superior wisdom stems from his adherence to the newer, rather than the older faith.

Jude 9–13, the passage alluding to the Fight for Moses' Body, is assigned in the Roman *Breviary* to the Saturday immediately preceding Pentecost Sunday.[32] Thus, like other narrative frescoes in Pope Sixtus's chapel, the repainted *Fight for the Body of Moses* illustrates verses assigned in the Roman liturgy during the period between Advent and Pentecost.

Moreover, the Saturday on which Jude 9–13 is assigned in the *Breviary* follows the Thursday marking the end of the Octave of the Ascension. On Ascension Thursday, eight days earlier, the *Roman Missal* and *Breviary* specify readings from Acts 1:1–11 and Mark 16:14–20, texts that record Christ's entry into heaven.[33] Consequently, the Roman Church assigns lections describing Christ's Ascension and the Fight for Moses' Body to liturgical commemorations spaced only ten days apart. This configuration of the Church Calendar may be mirrored in Pope Sixtus's chapel, where the two events are portrayed side by side on the short entrance wall (Fig. 2).

As John O'Malley has shown, sermons delivered at "papal chapels" during the Renaissance ascribe great importance to the Ascension, as the moment when the benefits of the Redemption were fully achieved and Christ took his place at his Father's right hand.[34] On the occasion of the Ascension, humanity was exalted above the choirs of angels, according to an Ascension Day sermon preached by Pietro Marsi before Sixtus IV's immediate successor, Pope Innocent VIII.[35] As O'Malley points out, the title of Marsi's sermon, *Oratio in die ascensionis de immortalitate animae*, plainly connects the liturgical commemoration of Christ's Ascension with the soul's immortality. These topics were already juxtaposed at the time of the early church, for example, by Leo the Great.[36] Serious discussion of this point continued in Renaissance Rome.[37] A sermon by Pietro Gravina, who preached for Pope Alexander VI, maintains that Christ's Ascension demonstrates the immortality not only of men's souls, but also of their bodies.[38] Perhaps contemporary assertions about the immortality of both soul and

---

31. See Chapter V, 68f.
32. *BR*, 488: Sabbato in Vigilia Pentecostes.
33. *MR*, 345ff.: In Ascensione Domini; *BR*, 445ff.
34. O'Malley, 1979, 151.
35. O'Malley, 1979, 151 n. 102.

36. Leo, Sermon 73, *PL* LIV, col. 396, cited in O'Malley, 1979, 151 n. 102.
37. O'Malley, 1979, 152 and n. 105 for references.
38. O'Malley, 1979, 152.

body had some impact upon the decoration of Pope Sixtus's chapel. Interest in these matters among members of the papal circle may have inspired the decision to represent Christ's bodily Ascension in the *Resurrection* fresco on the entrance wall of the Sistine Chapel, and Moses' bodily assumption in the *Fight for the Body of Moses,* the adjacent composition on the same wall.

Salvation was stressed on both end walls of Pope Sixtus's chapel. Salvation is evidently a prime theme of the narrative histories painted on the entrance wall of the papal chapel, where a fresco portraying Christ's Resurrection and his bodily Ascension adjoins a fresco depicting the successful Fight for Moses' Body and the patriarch's eventual Assumption into Heaven (Pls. VII, XIV). Plainly, both compositions point to the salvation of these great religious leaders from earthly death, and to their eternal triumph in heaven. A similar message was conveyed by the altarpiece once visible on the opposite wall of the papal chapel. In the drawing from Perugino's workshop that best records this lost composition, Sixtus IV is shown praying before the Virgin *Assunta,* to whom the Sistine Chapel is dedicated. The subject of the altarpiece that once graced Pope Sixtus's chapel thus reflected the theology of salvation as it was understood during the Renaissance, when Mary's bodily assumption was believed not only to mirror Christ's Resurrection and Ascension, but also to foretell the bodily resurrection of all Christians.[39]

39. O'Malley, 1986, 120.

# VIII
## EXPERIENCING THE NARRATIVE CYCLES

An unusually elaborate scheme of decoration was devised for Sixtus IV's chapel in the Vatican palace; as a result, the artists called upon to design individual frescoes of the Christ and Moses cycles were forced to labor under a heavy burden. In some cases, as in Perugino's justly celebrated *Gift of the Keys* (Pl. V), a master painter responded to the demands of the intricate program by creating a monumental composition of luminous clarity. But in other cases, as in Rosselli's relatively inharmonious *Lawgiving on Mount Sinai* (Pl. XI), a less gifted artist was evidently overwhelmed by the weighty requirements of the decorative scheme.[1]

The narrative cycles on the Sistine Chapel walls convey multiple messages originally aimed at an exceptionally erudite audience: the clerics and laymen of Pope Sixtus's court. During lengthy pontifical services, these learned persons doubtless sought mental refreshment by turning their attention now and then to the richly frescoed chapel walls.[2] But the painted decoration of Pope Sixtus's chapel and the liturgical ceremonies that the sacred chamber was designed to accommodate are not in competition; they are complementary. Indeed, it is vital to bear in mind that the narrative cycles of Pope Sixtus's chapel were not meant to be viewed in silence. When the sacred chamber was used for liturgical purposes, designated passages from Scripture were recited or sung, and the congregation heard sermons inspired by texts of the day. Consequently, members of Sixtus IV's court might hear spoken allusions to the very biblical scenes they were simultaneously admiring on the Sistine Chapel walls: in the weeks between Advent and Pentecost, the Roman liturgy could offer these worshipers an auditory guide to the painted narrative on the walls around them.[3]

At pontifical solemnities, clerics and laymen of Pope Sixtus's court occupied the privileged zone of the papal chapel: an area bounded on one end by the altar wall and on the other by the inner face of the marble screen, or *cancellata,* that divides the room horizontally into two almost equal sections.[4] But the participants in "papal chapels" did not necessarily stay seated beside the altar throughout religious ceremonies. Protocol

1. Lee, 44; Lavin, 1990, 201.
2. The decorum desirable at "papal chapels" was not always achieved; O'Malley, 1979, 20f., reports the "almost ineradicable proclivity for talking during sermons."

3. Here and in the pages that follow, I have been much influenced by Richard Brilliant's recent article (1991) on the Bayeux Tapestry (see Bibliography).
4. Shearman, 1986, 29.

required some members of this elite group to march up and down the Sistine Chapel, in procession, during the Pontifical Entrance and Exit.[5] Such processions seem to have followed a designated path. As Shearman observes, a strip of Constantinian Interlace worked out in mosaic and colored marble may mark the processional route.[6] This decorative band creates a vertical path on the pavement of the less prestigious zone in the chapel: an area bounded on one end by the outer face of the *cancellata* and on the other by the entrance wall of the chapel. Thus, the members of *cappelle pontificie* in Sixtus IV's day might experience the narrative frescoes of the papal chapel not only while sitting in the section of chapel nearest the altar but also while marching in procession up and down the part of the chapel nearest to the main entrance. A document of 1460 that offers suggestions for reforming the *cappelle pontificie* indicates that the congregation was often inattentive during religious rites.[7] A matching lack of decorum was presumably the norm at services later held in the Sistine Chapel. Restless worshipers who moved about in that sacred space would inevitably experience the painted narrative on the chapel walls from several different points of vantage.

By various devices, members of the Renaissance *cappelle pontificie* were encouraged to read the history cycles of Pope Sixtus's chapel, in sequence, from a liturgical, a typological, and a chronological point of view. These informed spectators may have discerned, as well, that subjects illustrated in four of the Christological frescoes on the long north wall evoke the Lenten voyage of initiation undertaken by early baptismal candidates.

As I have sought to demonstrate in the preceding chapters, narrative frescoes on the long walls of Pope Sixtus's chapel echo themes and texts of the Lenten liturgy. Although largely forgotten in modern times, this liturgical scheme was surely evident to the elite laymen and clerics of Renaissance Rome who worshiped regularly in the sacred chamber. As they scanned the history frescoes during elaborate pontifical services, the participants in "papal chapels" would soon have discovered that a Lenten sequence begins at the altar end of both long walls (where Perugino's *Baptism of Christ* [Pl. I] and his *Circumcision of Moses' Son* [Pl. VIII] evoke the Roman liturgy from Septuagesima Sunday through the second Lenten week) and concludes at the entrance end of both long walls (where Rosselli's *Last Supper* [Pl. VI] and Signorelli's *Last Testament of Moses* [Pl. XIII] mirror liturgical themes of Holy Week, the final week in Lent).

Legends inscribed above the narrative frescoes offer guidance to the liturgical scheme. The *titulus* over Botticelli's *Temptations* fresco, for example, calls attention to the images of Christ's Temptations in the background of the composition below (Pl. II). These scenes illustrate Matthew 4:1–11, a passage assigned to the first Lenten Sunday from Christian antiquity onward, as the members of *cappelle pontificie* surely knew. In any case, the passage from Matthew would be read aloud in the Sistine Chapel on the first Sunday of Lent, and sermons preached on this day in Renaissance

---

5. Shearman, 1986, 34f.            7. Shearman, 1986, 24.
6. Shearman, 1986, 35.

Rome take up themes inspired by the Triple Temptations.[8] Responding both to the *titulus,* and to the spoken words of the service, Renaissance worshipers present in Pope Sixtus's chapel on the first Lenten Sunday could hardly fail to notice that Botticelli's *Temptations* fresco echoes liturgical motifs of *Caput Quadragesimae.*

Some *tituli* on the Sistine Chapel walls are designed to remind observers that the Lenten liturgy reflects the readying of early catechumens for their baptismal initiation at Easter. Ghirlandaio's *Calling of the First Apostles* (Pl. III), at the middle of the long north wall, is inscribed, CONGREGATIO POPULI LEGEM EVANGELICAM RECEPTURI, and the unexpected future verb form, *recepturi,* might prompt knowledgeable spectators to look ahead, toward the altar end of the north wall. There, a related inscription, REPLICATIO LEGIS EVANGELICAE A CHRISTO, accompanies Rosselli's *Last Supper* (Pl. VI), the final fresco on the wall. Well-informed persons would recognize that the *titulus* over Ghirlandaio's fresco at the middle of the north wall evokes the middle weeks of Lent, when the Apostles' Creed was first communicated to early catechumens; keen observers would also grasp that the inscription over Rosselli's *Last Supper,* at the end of the north wall, evokes the baptismal Mass on Holy Saturday, at the end of Lent, when a repetition (*replicatio*) of this fundamental Christian text was once required of baptismal candidates.

*Tituli* are not the only linguistic elements visible on the Sistine Chapel walls. Some of the narrative frescoes incorporate minimal written material,[9] while Latin texts of greater length (and obscurity) appear in Perugino's *Gift of the Keys* (Pl. V) and Botticelli's *Punishment of Korah* (Pl. XII). As made clear in Richard Brilliant's stimulating account of narrative structure in the Bayeux Tapestry, words may be clustered in certain scenes to signal their ceremonial importance;[10] this observation plainly applies to the juxtaposed frescoes by Perugino and Botticelli. While these compositions have their place within the liturgical, chronological, and typological schemes worked out on the Sistine Chapel walls, both Perugino's *Gift of the Keys* and Botticelli's *Punishment of Korah* also celebrate the power and authority of the papacy. Gilded inscriptions within both compositions help spectators competent in Latin to appreciate this crucial point.

But not every viewer is equipped to interpret the Latin epigraphs in Perugino's *Gift of the Keys* and Botticelli's *Punishment of Korah.* In fact, the inscriptions are evidently aimed at a smaller and more elite circle of spectators than the paintings themselves, for the puzzling texts require greater learning and more interpretation from the observer than the figurative scenes.[11] But if these Latin epigraphs are somewhat obscure, their obscurity has a virtue. It ensures that viewers seeking to decipher the inscriptions must pause before Perugino's *Gift of the Keys* and Botticelli's *Punishment of Korah;* as a result,

---

8. For examples, O'Malley, 1979, 246, 250, citing the titles of sermons preached on this day: Cajetan (Thomas de Vio), "Oratio de causa et origine mali"; Lodovico de Ferrara, "Sermo de pugna a Christi cum daemone."

9. An inscription containing Perugino's name is inscribed on the molding that frames his *Baptism of*

*Christ;* a cartouche on Moses' catafalque in Hendrik Van den Broeck's *Fight for the Body of Moses* bears the initials HVDB.

10. Brilliant, 108.

11. This is formulated as a general rule by M. Wallis, "Inscriptions in paintings," *Semiotica,* IX.1, 1973, 1f., as cited in Brilliant, 108 n. 41.

these spectators will inevitably pay particular attention to the two narrative frescoes of Pope Sixtus's chapel that most vividly glorify the papacy.

A typological reading of the narrative frescoes on the Sistine Chapel walls is encouraged by the parallel Old and New Testament cycles disposed on opposite sides of the chamber. While glancing across the chapel from one long wall to the other, most worshipers in quattrocento Rome would quickly have grasped the clear-cut thematic correspondences between such juxtaposed works as Rosselli's *Sermon on the Mount* and his *Lawgiving on Mount Sinai* (Pls. IV, XI). Parallel wording in the gilded legends above these two frescoes (PROMULGATIO LEGIS SCRIPTE PER MOISEM and PROMULGATIO EVANGELICE LEGIS PER CHRISTUM) underscores the point that both compositions deal with matching themes. Other pairings are less obvious. But learned members of Sixtus IV's "papal chapels" probably understood, for example, that Ghirlandaio's *Calling of the First Apostles* is juxtaposed with Rosselli's *Crossing of the Red Sea* (Pls. III, X) because the watery setting in each work recalls the efficacy of baptism: in both frescoes, chosen individuals move from (through) water to salvation.

A typological reading of the narrative frescoes in Pope Sixtus's chapel is further encouraged, as Marilyn Lavin discovered, by the arrangement of papal portraits in the zone over the narrative cycles. Above each history fresco on the long walls of the chamber, there are full-length images of two early popes, standing in painted niches on either side of a real window (Fig. 3). These papal figures are arranged chronologically, in a sequence that moves back and forth across the chamber in a zigzag pattern, a Boustrophedon. This means that persons seeking to view the pontifical portraits in chronological order must turn alternately from wall to wall, in much the same back-and-forth pattern required of spectators contemplating typological parallels between the juxtaposed Christ and Moses frescoes. In this way, the organization of papal portraits in Pope Sixtus's chapel encourages a typological reading of the narrative frescoes below them.[12]

Renaissance visitors well versed in Scripture would soon have noticed that a linear, chronological sequence of biblical events appears on the Sistine Chapel walls, although there are occasional deviations from biblical chronology.[13] These same discerning viewers could also observe that anyone proposing to follow the chronological narratives that line the sacred chamber must embark upon a "journey" recalling the voyages of Christ and Moses, the heroes of these narratives.

The Moses cycle once began with the future patriarch's adoption by Pharaoh's daughter (lost *Finding of Moses*), and it continues with his travels between Midian and Egypt (*Circumcision of Moses' Son; Moses in Egypt and Midian*). Moses then traverses the Red Sea (*Crossing of the Red Sea*); journeys to Sinai (*Lawgiving on Mount Sinai*); and ends his life's voyage at "the plain this side of the Jordan in the wilderness," as described in Deuteronomy 31 (*Last Testament of Moses*). The Christological cycle

12. Lavin, 1990, 197.

13. For example, in the first and second Christological frescoes on the north wall, and in the first and second Mosaic frescoes on the south wall (See Chapters II, III, 26, 33).

records similar journeys. Jesus is born in Bethlehem (lost *Nativity* fresco), baptized in Judea (*Baptism of Christ*), and tempted in the wilderness (*Temptations* fresco). He summons his first disciples from the Sea of Galilee (*Calling of the First Apostles*); then, traveling further in Galilee, he delivers his most memorable homily (*Sermon on the Mount*). After consigning the apostolic keys to Peter at Caesarea Philippi (*Gift of the Keys*), he eats the Passover meal with his disciples in Jerusalem (*Last Supper*). The culminating voyages of both religious leaders, their death and ascension into heaven, are portrayed in the final frescoes of each narrative (*Fight for the Body of Moses; Resurrection and Ascension of Christ*).

Drawing upon their extensive knowledge of Scripture, members of Renaissance "papal chapels" may well have noticed that the central scene in each fresco of both history cycles locates the protagonist in a different venue.[14] Indeed, Christ and Moses are more than once shown actually in transit (Pls. IV, VIII, IX, X). The emphasis upon travel in these narratives may be linked with the stress upon Lenten themes in the Christ and Moses cycles, for the travels of the two great spiritual leaders recall both the Lenten voyage of initiation undertaken by early catechumens and the spiritual journey on which all Christians must embark during Lent.

Worshipers in Pope Sixtus's chapel seeking to experience the Christological narrative in chronological order must look or move around the papal chapel from altar to entrance, that is, from their left to their right. Several devices encourage spectators to follow that course. *Tituli* accompanying the Christological frescoes on the long north wall must be read from left to right, as required by Latin prose. Individual scenes within each Christological fresco are often ordered chronologically from left to right. In many of the Christological compositions, the primary image of Jesus (usually located at or near the center) faces right. Although Christ is absent from the foreground of Botticelli's *Temptations* fresco (Pl. II), the Jewish high priest who dominates this part of the composition also faces right. In Rosselli's *Sermon on the Mount* (Pl. IV), Christ faces leftward while preaching; but he turns toward the right while curing the leper, as represented in a subsidiary (though doctrinally crucial) scene at the right-hand side of the composition. Rosselli's *Last Supper* (Pl. VI) displays a balanced composition with Christ at its center; but the rightward tilt of Jesus' head directs spectators further to the right, toward the final Christological fresco: the *Resurrection and Ascension of Christ*.

Directional indications are far less clear-cut in the Moses cycle. In a general way, the Mosaic frescoes on the long south wall were designed to fall into chronological order when read from the altar to the entrance wall of the papal chapel, that is, from the spectator's right to his or her left; but this directional flow is weaker than the opposing left-to-right movement of the Christological narrative. Even the *tituli* over the Mosaic frescoes run counter to the basic directional thrust of the Moses narrative, because these Latin inscriptions must be read from left to right.

In fact, the very first Mosaic fresco on the long south wall, Perugino's *Circumcision of*

---

14. In the case of Botticelli's *Temptations* fresco (Pl. II), I am thinking of the central Christological scene in the background; the foreground of the composition is, of course, devoted to a scene of Jewish sacrifice.

Moses' Son (Pl. VIII)—originally the second work of the Moses cycle—creates a break in the right-to-left flow of Mosaic narrative, for many figures in the foreground of Perugino's composition face right. Moreover, the Jewish ritual operation, the most consequential event portrayed in the fresco, occupies the far right-hand corner. By such compositional devices, spectators seeking to follow the cycle of Mosaic frescoes in chronological sequence from altar to entrance are quickly halted in their tracks. It is surely not coincidental that the viewers' experience matches the experience of Moses, as represented by Perugino; at the center foreground of Perugino's fresco, a handsome angel, unexpectedly seen from the rear, abruptly halts the patriarch's forward progress. The angel's commanding gesture marks a visual break in the flow of the narrative. This calculated pause permits spectators to observe that the *Circumcision* fresco is misplaced with respect to biblical chronology, in part, so that the Mosaic composition can serve as a typological parallel for Perugino's *Baptism of Christ*, the work located directly across the chapel. (Pl. I).[15]

There is a return to the customary right-to-left flow of Mosaic narrative is reinforced in the following Mosaic fresco, Botticelli's *Moses in Egypt and Midian* (Pl. IX); in a scene at the far left side of the composition, Moses shepherds a band of Israelites who march from right to left. These voyagers seem determined to move beyond the confines of the framing pilaster at the left edge of Botticelli's fresco, and viewers who follow the path of these travelers are thereby directed to the adjacent work, Rosselli's *Crossing of the Red Sea* (Pl. X).[16]

A centralized composition in Rosselli's *Red Sea* fresco creates another caesura in the Mosaic narrative. Rosselli's fresco is unique among the historiated frescoes of Pope Sixtus's chapel in that the center of the composition is occupied, not by biblical personages, but rather by a classical column (symbolizing the scriptural pillar of fire) and by the rosy waters of the Red Sea. Observing this compositional anomaly, alert visitors to the papal chapel during the Renaissance probably recognized that Rosselli has highlighted some elements at the center of his fresco that point ahead in time. Like the future tense of the *titulus* accompanying Rosselli's fresco, the Red Sea waters and the pillar of fire proleptically evoke the baptismal Mass of Easter Eve.[17] At that service, there is always a reading of the passage from Exodus that tells how Moses and the Israelites followed a pillar of fire to safety through the Red Sea waters. Even erudite participants in "papal chapels" of the Renaissance probably needed to pause before Rosselli's composition as they worked out these symbolic connections between the central elements in the *Red Sea* fresco and the baptismal liturgy of Holy Saturday.

The following composition in the Mosaic cycle, Rosselli's *Lawgiving on Mount Sinai* (Pl. XI), exhibits a weak right-to-left flow, most notable in a subsidiary scene located near the left side of the fresco; in that part of the composition, Moses is shown moving leftward as he descends the mountain carrying tablets of the law. A far stronger right-to-left movement in the following Moses fresco, Botticelli's *Punishment of Korah* (Pl.

15. See Chapter II, 26.                    17. See Chapter IV, 57f.
16. Schubring, 14.

XII), is underscored by three images of the patriarch, all facing leftward, that punctuate the foreground of the composition at almost equidistant intervals. At the same time, however, the imposing Constantinian arch on the central axis of Botticelli's fresco creates a slight pause in the narrative flow, giving spectators time to study the epigraph on the attic of the arch.[18] Those seeking to decipher this puzzling Latin text naturally require an extended visual and mental engagement with the *Korah* fresco.[19]

As is customary in the Mosaic narrative, scenes in the background of the following work, Signorelli's *Last Testament of Moses* (Pl. XIII), flow in chronological order from right to left, thereby directing spectators to the entrance wall of the Sistine Chapel and the final Mosaic fresco, the *Fight for the Body of Moses*. But the chronological sequence of events depicted in the foreground of Signorelli's composition instead progresses from left to right. This deviation from the habitual direction of Mosaic narrative in Pope Sixtus's chapel inclines viewers to pause, thus giving them time to interpret a cryptic figure: a half-naked youth of the *Spinario* type who sits at the center foreground of Signorelli's fresco.[20]

The unanticipated left-to-right flow of events in the foreground of Signorelli's composition, the last on the south wall, matches the equally unexpected left-to-right flow of events in the foreground of Perugino's *Circumcision of Moses' Son* (Pl. VIII), the first work on that wall. Observing the repetition of this phenomenon in the frescoes located at either end of the long south wall, alert worshipers might recognize that both works recall a recurrent theme of the Lenten liturgy much stressed in Pope Sixtus's chapel: the supplantation of Judaism by Christianity. In Perugino's *Circumcision* fresco, the inevitable process is symbolized by the circumcision of Moses' younger son rather than the older brother; in Signorelli's *Last Testament of Moses* the historical imperative is symbolized by the transfer of Moses' staff of leadership to the Jewish hero Joshua, who shares his name with Jesus.

While the narrative cycles of Pope Sixtus's chapel seem designed to be read primarily from altar to entrance, one segment of the Christological cycle was evidently meant to be read in the opposite sense as well. The frescoes to which I refer were (and are) bracketed between the altar wall of the chapel and the inner face of the *cancellata*, an architectural divider modeled on similar screens in Early Christian churches.[21] The marble screen of the Sistine Chapel, now no longer in precisely its original position, once stood on line with the fourth fresco from the altar end of each long wall.[22] Christological frescoes within this zone evoke the spiritual preparation of early catechumens during Lent.

At the middle of Lent in the early church, the *Pater noster* and the *Credo* were first taught to catechumens awaiting baptism on the coming Holy Saturday; these occasions are recalled by Rosselli's *Sermon on the Mount* (Pl. IV) and Ghirlandaio's *Calling of the First Apostles* (Pl. III). Lenten exorcisms and ascetic practices experienced by catechu-

18. See Lewine, 17f.
19. See Brilliant, 108, on this point.
20. Identified here as a newly baptized catechumen

(see Chapter VI, 90).
21. Shearman, 1972, 4, 22.
22. Shearman, 1972, 26f.; Goffen, 251 and n. 113.

mens are echoed in scenes of Christ repulsing Satan at the background of Botticelli's *Temptations* fresco (Pl. II). The baptismal initiation of catechumens on Holy Saturday is reflected in Perugino's *Baptism of Christ* (Pl. I); and the catechumens' First Communion at that service is evoked by the adjacent altar of the chapel, where the Eucharistic sacrifice takes place. Perugino's *Nativity* (still visible above the altar during Sixtus IV's pontificate) presented an image of Christ's birth, thereby matching another experience of baptismal candidates, who are reborn with Christ through the sacrament of baptism.[23]

Until early catechumens were taught the Lord's Prayer and Apostles' Creed, until they were purified by ascetic practices and exorcisms, until their baptism and First Communion, these would-be Christians could not be numbered among the elect. But once accepted into the Christian community, the place of the former catechumens was on the inside, metaphorically speaking. If the catechumens' spiritual voyage is located, figuratively, within the Sistine Chapel, the proper place for the newly baptized must be within the prestigious area bounded by *cancellata* and altar, the zone containing a sliver of Rosselli's *Sermon on the Mount*, Ghirlandaio's *Calling of the First Apostles*, Botticelli's *Temptations* fresco, Perugino's *Baptism of Christ*, and (during Sixtus IV's lifetime) Perugino's *Nativity*. This was, of course, the area reserved for privileged Renaissance "insiders": members of the *cappelle pontificie*.

The scheme that I have just outlined unfolds toward the altar. But the liturgical, typological, and chronological sequences examined earlier make sense only when the history frescoes are read in the opposite direction: toward the primary entrance of the chapel. Such competing directional signals were doubtless implanted in the history cycles of Pope Sixtus's chapel so that the history frescoes would fall into meaningful sequences whether worshipers began their examination of the biblical narratives from the altar or from the entrance end of the room. Such flexibility was clearly desirable in a chamber that could be approached both from a relatively inconspicuous opening beside the altar,[24] and from a wider ceremonial doorway on the opposite wall.[25] Moreover, members of Renaissance "papal chapels" who walked in liturgical processions would inevitably experience the narrative cycles from at least two directions: while moving away from the altar and while proceeding toward it.

The Christological and Mosaic narratives of Pope Sixtus's chapel once began on the altar wall and they still end on the entrance wall (Fig. 2), an arrangement known at some of the most venerable Roman basilicas: Old St. Peter's, S. Maria Maggiore, and S. Paolo fuori le Mura.[26] As Marilyn Lavin points out, the Early Christian decorators of S. Paolo and Old St. Peter's adopted a relatively common solution, placing the chronologically earlier Old Testament scenes on the right nave wall, and the later New Testament scenes on the left. But the narrative in Pope Sixtus's chapel (where the earlier Moses cycle

23. Hardison, 81.

24. This smaller door led to the sacristy, provided by Sixtus IV, but perhaps completed by his successor, Innocent VIII, whose arms appear in this space. In Sixtus's day, the door in this wall was located to the left of the altar. The present door, to the right of the altar, bears the arms of a later Renaissance pope, Alexander VI (Shearman, 1986, 31).

25. The pope and his entourage entered the chapel through this ceremonial doorway on the sixth Lenten Sunday, in the Palm Sunday procession (O'Malley, 1986, 122).

26. Ettlinger, 35; Shearman, 1986, 40.

occupies the left wall, and the later Christ cycle the right) echoes the less common scheme that orders the nave mosaics at S. Maria Maggiore. In that ancient church, the chronologically earlier biblical cycles (Abraham and Jacob) occupy the left wall, and the later cycles (Moses and Joshua) occupy the right. Reverence for S. Maria Maggiore, whose nave was decorated during the fifth-century pontificate of Sixtus III (Sixtus IV's immediate predecessor of the same name) may well have inspired the diposition of narrative in Sixtus IV's chapel, another sacred structure dedicated to the Virgin.[27]

It may be significant that the final composition in each history cycle of Pope Sixtus's chapel is located above the primary entrance to the room. This juxtaposition of end (culminating fresco in each series) and beginning (ceremonial entrance to the chamber) recalls the fundamental Christian cycle of birth, life, death, and resurrection; this pattern, inherent in the liturgy of Christmas, Lent, and Easter, is echoed in the Christ and Moses narratives of the pontifical chapel.[28] These cyclical patterns mirror the character of liturgical rites celebrated in the papal chapel, where, year after year, worshipers have for centuries sanctified the recurring cycle of Time.

From whatever point of vantage they are viewed, the monumental history frescoes designed for Pope Sixtus's chapel illustrate both familiar and unfamiliar episodes in the lives of Christ and Moses. From the late quattrocento on, most worshipers in the sacred space probably experienced little difficulty in interpreting the biblical episodes portrayed in such frescoes as Perugino's *Baptism of Christ* (Pl. I) or Rosselli's *Crossing of the Red Sea* (Pl. IV). But more obscure scriptural episodes, like the *Fight for the Body of Moses* (Pl. XIV), also appear on the Sistine Chapel walls. And one puzzling Old Testament subject, the Jewish sacrifice at the foreground of Botticelli's *Temptations* fresco (Pl. II), has proved notably resistant to interpretation.[29]

It is only in the past few decades that scholars have made much progress in disentangling the strands of doctrine, theology, and liturgy woven together in the decoration of Pope Sixtus's chapel. It is well known that the sacred chamber was intended from the outset to serve as the primary Roman chapel of the popes. Yet Ettlinger's fundamental discovery, that the decoration of the Sistine Chapel before Michelangelo was designed to stress papal authority and Roman primacy, first appeared in print only a few decades ago. Likewise, it is abundantly clear that the papal chapel and its decoration were commissioned by a Franciscan pope deeply devoted to his order. Yet Goffen's illuminating thesis, that the narrative cycles of Friar Sixtus's chapel reflect many central concerns of the Friars Minor, remained hidden from view until even more recently. Similarly, it is self-evident that Pope Sixtus's palace chapel was designed to provide a splendid setting for liturgical celebrations. Yet before now, there has been no systematic attempt to link specific texts and motifs of the Roman liturgy with biblical episodes portrayed in the Christ and Moses cycles that decorate the chapel walls.

27. Lavin, 1990, 197.

28. Goffen, 260, also comments on the circularity of the scheme, noting that the last episode of each narrative cycle brings the spectator back to the first.

29. But see Chapter III, 41ff.

Even though the painted decoration of Sixtus IV's chapel reflects some well-known themes of his pontificate, it has required considerable effort (speaking for myself at least) to unravel the tangle of meanings communicated by this complex artistic ensemble. As Peter Partner, the learned historian of Renaissance Rome, astutely comments, "To trace the theology and politics which lie behind . . . great works of art . . . carried out for the popes has proved extremely difficult."[30] The exceptional difficulty of which Partner speaks provokes my suspicion that much of the decorative scheme devised for Pope Sixtus's chapel was deliberately cloaked in mystery, so that only a privileged few might fully grasp the overall design.[31] The obscurity of this and other artistic projects undertaken by Renaissance popes seems to echo the delight of contemporary theologians in the "mysteriously meant."[32]

Some of Pope Sixtus's IV's contemporaries held parallel opinions about the inadvisability of publicizing the particulars of papal ritual. While not everyone in Renaissance Rome believed that details of pontifical ceremony should be kept entirely secret, the revised papal *Ceremonial* issued in 1488 seems not to have been intended for general circulation.[33] In this connection, it is instructive to recall Paris de Grassis's angry reaction in 1517, when a Venetian printer offered Cristoforo Marcello's text of the *Ceremoniarum Romanum* for public sale. De Grassis expressed a desire to burn Marcello's edition of the *Ceremonial*, even though the very same text had already been published in the preceding year under the title *Rituum ecclesiasticorum sive sacrarum ceremoniarum ss. Romanae Ecclesiae libri tres non ante impressi* (1516). De Grassis had far fewer objections to the earlier publication, because it was made available only to a restricted number of privileged persons.[34]

A parallel elitism may help to explain why certain Renaissance humanists recommend restricted access to esoteric interpretations of the Bible. Citing Matthew 7:6, Giovanni Pico della Mirandola cautions, in his *Oration*, that making public the occult mysteries concealed within Scripture is like giving holy things to dogs.[35] A tradition reaching back to Christian antiquity stands behind this formulation: Matthew 7:6 is already cited in Tertullian's *De Baptismo* to justify the doctrine of the arcane.[36] Religious arcana evidently appealed to Sixtus IV; according to Pico's *Apologia*, one cherished project of the della Rovere pope was a translation into Latin of the secret Jewish writings known as the Cabala.[37]

30. Peter Partner, *Renaissance Rome, 1500–1559: A Portrait of a Society*, Berkeley, Los Angeles, and London, 1976, 124.

31. Despite justifiably negative reactions to the concept of "concealed symbolism" in recent art-historical literature (see, for example, James H. Marrow, "Symbolism and Meaning in Northern European Art of the Late Middle Ages and Early Renaissance," *Simiolus*, XVI, 1986, 151), it seems plausible that arcane elements might play some role in a decorative scheme aimed at Sixtus IV and his highly learned court.

32. O'Malley, 1986, 122. Frances A. Yates, *The Art of Memory*, London, 1966, 125, speaks of "Renaissance taste with its love of mystery."

33. Nabuco, 31*.

34. Kenneth M. Setton, *The Papacy and the Levant (1204–1571)*, III, *The Sixteenth Century to the Reign of Julius II*, Philadelphia, 1984, 137 n. 171. De Grassis, however, chides his fellow master of ceremonies, Johannes Burckhard, for keeping secret his vast knowledge of the complex etiquette of the Roman curia (Setton, 137 n. 171).

35. Pico della Mirandola, *Oration*, cited in Trinkaus, II, 756.

36. Tertullian, *Traité*, 91.

37. Pico della Mirandola, *Oration*, cited in Trinkaus, II, 757.

As Kathleen Weil-Garris and John D'Amico reveal, Paolo Cortesi's *De Cardinalatu* expresses a matching attitude toward hermetic iconography in the visual arts. Cortesi's treatise, which contains an extended account of the decoration suitable for a Renaissance cardinal's palace, was first published in 1510; but the work is already cited by 1506,[38] and it may shed light on the way that Renaissance spectators were expected to experience Pope Sixtus's chapel.

Taking his cue from Aristotle's *Poetics* and the rules of classical rhetoric, Cortesi argues that works of art have the power to move men to imitate the virtuous acts and emotions that art depicts.[39] Because the message of painting may be extremely subtle, it is best understood by those with the most cultivated minds,[40] who can benefit most from the challenge presented by images with arcane meanings.[41] For these well-educated viewers, Cortesi recommends paintings that portray riddles (*enigmata*) and fables because he believes that the effort required to interpret puzzling images can sharpen the spectator's intelligence and even improve him spiritually. A less complex message conveyed by a work of art may not be remembered or acted upon because the spectator's mind is not fully engaged in deciphering it;[42] but a more erudite message conveyed by a painting requires increased mental activity from the viewer, and the greater the intellectual effort the viewer exerts, the more he will be stimulated to imitate the virtues depicted in the work of art. For Cortesi, the intellectual exercise of deciphering complex iconography in the visual arts ought ideally to become a spiritual exercise.[43] In this connection Cortesi specifically cites the "histories painted in Sixtus IV's votive chapel (*votivum sacellum*) in the Vatican" as examples of "ingenious" and challenging works of art that have the power to stimulate spiritual self-improvement in the educated viewer.[44]

Cortesi's *De Cardinalatu* suggests that the intricate, and sometimes enigmatic, scheme of painted decoration devised for Pope Sixtus's chapel was purposefully designed to engage the minds and emotions of an elite. Allusions to the ancient Lenten liturgy encoded on the Sistine Chapel walls were surely intended for a relatively narrow circle of spectators, both willing and able to solve intellectual puzzles. Based on Cortesi's comments, the occasional obscurity of this liturgical program may reflect a documented enthusiasm for erudite narrative painting among curial humanists in Renaissance Rome.[45] And if Cortesi's *De Cardinalatu* is an accurate guide, Sixtus IV and his highly educated court might well have judged that the very complexity of the painted decoration devised for the papal chapel endowed the complex scheme with exceptional spiritual value for those engaged in deciphering it.

Around the time when the Christ and Moses narratives were first painted on the Sistine Chapel walls, influential persons in papal Rome apparently thought it prudent

38. Weil-Garris–D'Amico, 64, 66.
39. Weil-Garris–D'Amico, 60 and n. 45; 62; 91 and n. 97.
40. Weil-Garris–D'Amico, 62f.
41. Weil-Garris–D'Amico, 63, 95 and n. 129.
42. Weil-Garris–D'Amico, 95.

43. Weil-Garris–D'Amico, 91 n. 109.
44. Weil-Garris–D'Amico, 91, 93.
45. Weil-Garris–D'Amico, 93, 109: on the curial humanists, see John F. D'Amico, *Renaissance Humanism in Papal Rome, Humanists and Churchmen on the Eve of the Reformation*, Baltimore, 1983.

to reserve details of pontifical ceremony, arcane interpretations of Scripture, and history paintings with erudite or cryptic content for the pleasure and edification of a favored few. Privileged members of the "papal chapels" in Renaissance Rome, who plainly constituted an intellectual elite, were exceptionally well equipped to uncover any allusions to liturgy, theology, and doctrine in the decoration of Pope Sixtus's chapel. (Moreover, as Egmont Lee suggests, these learned men, with extensive knowledge of Scripture, may have helped to select the more uncommon biblical subjects eventually depicted on the Sistine Chapel walls.)[46] But the ideal viewer of the intricate program was surely Pope Sixtus IV, a devout Franciscan and learned theologian, who stamped his personal imprimatur upon the complex scheme of painted decoration still much admired today by visitors to his papal chapel in the Vatican palace.

46. Lee, 141.

# APPENDIX:

## Liturgical Themes Reflected in the History Frescoes of Pope Sixtus's Chapel

Titles of Christological and Mosaic frescoes appear in italics. Individual scenes within the frescoes, and individual figures or groups of figures, appear within quotation marks. *Tituli* and liturgical references appear in small caps.

Altar wall, Christological fresco:
Perugino, *The Nativity* (destroyed)
*Titulus:* not preserved

> "Nativity Scene"
> —CHRISTMAS DAY, commemoration of Christ's birth

Altar wall, Mosaic fresco:
Perugino, *The Finding of Moses* (destroyed)
*Titulus:* not preserved

> "Finding of Moses"
> —BAPTISM emphasized throughout LENTEN LITURGY

North wall, first Christological fresco:
Perugino, *The Baptism of Christ*
*Titulus:* INSTITUTIO NOVAE REGENERATIONIS A CHRISTO IN BAPTISMO

> "Christ's Baptism by John"
> —FEAST OF THE EPIPHANY (6 January), commemoration of Christ's BAPTISM
> —BAPTISM emphasized throughout LENTEN LITURGY
> —EPISTLE, SEPTUAGESIMA SUNDAY, I Corinthians 10:2 (alludes to BAPTISM)
> —STATIONAL CHURCH, FIRST LENTEN SUNDAY, S. Giovanni in Laterano (dedicated to John the Baptist)

"St. John Approaches the Jordan to Perform the Baptism of Repentance"
—EPISTLE, SEPTUAGESIMA SUNDAY, I Corinthians 10:2 (alludes to BAPTISM)
—FIRST LENTEN MONDAY, once opened period of LENTEN PENITENCE
"Jesus Preaches Repentance"
—Importance of LENTEN PREACHING
—FIRST LENTEN MONDAY, once opened period of LENTEN PENITENCE
"John the Baptist Preaching"
—Importance of LENTEN PREACHING
"*Spinario*" and "Half-Nude Catechumens"
—BAPTISM emphasized throughout the LENTEN LITURGY

South wall, first Mosaic fresco:
Perugino and Pinturicchio, *The Circumcision of Moses' Son*
*Titulus:* OBSERVATIO ANTIQUE REGENERATIONIS A MOISE PER CIRCONCISIONEM

    "Twofold Representation of Moses' Sons"
    —SECOND LENTEN WEEK, liturgical allusions to brothers
    "Circumcision of Moses' Younger Son"
    —PURIFICATION, emphasized throughout LENTEN LITURGY
    —SECOND LENTEN WEEK, liturgy alludes to preference for younger brothers and
        younger sons

North wall, second Christological fresco:
Botticelli, *The Temptations of Christ*
*Titulus:* TEMPTATIO IESU CHRISTI LATORIS EVANGELICAE LEGIS

    "Christ Rejects the Devil's Temptations"
    —GOSPEL, FIRST LENTEN SUNDAY, Matthew 4:1–11 (Temptations)
    —LENTEN EMBERTIDE, themes of EXORCISM in liturgy
    "Angels Prevent Jesus from Hitting His Foot on a Stone"
    —GOSPEL, FIRST LENTEN SUNDAY, Matthew 4:6 (describes the incident)
    —OFFICE, FIRST SUNDAY OF LENT, Psalm 90 assigned in liturgy (Psalm 90:12 de-
        scribes this incident)
    "Priestly Sacrifice"
    —ORDINATION, SATURDAY OF LENTEN EMBERTIDE, FIRST LENTEN WEEK
    —LESSON, SATURDAY OF LENTEN EMBERTIDE, II Maccabees 1:18–23 (High Priest
        Nehemiah)

South wall, second Mosaic fresco:
Botticelli, *Moses in Egypt and Midian*
*Titulus:* TEMPTATIO MOISI LEGIS SCRIPTAE LATORIS

    "Moses Waters Jethro's Flocks"
    —BAPTISM emphasized throughout LENTEN LITURGY

"Moses' Flight to Midian"
—ASCETICISM emphasized throughout the LENTEN LITURGY
"Moses Murders the Egyptian Taskmaster"
"Moses Drives away the Hostile Shepherds"
—Allusions to EXORCISM in liturgy of LENTEN EMBERTIDE
"Moses and the Burning Bush"
—EPISTLE, ASH WEDNESDAY, Exodus 3:1–2 (Moses and the Burning Bush)

North wall, third Christological fresco:
Ghirlandaio, *The Calling of the First Apostles*
*Titulus:* CONGREGATIO POPULI LEGEM EVANGELICAM RECEPTURI

"Calling of the First Apostles"
—THIRD LENTEN SUNDAY, catechumens first taught Apostles' Creed
—WEDNESDAY, FOURTH LENTEN WEEK, catechumens first called upon to enroll for
  BAPTISM
"*Titulus*" (couched in future tense)
—Proleptic reference to HOLY SATURDAY, when baptismal candidates publicly repeat
  Apostles' Creed

South wall, third Mosaic fresco:
Rosselli, *The Crossing of the Red Sea*
*Titulus:* CONGREGATIO POPULI A MOISE LEGEM SCRIPTAM ACCEPTURI

"Crossing of the Red Sea"
—THIRD AND FOURTH LENTEN WEEKS, watery themes emphasized in the liturgy
"Song of Moses and Miriam"
—EPISTLE, THURSDAY OF FOURTH LENTEN WEEK, Exodus 15 (Crossing of the Red
  Sea)
—Proleptic reference to HOLY SATURDAY, LESSON, Exodus 14:24–31; 15:1 (Crossing
  of the Red Sea)
"*Titulus*" (couched in future tense)
Proleptic references to HOLY WEEK
"Pillar of Fire"
—Proleptic reference to HOLY SATURDAY, BENEDICTION OF PASCHAL CANDLE
"Red Sea Water"
—Proleptic reference to GOOD FRIDAY SERVICE, commemorating blood and water
  shed by Christ on the Cross

North wall, fourth Christological fresco:
Rosselli, *The Sermon on the Mount*
*Titulus:* PROMULGATIO EVANGELICAE LEGIS PER CHRISTUM

"Jesus' Sermon on the Mount"
—THIRD LENTEN SUNDAY, early catechumens first taught the Lord's Prayer
—Traditional GOSPEL, MONDAY, THIRD LENTEN WEEK: Matthew 6:9–13 (Sermon on the Mount)
"Jesus Heals a Leper"
—GOSPEL, MONDAY, THIRD LENTEN WEEK, Luke 4:23–30 (Naaman the Leper)
—EPISTLE, MONDAY, THIRD LENTEN WEEK, 4 Kings 5:1–5 (Naaman the Leper)

South wall, fourth Mosaic fresco:
Rosselli, *The Lawgiving on Mount Sinai*
*Titulus:* PROMULGATIO LEGIS SCRIPTE PER MOISEM

"Lawgiving on Mount Sinai"
"Moses with the Tablets of the Law"
—EPISTLE, WEDNESDAY, THIRD LENTEN WEEK, Exodus 20:12–24 (Mosaic Commandments)
—GOSPEL, WEDNESDAY, THIRD LENTEN WEEK, Matthew 15:1–20 (Moses as Lawgiver; Mosaic Commandments)
—GOSPEL, THURSDAY, FOURTH LENTEN WEEK, John 7:19 ("Did not Moses give you the Law?")
"Worship of the Golden Calf"
—EPISTLE, THURSDAY, FOURTH LENTEN WEEK, Exodus 32:7–14 (Worship of the Golden Calf)

North wall, fifth Christological fresco:
Perugino, *The Gift of the Keys*
*Titulus:* CONTURBATIO IESU CHRISTI LEGIS LATORIS

"Gift of the Keys"
—ORDINATIONS conferred on SATURDAY PRECEDING PASSION SUNDAY
—ORDINATIONS commemorated in PASSION SUNDAY liturgy
—LESSON, MASS FOR RECONCILIATION OF PENITENTS, HOLY THURSDAY, Matthew 16:17–19 (Gift of the Keys)
"Stoning of Christ"
—GOSPEL, PASSION SUNDAY, John 8:59 (Stoning of Jesus)
"Payment of the Tribute Money"
—SATURDAY OF PASSION WEEK, papal almsgiving
"Triumphal Arches"
—EASTER MONDAY, FESTIVAL OF *ARCHI E TURIBOLI*
—PAPAL *POSSESSO* (triumphal arches featured in the ceremony)

South wall, fifth Mosaic fresco:
Botticelli, *The Punishment of Korah*
*Titulus:* CONTURBATIO MOISI LEGIS SCRIPTAE LATORIS

"Sacrifice of Aaron and Eleazar"
"Sacrifice of Korah and the Rebels"
—SATURDAY PRECEDING PASSION SUNDAY, ORDINATIONS conferred
—PASSION SUNDAY, ORDINATIONS commemorated in liturgy
"Inscription on Triumphal Arch"
—GOOD FRIDAY, OFFICE OF TENEBRAE, Hebrews 5:4 (related to text on triumphal arch)
—*SEDE VACANTE,* Hebrews 5:4 recited in OFFICE (related to text on triumphal arch)
"Triumphal Arch and Censers"
—EASTER MONDAY, FESTIVAL OF *ARCHI E TURIBOLI* (triumphal arches and censers prominent in ceremony)
—PAPAL *POSSESSO* (triumphal arches and censers prominent in ceremony)
"Moses' Wand"
—PAPAL *POSSESSO* (popes presented with staff of office)
"Fire in censers; Fire on the altar"
—HOLY SATURDAY, BENEDICTION OF NEW FIRE OF EASTER
"Stoning of Moses"
—EPISTLE (traditional), SATURDAY PRECEDING PALM SUNDAY, Exodus 15:17–16:2 (events at Seventy Palms of Elim)

North wall, sixth Christological fresco:
Rosselli, *The Last Supper*
*Titulus:* REPLICATIO LEGIS EVANGELICAE A CHRISTO

"Last Supper"
—GOSPEL, PALM SUNDAY, Passion according to Matthew (describes Last Supper)
—HOLY THURSDAY, INSTITUTION OF THE EUCHARIST commemorated
—HOLY SATURDAY, FIRST COMMUNION of early catechumens
"Cat and Dog"
—HOLY THURSDAY, INSTITUTION OF THE EUCHARIST commemorated
—HOLY SATURDAY, FIRST COMMUNION of early catechumens
"Basin and Pitchers"
—GOSPEL, HOLY THURSDAY, John 13:1–15 (Feet-washing)
"Agony in the Garden"
"Betrayal of Christ"
—PALM SUNDAY LITURGY, Passion according to Matthew (refers to Agony in the Garden and Betrayal)

—HOLY THURSDAY LITURGY (refers to Agony in the Garden and Betrayal)
"Crucifixion"
—PALM SUNDAY LITURGY, Passion according to Matthew (describes Crucifixion)
—GOOD FRIDAY SERVICE, commemorates crucifixion

South wall, sixth Mosaic fresco:
Signorelli, *The Last Testament of Moses*
*Titulus:* REPLICATIO LEGIS SCRIPTAE A MOISE

"Appointment of Joshua as Moses' Successor"
"Moses Reads the Law to the Elders of Israel"
—LESSON, HOLY SATURDAY, Deuteronomy 31:22–30 (Appointment of Joshua; Moses
  reads the Law)
"Moses Shown the Land of Milk and Honey"
—HOLY SATURDAY, LITURGICAL DRINK OF MILK AND HONEY
"*Spinario*"
—HOLY SATURDAY, BAPTISM of early catechumens

Entrance wall, Christological fresco:
Van den Broeck, *The Resurrection and Ascension of Christ*
*Titulus:* RESURRECTIO ET ASCENSIO CHRISTI EVANGELICAE LEGIS LATORIS

"Resurrection of Christ"
—HOLY SATURDAY AND EASTER SUNDAY LITURGY (commemorates Christ's Resurrec-
  tion)
"Ascension of Christ"
—ASCENSION THURSDAY LITURGY (commemorates Christ's Ascension)

Entrance wall, Mosaic fresco:
Matteo da Lecce, *The Fight for the Body of Moses*
*Titulus:* not preserved

"Fight for the Body of Moses"
—OFFICE, SATURDAY VIGIL OF PENTECOST, Jude 9–13 (Fight for Moses' Body)

# BIBLIOGRAPHY

## PRIMARY SOURCES

Amalarius, *De ecclesia officio*
    Amalarius of Metz. *De Ecclesia Officio, libelli quattuor* (*De Divinis Catholicae Ecclesiae Officiis*. Edited by Melchior Hittorp). Cologne, 1568.

Amalarius, *Liber officialis*
    ———. *Liber Officialis* (*Studi e Testi*, 139). Edited by J. M. Hanssens. Vatican City, 1948.

Amalarius, *Liber de ordine antiphonarii*
    ———. *Liber de Ordine Antiphonarii* (*Studi e Testi*, 140). Edited by J. M. Hanssens. Vatican City, 1950.

Ambrose, *Pénitence*
    Ambrose of Milan. *La pénitence* (*SC*, 179). Edited by Roger Gryson. Paris, 1971.

Ambrose, *Sacrements*
    ———. *Des sacrements. Des mystères* (*SC*, 25). Edited by Bernard Botte. Paris, 1961.

Augustine, *Pâque*
    Augustine of Hippo. *Sermons pour la Pâque* (*SC*, 116). Edited by Suzanne Poque. Paris, 1961.

Augustine, *Sermons*
    ———. *Sermons on selected lessons of the New Testament* (*Nicene and Post-Nicene Fathers*, vi). Edited by P. Schaff. Translated by Ramsey MacMullen. Grand Rapids, Mich., 1956.

Bede, *In Pentateucham*
    Bede, the Venerable. *In Pentateucham Commentarii. Exodus*, PL xci.

Bede, *De divinis . . . officiis*
    ———. *De Divinis Catholicae Ecclesiae Officiis ac Ministeriis, varii vetustorum aliquot ecclesiae patrum ac scriptorum libri. . . .* Edited by Melchior Hittorp. Cologne, 1568.

Durandus, 1479.
    Durandus of Mende, Bishop William. *Rationale divinorum officiorum*. Treviso[?], 1479 (Hain 6481; Proctor 6471).

Durandus, 1568
    ———. *Rationale divinorum officiorum*. Venice, 1568.

*Glossa Ordinaria*
    [Walafrid Strabo]. *Glossa Ordinaria*. PL cxiii.

Gregory of Nyssa, *Moïse*
    Gregory of Nyssa. *La Vie de Moïse* (*SC*, 1). Edited by Jean Daniélou. Paris, 1968.

Hippolytus, *Tradition*
    Hippolytus of Rome. *La Tradition apostolique . . .* (*SC*, 11). Edited by Bernard Botte. 2d edition. Paris, 1968.

Josephus, *Antiquities I–IV*
    Flavius Josephus. *Jewish Antiquities, Books I–IV* (*Loeb Classical Library*). Translated by H. St. John Thackeray. London, 1930.

Josephus, *Antiquities IX–XI*
    ———. *Jewish Antiquities, Books IX–XI* (Loeb Classical Library). Translated by Ralph Marcus. London, 1937.

Legg
    *The Second Recension of the Quignon Breviary* (Henry Bradshaw Society). Edited by J. Wickham Legg. 2 vols. London, 1912.

Leo, *Sermons I*
    Leo the Great. *Sermons, I* (SC, 22 bis). Edited by René Dolle. Paris, 1964.

Leo, *Sermons II*
    ———. *Sermons, II* (SC, 49 bis). Edited by René Dolle. Paris, 1966.

Leo, *Sermons III*
    ———. *Sermons, III* (SC, 74). Edited by René Dolle. Paris, 1961.

Lippe
    *Missale Romanum Mediolani, 1474.* I, II (Henry Bradshaw Society). Edited by R. Lippe. London, 1889, 1907.

Nicolaus de Lyra, *Postillae maiores*
    Nicolaus de Lyra. *Postillae maiores seu enarrationes in epistolas et evangelia totius anni.* Lyon, 1569.

Nicolaus de Lyra, *Postilla . . . literalis*
    ———. *Postilla seu expositio literalis et moralia super epistolas et evangelia quadragesimalia.* Venice, 1506.

Ordo Romanus I
    *Ordo Romanus de Missae et reliquis per annum officis* (*De Divinis Catholicae Ecclesiae Officiis ac Ministeriis, varii vetustorum aliquot ecclesiae patrum ac scriptorum libri. . . .* Edited by Melchior Hittorp. Cologne, 1568.

Origen, *Nombres*
    Origen. *Homélies sur les Nombres* (SC, 29). Edited by André Méhat. Paris, 1951.

Panvinio
    *Le Vite de' Pontefici de Bartolomeo Platina Cremonese, II, Da Sisto IV sino al present pontefice Benedetto XIII* (Descritto da Onofrio Panvinio e da altri autori più moderni). Venice, 1730.

Philo, *De Vita Mosis*
    Philo of Alexandria. *De Vita Mosis* (Les Oeuvres de Philon d'Alexandrie, 22). Edited by R. Arnaldez, C. Mondésert, J. Pouilleux, P. Savinel. Paris, 1967.

Rabanus Maurus, *In Exodum*
    Rabanus Maurus. *Commentaria in Exodum, PL* CVIII.

Rupert of Deutz, *Liber de divinis officiis*
    Rupert of Deutz. *Liber de divinis officiis* (Corpus Christianorum, continuatio medievalis, VII). Edited by Rhabanus Haacke. Turnholt, 1967.

Sicard of Cremona, *Mitrale*
    Sicard of Cremona. *Mitrale. PL* CCXIII.

Tertullian, *Traité*
    Tertullian. *Traité du Baptême* (SC, 35). Edited by R. F. Refoulé, M. Drouzy. Paris, 1952.

Vasari (Milanesi)
    Giorgio Vasari. *Le Vite de' più eccellenti Pittori, Scultori ed Architettori.* Edited by Gaetano Milanesi. 8 vols. Florence, 1878.

## SECONDARY SOURCES

Anciaux
    P. Anciaux. *La Théologie du sacrement de pénitence au XIIe siècle* (Universitas Catholica Lovanensis, Dissertationes Theologicae, Series II, 41). Louvain, 1949.

Andrieu
    Michel Andrieu. "Le Missal de la chapelle papale à la fin du XIIIe siècle." *Miscellanea Fr. Ehrle*, II (Studi e Testi, 38), 1924, 348–76.

Armellini
    Mariano Armellini. *Le Chiese di Roma.* I. Rome, 1942.

Baldwin
    Robert Baldwin. "Triumph and the Rhetoric of Power in Italian Renaissance Art." *Source: Notes in the History of Art*, IX, 1990, 7–13.

Barzotti
Luigi Tombolini Barzotti. *Monografia sulla Cappella Sistina in Vaticano.* Rome, 1933–39.

Bäumer
Dom Suitbert Bäumer. *Histoire du Bréviaire.* I. Translated by Dom R. Biron. Paris, 1905.

Bernabei
Franco Bernabei. "Captions." In *The Sistine Chapel: The Art, the History, and the Restoration.* New York, 1986.

Bober–Rubinstein
Phyllis Pray Bober and Ruth Rubinstein. *Renaissance Artists and Antique Sculpture.* London, 1986.

Brenk, 1966
Beat Brenk. *Tradition und Neuerung in der christlichen Kunst der ersten Jahrtausends, Studien zur Geschichte des Weltgerichtsbilden* (Wiener Byzantinische Studien, 3). Vienna, 1966.

Brenk, 1975
———. *Die frühchristlichen Mosaiken in S. Maria Maggiore zu Rom.* Wiesbaden, 1975.

Brilliant
Richard Brilliant. "The Bayeux Tapestry: A Stripped Narrative for Their Eyes and Ears." *Word and Image,* VII, 1991, 98–126.

Cabrol
Ferdinand Cabrol. *Liturgical Prayer.* Westminster, Md., 1950 (1st edition, 1905).

Callewaert, 1924
Camille Callewaert. "La semaine *mediana* dans l'ancien Carême romain et les Quatre-Temps." *Revue bénédictine,* XXXVI, 1924, 200–28.

Callewaert, 1940 (1)
———. "La durèe et le caractère du Carême ancien dans l'Eglise latine." In *Sacris Erudiri.* Steenbrugge, 1940.

Callewaert, 1940 (2)
———. "La messe du Jeudi de la semaine de la Passion." In *Sacris Erudiri,* Steenbrugge, 1940.

Camesasca
Ettore Camesasca. *See* Salvini–Camesasca

Cancellieri, 1802
Francesco Cancellieri. *Storia de' solenni possessi de' sommi pontefici. . . .* Rome, 1802.

Cancellieri, 1818
———. *Descrizione della Settimana Santa nella Cappella Pontificia.* Rome, 1818.

Cartwright
Julia Cartwright. *The Life and Art of Sandro Botticelli.* London, 1904.

Chavasse
A. Chavasse. *Le Sacrementaire Gélasien* (*Vaticanus Reginensis 316*) (Bibliothèque de Théologie, 4). Tournai, 1958.

Concise ODCC
*The Concise Oxford Dictionary of the Christian Church.* Edited by Elizabeth A. Livingstone. Oxford and New York, 1987.

Daniélou, 1950
Jean Daniélou, S.J. *Sacramentum Futuri: Etudes sur les origines de la typologie biblique.* Paris, 1950.

Daniélou, 1964
———. *The Bible and the Liturgy* (Liturgical Studies, 3). 3d edition. Notre Dame, Ind., 1964.

Davidson
Bernice F. Davidson. *Raphael's Bible: A Study of the Vatican Logge* (College Art Association Monographs on the Fine Arts, 39). University Park, Pa., 1985.

Dix
Gregory Dix. *The Shape of the Liturgy.* Glasgow, 1947.

Eberlein
Johann Konrad Eberlein. "The Curtain in Raphael's *Sistine Madonna.*" *Art Bulletin,* LXV, 1983, 61–77.

Eisler
Colin Eisler. "The Athlete of Virtue, The Iconography of Asceticism. In *De Artibus Opuscula XL: Essays in Honor of Erwin Panofsky.* 2 vols. Edited by Millard Meiss. New York, 1961, 82–97.

Enciclopedia cattolica
*Enciclopedia cattolica.* 12 vols. Vatican City, 1949–54.

Ettlinger

Leopold D. Ettlinger. *The Sistine Chapel Before Michelangelo: Religious Imagery and Papal Primacy.* Oxford, 1965.

Fabre

Paul Fabre. *Etude sur le Liber Censum de l'Eglise Romaine* (Bibliothèque des Ecoles Françaises d'Athènes et de Rome, 1). Paris, 1892.

Ginzberg

Louis Ginzberg. *The Legends of the Jews.* Translated by Henrietta Szold and Paul Radin. II. Philadelphia, 1983. III. Philadelphia, 1982. V. Philadelphia, 1983. VI. Philadelphia, 1982.

Glass

Dorothy Glass. "The Archivolt Sculpture at Sessa Aurunca." *Art Bulletin,* XLIII, 1970, 119–31.

Goffen

Rona Goffen. "Friar Sixtus IV and the Sistine Chapel." *Renaissance Quarterly,* XXXIX, 1986, 218–62.

Hardison

O. B. Hardison, Jr. *Christian Rite and Christian Drama in the Middle Ages: Essays in the Origin and Early History of Modern Drama.* Baltimore, 1965.

Hastings, *Dictionary*

*A Dictionary of the Bible.* Edited by James Hastings. 5 vols. Edinburgh, 1927–35.

Heckscher

William S. Heckscher. *Reallexikon zur deutschen Kunstgeschichte.* IV, 1958, 289–99, s.v. "Dornauszieher."

Howe

Eunice D. Howe. "A Temple Facade Reconsidered: Botticelli's *Temptation of Christ.*" In *Rome in the Renaissance: The City and the Myths* (Medieval and Renaissance Texts and Studies, 18). Edited by P. A. Ramsey. Binghamton, N.Y., 1982, 209–21.

Huelsen

Christian Huelsen. *Le Chiese di Roma nel Medio Evo.* Florence, 1926.

Jungmann, 1959

Joseph A. Jungmann, S.J. *The Early Liturgy to the Time of Gregory the Great* (Liturgical Studies, 6). Translated by F. A. Brunner, S.J. Notre Dame, Ind., 1959.

Jungmann, 1986

———. *The Mass of the Roman Rite: Its Origins and Development (Missarum Solemnia).* Translated by F. A. Brunner, S.J. Westminster, Md., 1986.

Koehler

Wilhelm Koehler. *Die karolingische Miniaturen.* I, *Die Schule von Tours.* Berlin, 1933.

Krautheimer, 1942

Richard Krautheimer. "Introduction to the Iconography of Medieval Architecture." *Journal of the Warburg and Courtauld Institutes,* V, 1942, 1–33. Reprinted in *Studies in Early Christian, Medieval and Renaissance Art,* New York, 1969, 115–50.

Krautheimer, 1961

———. "The Architecture of Sixtus III: A Fifth-Century Renaissance." In *De Artibus Opuscula XL: Essays in Honor of Erwin Panofsky.* 2 vols. Edited by Millard Meiss. New York, 1961, 291–302.

Krautheimer, 1965

———. *Early Christian and Byzantine Architecture.* Baltimore, 1965.

Krinsky

Carol Herselle Krinsky. "Representations of the Temple of Jerusalem before 1500." *Journal of the Warburg and Courtauld Institutes,* XXXIII, 1970, 1–19.

Kury

Gloria Kury. *The Early Work of Luca Signorelli: 1465–1490.* New York and London, 1978.

Laborde

Alexandre de Laborde. *Etudes sur la Bible moralisée illustrée.* I. Paris, 1911.

Lavin, 1981

Marilyn Aronberg Lavin. *Piero della Francesca's "Baptism of Christ"* (Yale Publications in the History of Art, 29). New Haven, 1981.

Lavin, 1990

———. *The Place of Narrative: Mural*

*Decoration in Italian Churches 431–1600.*
Chicago, 1990.

Lee

Egmont Lee. *Sixtus IV and Men of Letters*
(*Temi e Testi*, 26). Vatican City, 1978.

Levey

Michael Levey. *The Complete Paintings of
Botticelli.* New York, 1967.

Levi D'Ancona, 1968

Mirella Levi D'Ancona, "The *Doni Ma-
donna* by Michelangelo: An Iconographic
Study." *Art Bulletin*, L, 1968, 43–50.

Levi D'Ancona, 1977

————. *The Garden of the Renaissance:
Botanical Symbolism in Italian Painting.* Flor-
ence, 1977.

Lewine

Carol F. Lewine. "Botticelli's *Punishment of
Korah* and the 'Sede Vacante.'" *Source:
Notes in the History of Art*, IX, 1990, 14–18.

Lightbown

Ronald Lightbown. *Sandro Botticelli.* 2
vols. Berkeley and Los Angeles, 1978.

Lundberg

P. Lundberg. *La Typologie baptismale dans
l'ancien Eglise* (Acta Seminarii Neotesta-
mentici Upsaliensis, 10). Uppsala, 1942.

Martimort

Aimé-Georges Martimort, ed. *L'Eglise en
prière.* Paris, 1961.

Mollat

Guy Mollat. *The Popes at Avignon (1305–
1378).* Translated by J. Love from the 9th
French edition. New York, 1965.

Monfasani

John Monfasani. "A Description of the
Sistine Chapel under Pope Sixtus IV."
*Artibus et Historiae*, VII, 1983, 9–18.

Moroni

Gaetano Moroni. *Histoire des chapelles pa-
pales.* Translated by A. Manavit. Paris, 1846.

Müntz–Fabre

Eugène Müntz and Paul Fabre. *La Biblio-
thèque du Vatican au 15e siècle.* Paris, 1887.

Nabuco

Joaquim Nabuco. *Le Cérémonial Apostolique
avant Innocent VIII, texte du MS Urbinate
Latin 469* (Bibliotheca "Ephemerides Litur-
gica," Sectio Historica, 30). Established by
Dom F. Tamburini. Introduction by Msgr.
Joaquim Nabuco. Rome, 1966.

Narkiss

Bezalel Narkiss, "Pharaoh Is Dead and
Living at the Gates of Hell." *Journal of
Jewish Art*, X, 1984, 6–13.

*New Catholic Encyclopedia*

*New Catholic Encyclopedia.* 18 vols. Wash-
ington, D.C., 1967–89.

O'Malley, 1974

John W. O'Malley, S.J. "Preaching for the
Popes." In *The Pursuit of Holiness in Late
Medieval and Renaissance Religion.* Edited by
Charles Trinkaus, with Heiko A. Ober-
man. Leiden, 1974, 408–40.

O'Malley, 1979

————. *Praise and Blame in Renaissance
Rome: Rhetoric, Doctrine and Reform in the
Sacred Orators of the Papal Court, c. 1450–
1521* (Duke University Monographs in
Medieval and Renaissance Studies, 3).
Durham, N.C., 1979.

O'Malley, 1986

————. "The Theology Behind Michelan-
gelo's Ceiling." In *The Sistine Chapel: The
Art, the History, and the Restoration.* New
York, 1986, 92–148.

Pagden

Sylvia Ferino Pagden. "Iconographic De-
mands and Artistic Achievements." In
*Raffaello a Roma: Il Covegno del 1983*
(Bibliotheca Hertziana, Musei Vaticani).
Edited by C. L. Frommel and M. Winner.
Rome, 1986, 13–28.

Pastor

Ludwig von Pastor. *The History of the Popes.*
Translated by F. I. Antrobus. 5th edition.
Vol. IV. London, 1949.

Ragusa–Green

Isa Ragusa and Rosalie B. Green, eds.
*Meditations on the Life of Christ: An Illus-
trated Manuscript of the Fourteenth Century,
Paris, Bibliothèque Nationale, MS Ital. 115*

(Princeton Monographs in Art and Archaeology, xxv). Translated by Isa Ragusa. Princeton, 1961.

Réau

Louis Réau. *Iconographie de l'art chrétien.* II. *Iconographie de la Bible.* 1. *Ancien Testament.* Paris, 1956. 2. *Nouveau Testament.* Paris, 1957.

Redig de Campos, 1967

Deoclecio Redig de Campos. *I palazzi Vaticani* (Roma Christiana, 18). Bologna, 1967.

Redig de Campos, 1970

————. "I 'tituli' degli affreschi del Quattrocento nella Capella Sistina." *Rendiconti della pontificia accademia romana di archeologia,* XLIII, 1970, 299–314.

Rice

Eugene F. Rice, Jr. *Saint Jerome in the Renaissance.* Baltimore, 1985.

Righetti

Mario Righetti. *Manuale di storia liturgica.* I. Ancona, 1950. II. Milan, 1955. III. Milan, 1956. IV. Milan, 1953.

Rodocanachi

Emmanuel Pierre Rodocanachi. *Histoire de Rome: Une cour princière au Vatican pendant la Renaissance—Sixte IV—Innocent VIII—Alexandre VI Borgia, 1471–1503.* Corbeil, 1925.

Salvini–Camesasca

Roberto Salvini. *La cappella Sistina in Vaticano.* Appendix by Ettore Camesasca. Milan, 1965.

Schiller

Gertrude Schiller. *Iconography of Christian Art,* I. Translated by Janet Seligmann. Greenwich, Conn., 1971.

Schubring

Paul Schubring. *The Sistine Chapel.* Rome, 1910.

Shearman, 1961

John Shearman. "The Chigi Chapel in S. Maria del Popolo." *Journal of the Warburg and Courtauld Institutes,* XXIV, 1961, 129–60.

Shearman, 1972

————. *Raphael's Cartoons in the Collection of Her Majesty the Queen and the Tapestries for the Sistine Chapel.* London, 1972.

Shearman, 1986

————. "The Chapel of Sixtus IV: The Fresco Decoration of Sixtus IV." In *The Sistine Chapel: The Art, the History, and the Restoration.* New York, 1986, 22–87.

Slatkes

Leonard J. Slatkes. "Caravaggio's Painting of the Sanguine Temperament." *Actes du XXXIIe Congrès d'Histoire de l'Art, Budapest, 1969,* II. Budapest, Akademia l Kiadò, 1972, 17–24.

Smith, *Dictionary*

*A Dictionary of the Bible.* Edited by W. Smith. I. London, 1863.

Stastny

Francisco Stastny. "A Note on Two Frescoes in the Sistine Chapel." *Burlington Magazine,* CXXI, 1979, 777–83.

Steinberg

Leo Steinberg. *The Sexuality of Christ in Renaissance Art and Modern Oblivion.* Postscript by John W. O'Malley, S.J. New York, 1983.

Steinmann

Ernst Steinmann. *Die Sixtinische Kapelle.* I. *Der Bau und Schmuck der Kapelle unter Sixtus IV.* Munich, 1901.

Stinger

Charles L. Stinger. *The Renaissance in Rome.* Bloomington, 1985.

Trinkaus

Charles Trinkaus. *In Our Image and Likeness: Humanity and Divinity in Italian Humanist Thought.* 2 vols. Chicago, 1970.

Underwood

Paul Underwood, "The Fountain of Life in Manuscripts of the Gospels." *Dumbarton Oaks Papers,* V, 1950, 41–138.

Van Dijk, 1963

S.J.P. Van Dijk. *Sources of the Modern Roman Liturgy: The Ordinals by Haymo of Faversham . . .* (Studia et Documenta Franciscana, 1). 2 vols. Leiden, 1963.

Van Dijk, 1975

———. *The Ordinal of the Papal Court from Innocent III to Boniface VIII and Related Documents* (Spicilegium Friburgense, 22). Completed by Joan Hazelden Walker. Fribourg, 1975.

Van Engen

John H. Van Engen. *Rupert of Deutz.* Berkeley and Los Angeles, 1983.

Webster

J. Carson Webster. *The Labors of the Months in Antique and Medieval Art* (Princeton Monographs on Art and Archaeology, 21). Princeton, 1938.

Weil-Garris–D'Amico

Kathleen Weil-Garris and John D'Amico. "The Renaissance Cardinal's Ideal Palace: A Chapter from Cortesi's *De Cardinalatu.*" In *Studies in Italian Art and Architecture, Fifteenth through Eighteenth Centuries* (Memoirs of the American Academy in Rome, xxxv). Edited by Henry A. Millon. Rome, 1980, 45–123.

Westfall

Carroll William Westfall. *In This Most Perfect Paradise: Alberti, Nicholas V, and the Invention of Conscious Urban Planning in Rome, 1447–55.* University Park, Pa., 1974.

Wilde

Johannes Wilde. "The Decoration of the Sistine Chapel." *Proceedings of the British Academy,* XLIV, 1958, 61–81.

Wind, 1954

Edgar Wind. "The Revival of Origen." In *Studies in Art and Literature for Belle da Costa Greene.* Edited by Dorothy Miner. Princeton, 1954, 412–24.

Wind, 1960

———. "Michelangelo's Prophets and Sibyls." *Proceedings of the British Academy,* LI, 1960, 47–84.

# INDEX

Aaron, 62, 64, 74, 75–76, 77, 79, 81–82

Abihu (son of Aaron), 75–76

Abiram, 74, 75, 76, 77, 79–80

absolution, 70–71

Advent, xv, 2, 3, 4, 5, 15, 17, 96

Alberti, Leon Battista, 78

Alcuin of York, 73

Alexander VI (pope, Rodrigo Borgia), 9, 100, 110 n. 24

All Saints' Day, 17

Amalarius of Metz, 11, 39, 45, 46, 51 n. 23, 54, 55, 58, 67, 87, 91

Ambrose, Saint, 10, 15, 29, 50, 53–54, 59, 73, 91

Andreas of Trebizond, 44

Andrew, Saint, 51–52

angels, 22, 27, 35, 87, 89, 108

antiquity, Early Christian
  preservation of, 13 n. 86
  Renaissance revival of, xiii, xviii–xix, 3, 10, 13–16, 44

Apostles' Creed, 6, 9, 15, 30, 50–51, 52, 58, 85, 105, 109–10

*Apostolic Constitutions*, 71

*Aqua Vergine*, 37 n. 30

*archi e turiboli*, festival of, 80, 81

Aristotle, 113

Ark of the Covenant, 88

Ascension Thursday, 4, 6, 17, 97–98, 100

asceticism, 40, 45, 109

Ash Wednesday, xvi, 17, 24 n. 34, 34, 39, 40, 67

Assumption
  feast of the, xviii, 1, 18
  of the Virgin. *See* Mary (mother of Jesus), *Assunta*

*Assumption of Moses, The*, 98

athletes, 90–91

Augustine, Saint, 10, 15, 21, 26, 27, 30, 38 n. 40, 42 n. 74, 45, 50, 54, 55, 74, 89

Avignon, xvii, 16, 17, 44–46, 99

Babylonian captivity. *See* Jews, Babylonian captivity of; papacy, so-called Babylonian captivity of

Baglione, Giovanni, 97

baptism
  of catechumens, 37, 38, 39, 50, 55, 91–92
  and Christ Washing the Disciples' Feet, 84
  and circumcision, 26
  and Crossing of the Red Sea, 54–56, 57
  as Lenten theme, xvii, 7, 8, 12, 21–22, 33, 37, 40, 54–55, 96
  and number eight, 15, 66, 84–85
  of repentance, 24–25
  as sacrament, 21, 23–24, 25

Bartolomeo della Gatta, 86 n. 24

Battisti, Eugenio, 67, 68

Bede, Saint ("the Venerable"), 11, 31, 70, 99

Berchorius, Peter, 92

Bernardino of Siena, 19

Bible. *See also* New Testament (NT); Old Testament (OT)
  Septuagint version, 27
  Vulgate version, 27
  Books
  Genesis, xvii, 7, 12, 28
  Exodus, 5, 8, 9, 26, 27, 30, 36, 37, 38, 39, 40, 54, 55, 56, 57, 58, 61, 62–63, 78, 108
  Leviticus, 34 n. 3, 42
  Numbers, 5, 9, 55, 74–75, 76–77, 81, 90

Deuteronomy, 5, 8, 41, 53, 87–88

III Kings, 66

IV Kings, 59

Isaiah, 55

Ezekiel, 27

Daniel, 55

I Maccabees, 43

II Maccabees, 34, 41–44, 47

Matthew, 5, 8, 22, 23, 24, 25, 27, 28, 29, 31, 33, 34–36, 39, 40, 41, 44, 46, 50, 51, 52, 58, 59, 60, 62, 66, 68, 69, 70, 71, 73, 74, 83–84, 104, 112

Mark, 83, 100

Luke, 15, 28, 60, 83

John, 22, 39, 51, 54, 55, 59, 63, 66, 67, 71–73, 83–84

Acts of the Apostles, 100

Romans, 54

I Corinthians, 13, 22, 31

II Corinthians, 54

Colossians, 26

Hebrews, 34 n. 3, 42, 71, 75, 81, 82, 88, 92

Jude, 98, 99, 100

*Bible moralisée*, 36, 38

*Biblia Pauperum*, 3

Biblioteca Apostolica Vaticana, xx, 13, 43

Bonaventure, Saint, 13, 31

Boniface VIII (pope, Benedetto Caetani), 11

*Book of Kells*, 34 n. 10

Botticelli, Sandro
  commissioned by Sixtus IV, xiii, 7 n. 40
  Works
  *Moses in Egypt and Midian*
    description of, 26, 36–40, 108
    inscription above, 36

liturgical references in, 5, 33, 36–
   40
references to earlier art in, 39
*Punishment of Korah*
   description of, 75–77, 108–9
   inscription above, 77, 105
   liturgical references in, 5, 9, 64,
      65, 74–82, 105
   references to earlier art in, 75
*Purification of the Leper. See* Botticelli,
      Sandro: Works, *Temptations of
      Christ*
*Temptations of Christ*
   description of, 33–36, 107
   inscription above, 34, 36, 105
   Jewish sacrifice in, 2, 33–34, 40–
      47, 99, 111
   liturgical references in, 5, 8, 15,
      33–36, 38, 39, 40, 110
Brandolini, Aurelio, 43
*Breviary,* Roman, xv, xvii, 11, 34, 55,
      56, 63 n. 110, 100
Brilliant, Richard, 105
Broeck, Hendrik van den (Arrigo
      Fiammingo), *Resurrection and As-
      cension of Christ*
   description of, 97, 107
   inscription above, 97, 98
   liturgical references in, 3, 4, 6, 15,
      93, 95–96
   monogram in, 97, 105 n. 9
   repainted Ghirlandaio's fresco, 3, 6,
      95, 97
Burckhard, Johannes, 9, 89 n. 51,
      112 n. 34
Burning Bush, 39
bystanders and onlookers, 23, 36 n. 27,
      87 n. 32
Byzantine Church decoration, xv
Byzantine icons, xv
Byzantine-style costume, 23

*Cappella magna* (of Sistine Chapel), 1
*cappelle pontificie* (*cappelle palatine,* "pa-
      pal chapels"), 17, 68, 100, 103–
      4, 110, 114
*Caput Quadragesimae,* 34, 105
Casali, Battista, 31
catechumens
   Apostles' Creed and Lord's Prayer
      communicated to, 50, 52, 53,
      58, 59, 85, 105, 109–10
   and athletic imagery, 90–91
   baptism of, 37, 38, 39, 50, 55, 91–92
   church's reception of, 30
   depicted in Sistine Chapel frescoes,
      23, 90, 104, 109 n. 20
   early Christian, 8, 12, 23, 25
*electi,* 25

Lenten behavior of, 62
milk and honey drunk by, 89
washing the feet of, 84 n. 10
cats, 85, 86
*Ceremoniarum Romanum* (*Ceremonial*),
      10, 80, 81, 112
cherubim, 23
*Chludov Psalter,* 34 n. 12
Christianity, supplanting of Judaism by,
      29–30, 61–62, 75, 86, 99–100,
      109
Christmas, 4, 6, 18, 96
Christological frescoes, narrative sub-
      jects depicted in, 3–4
Christological narrative
   Adoration of the Kings, 4 n. 24
   Agony in the Garden, 83, 84
   Baptism of Christ, 3, 7, 8, 21, 22–
      23, 24, 107
   Betrayal, 83, 84
   Birth of Christ, 107
   Calling of the First Apostles, 3, 9,
      51–53, 107
   Christ's Charge to Peter, 3
   Christ's First Sermon, 23, 25, 33
   Crucifixion, 58, 83, 84, 85, 93
   Cure of the Daughter of the Canaan-
      ite Woman, 39
   Cure of Peter's Mother-in-Law,
      60 n. 85
   Five Wounds of Christ, 85
   Gift of the Keys, 69, 71, 107
   Healing of the Leper, 3, 59–60, 63
   Healing at the Pool of Bethesda, 22,
      39
   Incarnation, 93
   Last Supper, 7, 107
   Meeting with Woman of Samaria, 55
   Miracle of the Man Born Blind, 55
   Parable of the Vine Dressers, 29, 31
   Payment of the Tribute Money, 65,
      73–74, 81
   Raising of Lazarus, 3
   "Render unto Caesar," 73
   Resurrection and Ascension of
      Christ, 3, 15, 93, 97–98, 100–
      101, 107
   Sermon on the Mount, 3, 8, 50, 58–
      60, 107
   Stoning of Christ, 65, 71–73
   Temptations by the Devil, 3, 8, 33,
      34–35, 44, 46, 107
   Transfiguration, 28, 40
   Washing the Disciples' Feet, 84
Church Calendar, xv, 10, 17 n. 132,
      18–19, 100
Church of the Nations (Gentiles), 30,
      90
circumcision

and baptism, 26
and Holy Spirit, 30
and number eight, 15
and purification, 31–32
and salvation, 30
with stone knives, 30–31
Circumcision, feast of, 4 n. 24, 17, 32
Clement of Alexandria, 98
Cletus (pope), 1 n. 5
Cohen, Evelyn M., 57
*Comes of Alcuin,* 63, 66 n. 12, 87 n. 37
*Concordantia Caritatis* (Ulrich von
      Lilienfeld), xv, 3
*Contra impugnantes sedis apostolicae
      auctoritatem* (Piero da Monte),
      14, 79
Coronation Gospel Book of Vyšehrad,
      35 n. 18
Cortesi, Paolo (*De Cardinalatu*), xviii–
      xix, 54, 68, 113
Council of Florence, Ferrara, and
      Rome, 42 n. 74, 52
Council of Nicaea, 12
*Credo. See* Apostles' Creed

D'Amico, John, xix, 54, 113
Daniel (prophet), 70
Dathan, 74, 75, 76, 77, 79–80
David (king of Judea and Israel), 43
De Grassis, Paris, 112
della Rovere *stemma,* 6–7, 37, 47, 85
demons, 38
Devil, 35, 38, 46, 84, 98, 99, 110
dogs, 85–86, 112
Dominican order, 18
*Donation of Constantine,* 80
Durandus of Mende, 11, 22, 30, 38, 40,
      41, 45, 51, 55, 65, 66, 71, 73,
      84, 87

early Christian revival movement, xiii,
      xviii–xix, 3, 10, 13–16, 44
Easter Eve. *See* Holy Saturday
Easter Monday, 80
Easter Sunday, xvi, 4, 6, 15, 76
Easter Vigil, 22, 76, 89
*Ecclesia*
   Pharoah's daughter as, 96
   Zipporah as, 30, 37
Egbert of York, 89
Egidio da Viterbo, 10, 47
Eisler, Colin, 91
Eldad, 77 n. 99
Eleazar (son of Aaron), 74, 75–76, 77
Eliezer (son of Moses), 28
Elijah (prophet), 34 n. 11, 59
*Encaenia,* 67
Epiphany, feast of, xvi, 4 n. 24, 17, 19,
      21, 92–93, 96

Esau (son of Isaac), 28–29
Ettlinger, Leopold D., xiii–xiv, xv, 3, 4,
    12, 26, 27, 33, 35, 37, 42, 46, 73,
    75, 77, 78, 90, 96, 98, 99, 111
Eucharist, 7, 8, 15, 25, 84, 85, 86, 88
exorcism, 38–39, 40, 109

Filarete (Antonio di Pietro Averlino),
    23 n. 24
Florence, Church of S. Giovanni, xv
Francis, Saint, 13
Franciscan Rule, 13
Franciscan symbolism
    and Marian devotion, xix, 18
    in Sistine Chapel frescoes, xiv, 4, 19,
        111
    Sixtus IV's interest in, xiv, xix, 4, 13

Gabriel (archangel), 98
Gelasian Sacramentary, 69
Gelasius I (pope), 71 n. 51
Gershom (son of Moses), 28
Gesta Romanorum, 92
Gherardi, Jacopo, xviii, 1 n. 1
Ghirlandaio (Domenico Bigordi)
    commissioned by Sixtus IV, xiii
    WORKS
        Calling of the First Apostles
            description of, 51, 70
            inscription above, 2, 52–53, 54,
                89, 105
            liturgical references in, 5, 9, 15,
                49, 51–53, 54, 106, 109
        Resurrection
            repainted, 3, 6, 95, 97
Giovanni de' Dolci, 67
Girl with the Snake, 46 n. 102
Glossa Ordinaria (Anonymous), 11, 88
God the Father, 22
Goffen, Rona, xiv, 4, 13, 83, 111
Golden Legend. See Jacobus de Voragine
Good Friday, xvi, 14, 17, 35, 58, 66,
    81, 83, 85, 93
Gospels. See Bible
grapes, 46
Gravina, Pietro, 100
Gregorian Sacramentary, 91 n. 80
Gregory I (pope, "the Great"),
    16 n. 120, 70, 92
Gregory XI (pope, Pierre-Roger de Beau-
    fort), 45 n. 92
Gregory XIII (pope, Ugo
    Buoncompagni), 97
Gregory of Nazianzus, 51 n. 29, 79
Gregory of Nyssa, 36, 79

Hadrian VI (pope, Adrian Florensz
    Boeyens), 3
Haggadah, 57

Haymo of Faversham, 11, 22, 41, 63, 66
Hippolytus, Saint (Apostolic Tradition),
    89, 90
Hittorp, Melchior, 11
Holy Saturday, xvi, 6, 8, 12, 21, 23,
    30, 30 n. 78, 37, 38, 50, 52, 53,
    54, 58, 66, 67, 76, 83, 87–88,
    89, 90, 91, 93, 105, 109–10
Holy Spirit
    and circumcision, 30
    Dove of the Holy Spirit, 22
Holy Thursday, xvi, 7, 46, 66, 68, 69,
    70–71, 83, 84, 88, 93
Holy Week, xvi, 5, 7, 24, 65, 66, 72,
    83, 87, 90, 93, 104
Howe, Eunice D., 44

Immaculate Conception
    concept of, xviii, 18
    feast of, 18 n. 138
immortality, 100–101
Innocent III (pope, Lothar of Segni),
    11, 60 n. 91, 80 n. 129
Innocent VIII (pope, Giovanni Battista
    Cibò), 9, 11, 34 n. 8, 80 n. 130,
    86, 100, 110 n. 24
inscriptions, 2, 6, 26, 27, 52–53, 72,
    104–5, 107, 108. See also names
    of individual frescoes
Institoris, Henricus, 79
irises, 88
Isaac (son of Abraham), 28–29,
    37 n. 33
Ithamar (son of Aaron), 75

Jacob (son of Isaac), 28–29, 37 n. 33
Jacobus de Voragine (Legenda Aurea,
    Golden Legend), xv
James, Saint, 28, 51–52
Jeremiah's Lamentations, 66
Jerome, Saint, 10, 37, 70, 73, 92
Jerusalem
    Dome of the Rock, 66
    Lenten references to, 65–66
    Rome as, xvii
Jesus Christ. See also Christological fres-
    coes; Christological narrative
    circumcision of, 15, 31
    as corpus domini, 67
    Jewish prophecies about, 15
    ministry of, 3
    miracles of, 3
    as a stone, 30, 31
    as subject of lost altar wall frescoes,
        1 n. 5
Jethro (father-in-law of Moses), 26, 27,
    37, 39
Jews, Babylonian captivity of, xvii, 41–
    47, 55 n. 49, 67, 70, 99

John the Apostle, Saint, 28, 51–52
John the Baptist, Saint, 22, 23, 24–25,
    90, 91, 92
John the Deacon, 89
John the Evangelist, Saint, feast of,
    4 n. 24, 17
Joseph (son of Jacob), 28, 29
Josephus, Flavius, 43, 47 n. 110, 56
    Jewish Antiquities, 56, 79
    Jewish War, 56 n. 58
Joshua, 61, 62, 77, 86, 87, 109
Jouffroy, Jean (cardinal), 9
Judaism. See also circumcision; Jews,
        Babylonian captivity of
    and Cabala, 112
    supplanted by Christianity, 29–30,
        61–62, 75, 86, 99–100, 109
Judas, 83, 84
Julius II (pope, Giuliano della Rovere),
    xvii, 25, 32, 44 n. 86, 47
Jungmann, Joseph A., xviii, 12
Justin Martyr, Saint, 15
Justinian (Byzantine emperor), 69 n. 28

Korah the Levite, 74–76, 77, 79

Lavin, Marilyn Aronberg, 23, 92, 106,
    110
lectionaries, xiv, 11, 16
Lectionary, Milanese, 39, 55, 63 n. 109,
    66 n. 12
Lee, Egmont, xiv, 114
Legenda Aurea. See Jacobus de Voragine
Lent
    baptism as theme of, xvii, 7, 8, 12,
        21–22, 33, 37, 40, 54–55, 96
    and the devil, 38
    fasting during, 34, 38, 40, 45, 61,
        63 n. 113, 73, 109
    as focus of Sistine Chapel frescoes,
        xvi, 2–9
    importance in Christian liturgy, 11–
        13
    lections illustrated in Rossano Gospel
        Book, xv, 12
    Masses during, xvi
    outline of liturgy during, xvi
    penitential themes during, xvii, 24–
        26, 33, 36, 40, 45, 69–71, 73–
        74
    purification during, 60
    and salvation, xix, 101
    stational Masses during, 16–17,
        25 n. 39, 28
    Sundays of, xvi, 6, 15, 16, 17, 33–
        36, 49–51, 55, 65, 66, 71, 72,
        73, 77, 78, 80, 83, 84, 90, 105
    themes of, xvii, 10, 11–13, 21–22,
        37, 40, 54

Lenten Embertide, xvi, 38–39, 46, 50
Leo I (pope, "the Great"), 10, 11, 24, 25, 38, 54, 69, 70, 73, 85, 90, 91 n. 80, 100
Leo X (pope, Giovanni de' Medici), 70
Leonine tapestries, xiv
lepers, 3, 42, 58, 59–60, 63
Leto, Pomponio, 16
Levey, Michael, 35
*Liber caeremoniarum*, 11
*Liber censum*, 80
Lightbown, Ronald, 75
Linus (pope), 1 n. 5
Lord's Prayer, 6, 15, 50–51, 58, 59, 85, 109–10
*Luxuria*, 92

Magister Gregorius, 92
Mander, Carel van, 97
Manetti, Giannozzo, 9, 69
manna, 88
Marcello, Cristoforo, 112
Mark, Saint, 60
Marsi, Pietro, 100
Mary (mother of Jesus)
    *Assunta*, xviii, xix, 1, 18, 101
    circumcision of Jesus by, 31
    dedication of Sistine Chapel to, xvii–xviii, 1, 18
    Eve as OT precursor of, xvii
    as spinner, 37
    as subject of lost Sistine Chapel altarpiece by Perugino, xviii, xix, 18–19
Mary Magdalen, 70
*Marzo*. See *Spinario* (The Thorn-Puller)
Masaccio (Tommaso di Giovanni di Simone Guidi), 74
Mass of Ordination, 40–41, 46
Masses, stational, 16–17, 25 n. 39, 28
Matteo da Lecce (Matteo Pérez de Alesio), *Fight for the Body of Moses*
    description of, 109
    liturgical references in, 6, 95–96, 98–101, 111
    painted over Signorelli's fresco, 4, 95, 97
Medad, 77 n. 99
mediation, 63
Medici, Cosimo de', 69 n. 30
*Meditations on the Life of Christ. See* Pseudo-Bonaventure
Meiss, Millard, 74
Melchizedek, 7
Melozzo da Forlì, 43
Michael (archangel), 98
Michelangelo Buonarroti
    WORKS
        *Doni Madonna*, 91 n. 75

*Last Judgment*, 3, 4, 18, 21, 96
    Sistine Chapel ceiling, xvii, 2
Midrash, 57
Miriam (sister of Moses), 56, 58
*Missal*, xv, xvii, 11, 78, 89, 90
*Missal of Cardinal Bertrand de Deux*, 72
*Missal of 1474*, 11, 16, 22, 24, 28, 34, 39, 50, 51, 55, 59 n. 80, 60, 62, 63, 66, 68, 71, 78, 83, 84, 87
*Missale Romanum (Roman Missal)*, xvi, 11, 12, 17 n. 132, 69, 82 n. 149, 90, 93, 100
Mithridates, Flavius, 15 n. 101
Molho, Anthony, 74
Monfasani, John, xviii, 44
Mosaic narrative
    Canticle of Moses, 56
    Circumcision of Moses' Son, 3, 9, 21, 26, 30, 106
    Crossing of the Red Sea, 13, 40, 54–55, 56, 106
    Fight for the Body of Moses, 4, 98, 107
    Finding of Moses, 4, 106
    Flight to Midian, 36
    Last Testament of Moses, 106
    Lawgiving on Mount Sinai, 8, 60–64, 76 n. 96, 106
    Meeting of Moses and Zipporah, 37
    Miracles in the Desert, 3
    Moses and the Burning Bush, 39–40
    Moses Driving Away the Hostile Shepherds, 37–38
    Moses Going to his Death, 87
    Moses in Egypt and Midian, 26–27, 36–40, 106
    Moses Shown the Promised Land, 87, 89
    Moses Slaying the Egyptian Taskmaster, 36, 38
    Punishment of Korah, 3, 9
    Ten Plagues, 3
    Worship of the Golden Calf, 8, 62, 63–64, 76 n. 96
Moses. *See also* Mosaic narrative
    challenged by Korah the Levite, 74, 79
    forty days in the cloud, 34 n. 11
    as lawgiver, 8, 36 n. 23, 53–54, 63, 87
    naming of, 96 n. 5
    as prefiguring Christ, 13, 14
    as shepherd, 26–27
    as subject of Sistine Chapel frescoes, 1, 3–4, 12–13, 19, 106
    as *typus papae*, 12–13

Naaman the Syrian, 59–60
Nabuco, Joaquim, 11
Nadab (son of Aaron), 75–76

Narkiss, Bezalel, 57
Nehemiah, 41–46, 99
New Testament (NT), foreshadowed by OT, xvii, 14–15
Nicholas V (pope, Tommaso Parentucelli), 9, 10, 14, 16, 69
Nicolaus of Lyra, 11, 29, 31, 41, 77
number eight, 14 n. 97, 15, 66, 84–85
number five, 85

octagonal structures, 15, 65, 66–67, 83
*Octateuch*, Byzantine, 37 n. 34, 87 n. 33
Octave of the Ascension, 100
Old Testament (OT)
    foreshadowing NT, xvii, 14–15
    Lenten reading of, 12
O'Malley, John W., xviii, 93, 100
Onias (high priest), 47
*Ordinal* (Haymo of Faversham), 11, 22, 41, 63, 66
*Ordinal* (Van Dijk, ed.), 11, 24, 28, 39, 55
ordination, 71, 77
*Ordo Romanus antiquus*, 11, 51, 52, 68, 76, 78, 93
*Ordo L*, 70, 76
Origen, 10, 35, 37, 77, 79, 98
Original Sin, 18, 92

Pacheco, Francisco, 97
Palm Sunday, xvi, 16, 17, 66, 73, 78, 80, 83, 84, 87, 93, 110 n. 25
*Pantocrator Psalter* of Mount Athos, 34 n. 12
papacy
    almsgiving by, 73–74
    so-called Babylonian captivity of, xvii, 44, 45, 46, 99
    Masses celebrated by, 30
    and Moses as *typus papae*, 12–13
    and papal elections, 82
    and papal inerrancy, 14
    papal portraits in Sistine Chapel, xix, 1 n. 5, 6, 78, 106
    and papal primacy, xiv, xix, 4, 13, 14, 19, 65, 69–71, 74, 78–82, 99, 111
    and papal tiara, 47, 75, 82
    and purple mantle, 99 n. 24
    return from Avignon to Rome, xvii, 16, 17, 44–46, 99
    and ritual, 9–10
    and salvation, xix
    *sede vacante* in, 81, 82
"papal chapels." See *cappelle pontificie*
papal liturgies, 17
Partner, Peter, 112
paschal candle, 58
Passion Sunday, xvi, 12, 16, 34, 66, 70, 71, 72–73, 77

Passion Week, 5, 6, 65, 66–67, 70, 72, 78
Passover, 57
Pastor, Ludwig von, 37
*Pater noster. See* Lord's Prayer
Paul, Saint, 1 n. 5, 18, 26
Paul II (pope, Pietro Barbo), xv, 16, 47 n. 110
Pazzi conspiracy, 71
*pedilavium*, 84
penance, sacrament of, 25–26, 60
penitence
    during Embertide, 38–39
    as Lenten theme, xvii, 24–26, 33, 36, 40, 45, 69–71, 73–74
penitents, 24–25
Pentecost Sunday, xv, xvi, 2, 3, 5, 6, 15
*Pericope Book of Henry II*, 72
Perugino (Pietro Vannucci)
    commissioned by Sixtus IV, xiii, 7 n. 40, 22, 103
    lost altar wall frescoes by, 1 n. 5, 3, 4, 6, 21, 95, 96
    lost altarpiece for Sistine Chapel by, xiv, xviii, xix, 1 n. 5, 18–19, 101
    work on *Last Testament of Moses* by, 86 n. 24
    WORKS
    *Baptism of Christ*
        description of, 22–25
        inscription above, 22, 26, 27
        liturgical references in, 5, 8, 21, 22–26, 33, 54, 104, 108, 110, 111
        name inscribed in, 105 n. 9
        references to earlier art in, 23, 91
    *Circumcision of Moses' Son*
        description of, 26–28, 107–8, 109
        inscription above, 26
        liturgical references in, 5, 9, 21, 26–32, 54, 62 n. 101, 104
    *Finding of Moses*
        liturgical references in, 95, 96
        painted over, 4, 21, 95, 96
    *Gift of the Keys*
        description of, 65–66, 67–70, 71, 73, 103
        inscription above, 72, 105
        liturgical references in, 5, 15–16, 60, 65–74, 77, 78–82, 100, 105
        references to earlier art in, 68
    *Nativity*
        liturgical references in, 95, 96, 110
        painted over, 3, 4, 6, 21, 95, 96
Peter, Saint, 1 n. 5, 18, 51–52, 60, 65, 68, 69, 70, 73, 77, 79
Petrarch (Francesco Petrarca), xvii
Petrus Comestor (*Historia Scholastica*), 27, 56

Petrus Lombardus (Peter Lombard), 24
Pharaoh, 56–57
Philo of Alexandria, 26–27, 36 n. 23, 98
Piccolomini, Agostino Patrizi de', 9, 89 n. 51
Pico della Mirandola, Giovanni, 54
    *Apologia*, 112
    *Oration*, 112
Piero da Monte (Pietro del Monte), 14, 79
pillar of fire, 58, 108
Pinturicchio (Betto di Biago), 21 n. 2, 22 n. 11, 26 n. 49
Pius II (pope, Aeneas Silvius Piccolomini), 9, 79
Pius V (pope, Antonio Ghislieri), 97
Platina (Bartolommeo de' Sacchi), 14, 43, 56 n. 58, 80 n. 130
Platner, Samuel Ball, 56
Pontelli, Baccio, 67
Pontifical, 9–10
*Pontifical* (Egbert of York), 89
*possesso*, 80, 81, 86
Poussin, Nicolas, 71
Prodigal Son, Parable of the, 28, 29–30
Proper of Saints, xviii, 18
Proper of Time, xviii, 19
*Protoevangelion of James*, 37
Pseudo-Bonaventure, 31, 35 n. 17, 59
Ptolemy (*Almagest*), 44
purification, and baptism, 60

Quadragesima Sunday, 22, 34, 40, 105

Rabanus Maurus, 11, 30, 36, 77
Raphael Sanzio
    Leonine tapestries by, xiv
    *Stanza d'Eliodoro*, 47
Renaissance
    concern with liturgical matters during, 9–10
    revival of early Christian antiquity during, xiii, xviii–xix, 3, 10, 13–16, 44
Resurrection, feast of the, 91
Riario, Pietro (cardinal), 62
Rice, Eugene F., 92
*Ripoll Bible*, 59 n. 82
*Rituum ecclesiasticorum sive sacrarum ceremoniarum ss. Romanae Ecclesiae libri tres non ante impressi*, 112
Roman Missal. See *Missale Romanum*
Rome
    monuments of
        Arch of Constantine, xvii, 68, 75, 78–79, 80, 81, 109
        Old St. Peter's, 14 n. 98, 44, 78, 110

Oratory of S. Niccolò al Laterano, 78
Ospedale di S. Spirito, 14 n. 97, 43 n. 82, 44
S. Cecilia, 28
S. Giovanni in Laterano, 22, 90
S. Marco, 60
S. Maria della Pace, 14
S. Maria del Popolo, 14
S. Maria Maggiore, 7–8, 56 n. 60, 57, 110–11
S. Paolo fuori le Mura, 14 n. 98, 78, 110
St. Peter's basilica, 2 n. 12, 17, 23 n. 24, 80
S. Pietro in Vincoli, 24, 25
S. Sabina, 57
S. Sisto, 62
S. Urbano alla Caffarella, 14 n. 98
S. Vitale, 31
SS. Cosmas and Damian, 60 n. 85
Ss. Croce in Gerusalemme, 55 n. 49, 65
return of papacy from Avignon to, xvii, 16, 17, 44–46, 99
as *sancta Latina Ierusalem*, xvii
stational Masses in, 16–17, 25 n. 39, 28
rose, golden, 55 n. 49
*Rossano Gospel Book*, xiv–xv, 12
Rosselli, Cosimo
    WORKS
    *Crossing of the Red Sea*
        description of, 54, 56–58, 108
        inscription above, 2, 53–54, 57, 88, 108
        liturgical references in, 5, 40, 49, 53–58, 106, 111
    *Last Supper*
        description of, 83–86, 107
        inscription above, 53, 85, 89, 105
        liturgical references in, 5, 16, 72, 83–86, 93, 104
    *Lawgiving on Mount Sinai*
        description of, 61–64, 88, 103, 108
        inscription above, 60–61, 106
        liturgical references in, 5, 8, 49, 60–64, 106
    *Sermon on the Mount*
        description of, 58–60, 63, 107
        inscription above, 59, 60, 106
        liturgical references in, 3, 5, 8, 15, 49, 58–60, 106, 109
Rucellai, Giovanni, 85
Rupert of Deutz, 11, 28, 29, 40 n. 62, 45, 52 n. 35, 58, 86, 90

*Sacramentary of Bergamo*, 63 n. 109, 66 n. 12

sacraments, 7
Salutati, Coluccio, 14
Sanchez de Arevalo, Rodrigo, 79
Satan. *See* Devil
Septizonium of Septimius Severus, 75
Septuagesima Sunday, xvi, 3, 5, 6, 12, 22, 31, 33, 45, 90, 104
sermons
  *coram papa*, 17
  Lenten, 25, 33
Seventy Palms of Elim, 78
Shearman, John, xiv, 68, 104
sheep
  black, 37
  separation from goats, 24, 27
shepherds, 38, 39
shipwrecked vessels, 79–80
Sicard of Cremona, 39, 57
Signorelli, Luca
  commissioned by Sixtus IV, xiii
  WORKS
  *Fight for the Body of Moses*
    repainted, 4, 95, 97
  *Last Testament of Moses*
    description of, 86–93, 109
    inscription above, 53, 87, 89
    liturgical references in, 5, 8, 83, 86–93, 104, 109
    references to earlier art in, 91
  Munich *tondo*, 91
sin, removed by baptism, 23, 24–25, 60, 92
Sistine Chapel
  altar wall, decoration of, 1 n. 5, 3, 4, 6, 21, 95–96
  altarpiece, lost, xiv, xviii, xix, 1 n. 5, 18–19, 101
  architects of, 67–68
  *cancellata* in, 103, 109–10
  *cantoria* (singers' gallery) in, 60 n. 91
  ceiling, xvii, 1 n. 5, 2
  entrance wall, decoration of, 1 n. 5, 3, 95, 97–101
  first Mass said in, xviii, 1
  liturgical references in frescoes of, 5–6, 103–14, 115–20. *See also names of individual frescoes*
  as papal chapel, 17

placement of papal throne in, 46
wall organization in, 1 n. 5, 6–7
work on, 18, 44–45
Sixtus II (pope), 14, 46, 62
Sixtus III (pope), 7, 14, 111
Sixtus IV (pope, Francesco della Rovere)
  and almsgiving, 74
  Biblioteca Apostolica Vaticana established by, xx, 13, 43
  building of wall around Vatican City, 43
  commissioning of Sistine Chapel by, xiii, 1, 44–45
  depicted in lost Sistine Chapel altarpiece, 18, 101
  first recorded visit to Sistine Chapel, xviii, 1
  and Franciscan order, xiv, xix, 4, 13, 111
  knowledge of liturgy, xiv, xv, 2, 10–11, 27, 98
  and Marian devotion, xix, 14, 18
  papal bulls of, 18, 25, 74
  papal name chosen by, 13–14
  and papal primacy, 4, 13, 14, 99
  revival of traditional forms of worship by, xviii, 10, 13–16, 44
  sermons by, 25
  as theologian, 2
  theological works by
    *De potentia Dei*, 98, 99
    *De sanguine Christi*, xv, 10, 11, 13, 58
snakes, 46
Solomon's temple, 44, 66–67, 68–69
*Spinario* (The Thorn-Puller), 23, 39, 91–92, 109
spindles, 37
Stastny, Francisco, 97, 98
Steinberg, Leo, 85
Steinmann, Ernst, xiii, xv, 2, 35, 42, 46, 56–57, 61, 63, 71–72, 73, 77, 79, 81, 90, 93
Stephen, Saint, feast of, 4 n. 24, 17
Stinger, Charles L., xvii, 73
stone knives, 30–31
stones, 30, 31

*Stuttgart Psalter*, 34 n. 12
Sunday, as eighth day, 15
Susanna, bath of, 55
*symbolum. See* Apostles' Creed

tapestries, fictive, 1 n. 6, 7 n. 40
Tertullian (Quintus Septimus Florens Tertullianus), 10, 24, 38, 78 n. 109
  *De Baptismo*, 89, 112
*Theodore Psalter*, 61
Thomas Aquinas, Saint, 11 n. 59, 15, 70
thorns, 23, 92
Tifernate, Lilio, 98
Timotheis de Totis, 54
Tintoretto (Jacopo Robusti), 88 n. 45
*tituli. See* inscriptions
transubstantiation, 40
tree trunks, severed, 92–93
Trinity Sunday, 17
triumphal arches, xvii, 68, 75, 78–79, 80, 81–82, 100, 109

Ulrich von Lilienfeld, xv, 3

Valla, Lorenzo, 52 n. 33
Van Dijk, S.J.P., 11
Vasari, Giorgio, 18, 75–76, 85, 89, 96, 97
Vatican library. *See* Biblioteca Apostolica Vaticana
*Verdun Altar*, 88
*Via papalis*, 80
*Via sacra*, 80
Virgin Mary. *See* Mary (mother of Jesus)
voyage imagery, 107

Weil-Garris, Kathleen, xix, 54, 113
Wickhoff, Franz, 90

Xystus, Saint. *See* Sixtus II (pope)

Zagzagel (archangel), 98
Zamometič, Andreas, 79, 81 n. 147
Zebedee (father of James and John), 51
Zipporah (wife of Moses), xvii, 27, 30, 31, 37

ILLUSTRATIONS

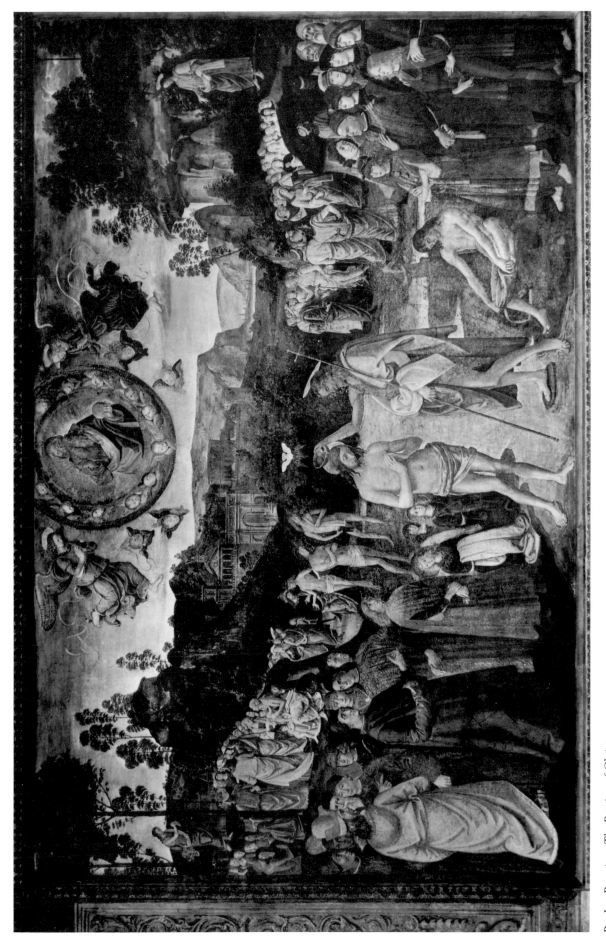

Pl. I.  Perugino: *The Baptism of Christ*

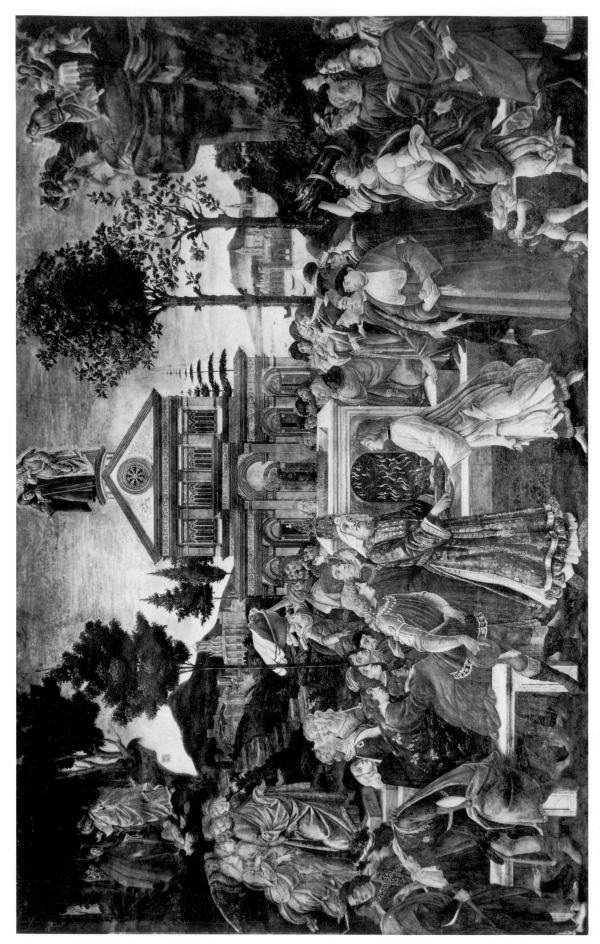

Pl. II.  Botticelli: *The Temptations of Christ*

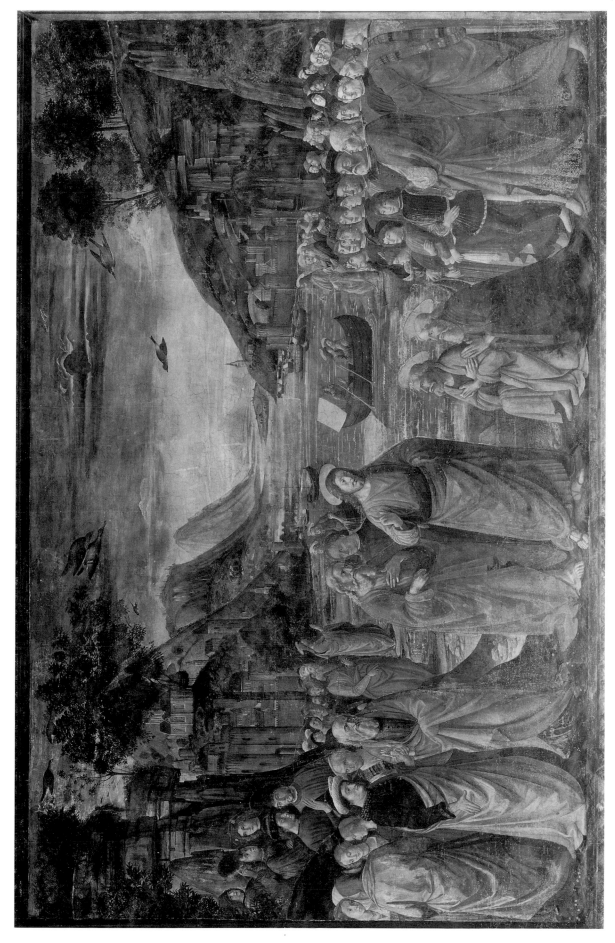

PL. III.   Ghirlandaio: *The Calling of the First Apostles*

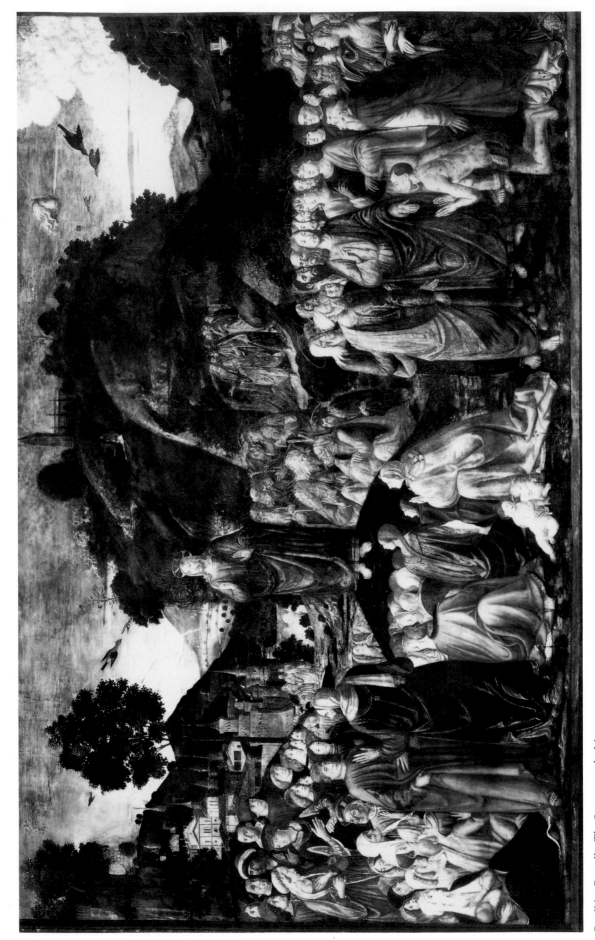

PL. IV. Rosselli: *The Sermon on the Mount*

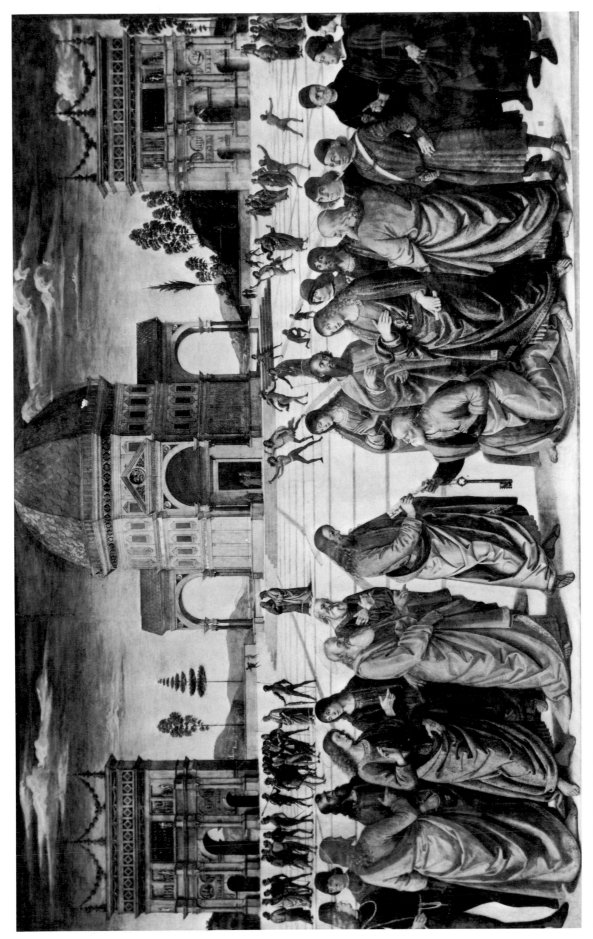

Pl. V.  Perugino: *The Gift of the Keys*

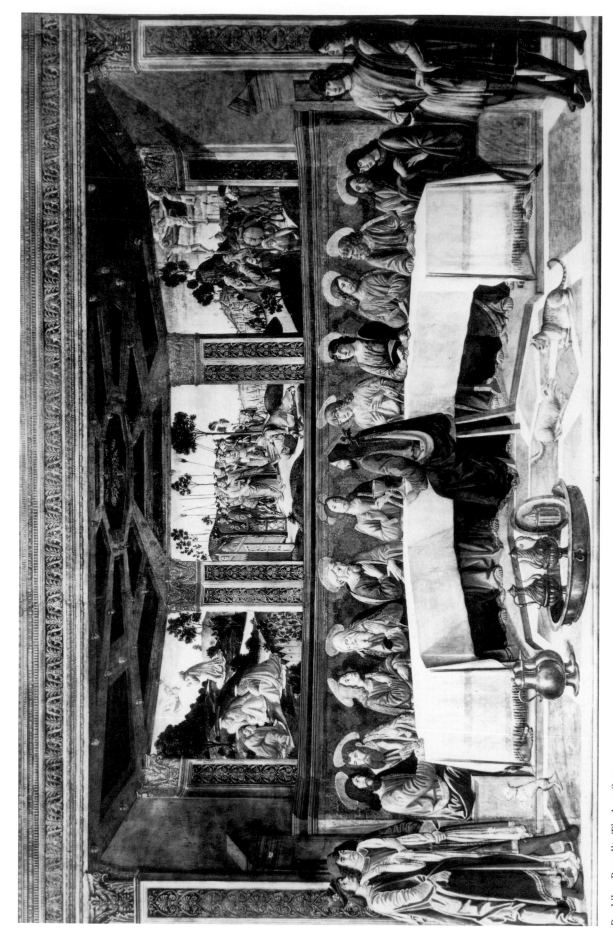

Pl. VI.   Rosselli: *The Last Supper*

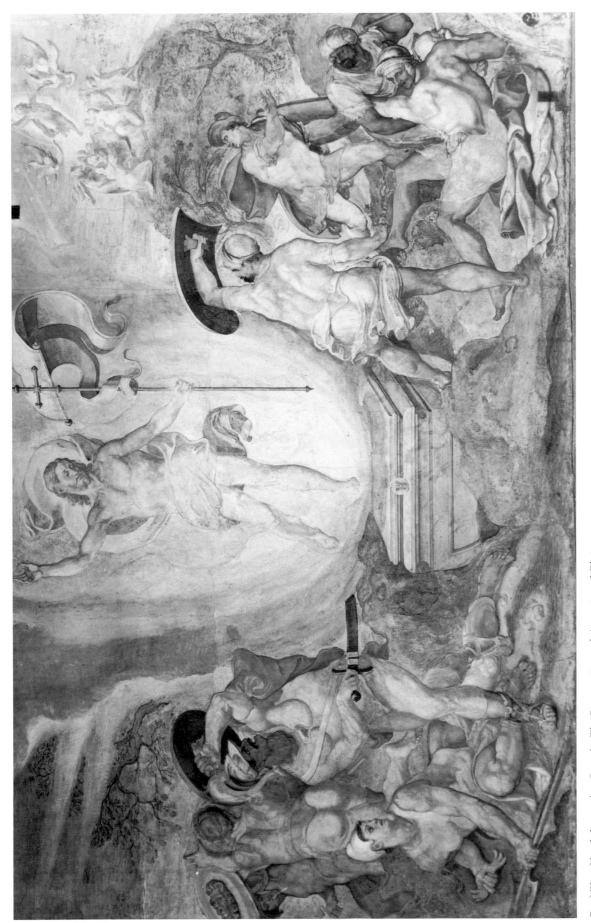

Pl. VII.  Hendrik van den Broeck: *The Resurrection and Ascension of Christ*

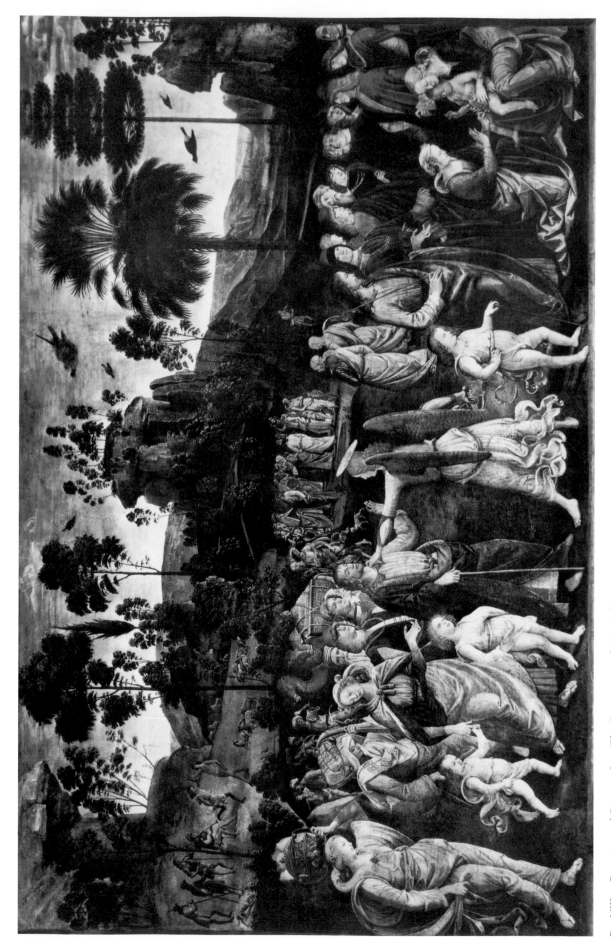

Pl. VIII.  Perugino and Pinturicchio: *The Circumcision of Moses' Son*

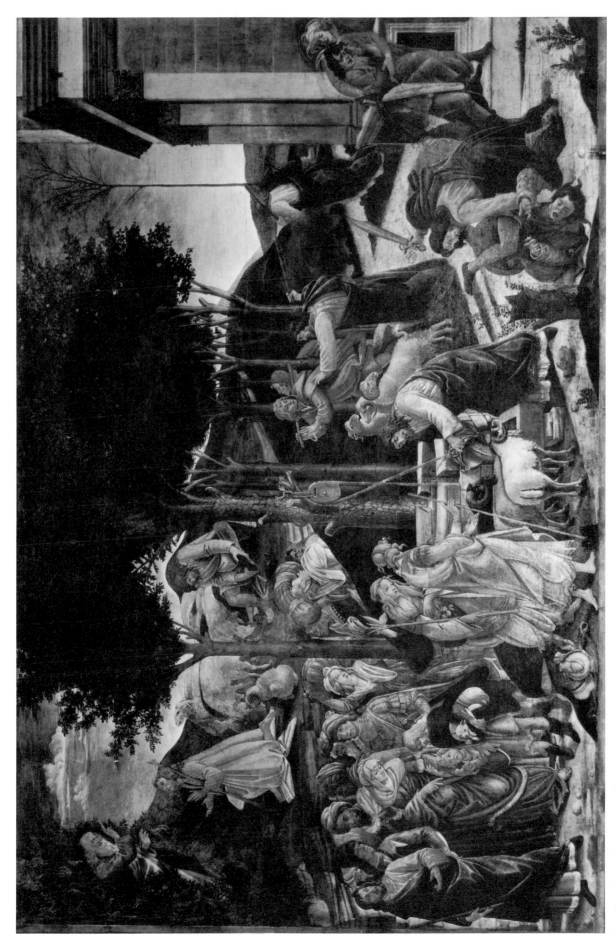

Pl. IX.   Botticelli: *Moses in Egypt and Midian*

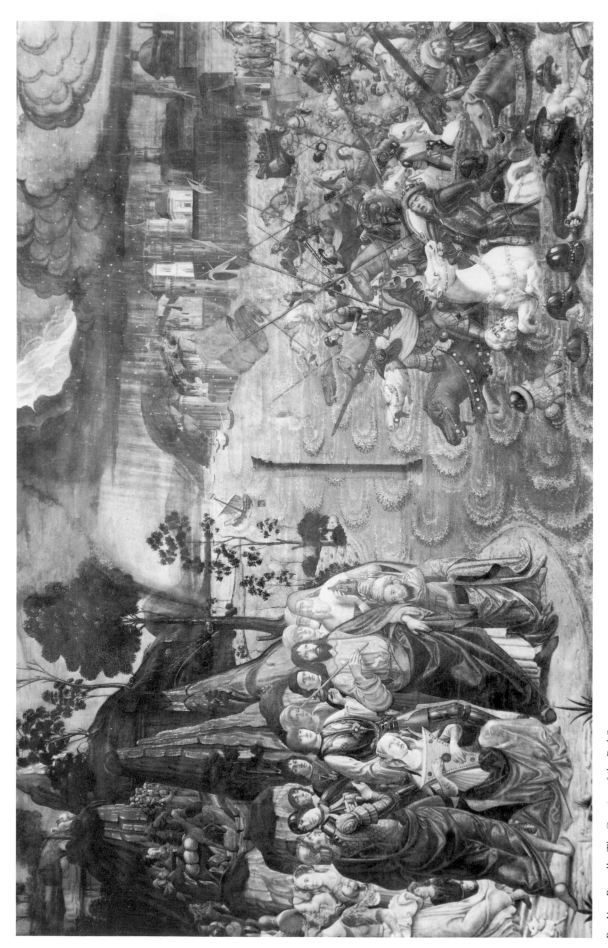

PL. X.   Rosselli: *The Crossing of the Red Sea*

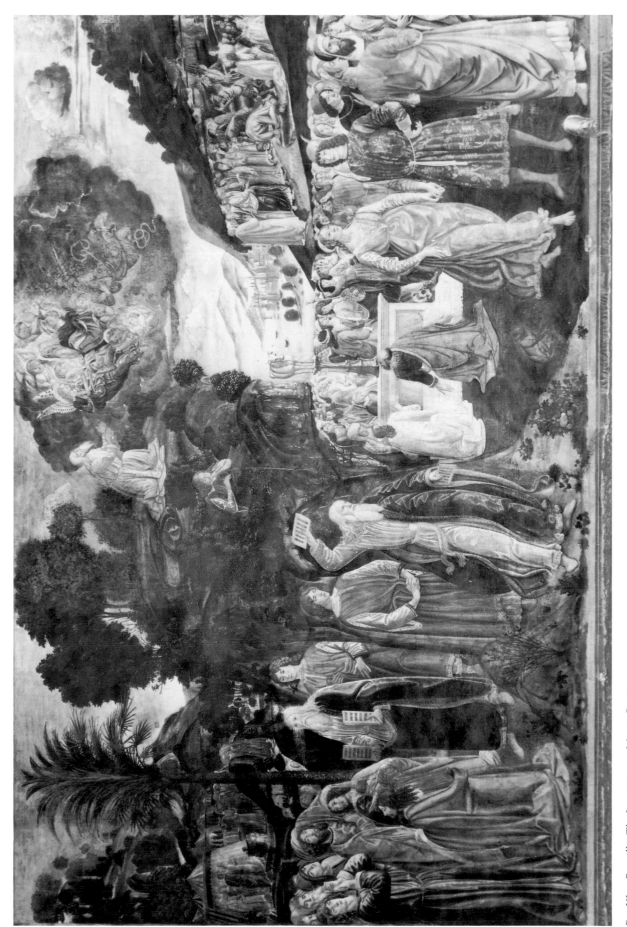

PL. XI.  Rosselli: *The Lawgiving on Mount Sinai*

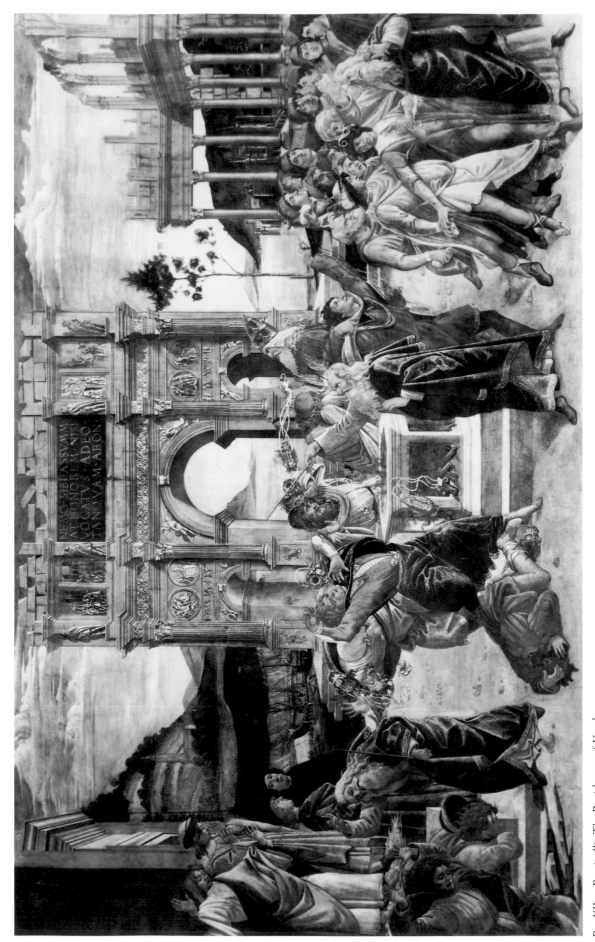

Pl. XII.  Botticelli: *The Punishment of Korah*

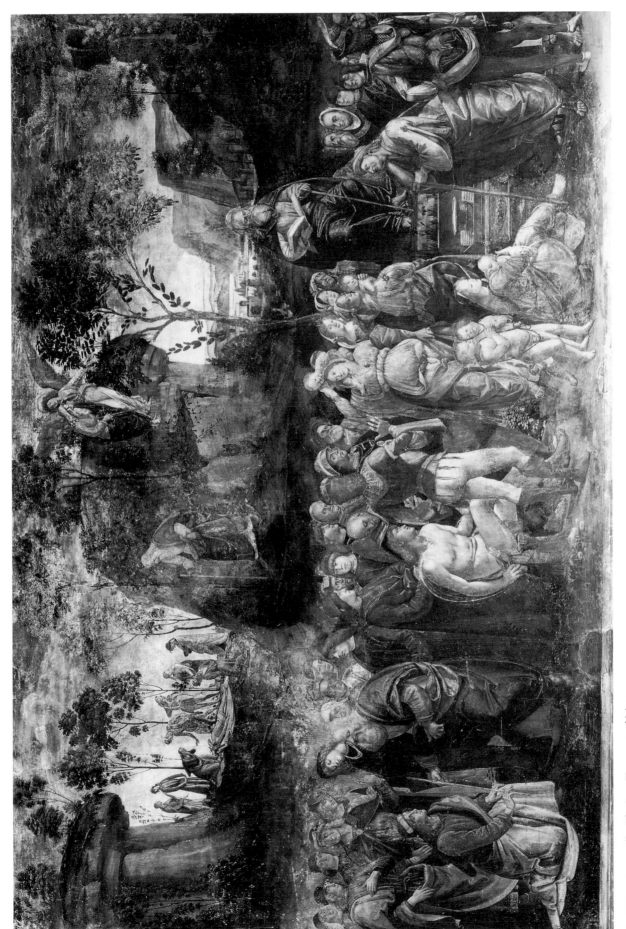

Pl. XIII.  Signorelli: *The Last Testament of Moses*

PL. XIV.   Matteo da Lecce: *The Fight for the Body of Moses*

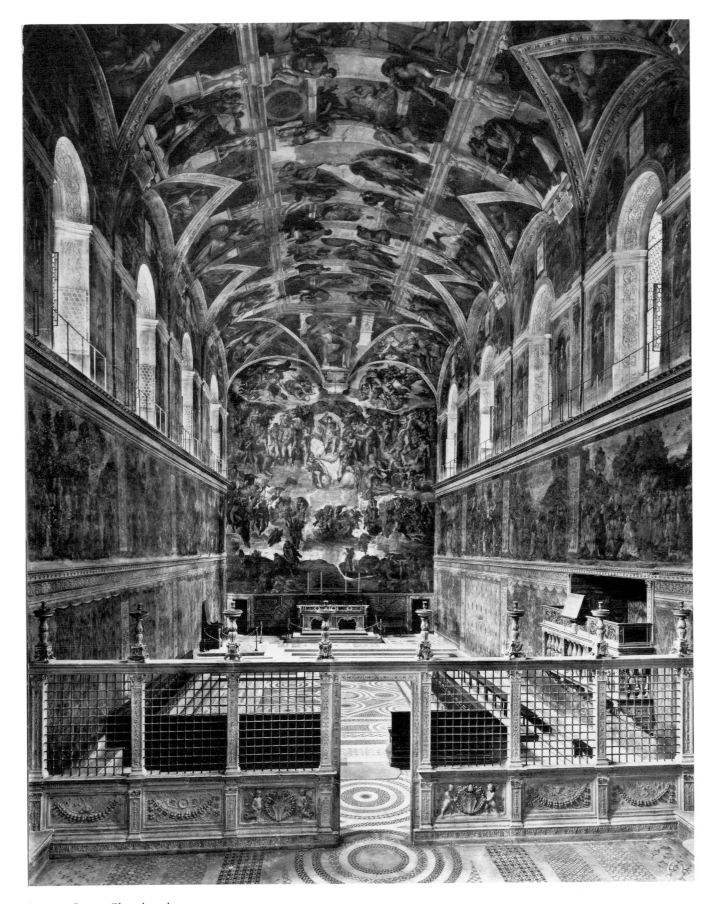

FIG. 1. Sistine Chapel to the west

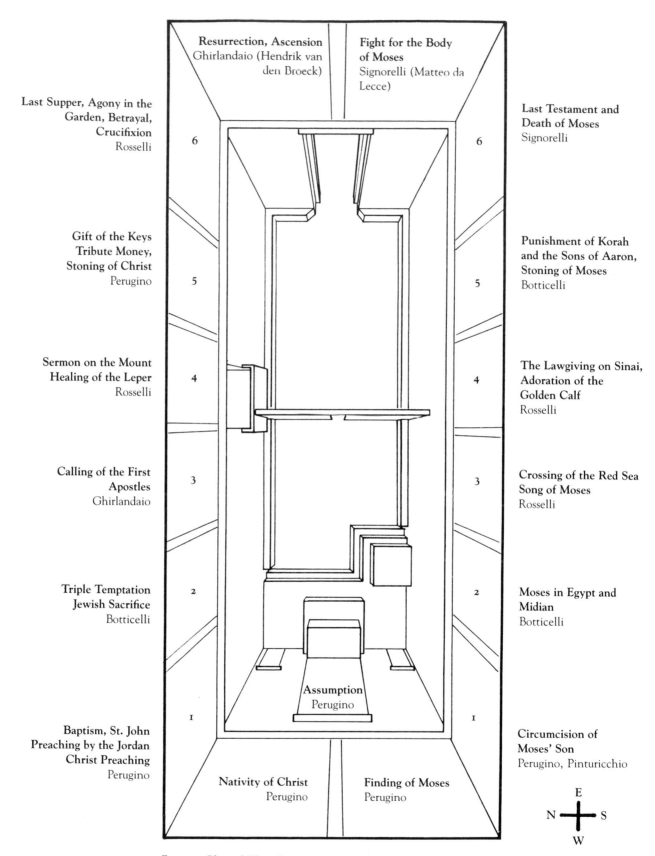

Last Supper, Agony in the
Garden, Betrayal,
Crucifixion
Rosselli

Gift of the Keys
Tribute Money,
Stoning of Christ
Perugino

Sermon on the Mount
Healing of the Leper
Rosselli

Calling of the First
Apostles
Ghirlandaio

Triple Temptation
Jewish Sacrifice
Botticelli

Baptism, St. John
Preaching by the Jordan
Christ Preaching
Perugino

Resurrection, Ascension
Ghirlandaio (Hendrik van
den Broeck)

Fight for the Body
of Moses
Signorelli (Matteo da
Lecce)

Last Testament and
Death of Moses
Signorelli

Punishment of Korah
and the Sons of Aaron,
Stoning of Moses
Botticelli

The Lawgiving on Sinai,
Adoration of the
Golden Calf
Rosselli

Crossing of the Red Sea
Song of Moses
Rosselli

Moses in Egypt and
Midian
Botticelli

Circumcision of
Moses' Son
Perugino, Pinturicchio

Assumption
Perugino

Nativity of Christ
Perugino

Finding of Moses
Perugino

E
N — S
W

Fig. 2.   Plan of Chapel

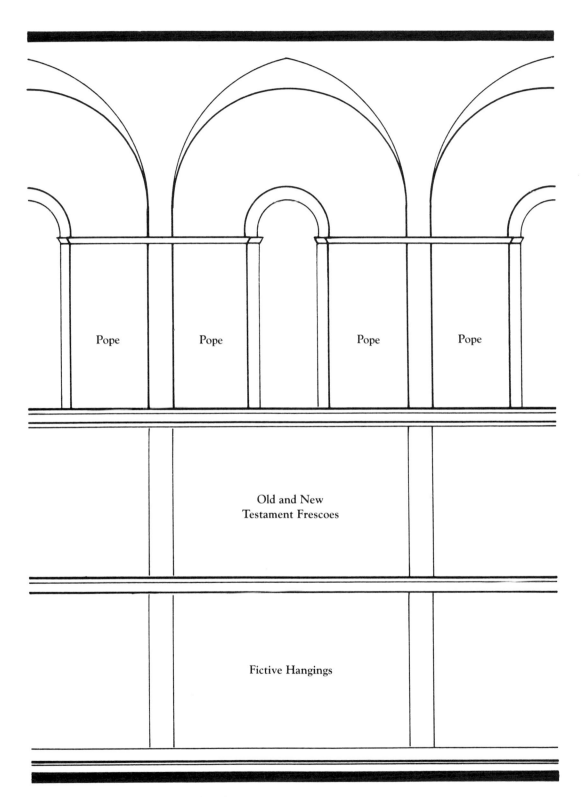

Pope    Pope    Pope    Pope

Old and New
Testament Frescoes

Fictive Hangings

FIG. 3. Elevation, side wall of Chapel

FIG. 4.   Perugino, *The Baptism of Christ* (detail), Seated Catechumen

FIG. 5.   Perugino, *The Baptism of Christ* (detail), Christ Preaching

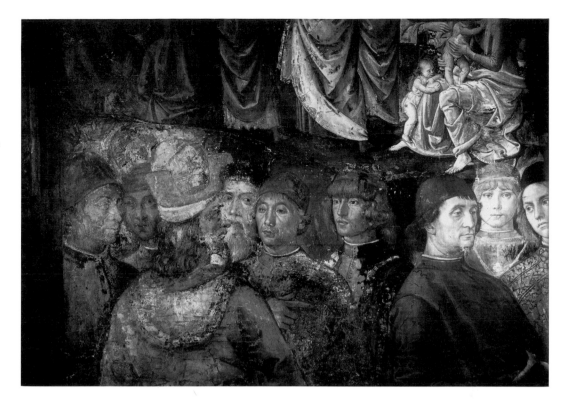

FIG. 6. Perugino, *The Baptism of Christ* (detail), Man in Oriental Hat

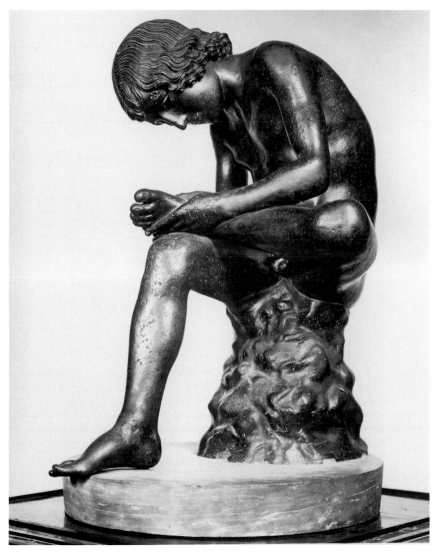

FIG. 7. The *Spinario*, Museo Nuovo, Palazzo dei Conservatori, Rome

FIG. 8.    Perugino and Pinturicchio, *The Circumcision of Moses' Son* (detail), Zipporah and Her Sons

FIG. 9.    Perugino and Pinturicchio, *The Circumcision of Moses' Son* (detail), The Circumcision

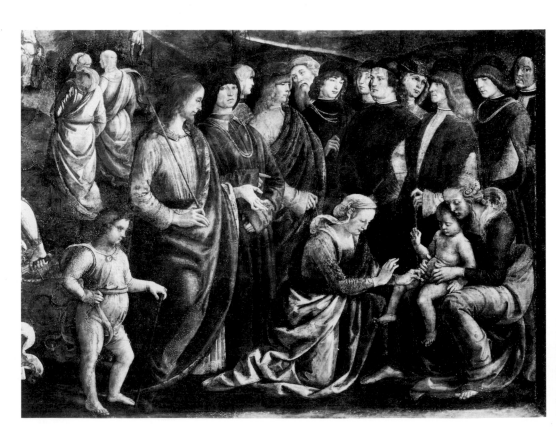

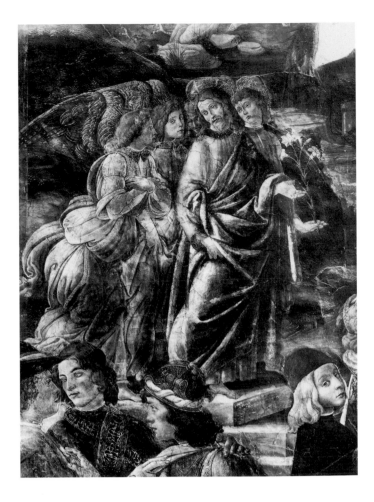

Fig. 10. Botticelli, *The Temptations and Jewish Sacrifice* (detail), Christ and Angels

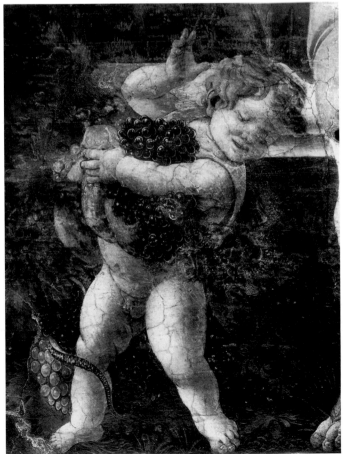

Fig. 11. Botticelli, *The Temptations and Jewish Sacrifice* (detail), Boy with Grapes

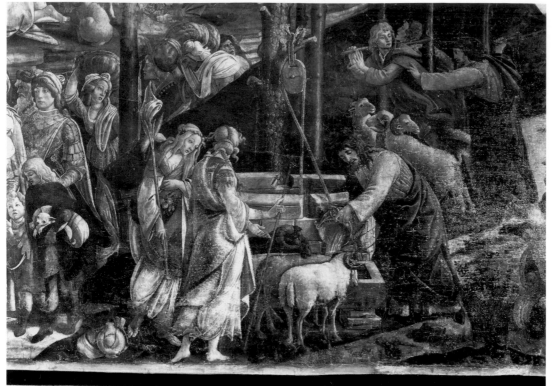

FIG. 12. Botticelli, *Moses in Egypt and Midian* (detail), center of Fresco

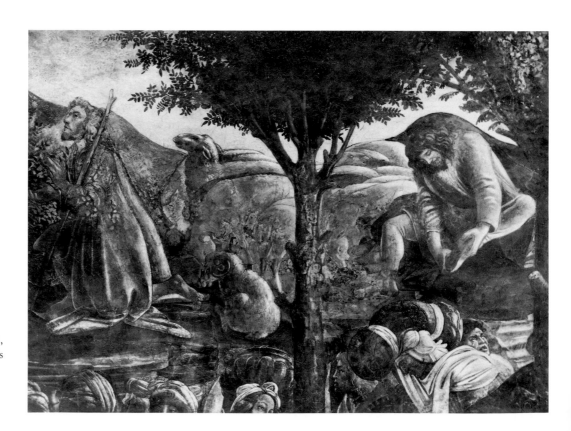

FIG. 13. Botticelli, *Moses in Egypt and Midian* (detail), Moses Removes His Sandals

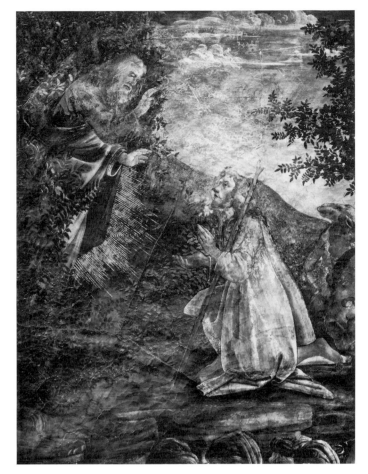

FIG. 14. Botticelli, *Moses in Egypt and Midian* (detail), Moses and the Burning Bush

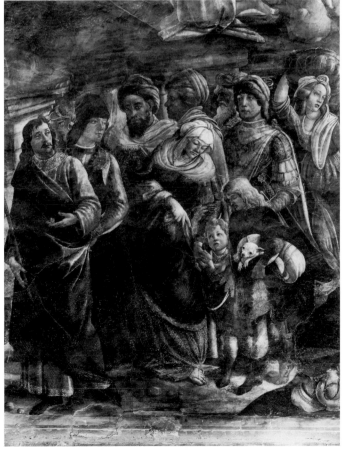

FIG. 15. Botticelli, *Moses in Egypt and Midian* (detail), Traveling Israelites

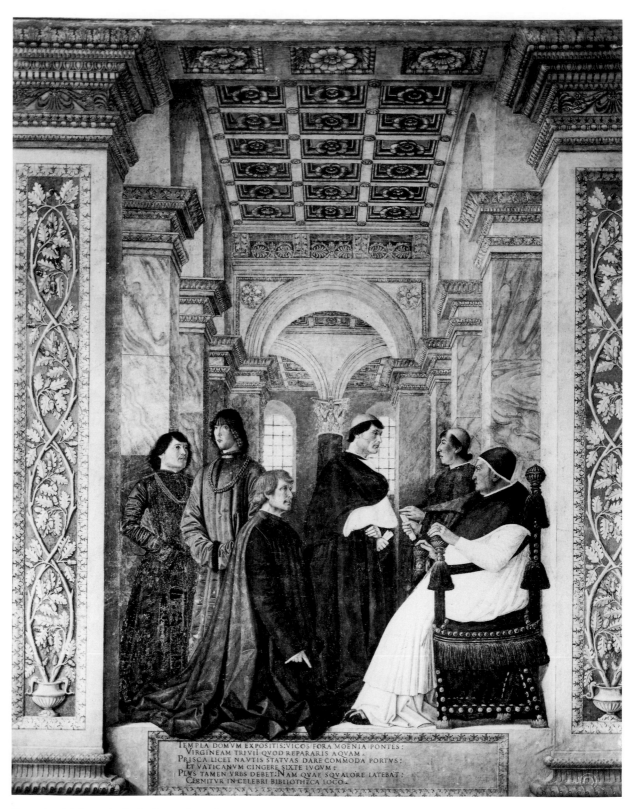

TEMPLA·DOMVM·EXPOSITIS·VICOS·FORA·MOENIA·PONTES:
VIRGINEAM·TRIVII·QVOD·REPARARIS·AQVAM·
PRISCA·LICET·NAVTIS·STATVAS·DARE·COMMODA·PORTVS:
ET·VATICANVM·CINGERE·SIXTE·IVGVM:
PLVS·TAMEN·VRBS·DEBET:NAM·QVAE·SQVALORE·LATEBAT:
CERNITVR·IN·CELEBRI·BIBLIOTHECA·LOCO·

FIG. 16.   Melozzo da Forlì, *Sixtus IV and His Retinue at the Opening of the Vatican Library*

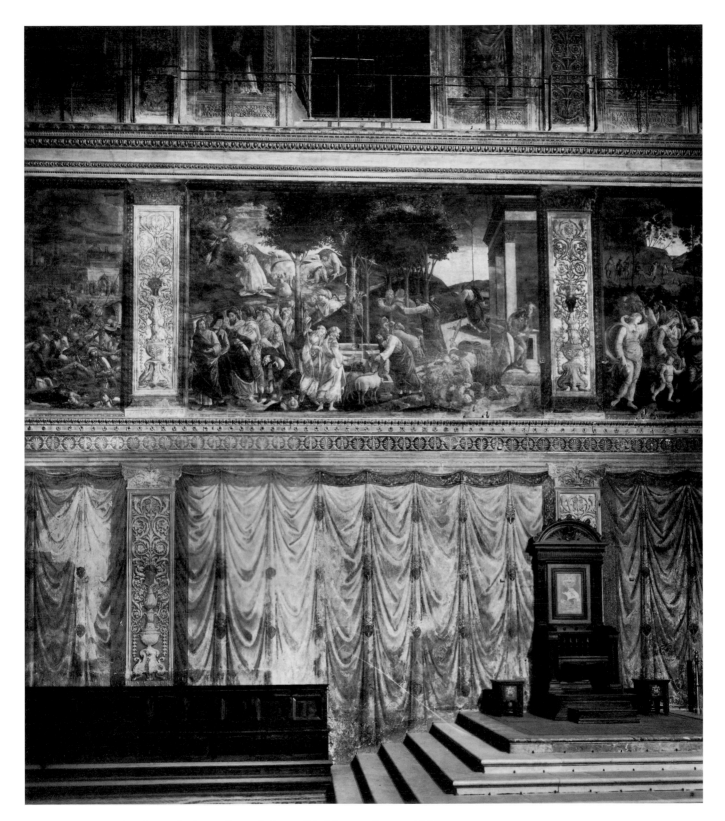

Fig. 17. Sistine Chapel, Papal Throne Beneath Botticelli's *Moses in Egypt and Midian*

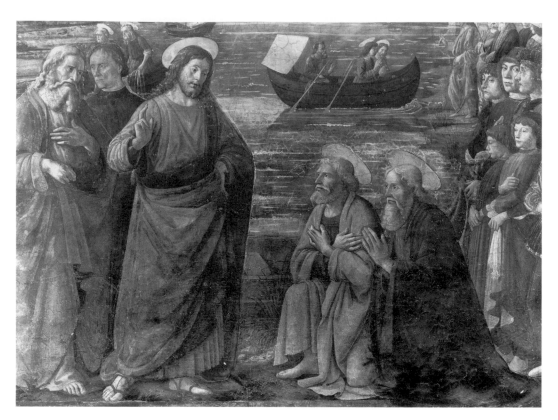

FIG. 18.   Ghirlandaio, *The Calling of the First Apostles* (detail), Christ, Peter, and Andrew

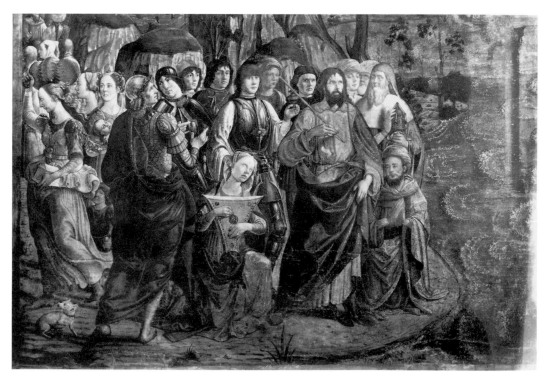

FIG. 19.   Rosselli, *The Crossing of the Red Sea* (detail), Song of Miriam

FIG. 20.   Rosselli, *The Crossing of the Red Sea* (detail), Horseman

FIG. 21.   Rosselli, *The Crossing of the Red Sea* (detail), Enigmatic Scene in Upper Right Corner

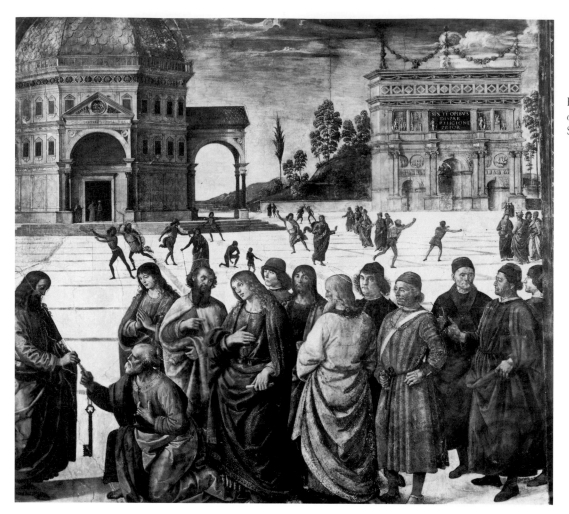

FIG. 22. Perugino, *The Gift of the Keys* (detail), The Stoning of Christ

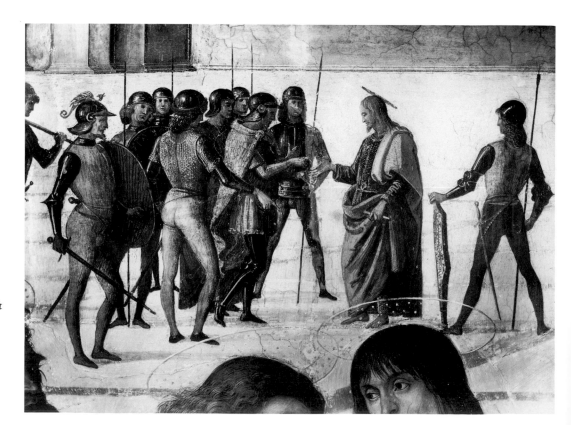

FIG. 23. · Perugino, *The Gift of the Keys* (detail), The Payment of the Tribute Money

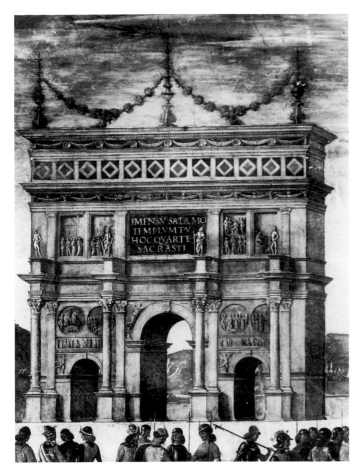

FIG. 24. Perugino, *The Gift of the Keys* (detail), Left Triumphal Arch

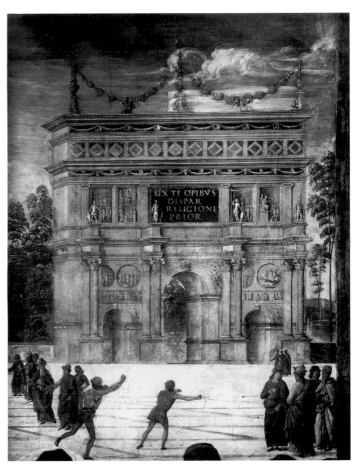

FIG. 25. Perugino, *The Gift of the Keys* (detail), Right Triumphal Arch

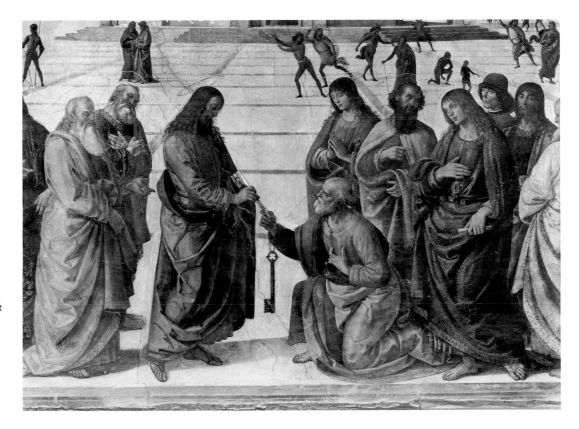

FIG. 26. Perugino, *The Gift of the Keys* (detail), Christ Hands the Keys to Peter

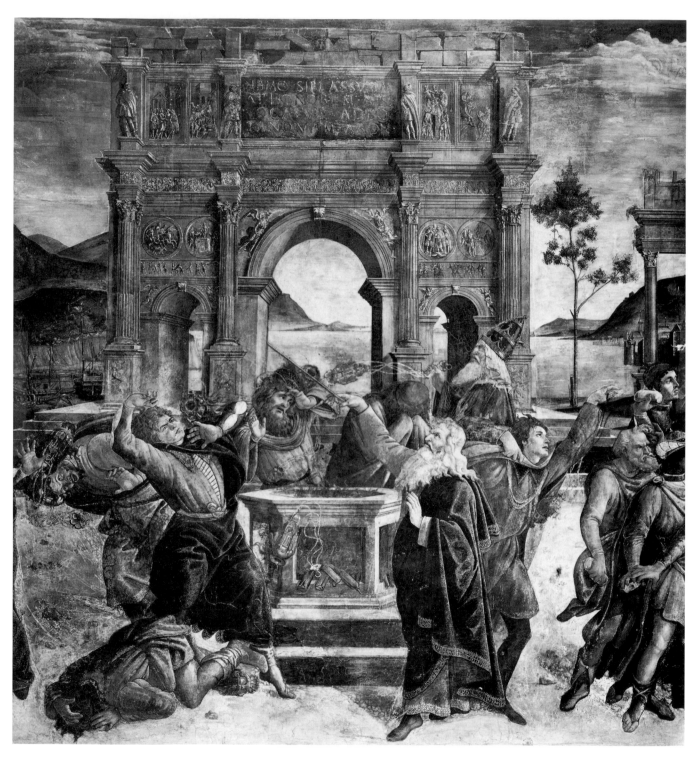

Fig. 27.   Botticelli, *The Revolt of Korah* (detail), The Punishment of Korah and His Followers

FIG. 28. Botticelli, *The Revolt of Korah* (detail), The Earthquake

Fig. 29. Botticelli, *The Revolt of Korah* (detail), The Beached Ships

Fig. 30. Botticelli, *The Revolt of Korah* (detail), Joshua (?)

FIG. 31. Signorelli, *The Last Testament of Moses* (detail), Moses Hands His Staff to Joshua; Nude Youth

FIG. 32. Signorelli, *The Last Testament of Moses* (detail), Moses Reads from the Book of the Law

FIG. 33.   Signorelli, *The Last Testament of Moses* (detail), Moses Shown the Promised Land

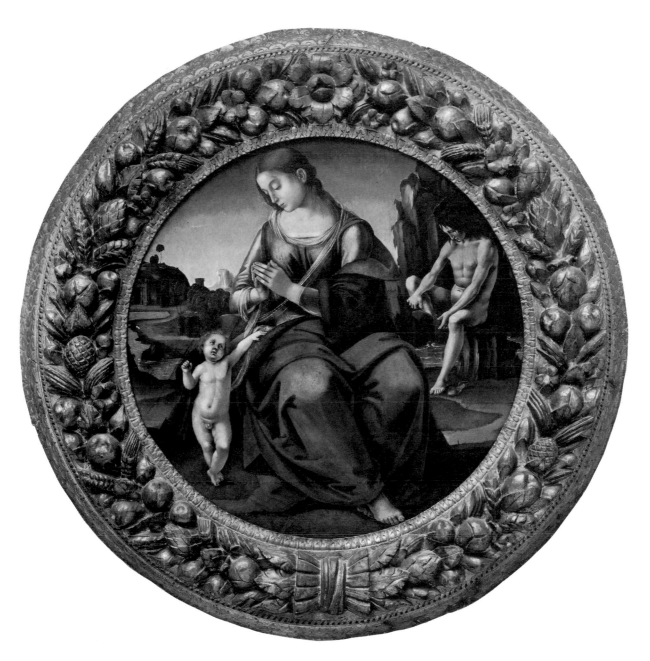

Fig. 34. Signorelli, *Madonna and Child*

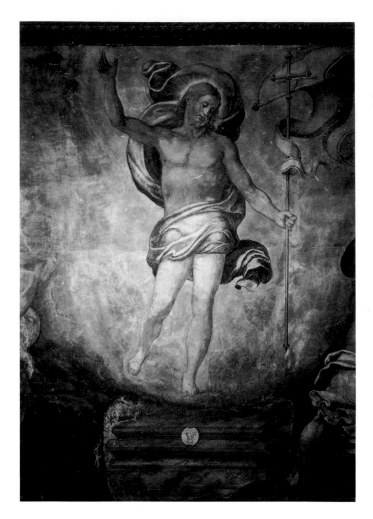

FIG. 35.   Van den Broeck, *The Resurrection and Ascension of Christ* (detail), The Risen Christ

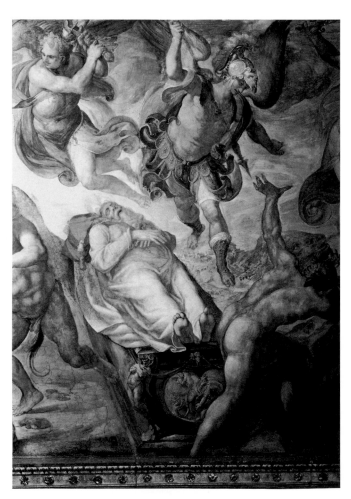

FIG. 36.   Matteo da Lecce, *The Fight for the Body of Moses* (detail), Moses' Catafalque